GET THE MESSAGE?

GET THE MESSAGE?
A Decade Of Art For Social Change

LUCY R. LIPPARD

E. P. DUTTON, INC. • NEW YORK

All photographs copyright the artist.

Copyright © 1984 by Lucy R. Lippard
All rights reserved. Printed in the U.S.A.

Published in the United States by
E.P. Dutton, Inc., 2 Park Avenue, New York, N.Y. 10016

Library of Congress Catalog Card Number: 83-71105
ISBN: 0-525-48037-4

Published simultaneously in Canada by
Fitzhenry & Whiteside Limited, Toronto

W

10 9 8 7 6 5 4 3 2 1

First Edition

Contents

Author's Note

This book is the third collection of essays I've published in a little over a decade. Each of my books has marked the beginning of a specific phase of my life, though not necessarily its end. *Changing* (1971) was the product of my "formalist" or art-educational period; it consisted primarily of essays written from 1965 to 1968, with a few late additions foreshadowing my next book—*Six Years: The Dematerialization of the Art Object . . .* (1973). *From the Center* (1976) and *Eva Hesse* (1976) documented my developing conversion to feminism, which expanded all the possibilities that had seemed to be closing down in the "cultural confinement" of the early 1970s. *Get the Message?* is the result of a need to integrate the three sometimes contradictory elements of my public (and often private) life—art, feminism, left politics. Owing to publication delays, only two essays from the last two years are included.

I would like to thank the Heresies Collective, Joan Braderman, Carl Andre, May Stevens, Rudolf Baranik, Elizabeth Hess, Suzanne Lacy, Judy Chicago, Jerry Kearns and the members of PADD for everything I've learned while working with them (among many others); Lanie Lee for assistance in preparing the manuscript, Jan Hoffman for editing the *Voice* pieces and Agnes Zellin for photographic assistance.

This book is dedicated to my son, Ethan Ryman, as he leaves home for a world the artists in this book are trying to change.

I

THE DILEMMA

Prefatory Note

The dilemma is, of course, how to integrate art and politics—those two crucial elements of our culture that have been called oil and water (by those who fear the merger). I personally came late to the Left. I was raised a caring liberal with no real political education. What social consciousness I gained from my parents, and from the revelatory experience of working for several months after college in a Mexican village with the American Friends Service Committee, was buried when I immersed myself in the New York art world in 1959. It surfaced again on a jurying trip to Argentina in 1968, when I was forced to confront and reject corporate control and met for the first time artists who had committed themselves to militant social change, feeling that isolated art for art's sake had no place in a world so full of misery and injustice.

When I returned to New York from Latin America, I fell belatedly into that pocket of the art community that was actively protesting injustices. In October, the painter Robert Huot involved me and antiwar activist Ron Wolin in organizing a "peace" exhibition at the Paula Cooper Gallery, for the benefit of the Student Mobilization Committee to End the War in Vietnam. If I do say so, this was the best "Minimal show" I ever saw. Andre, Baer, Flavin, Judd, LeWitt, Mangold, Ohlson and Ryman, among others, rose to the occasion and made or gave major works for it. The organizers' statement read:

> These 14 non-objective artists are against the war in Vietnam. They are supporting this commitment in the strongest manner open to them, by contributing major examples of their current work. The artists and the individual pieces were selected to represent a particular esthetic attitude, in the conviction that a cohesive group of important works makes the most forceful statement for peace.

As this book demonstrates, I have since come to think that artists can also make art directly involved in social change. But that show raised a lot of money for the movement and provided what was for me the unprecedented experience of working politically with artists. A few months later I was in on the beginnings

of the Art Workers' Coalition (AWC) and became an activist myself. In the next two or more years I learned more about the relationship of art and artists to social structures than I had in college, graduate school and ten years in the art world altogether. Like many others, I could never again pretend ignorance (or innocence) of the way art is manipulated by greed, money and power.

The AWC came at just the right moment for me. I already sensed the art world was an unhealthy place for art and artists, but had no progressive theory with which to analyze my discontent. By 1968 I was indirectly radicalized, or alienated, by the competitive careerism that dominated the art world. I saw what was happening to old friends who had "made it" and I was afraid of being kicked upstairs into the ivory tower. After publishing prolifically for four years, I realized that if this was success, I enjoyed it, but it wasn't enough. I was losing some of my starry-eyed idealism about art and I worried about its involuntary separation from daily life. I had long been an adversary of Greenbergian elitism; I had learned a good deal about "political art" since the 1930s from writing a book on Philip Evergood, and about the artworld commodity system from writing a book on Pop Art. Since 1966, I had been writing a book on Ad Reinhardt (self-defined "last artist on the picket line") and was much influenced by his witty and jaundiced view of the New York art world. In 1967, I became unduly excited about Conceptual Art's potential for a politicized populism, partly because it incorporated words with images and seemed to deny the primacy of the object.

I have always identified with artists rather than with other critics and curators, a fact I attribute to a life of free-lancing which in turn is rooted in a basic "authority problem"; I don't like being told what to do, and art has a reputation for some mythical "freedom." I've always lived with and among artists, and when talking about artists organizing in the essays below, I often say "we." I have written fiction off and on since high school, but in 1969 I began to make streetworks and in 1970 I wrote the first of three novels. I am occasionally "accused" of being an artist. I used to deny this adamantly and it still makes me feel funny, since I am primarily a writer. Words are my medium. But I discovered in Conceptual Art a "third stream" that has allowed me to work at times in some blurred area between art and criticism. Now, having urged everyone else to break out of boundaries, I find myself wandering in a well-deserved no-one's land.

In the AWC, I was first exposed to activist art and to Marxism. Put off by the high-flown rhetoric and apparent hypocrisy of some who subscribed to Marxist chic (but disavowed social action to support their supposed beliefs), I only gradually began even to call myself a socialist. (Feminism, of course, threw another, constructive, wrench into that process.) In the AWC's anarchic meetings I learned to speak in public; in the Action Committee I learned to take my rage into the streets, to leaflet, picket and fight back in person and in print; the Decentralization Committee gave me a glimpse of community organizing.

In the AWC I was also first confronted with feminism, via Women Artists in Revolution (WAR). I was embarrassed by it and resisted it, declaring I was a person, not a woman. I was unwilling to admit my own oppression, willing as I was to stand up for other "underdogs." Looking back, I wonder why I heard about the Women's Movement so late and how I managed to keep my head under the sand for so long. Resistance was dispelled when I wrote my first novel and was forced to examine a woman's life in terms of personal politics. I found my own lacking, and fell into the arms of feminism in the summer of 1970.

Being an impatient type, I did a lot more yelling and acting than thinking and reading in the AWC, but for the first time in my life I understood how much a community's social responsibility depended on the individual, and how much the individual's fate depended on collective action. From being highly antagonistic to groups, I became and remain a fanatic "clubwoman." Looking over the 1970 essays in this first section, I am simultaneously annoyed by their arrogance, amused by their naïveté, and touched by their passion. (I can't imagine how I ever thought Charles Manson was even an antihero.) I am also somewhat saddened by the similarity to our needs and strategies today, though the world situation in February 1982, as I write this, seems far more ominous than I could have imagined in the newfound oppositional exuberance of the late '60s.

The Dilemma*

"Naturally the deadly political situation exerts an enormous pressure.

"The temptation is to conclude that organized social thinking is 'more serious' than the act that sets free in contemporary experience forms which that experience has made possible.

"One who yields to this temptation makes a choice among various theories of manipulating the known elements of the so-called objective state of affairs. Once the political choice has been made, art and literature ought of course to be given up.

"Whoever genuinely believes he knows how to save humanity from catastrophe has a job before him which is certainly not a part-time one.

"Political commitment in our time means logically—no art, no literature. A great many people, however, find it possible to hang around in the space between art and political action.

"If one is to continue to paint or write as the political trap seems to close upon him he must perhaps have the extremest faith in sheer possibility.

"In his extremism he shows that he has recognized how drastic the political presence is." —ROBERT MOTHERWELL;
 HAROLD ROSENBERG, 1947

"Do you think that when a painter expresses an opinion on political beliefs he makes even more of a fool of himself than when a politician expresses an opinion on art? NO!" —AD REINHARDT, 1946

"The artist does not have to will a response to the 'deepening political crisis in America.' Sooner or later the artist is implicated or devoured by politics without even trying If there's an original curse, then politics has something to do with it." —ROBERT SMITHSON, 1970

"I think the time for political action by artists is now and I believe action should

*Reprinted by permission from *Arts Magazine* (Nov. 1970).

be taken in the art world and in the world at large. Political action need not inhibit art-making; the two activities are dissimilar, not incompatible."

—JO BAER, 1970

"It's all a matter of economics, not politics. Throughout the centuries of art-making there have been wars, investigations, pogroms. The artist does battle on his own field, and resents being forced into combat with strangers, by a government that does not nourish him." —ROSEMARIE CASTORO, 1970

"The hierarchical make-up of the art world is simply a network of community and interest, filled with art men and women, no more, no less. If it strikes at the war and racism, I will be there; if it doesn't, I'll be elsewhere."

—IRVING PETLIN, 1970

"What is the relationship between politics and art?
 A. Art is a political weapon.
 B. Art has nothing to do with politics.
 C. Art serves imperialism.
 D. Art serves revolution.
 E. The relationship between politics and art is none of these things, some of these things, all of these things." —CARL ANDRE, 1969

"A cleaner New York School is up to you." —AD REINHARDT, 1959

" . . . History being perhaps the most viable tool of politics. All Art as it becomes known becomes political regardless of the intent of the Artist. . . . I accept fully the responsibility for the position of my Art in Culture Politics—but hold firmly that my actions as a man constitute only that." —LAWRENCE WEINER, 1970

"For me there can be no art revolution that is separate from a science revolution, a political revolution, an educational revolution, a drug revolution, a sex revolution or a personal revolution." —LEE LOZANO, 1969

The "growing ethical and political concern" manifested over the last few years in the art world is not new. The writings and published discussions of the Abstract Expressionist generation, to say nothing of the 1930s, are full of references to morality, with the artist (or at least art) seen as the ultimate good. So far, Lenin's much-quoted remark that ethics will be the esthetic of the future (and its subsequent reversals and paraphrasings) has not been borne out by actual events even in times as grim as these. If esthetics is turning into anything else at the moment, it may not be ethics so much as anarchy. On the other hand, the root of the word *ethic* means "essential quality" and "conforming to the standards of a given profession" as well as morality. In this sense it applies to the rigidities of so-called modernism, by which keen perception becomes good taste becomes the *only* taste becomes an ethic, or lack thereof. Actually, all the words that familiarly define American art in chauvinist terms imply an ethic rather than an esthetic, among them the words the first generation of the New York School preferred in reference to their own work: *direct, honest, tough, presence, moral, sublime,* etc.

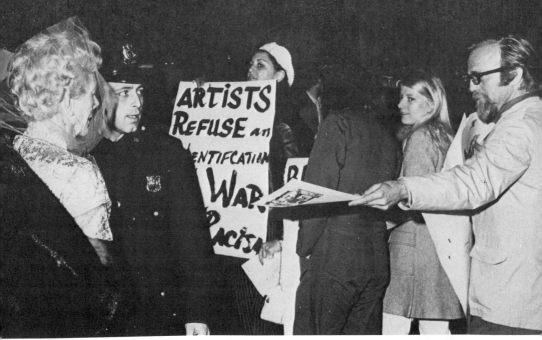

The Art Workers' Coalition protests the opening of the Nelson Rockefeller Collection at The Museum of Modern Art, New York, 1971. (Photo: Mehdi Khonsari)

Perhaps honesty has been a major criterion in American art for some time now. If so, honesty to what? To the "nature of the medium" in the case of rejective artists, to communication and sometimes "the people" in the case of acceptive artists, to art as objectless concept in the case of some "dematerialists," and to an undefined level of "quality" for most artists, although this has been twisted by one small group into something resembling fascism more than any ethic (i.e., you can't like a good work unless you like it for the "right" reasons). Or maybe honesty to a quality of life, or to the keenness of one's own perceptions. Honesty to oneself? Or maybe to an ideal of art as the ultimate honesty in dealing with the world or with oneself. An Art Workers' Coalition tract defined *esthetics* as "philosophizing about art" and *ethics* as "philosophizing about artists."

In all the complaints about and equally idiotic eulogies of a "new politicization" which promises to be this season's dead horse, there is a fundamental confusion between art-politics and politics-politics. It is too simple to say that the latter deals with the "real world" and the former with intramural competition for the money, power and social success up for grabs in the "art world." Esthetics enters into neither one. Sure, a lot of the best artists are also the most successful (so are a lot of the worst), but the history of a work of art once it gets out of the studio is far more closely entwined with the actions of a discriminatory, martial government and the capitalist system that supports it than it is with the ideas and aims of the artist who made it. It's all very well for an artist to say that esthetics is his ethics, or his art is his politics, but no one today should be capable of living a purely esthetic life. A successful artist who has profited from the system has a certain responsibility to put some money back into changing the system (benefits, posters, etc.) but he also has some responsibility to the broad art community from which he emerged. The major contribution of organizations

like the Art Workers' Coalition is a nagging insistence on general awareness of issues like artists' control of their work, consistent contracts, use of artists' power to persuade institutions to speak up on "political" issues. Is war a "political issue"? Is racism? Is sexism?

The interrelationship between art politics (basically economics) and national or international politics makes many artists unwilling to think about improving their own conditions as artists. The minute an artist begins to think about his own economic and psychological dignity he is reminded of those in much worse shape and more helpless than he is. Many will draw the conclusion that art is "outside" the kind of political considerations found in "life"; that the artist is therefore powerless, and must guard his art from the threat of absorption into the politicization inherent in life.

False, on several levels. First, an artist has power as a human being, and also as an artist. The museums in New York are politically compromised weekly: witness Rockefeller's campaign in the form of three one-man shows for his collections at three major New York museums last year; witness the Metropolitan's proposed expansion and the nitty-gritty political plane on which it is being discussed; witness the Lower Manhattan Expressway and the real-estate versus human values it brought up, or the SoHo Hearings, and so on. Museums of art are among a living artist's responsibilities. An artist who withdraws his work from a museum exhibition because the show is backed by a company thriving on the war in Indochina, who refuses to participate in a government-sponsored exhibition because the government perpetrates that war, as well as racism and repression, who won't show an ecological piece in a show backed by American Motors, is not *using* his art in a manner contrary to its creation any more than is an artist who withdraws because his work has been mistreated, misdisplayed or misinterpreted. In fact, his art, which he has made presumably in hopes of potential communion with others to provoke a different vision of or closer look at or alternative to this sordid life (through abstraction, or idea or more overt protest)—this same art is being used in a manner contrary to its creation when it is used as public relations for a malignant government or an industrial monopoly.

One of the most common complaints heard nowadays from artists who feel threatened by political action in or out of the art world is that they are being *used*. One can only wonder why or how a successful artist allows himself or his work to be "used" by a critic or institution or system he claims to despise. Why can't he simply refuse to be used? But related questions can be asked about the "use" of art in calmer times. Is art decoration, escape, entertainment? Or does it in fact deal with the "new realities" as claimed by endless twentieth-century movements, abstract and figurative, object and nonobject? An exhibition of good abstract art held as a benefit for the antiwar movement does not seem to me a contradiction. Nor does an artist's participation in a strike to close art-business-as-usual for a day or more as a protest against what that business indirectly endorses—whether it is war or unfair trials. An artist's public power is as an artist, not "just" as a human being, but as a human being who makes art. Suggestions that he forget about making art because the world is in such rotten shape, that he go out and bomb buildings or build roads in Latin America, are inane except in terms of the most personal life-decisions. A "famous artist" who speaks out against social injustice or makes a protest poster or raises money for defense funds from his wealthy patrons (who often give because they respect him as an

artist, or want to be pals with a star) calls attention to that injustice far more effectively as an artist than he could as an anonymous performer in radical scenarios.

We are all too aware that art itself is "irrevelant," and that compared to the world of slums, wars, prisons, the art world is a bed of roses. At the same time art is what we do or art is the focus of what we do. A mass exodus from art-making would hardly contribute to the world a great factor for change, but a world without art or the desire to make art or the need for some kind of art activity would be a hopeless world indeed. There is no reason why an artist has to "step out of art and into politics," as one man recently put it, to act as a human being with a conscience. (Ad Reinhardt, a case in point, called himself "the last artist on the picket line," but just as he may have been the last of his generation, he was joined by the first of the current generation in peace marches, endorsement of candidates, fund raising, etc.) It is simply a matter of priorities. If an artist (like anyone else) considers his time and money spent more valuably at parties or bars than working for social change, that is clearly his choice. But given the fate of artists in totalitarian societies, it would seem in his interest to use that time more wisely. Statements like "my guess is that most artists are better off out of politics"[1] are irresponsible. Perhaps intended to imply that artists are above it all, they suggest the reverse to me. If artists, like teachers and priests, "should be better than businessmen," if "art is not the spiritual side of business" (Reinhardt), then perhaps artists are guiltier than nonartists of crimes of silence, the political naïveté from which we all suffer notwithstanding. The critic's dilemma is, of course, the same, if not worse, since criticism is a secondary rather than a primary activity and therefore provides less rationale for a cop-out.

Few of us today have any illusions left about the existence of a truly political art. Such an art (not a style) would not merely illustrate the wrongs of a society nor even merely encourage rights, but would contain a built-in threat to that society. (Similarly, the AWC is more potent as a threat to the art-institutional status quo than as an activist organization.) It is curious that most art associated with and used by the revolution is stylistically so reactionary, psychedelic posters sharing their Art Nouveau and Art Deco heritage with Madison Avenue, interior decoration and the middle-class fashion world. Even the harsh tabloidism of Red Chinese art ultimately refers to bourgeois (and Western) styles. No matter how strongly felt (and the strong feelings are communicated in direct proportion to the artist's abilities as an artist, not as a propagandist), the *illustration* of any situation, no matter how ghastly, provides nothing but clichés. The first decision made about the execution of the My-Lai massacre protest poster, published by the AWC last year, was that it be "nonartistic," that no individual artist's name be connected with it, that the "art" be a documentary photograph. Forcefully designed and graphically revolting, or heartbreaking, captioned simply "Q: And Babies? A: And Babies," and distributed free in an edition of 50,000, despite CBS's William Paley's rejection for the Museum of Modern Art of the agreed joint sponsorship, this poster was more effective than anything done so far by a single artist. (It could have been still more effective if the proposal made by Art Strike that it be on the fall cover of all four New York art magazines, this one included, had been accepted; one can only speculate on the social safety-valves presented as excuses for its rejection by *ARTnews* and *Art in America*.) *Guernica* has outlived the Spanish Civil War, if not fascism, and become a million-dollar painting by

Picasso. The mere attachment of a name recalls too vividly the fact that the work is a commodity as well as a protest. Asking artists to design peace posters recently, I had to admit I was asking not for (perhaps impossible) "revolutionary art," but for a touching yet *salable* object, to finance antiwar demonstrations. It is frustrating to all concerned to be so aware that this art and this money disappearing into an honest attempt to change or forestall the system are in reality prolonging it by admission of a false value structure.

Artists asked to do this sort of thing, or even to contribute work to a benefit exhibition, are confronted with the fundamental and pathetic choice between adding a line of type to work in their own "style" and thereby identifying themselves and their art with a worthy cause (but at the same time, perhaps, diluting their art and "using" it for something other than its initial reason for existing, and even questioning that reason) or of underlining that commitment by using unaccustomed subject matter and thus competing, even on an unequal level, with the media. As Harold Rosenberg has depressingly but accurately observed, "the more advanced the communications system, the less the impact of the unique aesthetic statement. To challenge the version of events disseminated by contemporary propaganda machines with a painting or sculpture is like battling a tank division with a broomstick."[2] Nevertheless, the My-Lai poster, by being handed out free, as posters by nature should be, was visible at the street level, and a lot of people are still in the streets as well as sitting in front of their TV sets. A poster workshop is now being set up so that such projects as the specially designed peace posters need not end up as *"editions de luxe"* but can also be tested on the confrontational level. On the other hand, many of them will be bought (not necessarily the artists' choice) for the boudoir or rumpus room. Mass distribution, free, of artist-designed posters will only bring up new problems for the artists concerning use of their art, or of their abilities to make forceful visual statements.

No matter how well meant, one can only regret such manifestations as the recent "blood show" at a downtown gallery. Presented as a political statement on a leaflet handed out in the gallery, but as art alone in the mailer sent out earlier, it turned out to be original only in its aroma; the precious-object–oriented plastic boxes were familiar vehicles for art. Without touching on the esthetic problems involved, I can say that if the work had been anonymous, if it had been presented out of a private art context (like the Guerrilla Art Action Group's animal-blood protest events in the streets and museums), if it had not been advertised so prettily, then it might have come off as more than a (hopefully well-intended) publicity gimmick. Across the street at the same time was a more effective display of stenciled "blood-stained" packets by Uruguayan artist Luis Camnitzer, who used his own art style for political subject matter not new to his work; however, he too suffers by comparison with his compatriots, the Tupamaros, simply because this is presented as art. A ring Camnitzer made for his wife, congealed "blood" and a bullet under a plastic dome, was perhaps the grisliest artifact of all; the translation of real mass murder into body ornament confirms the implications of Andy Warhol's *Disaster* series: the media have rendered all such horrors impotent to affect us more than momentarily. We know too much, once-removed. In all fairnesss, of course, one can see another, less chic, intention behind such objects—that of protest demonstrations: keep the facts out there where people are constantly reminded of them, no matter how sugar-coated or invisible they may have become from overexposure.

Abbie Hoffman (as *The Drama Review* and other sources have known for some time and the media are beginning to fully appreciate), the Weatherman bombings, Charles Manson, and the storming of the Pentagon are far more effective as radical art than anything artists have yet concocted. The event structure of such works gives them a tremendous advantage over the most graphic of the graphic arts. If the theatre was the deadest art form of all during the '60s (with the exception of a few visually or experience-oriented groups who often worked from or with visual artists' ideas), the visual arts may be scheduled for the same fate in the '70s. This is not to say that good art that gives pleasure and provocation won't be made in the '70s, but that the more the ethics of art as a commodity is questioned, the more frustrated artists become from running up and down the stairs between the ivory tower and the streets, the more artists question their own lack of rights and dignity, then the more that curious combination of freneticism, desperation, and apathy characterizing the art world these days may be threatened. The end of art is not, luckily, in sight. But only the hangers-on and profiteers would mourn the demise of the "art world" as we know it now. Perhaps as an artist's time becomes increasingly divided between the studio, the school (necessary to keep the majority alive and in a studio at all), and the streets (or whatever the artist's equivalent of the streets turns out to be), less time will be available for the social amenities demanded by the elaborate system of money-power-social contacts that nourishes the public image of artist and art world. Just as some artists are still social climbing, some will always remain to bolster the old image, the collector's ego, the institution's elitism, and get fat off it. What the others will do is anybody's guess. The only sure thing is that artists will go on making art and that some of that art will not always be recognized as "art"; some of it may even be called "politics."

NOTES

1. Darby Bannard, *Artforum* (Sept. 1970).
2. *The New Yorker* (Dec. 16, 1967).

The Art Workers' Coalition: Not a History*

On April 10, 1969, some 300 New York artists and observers thereof filled the amphitheatre of the School of Visual Arts for an "Open Public Hearing on the Subject: What Should Be the Program of The Art Workers Regarding Museum Reform, and to Establish the Program of an Open Art Workers' Coalition." The last time such a large and various group had got together for nonesthetic reasons concerned the Artists Tenants Association's threatened loft strike in 1961, which did not take place. The hearing was preceded by a list of thirteen demands to the Museum of Modern Art and demonstrations supporting them which emphasized

*Reprinted by permission from *Studio International* (Nov. 1970).

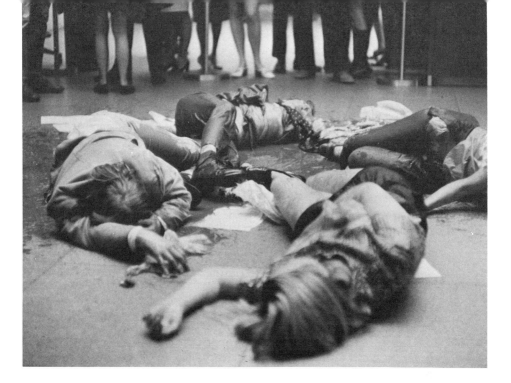

The Guerrilla Art Action Group (l. to r.: Jean Toche, Jon Hendricks, Poppy Johnson, Silvianna). *A Call for the Immediate Resignation of All the Rockefellers from the Board of Trustees of the Museum of Modern Art,* lobby of The Museum of Modern Art, New York, November 18, 1969. (Photo: © 1978 Ka Kwong Hui)

artists' rights: legal, legislative and loosely political; they were the product of the newly named Art Workers' Coalition (temporarily and simultaneously the Artists' Coalition). The AWC was conceived on January 3, 1969, when the kinetic artist Takis (Vassilakis) made a symbolic attempt to remove a work of art, made by him but owned by the Museum of Modern Art, from the museum's "Machine" show, on the grounds that an artist had the right to control the exhibition and treatment of his work whether or not he had sold it. Not a revolutionary proposition, except in the art world.

Despite the specific subjects announced for the open hearing, taped and later published verbatim by the AWC, the real content of the night was the airing of general complaints about The System, epitomized by Richard Artschwager's use of his two minutes to set off firecrackers instead of talk. The picture of frustrated violence that emerged from this motley cross section of the art community (the speakers were 70 artists, architects, film-makers and critics, a number of them Black) surprised the establishment at which it was aimed. As well it might, since artworld complaints are made loudly, but in the relative privacy of studios and bars, rarely in public. Those who voiced them were immediately accused of opportunism by some of those who remained closet protestants. A number of speakers considered the Museum of Modern Art an unworthy object of artists' attention, but a grudging consensus agreed it was the best place to start if only because it is the seat (in all senses) of power; not enough people, time and energy were available then to tackle all the museums at once, and MOMA qualified by its

rank in the world, its Rockefeller-studded board of trustees with all the attendant political and economic sins attached to such a group, its propagation of the star system and consequent dependence on galleries and collectors, its maintenance of a safe, blue-chip collection, and particularly, its lack of contact with the art community and recent art, its disdain for the advice and desires of the artists who fill its void. The demands made in February 1969 were boiled down from thirteen to eleven in June, and revised slightly as the nine-plus below to apply to all museums in March 1970.

A. WITH REGARD TO ART MUSEUMS IN GENERAL THE ART WORKERS' COALITION MAKES THE FOLLOWING DEMANDS:

1. The Board of Trustees of all museums should be made up of one-third museum staff, one-third patrons and one-third artists, if it is to continue to act as the policy-making body of the museum. All means should be explored in the interest of a more open-minded and democratic museum. Artworks are a cultural heritage that belong to the people. No minority has the right to control them; therefore, a board of trustees chosen on a financial basis must be eliminated.

2. Admission to all museums should be free at all times and they should be open evenings to accommodate working people.

3. All museums should decentralize to the extent that their activities and services enter Black, Puerto Rican and all other communities. They should support events with which these communities can identify and that they control. They should convert existing structures all over the city into relatively cheap, flexible branch-museums or cultural centers that could not carry the stigma of catering only to the wealthier sections of society.

4. A section of all museums under the direction of Black and Puerto Rican artists should be devoted to showing the accomplishments of Black and Puerto Rican artists, particularly in those cities where these (or other) minorities are well represented.

5. Museums should encourage female artists to overcome centuries of damage done to the image of the female as an artist by establishing equal representation of the sexes in exhibitions and museum purchases and on selection committees.

6. At least one museum in each city should maintain an up-to-date registry of all artists in their area, that is available to the public.

7. Museum staffs should take positions publicly and use their political influence in matters concerning the welfare of artists, such as rent control for artists' housing, legislation for artists' rights and whatever else may apply specifically to artists in their area. In particular, museums, as central institutions, should be aroused by the crisis threatening man's survival and should make their own demands to the government that ecological problems be put on a par with war and space efforts.

8. Exhibition programs should give special attention to works by artists not represented by a commercial gallery. Museums should also sponsor the production and exhibition of such works outside their own premises.

9. Artists should retain a disposition over the destiny of their work, whether or not it is owned by them, to ensure that it cannot be altered, destroyed, or exhibited without their consent.

B. UNTIL SUCH TIME AS A MINIMUM INCOME IS GUARANTEED FOR ALL PEOPLE, THE ECO-
NOMIC POSITION OF ARTISTS SHOULD BE IMPROVED IN THE FOLLOWING WAYS:

1. Rental fees should be paid to artists or their heirs for all work exhibited where admissions are charged, whether or not the work is owned by the artist.

2. A percentage of the profit realized on the resale of an artist's work should revert to the artist or his heirs.

3. A trust fund should be set up from a tax levied on the sales of the work of dead artists. This fund would provide stipends, health insurance, help for artists' dependents and other social benefits.

The extent to which each "member" agrees with each "demand" fluctuates to the point where structural fluidity of the organization itself is unavoidable. The AWC has as many identities as it has participants at any one time (there are no members or officers and its main manner of fund raising is a "Frisco circle" at meetings; the number of participants varies as radically as does their radicality, according to the degree of excitement, rage, guilt, generated by any given issue). It has functioned best as an umbrella, as a conscience and complaint bureau in-corporating, not without almost blowing inside out, groups and goals that are not only different, but often conflicting. Advocates of a tighter structure, of a real dues-paying union situation, have reason but not reality on their side. Nobody, in-side or outside the Coalition, has illusions about its efficiency; the difference is that everyone outside thinks it could be done better another way and from the in-side that looks impossible.

Don Judd, for instance, has been interested in a union setup since the Coalition began but was disgusted with the meetings he visited (and did not, incidentally, try to change or influence them by saying anything about his own ideas, which is too bad, because we could use his blunt, articulate intelligence). In a recent statement on art and politics [1] he wrote: "There should be an artists' organization. It's very odd to have a whole activity that can't help anyone in the same activity, that can't defend itself against carelessness and corruptions. The organization should have its own money; there could be a self-imposed tax by members on all sales, part from the artist's portion, part from the dealer's." (We've discussed this, but need, naturally, the support of a few more artists who have a portion at all, or who have a dealer.) Judd also says that "unlike the Art Workers an artists' organization should decide what it wants to do and go after it practically." Yet he agrees with our first demand and suggests we state that and talk to the museums. (We have, and still are.) Then he says that those museums "who refuse without reasons can be struck." (By whom? Judd and the rest of the art community's silent majority? If all those artists who want a union would get together and take over Section B of the Coalition's demands, they could comprise another special interest group under the "umbrella," or as a separate entity. But as long as the AWC's notorious sightseers, now perennial (Robert Smithson, Rich-ard Serra and editor Philip Leider come immediately to mind), many of whom are respected members of the art community and good talkers and would be able to convince a lot of people—as long as they play intramural games in the bars, telling everyone how absurd or mismanaged the AWC is, instead of saying the same things in the public arena, they will be the bane and to some extent the downfall of the Coalition.)

If I sound wistful, *or* overoptimistic, it's because I can't help remembering the beginnings of the Coalition. At the first few open meetings there was a terrific atmosphere of esthetic and economic mistrust. Eventually basic dislike of organizations, innate snobbism about which artists should or could be associated with, the reluctance to waste time, and revulsion for yelling, rhetoric and opportunism (not unique to the AWC) broke down in favor of common excitement and, finally, even affectionate tolerance for some of the more therapeutically oriented participants. Nobody thought it was ideal; and nobody had ever seen New York artists come on any other way, either. Despite the heterogeneous composition, during the winter and spring of 1969 the AWC became a community of artists within the larger art community. The honeymoon period centered around plans for the open hearing and publication of its record and, later, around the "alternatives committee," whose search for alternative structures ran the gamut between a trade union complete with dental care, a massive takeover of the city's abandoned Hudson River piers for studio and exhibition space (that is now being done by the establishment itself), and an information center complete with Xerox machine, ending comfortably, if a little wearily, as a discussion group covering the highest tides of idealism and philosophical foam, with which New York art is very much at home. The weekly general meetings consisted of about 60 people, sometimes 100; the committees were much smaller. Both were characterized by reversals and arguments and endless bullshit (usually defined as somebody else talking), naïveté, commitment, and lack of knowledge about how to implement it, a high evangelical pitch reached in the bar after meetings, not to mention the endless phone calls that plague a small organization with no efficient communication channels, all backed up by an excited realization that MOMA was, for some inexplicable reason, afraid of us.

This period culminated in intramural quarrels surrounding the problem of what to do about what the AWC called MOMA's "blackmail" of first-generation New York School artists (which I consider one of our most important endeavors), and problems of structure, now that the Coalition was getting big with what sometimes seemed a false pregnancy. These most often concerned the point of whether or not the general meetings should have veto power over hardworking committees or special interest groups, including the usually controversial "action committee," where the militants and the Guerrilla Art Action Group were focused. I, for one, agreed wholeheartedly with Kestutis Zapkus' antiveto "Proposal" circulated in the summer of 1969, which stated, among other things: "There is no reason why the AWC should model itself on the procedures of conventional bureaucratic organizations. The development of special interests must not be dissipated by a less involved majority."

The most controversial aspect of the AWC among artists and establishment has been its so-called politicization of art, a term usually used to cover the Black and women's programs as well as demands that museums speak out against racism, war and repression. On May 4, 1969, Hilton Kramer of *The New York Times* left-handedly complimented us by saying that the open hearing proposed, "albeit incoherently. . . a way of thinking about the production and consumption of works of art that would radically modify, if not actually displace, currently established practices, with their heavy reliance on big money and false prestige." He had "the vivid impression of a moral issue which wiser and more experienced minds have long been content to leave totally unexamined." But as the AWC gath-

ered steam (or power), we became less attractive. His second article (January 18, 1970) ended with a plea to all those nice people "who believe in the very idea of art museums—in museums free of political pressures—to make our commitments known, to say loud and clear that we will not stand for the politicization of art that is now looming as a real possibility." We wrote a lengthy reply which was published with his third article on the subject (February 8, 1970). In it we said that if by the "politicization of art" he meant "political art," he should be made aware that the AWC has never offered any opinions on the content or form of art, which we consider the concern of individual artists alone; also, "Mr. Kramer ignores the fact that what radical critics are opposed to is the present conservative politicization of the museum If the men now controlling the Museum of Modern Art are not politically involved, who the hell is?"

The AWC did not begin as a political group, but its models were clearly the Black and student movements of the 1960s, and by the time of the open hearing it was obvious that nonart issues would assume, if not priority, a major rhetorical importance. Though the Black Panthers, the Chicago Seven and other radical causes have been supported; though we have protested by telegram and testimony ecological catastrophes, expressways, budget cutbacks to museums, etc., and once gave half the treasury (some $500 from sales of the two documentary books we had published) to a Biafran woman who delivered a particularly stirring plea at a meeting, the AWC, like its predecessor and sometime colleague, the Artists and Writers Protest, has concentrated its political energies on peace, as did the May 1970 Art Strike. On the first Moratorium Day (October 15, 1969) the AWC managed to get the Modern, the Whitney and the Jewish museums and most of the galleries to close, and (with the crucial help of the participating artists) the Metropolitan to postpone the opening of its big American painting and sculpture show till a more auspicious date, though the museum itself stayed open and, with the Guggenheim, was picketed.

The bitterest quarrel the AWC has had with the Museum of Modern Art (aside from the "First Generation" controversy) was over joint sponsorship of the My-Lai massacre protest poster—a ghastly colored photograph of the event by a *Life* photographer captioned, "Q: AND BABIES? A: AND BABIES," which was vetoed by the president of the board of trustees after an initial, though unexpected, executive staff acceptance of the proposal. We picketed and protested in front of *Guernica,* published 50,000 posters on our own and distributed them, free, via an informal network of artists and movement people; it has turned up all over the world. Our release read, in part: "Practically, the outcome is as planned: an artist-sponsored poster protesting the My-Lai massacre will receive vast distribution. But the Museum's unprecedented decision to make known, as an institution, its commitment to humanity, has been denied it. Such lack of resolution casts doubts on the strength of the Museum's commitment to art itself, and can only be seen as bitter confirmation of this institution's decadence and/or impotence." Via this and other experiences we discovered that semiprivate institutions are unable to buck their trustees, particularly when the issue is one that presents the trustees with a direct conflict of interest. We also discovered that one thing museum administrators can't seem to realize is that most of the artworkers lead triple (for women, often quadruple) lives: making art, earning a living, political or social action, and maybe domestic work too. When the museum official gets fretful about our distrust of long dialogues and our general inefficiency (irresponsi-

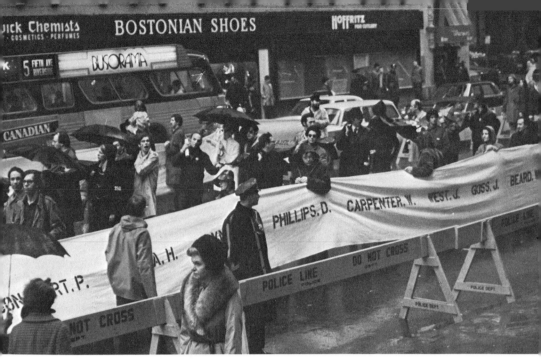

Artists and Writers Protest/Art Workers' Coalition marches up Sixth Avenue to War Memorial with black body bags marked with body counts and about 1,500 yard-long banners bearing the names of American and Vietnamese war dead, May 1969. The crowds, even the policemen, were sad and solemn. Along the way, the body bags were strewn with flowers.

bility, he calls it), he forgets that he is being paid a salary for "caring for" work and issues that his opposite number on the picket line produces in return for no financial assurances whatsoever, and that the Coalition itself has to beg time from the "real" world to get anything done at all.

Certainly it is everybody's individual choice as to how he is going to handle his political burden (though anyone so sheltered as to believe he has no such burden is riding for a shock). The AWC will be powerful only in the art field, where artists have power, and it seems to me that if an artist is more involved in the Peace Movement than in artists' rights, he should be working directly for the movement. What anyone can do via the AWC for the Panthers or for peace or for welfare mothers or trees can be done a hundred times better within those organizations specializing in each of those fields. As an artist, however, he can exert an influence on those institutions which depend on him for their life, to make them speak up and influence others. The fact that these institutions are run by people running other areas of the larger world makes artists' actions as artists all the more important. What is sad is how few artists will even acknowledge their political burden, how many seem to feel that art, and thus their own art, is so harmless that it needs no conscience. At least I don't hear that doubtful statement "My art is my politics" quite so often since Art Strike and other recent developments. It's how you give and withhold your art that is political. Your art is only your politics if it is blatantly political art, and most of the people who say that are blatantly opposed to political art. The Coalition is neutral; it has always been a nonesthetic group involved in ethics rather than esthetics. For the most part, however, the artist's dilemma—Is this the kind of society I can make art in? What

use is art in this or any society? Should it have any use, even morally?—remains unsolved in or out of the AWC.

On October 20, 1969, Carl Andre read the AWC a devastating litany of its failures as a "preamble" to its second year of operations. Among his complaints were: "We have failed to convince Artworkers that it is futile to recapitulate in the art world the enormities and injustices of the American economic system. . . . We have failed to convince Artworkers that the profession of art is not a career but a constant witness to the value of all life. We have failed to convince Artworkers that the essence of art is inspiration and not petty ambition. We have failed to convince Artworkers that a myth of quality is no substitute for the fact of art THEREFORE WE OF THE ART WORKERS' COALITION DEMAND OF OURSELVES THAT: 1. ART, OUR WORK, BE WIDELY AND HONORABLY EMPLOYED. 2. ART, OUR WORK, BE JUSTLY COMPENSATED. 3. ART, OUR WORK, BE ALL THE BEST THAT WE CAN LIVE OR DO."

Rhetoric, perhaps; eloquence, certainly. But the central issue always seems to come down to dignity, dignity and tolerance—the central issues of any civil rights cause. Black or women artists are most disturbing to their colleagues and to the art world at large because their demands for dignity in their profession carry a large quotient of rage. It makes them harder to live with and their cooperation— with other interest groups—harder to retain. Artists are the Blacks of the white intelligentsia. A bright, angry Black woman artist may be the most explosive factor around. She has the Nothing to Lose that has traditionally made potent revolutionaries.

The ethical role of the Coalition infuriates people. It is frequently criticized for not representing enough of the art community to be listened to; we in turn frequently criticize the rest of the art community for not speaking up, with *or* against us. The Coalition is out there working and occasionally accomplishing something; where do those guys get off resting smugly in a nest egg of their *own* compromises and preferring to fight us rather than the common enemy? In June 1969, during an exchange with artists who had (we charged) been pressured to donate works to MOMA for a "historical" show that just incidentally had to come from the museum's collections, we wrote: "Our actions should not be mistaken for those of the community as a whole, but rather as a 'conscience' in regard to the existing system. We represent the present membership [of the AWC] and, by default, the passive element in the art community. Anyone who does not speak for himself will be spoken for by us until he does take a position on the various issues The AWC does not begrudge the success of the artists in this show, to whom we all owe a major esthetic debt, nor are we judging the esthetic content of the exhibition. We are all too aware of the conditions in which these artists have existed for years under the present system, and it is this system we would like to change. We have no intention of letting the 'watchdog' ghost of Ad Reinhardt lie. In the 1960s, large sections of the world's population have realized what Reinhardt realized in the art world long before, that sins of omission and commission, crimes of silence and rhetoric, are equally indefensible."

The crux of the matter is, of course, that no artist, in or out of the AWC, wants to be told anyone else is thinking for him. Nor does anyone like to be reminded that he is a pawn of the system. It comes harder to more successful artists than to those who are just beginning. The artist is a person who has chosen a life of "independence" from the conventional structures. He is by nature unequipped

for group thinking or action. He has also made certain sacrifices in order to have the advantages of "freedom." However, he prefers to bitch to (and about) his fellow artists about the gallery system, museums' ignorance of art and artists' lives, how critics "use" him and his art, rather than do anything about it. And this is, I suspect, because if he admitted to himself how far up against the wall he has been driven, life would be pretty unbearable. The illusion of freedom is of the utmost importance to a person for whom society does nothing else. Even if he is successful (and some of the esthetically and ethically unhappiest artists in the city, the ones that act like cornered rats when talking to members of the Coalition, are the most successful socially and financially), even then, if he measures his success against his compromises, he is asking for a downer. It's pleasanter not to be aware of the issues than to feel nothing can be done about them. Ad Reinhardt and Carl Andre, two artists who have had the courage to expose publicly the contradictions inherent in their own situation, have come in for far more mudslinging than their weaker colleagues who have accepted to wallow in suspect patronage, than the artist who is content to be waterboy to a critic or mascot to a collector. A list of questions circulated by an artworker and glued to doors throughout the city in June 1969 enraged almost everyone by demanding, "Does money manipulate art? Does money manipulate galleries? Do galleries manipulate artists? Do artists manipulate art? . . . Is art a career (career—'highway, a running from or to, carting, carrying')? Is a career carousing? Are galleries pimps for carousing artists cruising immortality?"

The real value of the AWC is its voice rather than its force, its whispers rather than its shouts. It exists both as a threat and as a "place" (in people's heads, and in real space as a clearinghouse for artists' complaints). Its own silent majority is larger than is generally realized. More important than any of our "concrete" achievements is the fact that whether or not we are popular for it, the Coalition has brought up issues that American artists (since the '30s) have failed to confront together, issues concerning the dignity and value of art and artist in a world that often thinks neither has either. If the American artist looks with increased awareness at his shows, sales, conferences, contracts as an autonomous and independent member, even mover, of his own system, the AWC has made sense. But if esthetic differences are a barrier even to a successful artist's understanding or working with equally successful colleagues, as artists for artists' rights, maybe there's no ballgame. Maybe artists will have the unique distinction of being the only professionals in the world who can't get together long enough to assure their colleagues of not suffering from their mistakes. Maybe sweetness, light, idealism and personal integrity, conventionally presumed to characterize art, have been bred out of it by this brutal age. Maybe the Coalition is about not thinking so, even if the odds look bad.

Tomorrow night (September 21) there is a meeting of the AWC, the Art Strike, Soho Artists Association and an artists' housing group, the first of a season, the first of the AWC's third season, the first season after 2,000 artists gathered to protest Cambodia and Kent State and Augusta and Jackson and formed the Art Strike, the first of a season that promises to be low on the kind of social (as in socializing) stimulation generated by moneyed institutions. A lot of people know that their time this year might be best spent in the studio and in the streets. You have to be pretty far above it all to stay aloof. At the same time, the majority of the art world is afraid to take its bullshit out of the bars and into the streets, afraid of losing the

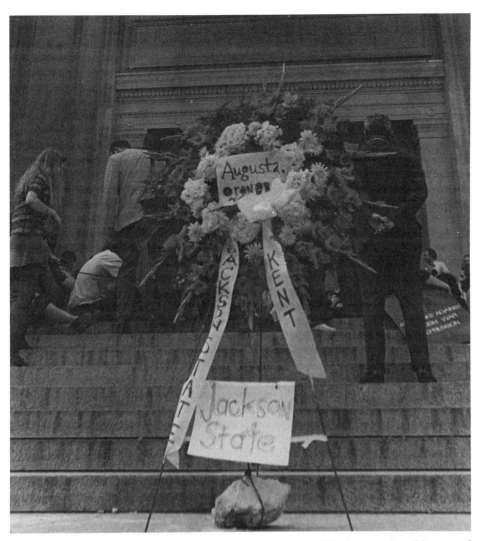

"Art Strike Against Racism, War, Oppression," on the steps of The Metropolitan Museum of Art, New York, May 1970. (Photo: Jan van Raay).

toehold it got last year on the next rung of the ladder, but at the same time afraid that the ladder will have been burned, toppled, or blown sky high just as it gets near the top (and there's no fury like that of a man who hates himself for compromising and is having the fruits of his ass-kissing taken from him too). Not a nice situation, but one that will, inside of the AWC or outside, have to be dealt with one way or another, now.

NOTE

1. *Artforum* (Sept. 1970).

Charitable Visits by the AWC
to MOMA and Met*

The Art Workers' Coalition struck far out three times last week, between January 9 and 12. The issues underlying the three actions were (1) discrimination against women in the Whitney Annual; (2) the "discretionary admission charge" on previously free days at the Modern and the Metropolitan; and (3) indiscreet spending at the Met (which from the other side of its poor-mouth, cries for public funds to continue its name-dropping, park-grabbing Expansion Plan). Discretionary admission or "pay what you wish . . . but *pay*" is a museuphemism for compulsory contributions, from one cent up; the penny option is not made clear. At both museums the visitor is reminded by signs that Big Brother is watching and He prefers a donation in line with "normal" admission charges—over one dollar. How many people have the nerve to give a penny? The poorer you are, the less you're likely to cry poor. (I'm not talking now about student radicals or most products of the middle class, but the stone poor, the breakfastless kids.) The cathedral law-courtlike halls of culture are intimidating; the guards at the barriers are intimidating; in America, culture itself is intimidating, and music-hall turns and jewelry-store exhibition installations aren't changing that; they cost a lot too.

Monday, 2 P.M., at the Museum of Modern Art, two lines form halfway down the block for the Stein collections show, because Monday was until recently the "free day" inveigled out of MOMA by the AWC a year ago. We got Monday because attendance was lowest then. Now it averages 4,500, and the museum's wounds are not healed by the immediate admission hike to $1.75 on other days. The AWC group moves past the ticket windows, where yellow slips register your "contribution" and remind you that it's tax-deductible; we refuse to pay at the guarded rope, blow whistles when we are stopped; a letter sent to director John Hightower is read to the crowd. It protests denial of free admission on the one day on which minority groups and students could possibly see the art at such prices and suggests that if the museum is so hard up, why doesn't it sell some of the blue-chips hidden in the vaults so people can see the art that *is* on the walls? A protester takes down the rope barrier and a lot of people in the line see their chance and bolt past the guards in the confusion, disappearing into the galleries. The rest of us stand our ground inside; the guards get rough and drag some of us out, saying we are under arrest (but the cops never show up). For the next half hour, chaos—as people in the lines try to figure it out. Sympathetic young people also refuse to pay ("You say pay what I wish, well, I don't wish to pay anything—is that OK?"). We scatter around the lobby to answer questions and persuade people to give only a penny if they must give at all (4,500 pennies instead of 4,500 dollars taken in that day would make our point nicely). The museum lawyer is

*Reprinted by permission from *The Element* (Jan. 1971). The third part of this essay on a charitable visit to the Whitney by the Ad Hoc Women Artists' Committee has already been published in *From the Center*.

present, gritting his teeth. The ticket seller is so disgusted that at one point he throws handfuls of yellow slips up in the air and out of his booth. The event is taped and photographed throughout. MOMA Mondays, like Whitney Saturdays,[1] may become institutions in themselves. This week a similar action was performed again.

Tuesday, 8 P.M., the Metropolitan Museum, an Acquisitions (and deaccessioning) Committee meeting cum trustees, cocktails and dinner is taking place in (symbolically) the Louis XVI Wrightsman period rooms. Tuesday is the Met's one night open, but that doesn't stop director Tom Hoving from closing off most of the French section for the banquet. Food and drinks are served in and around the art. Pre-Hoving, the museum acquired work in more businesslike circumstances, but it can't hurt to have everybody well wined and dined before the curators make their rival presentations. By 8 P.M., odd figures appear in the medieval hall near the screened-off Wrightsman rooms, peer around, disappear, reappear with others—the AWC playing intrigue, casing the joint, whispering in corners, distracting guards, checking entrances . . . but it works.

Suddenly about fifteen people invade the dinner; flashbulbs flash, recorders hum, the first few are greeted with polite resignation ("Oh my, is this the Art Workers' Coalition?"), but as the numbers increase, there is obvious unease, and then guilt? outrage? distaste for such bad taste? (The museum's secretary later tells us this is not "playing the game," that we should have told them ahead of time . . .) Guards appear and grab at cameras, push and shove us out; whistles shrill; comments are shouted about the taste and eating habits of the Acquisitions Committee in a people's museum; one invader liberates cockroaches from a box onto the dinner table ("to keep Harlem on your minds"); a rough guard is kicked back; film is confiscated, but our professional photographer saves hers, first by telling a rampaging guard, "Don't touch me, I'm pregnant," then by stuffing the goods into her underpants and marching out. Another member evades guards and leaflets the lobby, where a startled public has been herded to the tune of a noisy museumwide alarm; all outside doors are locked, frustrating those who think it's a fire. (I wonder if anybody got into the galleries free during the commotion.) One AWC member is choked and stood upon by guards, the invaders are locked into a security room and visited there by the secretary and another *petit fonctionnaire*. We are told, irrelevantly, that the dinner did not come out of public funds, but "out of the Acquisition Committee's own pockets" (so what; why wasn't that money used for something more useful than feeding the starving trustees? And this goes on every two months); that they ate only chicken "at twenty-nine cents a pound" (but someone noticed they were drinking red wine; how unchic, or what was the second course?). The question about cocktails was never answered. On top of which the museum allowed as how it was "disappointed" in the Coalition and Art Strike, which was supposed to be cooptable at any time with tea and talk. We replied that this was the Action Committee, not the tea and cookies committee, and that it had become all too clear that what we had gotten out of a year of talk was an admission charge to a previously free museum; we wanted, and got, exposure of the Met's disregard for the public and for the real value of money! If the dinner cost $1,000, that meant 100,000 people could have seen the art free at a discretionary penny each. Finally, it became obvious that the museum wasn't pressing charges. The AWC got up and

walked out. We were not stopped. The following day the man who had been choked wrote Hoving charging brutality; his house keys had been taken in the process and were never returned.[2]

Art isn't entertainment. It should be free to anyone who is or might be interested.

NOTES

1. The Whitney Annual was picketed every Saturday that year by protesting women.
2. For the further adventures of Jean Toche and Jon Hendricks, or the Guerrilla Art Action Group, see their book *GAAG* (Printed Matter, New York, 1978), in particular the accounts of the notorious "flag case" and the Judson Three.

II

ACTING OUT

Prefatory Note

By the end of 1971, the AWC had died quietly of exhaustion, backlash, internal divisions . . . and neglect by the women, who had turned to our own interests. We carried the Action Committee's ideas into the Ad Hoc Women Artists' Committee, best known for successfully challenging the number of women in the Whitney Annuals and for founding the Women's Slide Registry. Politically, I spent the next five years within the feminist stronghold, writing and organizing primarily around women's art and women's issues. There I came to terms with a vast area of personal politics I hadn't known existed. Our need at the time for such "separatist" activities was urgent; we were collectively discovering, nurturing and developing the art and theory that had been buried in women's lives and experiences.

Outside the feminist movement, the "art of the '70s" was disappointingly apolitical. The art world thrived on pluralism, on an underlying conservatism that was good for business as usual, and on the energies of the many "alternate spaces" that had sprung up as a result of '60s activism. SoHo flourished and rents careened out of reach of its artist-pioneers. Progressive art existed in the grass-roots but was barely visible outside the community mural movement and some obscure combinations of Marxism and Conceptual Art. I was lucky to be living at the time with an artist whose work took him daily into the streets of the Lower East Side. Through his experiences, I learned a good deal about the way art could affect people uneducated to see it as separate from life, and how an artist's individual mythologies could be politically catalytic when extended into community consciousness.

By 1975, many of us were tired of waiting for the '70s to happen. The women's art movement had been all too successful on some levels; it had been absorbed into the dominant culture to an unexpected extent, although many women artists were still just discovering feminism. Radical feminists who were holding out for a women's art of social change had given up on the artworld and begun to develop their own distribution and exhibition systems, at the same time as the "alternatives" were increasingly institutionalized. (An official conference for

such "artists' spaces" in the late '70s invited *no* representatives from minority art groups.)

In December 1975, some of the AWC's survivors got together to resist the Whitney Museum's curious decision to commemorate the Bicentennial of the American Revolution by exhibiting the collection of John D. Rockefeller III. Out of the initial protests grew Artists Meeting for Cultural Change (AMCC). When Whitney director Thomas Armstrong expressed amazement that "all this was still going on," and felt safe refusing "to enter into dialogue" with our group, he spoke for many. The AMCC made it clear that political consciousness among artists may have been slumbering, or invisible among grass-roots movements, but was not dead.

After organizing nationwide protests against the traveling Rockefeller show and other inappropriate and insulting Bicentennial numbers, the AMCC settled down to become a very large discussion group. Around 100 people came to each weekly meeting, where a formal paper was delivered and debated. The focus was theory, and theory about practice, but it was indeed artists meeting for rather than acting on cultural change. AMCC lasted till Winter 1977/78, when it fell prey to internal sectarianism. Some of its members abandoned the artworld altogether for Maoist or Marxist-Leninist cultural groups, such as the Anti-Imperialist Cultural Union. I fled back to the feminist fold.

In 1976 I had thought that maybe the time had come to take my feminism out into the world and work with men again, but it was disillusioning, to say the least, to find in the AMCC that even these supposedly radical changers of culture could not even change their own sexist speech habits; the exclusive use of the male pronoun in meetings and writings became a warning signal. Yet I took back to feminism a variety of lessons from the AMCC about the necessity to organize along broader cultural lines. Other women cultural workers were thinking the same way, and in that same winter (1975/76), we began to hold open meetings to form a new vehicle for feminism, art and politics, which by spring became the twenty-two-woman Heresies Collective. The book-like publication's first issue appeared in January 1977 and number 20 is now in the works.

At the same time, Sol LeWitt, Edit de Ak, Walter Robinson and I (soon joined by others) founded Printed Matter, Inc., as a publisher (briefly) and distributor of the proliferating number of artists' books. Through these two organizations, I found my energies focused on activism in print and began to get involved with its physical aspect, with production as well as writing and editing. Perhaps in unconscious preparation for the new wave of organizing that was building up in the arts, I gave myself a sabbatical from September 1977 to August 1978. I lived on an isolated farm in England where I wrote my third novel.

The first essays in this section, then, represent a kind of holding action, bridging the gap between AWC and AMCC, while those toward the end represent a renewed gathering of energies.

(I) Some Political Posters and (II) Some Questions They Raise About Art and Politics*

I

Since the late 1940s, when Motherwell and Rosenberg announced that "political commitment in our time means no art, no literature,"[1] there has been some confusion among contemporary American artists as to the degree and definition of their political responsibilities. In fact, there is disagreement even within the activist core as to what, if anything, defines protest or even politics in regard to art. In a panel held last year at Artists' Space in New York (the artist participants were Hans Haacke, Carl Andre, Nancy Spero, May Stevens, Rudolf Baranik, and Mel Edwards), there was an undercurrent of admission that art came first and protest second and that finally art was not true protest because it had no broad audience.

There are so few American artists who concentrate on political content that the most available field for analysis is that of political posters. A good focal point was provided last spring by an exhibition of a decade of American political posters, held as a benefit for the defense of the Attica inmates indicted for their part in the 1971 prison uprising. The artworld is notoriously self-focused, and history has shown that artists in any numbers can be hustled out of the ivory tower and into the street (or even into poster making) only when things get dramatically bad, as they did in 1970, when the Art Strike against Kent State, Jackson State, and Cambodia briefly produced more art political activity in New York than had been evident since the '40s. Even then, the response of the artist to external disaster was reflected back into internal artworld politics, presumably in acknowledgment of the artist's powerlessness in the international arena. One might expect the fine artist, once alerted, to be particularly good at making visual protests, but the confines and conventions of the art world usually prove too strong for the dissenting conscience. Lots of good intentions have paved the way back to the museums, magazines and marketplaces. David Kunzle has remarked that even much poster art "seems to challenge only the forms with which we live, not the ideas. It is hard for an American artist to make his [sic] anger tell. His fury is dismissed as a tantrum or clowning; his outrage is the caprice of children who are permitted anything, as long as the parents remain in control."[2]

Both abstract and figurative artists participated in the Attica show (and in others like it), neither being any better equipped than the other for the task. Many artists apparently find it impossible to expand their own recognizable "style" into an image transmitting a clear-cut "message"; it is frequently the lesser-known artists, and photographers and designers, with less exalted public images to defend, who come up with the strongest work. Though there is no question of

*Reprinted by permission from *Data Arte*, no. 19 (Nov.–Dec. 1975).

The Art Workers' Coalition 1969 poster *(Q: And Babies? A. And Babies.)* on My Lai massacre, collectively designed and distributed worldwide through the independent artists' network. (Photo: Mehdi Khonsari).

the goodwill and deep feeling behind most political posters, the esthetic is necessarily that of advertising (good propaganda requires a good marketplace sensibility) and it doesn't come easily to the traditionally educated fine artist. Artists working collectively have less ego problems, as demonstrated by the ART Group's simple and graphic, if predictable, black-and-white posters in a "right-on" '60s style; or the classic "Q: AND BABIES? A: AND BABIES" My-Lai massacre poster, designed anonymously by members of the Art Workers' Coalition in 1969 and spread all over the world by an artists' network after the Museum of Modern Art broke its promise to distribute it.

Jeff Schlanger's double photobroadside follows up this ironic question-and-answer technique, showing a man's business-suited arm holding a lighter under a tender little hand ("Would You Burn a Child?") over a Vietnamese child scarred by napalm ("When Necessary"). Others in this exhibition that worked: one of Iain Whitecross' brutal "Advertisements for War"—a comic-strip double portrait of a towering Westmoreland and a tiny Thieu standing at attention ("It's the Little Things That Make Us Big"); Faith Ringgold's jagged word puzzles on the subject of being Black, being a woman, and being here, especially her map of the "United States of Attica," detailing atrocities against the Third World in every state; Oyvind Fahlstrom's "world maps," mad comic strips of rage which sacrifice immediate or "posterlike" impact to incisive comment. Among the few feminist posters in the Attica show were Martha Conners O'Connor's and Joreen's "Santa Claus Must Have Been A Woman; Who Else Would Have Done So Much For So Little?"; Sheila de Bretteville's "Pink"—a pale grid striking home with a uniquely delicate note ("Pink Isn't Pale Anything"; "Scratch Pink and It Bleeds"), and

Judy Chicago's "Red Flag," a photolitho of a nude woman from the waist down, removing a bloody tampon—a natural image significantly more startling for much of the audience than all the burned children and attack dogs. Not incidentally, the most popular poster in the show, recalling the fact that posters in America are frequently more commercial than political, was Abbie Hoffman's dopy "High! I'm Abbie. Fly Me to Miami!!!" (and to the 1972 Democratic Convention).

In general there seem to be two approaches to political postermaking by "fine" or "high" artists: "My Art Is My Politics" (meaning the use of one's own image, perhaps with random addition of appropriate words; also meaning art is above, or below, it all); and the "engaged" approach, which demands a more legible and all too often banal symbolism. Organizers of benefit shows, politically committed to content but also out to make money for the cause, can be ambivalent about the former, though always grateful for a genuine response to any call for donations. The Attica Defense Fund was, therefore, lucky to have Frank Stella donate a poster design, which, if no more than an echo of one of his early black-and-white abstractions, has a name, will sell, and, perhaps coincidentally, can be interpreted as a barred window and the no-exit maze of this society. Which is more than can be said of Alexander Calder's poster for the "Safe Return" amnesty group, which is probably still more salable, if incongruously jolly. Famous artists' posters are much in demand as long as that artist's trademark is in sight. Style sells better than sincerity.

As a result, most of these artist-made posters seem destined to be framed in middle-class homes or student crash pads rather than to be carried in marches, slapped up on factory walls, read in the streets. Although poster workshops and exhibitions continue to play a part in the counterculture, they preach all too often to the converted within the most tried and true visual frameworks. It must also be said that familiarity is not necessarily a failing; clearly the esthetically "progressive" or "linear" criteria of the art world cannot be legitimately applied to political art. Put-downs of posters as lousy art, or "that's been done before," show a rather shocking contextual naïveté, as do many of the unreadable theoretical statements popular in would-be Marxist and Maoist conceptual groups. If the formal means hark back to the '30s and '40s as well as to Pop Art, so what? It is still difficult for the artworld artist to understand that communication, not "advance," is the point, and that outside the art world, no one knows or cares about advance.

One of the major problems is that it is so rare for professional artists to work *with* a community or an interest group to design a poster meaningful to a specific nonart audience. Posters are most valuable when put to work for and literally *in* the hands of groups whose realpolitikal needs are far clearer to them than they might be to the artist on his/her own. For example, The Progressive Art Movement in Adelaide, Australia, like the Rosario Group in Argentina in the late '60s, is beginning to work with labor unions and automobile workers, to concentrate their talents on protesting U.S. influence, presence and military bases, and general consciousness raising.

Several years ago, I asked some 100 New York artists, known and unknown, to design antiwar posters. The response was good and the collection of drawings, as it grew, was shown several times as "The Collage of Indignation II."[3] It seemed an exciting project—the only time a large number of American artists

had ever bent their energies to a common political subject. The plan was to sell the original designs at their expensive marketplace values and to use that money to print up the posters, which would then be sold very cheaply. As it turned out, the designs themselves did not sell (which I've never understood, since they are unique in most of the famous artists' oeuvres), and only one poster was finally executed—not cheaply—a handsome Rauschenberg collage print with a central white area reserved for each buyer to paste in a newspaper headline about peace, making each poster a potentially unique work of art.

However, had the money been available to print up more of these designs, they would still have remained in the art world. Most of them were effective as posters only if one were familiar with the style of the individual artist who made them. Since I was familiar with the work, I was much impressed by many of them: Carl Andre's Declaration of Independence with the wording changed to make America the oppressor, Sol LeWitt's simple direct statement, Robert Ryman's misspelled "Pease," Susan Hall's fond "A Woman Dreams of Peace," Alex Katz' sad child in pale pencil, Marjorie Strider's poisonous still life, Robert Smithson's Kent State buried woodshed, and so on. As art and as "good ideas," they worked. As political propaganda, most of them stank.

"Collage of Indignation II," exhibited at New York Cultural Center (among other places), 1970–71. (Photo: COSMO)

II

WHAT, THEN, IS THE RELATIONSHIP
OF ART TO POLITICS?[4]

Of course, the majority of the art world thinks there is no relationship. I can understand one's art not dealing with political subject matter, so long as one is honest enough not to claim, "My art is my politics," but I can't understand the notion that artists should have no political opinions, no political responsibilities. Does that go for architects, too? And writers and coal miners and ballet dancers and garbage collectors? Who *should* have political opinions? Only politicians? It's a hell of a thing if by being an artist you can opt out of any responsibility in society. It plays into the hands of those who are only comfortable with and can only profit from art that maintains the status quo. Ad Reinhardt, who painted totally "for art's sake," was, nevertheless, one of the few New York artists to continue to concern himself seriously with the morality of the world and the art world throughout his life. I like Carl Andre's statement that "Life is the link between art and politics."[5]

What do you mean by politics?

Several things. Today it seems to imply "radical" politics. The conservative politics that underlies the entire international art world is so pervasive, so taken for granted, that it isn't considered "political." But most artworkers calling themselves Marxists are interested in theory and completely out of their depth in its application to their own situations as artists in a capitalist society. Political art also means community organizing and development, working with people to whom art would normally mean nothing, working with them in their own rather than in an art context. A "political" artist on a far less direct level may also be someone whose work is not overtly political and is embedded in the current system, but who supports the left, gives to benefits, works for feminism or artists' civil rights—an artist whose consciousness is raised.

Last but not least, of course, there is "art politics," which incorporates all internal protest as well as all internal wheeling and dealing and ass kissing. I for one would make a distinction between passive and active politics, between lip service and activism. To be against the status quo and to be for change are not always the same thing.

Do you think the Art Workers' Coalition (active in New York City from 1969–1971) accomplished anything at all?

Yes. It provided an extremely important consciousness-raising experience for the art world, even for those who were scared to get near the Coalition or were repelled by its excesses. Before 1969, very few people were aware that artists had any civil rights whatsoever; few knew how the political structure of the art world affected the art, or related art to the politics of real life. Very few people were aware of the economic enmeshment of the arts institutions and their trustees in things like wars and military coups and exploitation all over the

world—and how these things were reflected in the insidious commodity image of art objects.

Before the late '60s the art world was a safe and superior little island built on "quality," "esthetics," and media, having no apparent connection with the low-life outside that formed it. Since the Coalition, for better or worse, artists and artworkers know what bullshit we all participate in. Now we are forced to acknowledge our participation, no matter how vehemently we may resist change or defend our right to participate. Or perhaps compete is a better word. It's true that the consequent demoralization has produced a rather horrible atmosphere in which to live, but at least it's an atmosphere based on knowledge rather than ignorance. There are more and more people thinking about these problems: How does art relate to the rest of the world? Is it a mythology or an ideology or entertainment or decoration or provocation? Max Kozloff and Eva Cockcroft wrote articles opening our eyes to the ways art has been used by U.S. foreign policy.[6] The belated political emphasis of the Art and Language Group is also symptomatic. Now all that remains is for something to come of such awareness. Even though I know we are to some extent trapped in the capitalist abyss in which we operate, I can't believe that such a disturbing awareness won't eventually produce change—reaction, reform, or rebellion.

Are there stages of consciousness? Things that are continuing now?

Yes. One thing many people begin with is the fact that so few artists or writers care about how their own work is used, or misused. It may involve something as minor as the way a work is framed or hung or photographed, or what esthetic context it is shown in, or the use of the Artists' Rights and Sales Agreement.[7] Censorship, sexism, racism should be defined wherever possible. Even the most politically pointed work should be withheld from certain situations. Art's use as propaganda for the government abroad in U.S. embassies and information agencies; its restriction to a small, unsympathetic audience; its ownership by individuals, corporations or institutions whose values are opposed to the artist's; participation in international exhibitions held in countries where censorship, torture and political imprisonment are rampant—all these are factors we should be aware of. Once we start thinking, we realize how much responsibility for what we have made is actually within our own control. This applies not only to the object but to the artist as well. If art is indeed a committed and inseparable reflection of the artist's deepest concerns, it should not be used for any purpose or be present at any place that the artist her/himself would not be able to attend in all conscience. During the Vietnam war, painter Irving Petlin pleaded for "No business as usual anywhere. . . . People will continue to make art. I will continue to make art, but what happens to it afterwards has now changed."[8] As it has turned out, the so-called end of the war has not changed that situation.

What has been done in the way of effective political or protest art in the United States?

The Guerrilla Art Action Group (Jon Hendricks and Jean Toche) is the only full-time political art group in the United States that I know of. They work as much outside as inside the art world. Their letters and actions have stirred up endless controversies and they're the only artists who are periodically arrested. They have replaced Reinhardt as watchdogs, the "conscience of the art world," fully committed to exposure of every instance of repression and oppression, putting the rest of us to shame with their energy.

One can't always agree with them and with their tactics, and they accomplish controversy more often than change, but that's still a breath of fresh air in the art establishment. The Metropolitan Museum had Toche arrested. The Guggenheim Museum canceled Hans Haacke's show because its directors, property owners to the core, indirectly supported the absentee landlords exposed in his real-estate systems piece (see p. 236). So Haacke's work was effective on that level; still, the information in that piece also was potentially effective in other areas, outside the art world, and these weren't followed up. The Art and Language groups theorize provocatively in public forums, though their audience, too, is a specialized one.[9] Painters like Leon Golub and May Stevens and Rudolf Baranik provoke questions by raising emotional/political issues. I showed a slide of Nancy Spero's *Torture in Chile* several times this past summer and was impressed by the effect it had on the audience, conveying in a visually powerful way some terrifying information that is not common knowledge, given the relative silence of the capitalist press on the Chilean horrors.

Then there have been isolated gestures like Carl Andre's show at Dwan in 1970, where the sculptures (made from elements found in the streets) were sold for 1 percent of the buyer's annual income, thus becoming available to a new class of buyers and unavailable to the conventional class of buyers. One of my favorite "political art" works is one sent out of New York City in 1971 by the anonymous "Orders & Co." Over a period of time, they sent commands to the military dictator of Uruguay which he could not refuse to carry out, like checking his fly, or: "You will simulate normal walking but you will be conscious that for this day Orders & Co. have taken possession of every third step you take. It is not necessary for you to obsess yourself with this." In their first letter, they wrote: "We will dispose of certain zones of your time in the future because we consider that an individual with the accumulation of power that you have can only humanize himself by receiving orders."

What about local political work that is active rather than commentary?

The next most important step now would be to break down the barriers between the accepted art audience and people in other "worlds," especially those separated from art and uneducated to "appreciate" art, who may be able to do so on a realer level. The audience imposed on (and welcomed by) artists and critics today is a narrow, specialized, dependent one. So if we are governed by the demands of that audience, we are in turn manipulated by the economic and political framework within which we live, which is capitalism. We've had no indication that art isn't as limited in socialist countries as well, but we're in no position to confront that till we change our own circumstances.

If the audience were much broader, what would change?

The breadth and scope of the art being made. That in turn would weaken the hold a single moneyed and educated class has on the art world and, consequently, on the art, on the artist, and on the rest of the world's experience of art. The avant-garde printout would be severely interrupted and the art world might even be integrated into the real world, changing artists' experience of art. This will necessarily be a long process, but if it doesn't start pretty soon, art may dry up and blow away from sterility and isolation.

If all artists had direct contact with, say a Third World audience, with a poor as well as a wealthy audience, with children, housewives, and what-have-you or even, for that matter, more direct contact with their current nonbuying and non-

artist gallery audience, I suspect that the emphasis on formal advance and on ways of "improving" the art product would disappear. There would be other and different kinds of people to please. In fact, I'd like to see steps taken which would almost force artists to have this opportunity through foundations or subsidies of some kind. I am not talking about siphoning art and information down from the top, from the people who decide what is "quality" down to the "masses," as it happens now in museums and magazines and on educational TV. I am talking about spreading *out* an art that has at least partially been instigated by, or in response to, that broad audience or any section of it. I am talking about getting rid of the patronizing process by which everyone is told, via the media, "We have decided what you should appreciate and here it is (usually several years late). *What?* You don't like it? You have no taste!"

How do you think art would change if this all took place?

It can't be predicted in a formal sense. Art would still be the unexpected result of unexpected sensibilities—though perhaps more the product of a collective sensibility. "Styles" might not change that much, but meaning might be restored to what has become for all but a brilliant, lucky and/or impervious few a virtually meaningless profession on any but the most careerist basis. When artists work outside galleries and museums, one result tends to be the collapse of conventional ideas about what art is and what its function is, a collapse of the criteria by which art has been "judged" by the elite for so long. I'm talking about the possibility that "good" art is art that communicates rather than art that passes the editors' and curators' tests by virtue of its appeal only to other specialists. And the possibility that the much derided pluralism is in fact a natural and healthy state for art in a pluralist society, much more democratic than dominating movements.

What experience I've had with other than art audiences has convinced me that the taste of the man and woman in the street is not restricted to bug-eyed ballerinas and luncheonette sunsets, but is as varied in taste, background, associations, as is that of the current art audience. Probably more so, since the current audience tends to wait and be told what to like by the experts. From the avant garde to the so-called masses may be an easier jump than from the avant garde to the upper-middle-class academic and professional classes, where the favorite artist has traditionally been Andrew Wyeth, or, for the hip, maybe Andrew Warhol. I seriously doubt whether the people who read *Vogue* share *my* tastes in art, not to mention those of people still farther out of that milieu. It's no accident that so many students and younger artists are spending so much energy trying to get art and life back together. This impulse *outward* has less to do with the Dada, Duchamp, Rauschenberg, Warhol historical model than it has to do with a real need to collaborate, communicate, correspond with other people. This doesn't mean that there can't be a dialectic between the two worlds of the sort Robert Smithson was trying to work out when he died. But there are all those artists who have found that an old friend who's a gas station attendant, or an aunt who teaches high school math, or a passerby on the street has more insight into their art than those who "know about it." This happens often enough to be real food for thought.

Are you saying all artists should use political subject matter?

Political art doesn't have to have political subject matter to have political effect, so long as political awareness is a motivation. I've always considered art an

important element in society because it is potentially provocative; it makes people think and feel in unexpected ways, focus on real life differently. Art for "other than art's sake," to borrow the title of a film by Peter Kennedy,[10] has been pioneered by community development groups rather than by artists—in the form of gardens, murals, playlots. The barrio murals exist as a process, an experience, and a catalyst to community and citywide action, conveying necessary messages about what needs to be done to make an area more livable (opposing absentee landlords, unjust taxation, rats, lack of public services, drugs, etc.). Less permanent pieces and events in and out of the community can subtly convey the need for change and deal with psychological needs as well as physical ones. In fact, the mural movement constitutes the most important political art being made in America today, and much of it is not even made by "fine" artists.

Perhaps the greatest danger is that this whole idea of artists working *out* from the art world will be stillborn or that it will never mature; that it will be trivialized, as it often is already, into picturesque gestures whose real referent is the art world, not a new audience. Most so-called public art—from streetworks more carefully documented than executed, to giant steel lumps plunked down in bank and business plazas—actually consists only of dipping a toe into the real world and then running back to the magazines and galleries to be patted on the back. It proves nothing but a discouraging lack of commitment and a willingness to exploit genuine interest in outreaching art, like the murals, or the work of feminist artworkers who are trying to develop a new transclass, all-female audience.

Is feminist art political art?

Absolutely. The only problem is, what is feminist art? And is there actually much of it? There are a lot of women artists who have joined together to bring more women into the system as it stands. But if the art itself, whatever its "quality," is indistinguishable from the art made by men already in the galleries, and if feminist criticism doesn't develop a new set of criteria applicable to the new values emerging from feminist politics, then women artists will simply be absorbed into the status quo. While I hope that the mere presence of more women in the art establishment is changing its values slightly, simply because women are different from men, I worry that we will be absorbed and misled before we can fully structure a solid system of our own.

Why are so many feminists, especially on the West Coast, restricting themselves and their art to a female audience?

Most women do not, so far, express themselves freely with men around. And since the art world is men, primarily, that feeling must affect the art being made too—the reason it's so often neutralized. Most men do not take women artists seriously or even as whole people. Who the hell wants to bother communicating with a person who doesn't respect what you have to communicate? At the moment, women have more to say to other women. The L.A. Woman's Building's separatism has been necessary to the contributions those groups have made. Women there have come together as a community, and only in communities or groups does anything decisive get accomplished. We don't need a messiah. I know all too well how easily an isolated voice for or against change is coopted. The minute you're patted on the back for dissenting, you're absorbed and lose your effectiveness.

Yes. What about your own situation? Where do you get off pushing artists to

leave the art world when you still write for the art magazines which are the
backbone of the status quo?

I haven't succeeded in pushing anyone out that I know of. I wish I'd been so effective. I'm hoping artists will move out from this convoluted center because, selfishly, I can't get out till the artists I admire and write about do it. But on the other level, I really have no defense. I just don't know where else to go. General magazines are even less interested in these problems, and anyone who'd publish me is just as specialist-oriented as the art magazines, though for different reasons. I can only make negative gestures. I have privately boycotted several art magazines because of policy disagreement or in protest of their cavalier treatment of writers or artists. I refused to do a lecture on Max Ernst for the Guggenheim last year because their directors are the same ones who canceled the Haacke show.[11] I returned to one of those magazines I'd left after I'd become a feminist, and after the management had changed, in order to assure the presence of more women in that part of the system. But today I'm still *more* ambivalent about that level of my activities. While I feel strongly that women should have a chance at everything that men have, even the bad things, I am all too aware of the traps set by the art world for the ambitious artist. And women are of course as ambitious as men. I'm in the curious position of opening doors and then warning people not to go through them. As a critic it's none of my business to tell artists not to grab whatever chances for fame and fortune present themselves, especially if I'm making a living off the same system. Some women, however, have realized how unsatisfying success can be in an alien world with an alien value structure. These are the ones who will make feminist art reflect a different set of values. But what precisely these values will be can be worked out only in relationship to the needs of a new community—not the present art world, which can be called a community only at times of severe stress or crisis, when the competition is temporarily submerged.

So I'm sort of all dressed up with nowhere to go. There is plenty of art that interests me on an esthetic level—mostly art by women—but little of it shows any sign of moving out into the real world or of instilling new values. I write about art, after all, because art moves and provokes me, and because I like working in that abyss between the verbal and the visual. I dislike writing polemic after polemic to fall on deaf or already converted ears. I use up most of that sort of outreaching energy in an immense amount of ad lib, open-discussion "lecturing" to students and women's groups. Talking and writing are two entirely different media, and at the moment, I find talking better adapted than writing to the presentation of political ideas which are not fully formed, ideas which are really questions I don't have the answers to. So I *talk* about "political" issues and *write* about "art" (though trying to bring some of my own state of mind to each artist's work, which attracts me because of its own qualities of openness, sensuousness, integrity, feminist awareness, etc.).

Which is why I'm writing this article in a "talk" format. It's all rather contradictory and I'm sick of the dilemma which has been hanging over me for several years now, but until I figure out an alternative, or someone else does, I'll periodically hammer away at my doubts in private and in public.

NOTES

1. Robert Motherwell and Harold Rosenberg, editorial statement, *Possibilities,* no. 1 (Winter 1947–1948), p. 1.

2. David Kunzle, "Posters of Protest," *ARTnews* (Feb. 1972); see also catalogs for his exhibitions "L'Era di Johnson" (Milan: La Pietra, 1968) and "American Posters of Protest 1966–1970" (New York: New School Art Center, 1971).

3. The title is in homage to the first "Collage of Indignation"—a wall of spontaneously created works made for the antiwar "Angry Arts Week," New York, 1967.

4. The first section of this essay is an enlarged and revised version of a short review that appeared in preview issue (No. 2) of *Seven Days* (June 2, 1975). From this point on, I am interviewing myself.

5. Carl Andre in "The Artist in Politics: A Symposium," *Artforum* (Sept. 1970).

6. Max Kozloff, "American Painting During the Cold War," *Artforum* (May 1973); Eva Cockcroft, "Abstract Expressionism, Weapon of the Cold War," *Artforum* (June 1974).

7. An artist's contract produced by Seth Siegelaub and Robert Projansky in 1971; a condensed version by Projansky was published in 1975.

8. Irving Petlin, *Artforum* symposium; see Note 5.

9. See the Art and Language magazine, *The Fox,* no. 1 (1975), and Terry Smith's discussions and "political" poster, Melbourne, Australia, 1975.

10. *Other Than Art's Sake,* a film shot by Peter Kennedy between June 1973 and February 1974 in London, Edinburgh, New York, and Los Angeles, presenting the work of seven artists "considered a model for art which refers to the world beyond itself." The artists were Adrian Piper, Hans Haacke, Ian Breakwell, David Medalla, Charles Simonds, Steve Willats, and Judy Chicago, Arlene Raven, and students at the Los Angeles Woman's Building.

11. Eventually I did speak at the Guggenheim, on a memorial panel for Ad Reinhardt; I went over the Haacke issue again, noted I hadn't changed my mind, and was there in the Reinhardtian spirit of contradiction and confrontation—no justification, but an acknowledgment of the continuing dilemma.

Community and Outreach: Art Outdoors, In the Public Domain

(Excerpts from a Slide Lecture)[*1]

Contemporary art in Western civilization has been essentially a private rather than a public art, an art for sale, an intimate art of easel painting and objects to be owned; so taking art out of the home and the gallery and putting it outdoors *should* be an expansive and democratic gesture. All too often, however, the result is the false monument—private, indoor art enlarged and plunked down outside—not in the streets, or in ordinary residential neighborhoods, but in museum gardens, bank plazas, and country estates. This process has more to do with prop-

*Reprinted by permission from *Studio International* (Mar.–Apr. 1977).

erty, ownership, and fashion than it does with any desire to provide the "masses" with esthetic experience related to their own real-life experience.

And the "masses" means almost everybody, aside from a very narrow, specialized audience. Such art remains private in another sense as well. It is usually familiar only to a museum-going public. It has been espoused by a single class and imposed on the others. When banks, corporations, institutions, municipalities risk money by erecting a "monument" to their success, they are even more conservative than when they are playing the stock market. They buy the kind of art that reflects their relationship to the public—aloof and superior *erections.* In the United States, only the work of Alexander Calder and Henry Moore is wholly acceptable as public art, but since it is horrendously expensive, inroads have been made by a few major sculptures by younger artists and by a hoard of second-string, faceless decorative objects that perfectly adorn the marketplace. The ambience is such that even Picasso can be coopted. His ponytailed head in sandblasted concrete gracing New York University's "Silver Towers" plaza looks like a cement lapel pin, and Picasso never even saw it. One of the few works that holds its own in such surroundings is Dubuffet's *Four Trees* in the Chase Manhattan plaza near Wall Street. Since this is a busy thoroughfare, the sculpture is part of life there, contradicting rather than accepting its site, magically making a fiberglass tree grow from a cement desert.

There is, of course, nothing new about the phenomenon of outdoor art.[2] Equestrian statues and other monuments to rulers, saints, warmongers and politicians have graced our cities since there have been cities. Long before that, the worship of natural forces produced extraordinary totems in the landscape, such as Stonehenge, the mysterious Nazca land drawings in Peru, Indian mounds, and innumerable barrows, burial sites and pictograms in virtually every culture. Some are ephemeral, some remain to tantalize us. Since the nineteenth century, the public parks have been the obvious sites for urban art; in fact, the park itself is the most effective public art that exists. However, a many-sculptured park runs the risk of providing too much of a good thing and reaching the saturation point also experienced in museums. (One suggested solution: Take all the equestrian statues in Central Park and put them in a single field, like toy soldiers in a cross-historical battleground.)

One of the virtues of seeing art outdoors is that it can be experienced at a more natural pace outside an artificial cultural context. On the other hand, perhaps this is only a step in the right direction, and Robert Smithson was right when he said that "parks are finished landscapes for finished art. . . .Nature is never finished. . . . The museums and parks are graveyards above ground."[3] (Auckland, New Zealand, has a cemetery in the center of the city which has been completely overgrown by vegetation, and provides a striking symbol of the triumph of life over death and nature over the monument.) Apropos of this, it is significant to note that cemeteries were among the first public parks in America. When the Parks Department in New York City held a public sculpture show in 1967, Claes Oldenburg's contribution was a trench dug by union gravediggers behind the Metropolitan Museum of Art.

This same Parks Department project began with a good idea: to have sculpture scattered around the city in areas where art had rarely penetrated.[4] But what happened was that, for the most part, gallery art was simply placed outside, and some of the sites chosen were absurd. One public-spirited gesture was to

place a work in the window of the Vidal Sassoon hairdressing establishment on Madison Avenue, in the heart of the uptown gallery district—an apparently unconscious illustration of the coals to Newcastle syndrome. There was a Calder in Harlem, but it was in the courtyard of an upper-income housing project because it was too valuable to be put out where it could be seen by an "ignorant" (and potentially belligerent) public—ignorance having to do less with knowledge of esthetics than with knowledge of the sculpture's commercial value.

In another similar project in New York a few years later, various communities were allowed to choose the art they were to live with from slide shows of work selected by experts; but a city agency censored the project because one community had chosen a supposedly obscene work. So much for esthetic self-determination. While living with art is really the only way to enjoy it fully, this does not mean that art must be owned, nor that it must last forever. Much of the exciting outdoor sculpture I have seen has been impermanent, its impact lasting longer than its objecthood. A reemphasis on experience rather than expense diminishes the big name fervor and weakens the corporate hold on public experience. It also stimulates the desire for art on a community level, not to mention another highly important factor: the artist's own consciousness of communication with his or her audience.

I should make it clear that I am not talking about siphoning "high" art and elite information about that art down from the top—from the people who bring you quality (and decide what it is) down to the "masses," as is the case now. It is not a matter, as Daniel Buren, among others, has pointed out, of putting, "good" art in the factories (or, by extension, in the streets) where it will improve the working environment but do nothing to solve fundamental social problems. In these conditions art can be used as a distraction or a veil rather than a provocation. What is needed is the spreading not *down* but *out* of an art that has to some extent originated in response to a broad audience or to a section, a community, of that audience—an art that rises *up* from the experience of the people who are living with it rather than an art patronizingly imposed from above.

The man and the woman in the street have differences of opinion, associations, memories, and varied responses to colors and shapes just like the middle class, though less constricted by "good taste." In fact, one of the most sophisticated theatrical ventures I know of took place entirely outside the boundaries of the art establishment and the avant garde. A building on New York's Lower East Side became a theatre, its residents the actors; the "plays" moved from apartment to apartment and the plots came from the actors/residents' own lives.

If public art is indeed to be public, if it is to fulfill the social needs of a specific environment as well as to satisfy the esthetic intent of the artist and to fulfill the highest possibilities of its culture, it must be more than decoration, more than cosmetic, more than an artifact. It must be able to engage at least a portion of its audience at the core of its own experience, and at the same time to extend that experience. The art must relate to the space in which it is located, not just in formal terms of scale and visibility, but also in terms of the ambience, the spirit, the significance of that space for its residents.

Nothing has responded better to these needs in American cities than the burgeoning mural movement, modeled in part on the Chilean mural brigades, whose effectiveness was proven by the junta's haste to erase them when Allende's government was overthrown. Most of the American mural groups are communi-

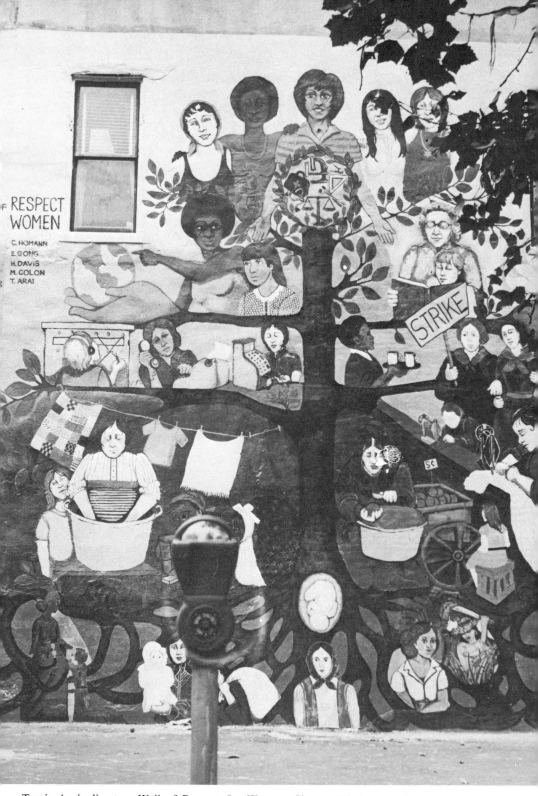

Tomie Arai, director, *Wall of Respect for Women*, Cityarts Workshop, New York, 1974. (Photo: Esther Lewitts)

ty-sponsored and -executed; some are commercially sponsored; and some are outgrowths of the gallery and museum establishment. In New York, for instance, there are two major groups which offer very different approaches. City Walls was originated by artists and then adopted by the Museum of Modern Art; most of its murals are easel paintings enlarged; they tend to be abstract and colorful, and made by artworld artists. City Arts Workshop, on the other hand, is a grass-roots organization on the Lower East Side whose murals are first and foremost public wall paintings, in style and subject matter. They are designed and painted by members of the community, usually young people, with the help, but generally not the dictatorship, of professional (but not usually artworld) artists. These murals serve as political as well as esthetic outlets, a message to the world ("We are here") as well as decoration. Their content ranges from social commentary (against inflation, absentee landlords, drugs) to pride in culture, race or sex (women's walls of respect, the Hispanic and African heritage).

Illusion, which has been rejected as evolutionarily unbecoming for "high" art, is paradoxically, or appropriately, a major factor in some of the most effective murals. It transforms a solid—a whole building, a whole view—rather than picturing on a surface. Illusion outdoors in real space is its own reality. A few examples: Tania's geometric City Walls mural, the precarious verticality of which makes the building look as though it is about to crumble; Richard Haas' City Walls mural which wraps the facade of an old cast-iron building around to its blank side by a highly effective trompe l'oeil; the L.A. Fine Arts Squad's *Snow in Venice* (California) and their *Brooks Street Painting,* which echoes the view down one side of the street on a wall on the opposite side of the street, so the unfocused pedestrian could be literally turned around. In *Beverly Hills Siddhartha,* the Squad doubles the illusion by turning a wall into a movie screen with a painted still. One of the most effective of the over 180 community walls in Chicago is William Walker's *Peace and Salvation, Wall of Understanding* (1970), in which the wall surface is illusionistically broken through, as though to reach the pain inside; the picture re-creates an event, a shootout and consequent police harassment, which took place in the tenement on which the mural is painted.

From the awareness of the environment that is stimulated by unofficial art has come an increased sensitivity to "found" public art—to sights and sites which provoke the imagination, recall other experience—the kind of image the photographer learns to see and capture. A number of streetworks have focused on this aspect, among them Marjorie Strider's 1969 frame pieces which called attention to objects and aspects of real life; or Robert Huot's daily renewed guide to an anonymous "painting" somewhere in the city as his contribution to the 1970 Whitney Annual; or Stephen Kaltenbach's "Guide to a Metropolitan Museum of Art" handed out to passersby on Fourteenth Street and pointing out "art-works" embedded in the environment which bore close resemblances to well-known (and expensive) contemporary art.[5] Once moved outdoors, this interest in found art (first raised by the Dadas) has led in turn to the discovery of new sites for sculpture, and with that, new reasons for sculpture to be outdoors.

Although he never actually worked in urban spaces, Robert Smithson was concerned with industrial wastelands and with the rehabilitation by art of "useless" spaces that have been discarded by society because they are temporarily incapable of earning money for anyone. This is perhaps the most exciting issue to which an artist trying to transcend the art world can address her/himself

today, but unfortunately it takes a heroic degree of dedication, persistence and hard labor to cut through the bureaucratic resistance to anything imaginative or anything which does not seem to maintain the status quo. The red tape, fund raising, and personal hassles are so unfamiliar (and so frightening) that at the moment most artists feel safer sticking to the art world, to formal rather than fundamental innovation.

Nor is it possible, of course, simply to drop into the real world from the art

William Walker, *Peace and Salvation, Wall of Understanding,* Chicago, 1970. The mural includes scenes of peace and violence that took place in the community and in that very building; Walker continued to change it as other events occurred. (Photo: Lucy R. Lippard)

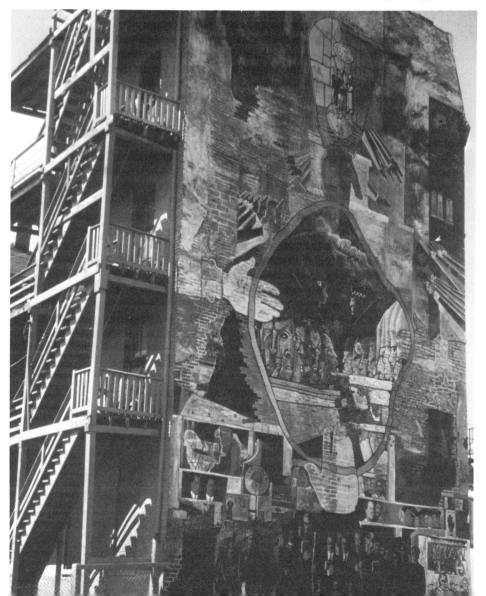

world and impose esthetic ideas that may be foreign and distasteful to a particular community. It is a temptation for the artist to retain the art world as referent, by dashing back into the gallery from the cold world outside and exhibiting documentation of such a short-lived foray into social conscience. This can be seen as exploitation rather than expansion of the audience. The art remains a safely esthetic, if picturesque, gesture rather than taking any of the real risks implied by venturing into new territory.

Some tentative moves in this direction have worked. Smithson's *Broken Circle* (1971), constructed for a sculpture show in Emmen, Holland, was so popular that the townspeople voted money to maintain it indefinitely. Byron Burford's traveling art circus, which moves around the state of Iowa with its own tent, band and sideshows, has been a great success. Utilization of urban energies was one of the major objectives of the now defunct Pulsa Group, based in New Haven, Connecticut, which from 1966 to 1971 collaborated on public environmental art made with light and computer technology. Their programmed configurations, such as the one in the Boston Public Gardens in 1969, altered spaces by means of intricate strobe systems which flashed high-speed patterning of light and sound through a passing crowd. Many people who walked through it did not know that they were being exposed to "art"; they sensed, rather than perceived, the way their physiological experience was being affected. Others became aware to the point where they could dance to the almost unseen rhythms. Pulsa hoped to implement far-reaching social changes with its environments, but the group finally disbanded after several years of collaborative work and communal living, in part because of disillusionment with big business, with which the scope of their ideas forced them to deal.

Other potentially workable projects have not been built. Lloyd Hamrol's *Earth Rings* was designed for Watts, the Black ghetto on the outskirts of Los Angeles where the riots took place; it would be both a handsome Minimal sculpture, an amphitheatre, a playground, and a meeting place. Athena Tacha's Charles River project for Cambridge, Massachusetts, would also transform an "unused" location into a park and a sculpture simultaneously. The huge cost that makes these projects impossible or idealistically improbable has been circumvented by those artists working on a smaller, temporary but not necessarily less effective scale. Mary Miss' wooden structure was erected in 1974 on an industrial landfill area along the Hudson River in downtown New York; its fencelike components with descending circular apertures offered a serial sculpture from the exterior and pictorialized the landscape like a hall of mirrors from the interior. Two years later, on the same site, Suzanne Harris made *Locus Up One,* an enterable sand mound with a narrow plaster interior corridor, a square in a circle, from which one saw only the white walls and the sky. Andrea Brown, in Santa Monica, California, is one of several artists to have used billboards as "easels"—in this case for an orange ground which sizzles in the sunlight and glows deeply when lit at night. Anne Healy's billowing fabric sculptures are as tough and delicate as the sails that inspired them; while the rigging is highly technical, the material itself is relatively cheap and easy to handle as well as evocative. Sheila Berkley makes portable playgrounds for children that can be brought into streets and vacant lots for short periods of time. In San Francisco, Bonnie Sherk and Howard Levine have made portable parks in the city center by laying down turf, adding a bale of hay, a picnic table, a cow, and a palm tree to turn the street into a bucolic plaza

where office workers can lunch. On this model, Sherk is now engaged with other artists in an ambitious scheme for a community farm, theatre, and art workshops at a site where three ethnic neighborhoods meet, and where in the past real farms were located (see p. 146). This is ground pioneered by community development groups, such as New York's Green Guerrillas, and it is only since 1970 that a few "fine" artists have set foot on it. One of the results will be to remind inner-city dwellers that the earth still exists beneath the asphalt, to vary flatness with hills, gray with green, congestion with open spaces; to recall, in short, the values implied by nature, and to alter the quality of urban life.

These goals can be approached with small-scale projects as effectively as— sometimes more so than—large ones. Artists working independently can represent and generate energy in affirmation of a community or an individual viewer, as in Poppy Johnson's 1970 Earth Day celebration, in which she planted sunflowers in a rubbish-strewn lot; or they can act in opposition to repressive systems. The Guerrilla Art Action Group has concentrated on street protests and public letter-writing campaigns. Among their actions was a scrubbing piece, performed to an unwarned audience at the Whitney Museum in 1970, which referred to the institution's failings and to the Vietnam war ("This place is a mess. We've got to wash it up."). The N.E. Thing Co. in Vancouver notified the public of atrocities to the land with a sign piece titled *Rapescape.* Ana Mendieta, in Iowa City, performed a shocking feminist rape piece when she invited people to an untitled performance and they discovered her half-naked bloody body in the woods.

One of the most efficient strategies of unsubsidized small-scale art in large-scale environments, country or city, is that of fragmentation—the establishment of many small units which, once visually associated with each other over spans of time, space, memory, make a whole—a continuity that is far greater than the sum of its parts. Historical precedents include Indian cairns, trail blazes, the *toas,* or location markers left on a site by a nomadic South Australian aboriginal tribe; or the serial Burma Shave signs which dotted American roadsides for thirty-odd years with such profundities as "Of all the drunks/Who drive on Sunday/Some are still/Alive on Monday."

In New Zealand, Kim Gray marked a longitudinal line up the North Island by a series of scarecrows made and erected with the help of local residents. For almost a decade now, all over the world, Daniel Buren has been pasting up on walls and billboards his striped posters, always the same except for color. As the visual foil to published texts, they extend the theory of art and attempt to demystify the art of painting, the myth of the artist as revolutionary. The very blankness of the "sign" and its repetition activates the ability to see, which, though not one of Buren's prime objects, is nevertheless a provocative result of his activity. A recent manifestation was to carry the placards in a small parade, or "ballet," routed through different New York neighborhoods.

A similar work, also intended for art audiences, is Hans Haacke's systems piece which was responsible for the cancellation of his one-man show at the Guggenheim Museum in 1971. It consists of photo and text documentation of intricate networks of buildings on the Lower East Side and in Harlem owned by various interrelated absentee landlords. Despite the fact that all the evidence had been gathered from public county records, the information was deemed unsuitable for the public.

A visual fragmentation rooted in direct experience rather than in theory and documentation is effected by Charles Simonds' migrating civilization of a fantasy Little People. In SoHo from 1970 to 1972, on the Lower East Side from 1972 on, passersby might come, unwarned, upon a tiny clay landscape, dwelling, and ritual place nestled in a niche in a broken wall. As the Little People infest a neighborhood, they become part of it. Their fragility, their precarious position in the midst of urban violence and destruction, as well as their religious attitudes toward the earth and a ritual, life architecture, make points of identification for the primarily poor, Black and Puerto Rican audience for whom Simonds works. This identification has led, in turn, to work on community projects: a playlot made in conjunction with two local groups (the Young New Yorkers and the Lower East Side Coalition for Human Housing), and current plans for total rehabilitation of the area's buildings and bombed-out-looking vacant lots. The Little People, and by extension these projects, encourage the people in the community to affect their environment. In this case, politicization of the audience arises from focusing on reality and simultaneously fantasizing change. Simonds' work is a rare guidepost toward an esthetically important art successfully integrated with social concerns.[6]

NOTES

1. This lecture was given in July 1975 in the following Australian cities under the auspices of the Power Institute of the University of Sydney (which has not yet been powerful enough to repay me for my airfare between several of these cities): Sydney, Brisbane, Canberra, Melbourne, Launceston and Hobart in Tasmania, Adelaide, and Perth. It is, as I state in the title, a slide lecture, depending heavily on visual material as well as on a long and lively question period at the end, without both of which it is sadly truncated.

I see essays and lectures as two decidedly different mediums: the former can be read again if they are not immediately understood and can therefore be more complex, whereas the latter must make their points clearly on the spot. Most lecture audiences are not only captive, but motley, and I feel strongly that the lecturer has an obligation to be as lucid and unpretentious as possible, saving her profound obscurities for the essay form. This lecture, therefore, has been revised only minimally and stands as the transcription of a spoken, rather than as a "written," text.

The lecture's second section, on art's relationship to nature, has been omitted as irrelevant to this collection; it has been expanded into parts of my book *Overlay* (New York: Pantheon Books, 1983).

2. As a reader of *Studio International* remarked in a letter after I published two forerunners of this lecture: *Two* and *Three*, in *Studio International* (Oct. and Nov. 1973).

3. See also Dale McConathy's "Keeping Time: Some Notes on Reinhardt, Smithson, Simonds," *Artscanada* (June 1975).

4. I discussed this show in "Beauty and the Bureaucracy" in *Changing* (New York: Dutton Paperbacks, 1971).

5. There are a great many other streetworks which deal similarly with perception; see my survey of streetworks in downtown New York, pp. 52–66.

6. I say this at the risk of being accused of nepotism, as I have lived with Simonds for four years, although I was impressed and influenced by the work before I met the artist.

The Death of a Mural Movement*

(Edited from an article by Eva Cockcroft)

On October 20, 1973, amid the boutiques, brownie stands, and business-as-usual art of SoHo, a group of concerned Latin American and American artists re-created a section of a Chilean popular revolutionary mural to condemn the junta's repression of the arts and call attention to the atrocities taking place in Chile. A 100-foot mural made up of 8-foot laminated panels was drawn in the studio after photographs of the original, made along Santiago's Rio Mapocho by a Ramona Parra Brigade. It was painted in the street by volunteer artists and passersby. The sun was shining, the colors bright, and spirits high, but reality, in the imagery and message of the mural itself, and in the leaflets handed out by the Chilean Solidarity groups, recalled the grim facts: Allende is dead; thousands of people have been summarily executed; the ubiquitous people's murals have been systematically destroyed and painted over during the first weeks of the military regime; artists have been killed, exiled, imprisoned and censored; books and paintings have been burned. The art-loving crowds in SoHo smiled and passed on, as did the Christmas-shopping crowds of Fifth Avenue a week later when the mural was set up outside the Chilean National Airlines. Given the political apathy of the American art community, the significance of such events lies less in effect than example. A work of art created collectively to celebrate the hope of freedom has been resurrected to protest the loss of that freedom. In another place and another context it has continued to carry its message. Its origins, however, are still more exemplary. The following text has been summarized from a long article by Eva Cockcroft which appeared in Towards Revolutionary Art.[1] *Cockcroft interviewed and worked with the brigades in Chile in 1972.* (L.R.L.)

Painting slogans on walls is a traditional mode of political communication in Latin America, since the formal media are normally dominated by U.S. interests and the political party in power. During the Allende campaign of 1969–1970, painted walls emerged as an essential communication link between the Left and the masses. Rival painting brigades were formed as part of the youth organizations of several parties in the Popular Unity coalition. When the Ramona Parra Brigades of the Communist Party began to draw political symbols to complement the verbal messages, a new mural style began to evolve, and when Allende was elected, this new style flourished on every available surface throughout the country. Named after a twenty-year-old worker-heroine shot down during a nitrate strike in 1946, each Ramona Parra Brigade (before the coup there were 50 in Santiago and 150 in all of Chile) consisted of twelve to fifteen members with an average age of seventeen, though some were as young as twelve. They worked cooperatively, creating some projects directly on the wall, while more complex designs were

*Reprinted by permission from *Art in America* (Jan.–Feb. 1974).

worked out beforehand and passed from group to group, though freely altered during the painting process.

A common imagery and a vocabulary derived from Cubism developed into a complex, organically evolved metaphor. Whole walls were transformed into a series of intertwined symbols much in the way that words are joined into sentences and sentences into paragraphs. A fist became a flag became a dove became hair became a face, and so on. Speed, a necessity for clandestine, illegal painting, determined the high degree of simplification and the use of flat, bright colors applied with more regard for visual clarity than for naturalistic effects. Thus elements of "modernity" developed naturally, without a conscious search for style. And within the limits of effectiveness, the styles were varied. Permanence was not a factor. As issues changed, some walls were painted over and the cheap tempera paint was quickly faded by rain and sun.

The primary function of the murals was mass political education. During the Allende campaign, traveling brigades were formed to go into isolated communities and paint walls, give puppet shows and political raps. Once Allende was president, the brigades worked with the people in communities, housing developments and factories, as well as on the streets and in parks, consciously attempting to revise and redirect the taste of the masses. In the case of Fabrilana, a textile factory nationalized in 1970, the young artists studied its processes and were impressed by the movement of huge skeins of colored yarn. In the resulting mural the great looms become rectangular forms and the colors of the wool flow throughout becoming hands, smoke, hair, flags. Initially the workers' preference for strict naturalism (resulting, the brigades were convinced, from cultural deprivation rather than any innate sensibility) led them to question the abstraction. But when the mural was completed, they felt it to be a more convincing reflection of

New York artists re-create Chilean mural in SoHo, October 20, 1973, to protest the overthrow of Allende's Popular Unity government by the military *junta*. (Photo: Eva Cockroft)

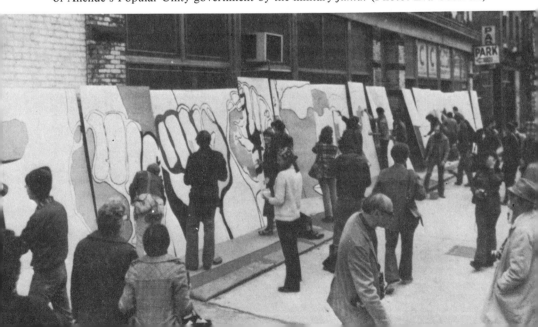

their experience than the conventional group of heroic figures would have been.

The Rio Mapocho mural re-created in New York was the most ambitious of all the BRP projects. Painted along a stone wall by the river beside a large and popular Santiago park, it ran for more than a quarter of a mile, between two bridges. About fifty Brigadistas worked for more than a week to complete it. The mural began with a quotation from Pablo Neruda: *"Me has dado la patria como un nacimiento"* ("You have given me the fatherland as a new birth"). Its five sections showed the nation mobilized for a new birth, marchers with their flags, the people reborn, the flag-face symbol of the *compañera;* a poem on the labor union struggle, workers, a mining village, and the martyrs of that struggle; the giant words NO TO FASCISM, prisoners, fists, flag and gun (this is the section reproduced in New York); a paean to Copper and Industry; a fanciful celebration of the fiftieth anniversary of the Chilean Communist Party. The brilliant colors took on subtlety from the uneven surface of the stone.

The figure of a massive laborer in the Rio Mapocho mural is a rare echo of Siqueiros. Although not unaware of the work of the Mexicans, individual BRP members stated that they did not consider Siqueiros an important influence: "The style of Siqueiros and the Mexican mural movement is no longer relevant even for Mexico, since it serves as the symbol of a prostituted revolution. Siqueiros is now a painter of the Mexican establishment, an establishment which needs to be overthrown by a new and legitimate revolution which will bring with it a new style."[2] The debt to Cubism and artists such as Léger is also acknowledged, but the Brigadistas pointed out that it was ideologically important to see that while Léger went from the sophisticated to the primitive, they were moving in the opposite direction, seeking an indigenous style, an art truly of the people which would foster a higher class consciousness. To what degree they succeeded before they were so rudely halted is difficult to determine. Certainly they were putting into practice the collective ethos, a genuine participation of the *pueblo* in its own art. In doing so they had to combat historically imposed colonialist deformations of taste by the capitalist mass media, and the prejudice of the international artistic elite against propagandist art.

The collective execution of these murals is perhaps the most important element for art in general, a significant departure from the concept of individual "genius" as a prerequisite for the creation of "art." Cooperative creation and collective responsibility help to diminish the ego conflicts and insecurities so common in competitive societies. There was in the brigades a strong group solidarity. Individual style was not encouraged, although experimentation and innovation were prized. In their attempt to forge a bridge of communication including modernistic simplifications and distortions but retaining a humanistic element, they experimented with several different styles, from fantasy and comic strip to an epic symbolism. As their reputation grew, they began to receive some recognition and exert some influence on the established art community. Occasionally students from the School of Fine Arts would paint with them, and on the wall at the Piscina La Granja, outside of Santiago, Surrealist Roberto Matta Echaurren worked with the BRP.

The gap between art and life, between art and people, was being closed. That process has stopped now. The junta has begun an "ideological struggle to try to wipe out the effects of three years of left-wing government on the consciousness of the working class and the very poor." The nine-foot statue of Che Guevara in

Santiago was pulled down by a group of soldiers and driven off in a truck to be melted down. On October 2 the junta announced that as part of its "clean-up campaign" it intended to "put an end to the black night of Marxist cinema" by importing American films, which will necessitate a tenfold increase in the price of admission to movie theatres, effectively eliminating movies as a recreation for workers. News as to the fate of hundreds of left-wing Chilean artists and intellectuals is still not known. There is, however, enough information to establish a general picture of the situation. Victor Jarra, the singer and innovator in the new folk music, was killed. In one of many mass executions, an entire left-wing ballet troupe was killed. When Pablo Neruda, Nobel prize-winning poet, died of cancer and heart disease a few days after the coup, his house and library were sacked and his books burned. A young American film-maker visiting Chile was arrested and killed. The reign of terror continues, and with it a determination to eliminate all forms of freedom of expression.

NOTES

1. *TRA,* San Francisco, no. 4 (1973).
2. *ARTnews* (Summer 1973).

The Artist's Book Goes Public*

The "artist's book" is a product of the 1960s which is already getting its second, and potentially permanent, wind. Neither an art book (collected reproductions of separate artworks) nor a book on art (critical exegeses and/or artists' writings), the artist's book is a work of art on its own, conceived specifically for the book form and often published by the artist him/herself. It can be visual, verbal, or visual/verbal. With few exceptions, it is all of a piece, consisting of one serial work or a series of closely related ideas and/or images—a portable exhibition. But unlike an exhibition, the artist's book reflects no outside opinions and thus permits artists to circumvent the commercial gallery system as well as to avoid misrepresentation by critics and other middlepeople. Usually inexpensive in price, modest in format and ambitious in scope, the artist's book is also a fragile vehicle for a weighty load of hopes and ideals; it is considered by many the easiest way out of the art world and into the heart of a broader audience.

The artist's book is the product of several art and nonart phenomena of the last decade, among them a heightened social consciousness, the immense popularity of paperback books, a new awareness of how art (especially the costly "precious object") can be used as a commodity by a capitalist society, new extra-art subject matter and a rebellion against the increasing elitism of the art world and its planned obsolescence. McLuhan notwithstanding, the book remains the cheapest, most accessible means of conveying ideas—even visual

*Reprinted by permission from *Art in America* (Jan.–Feb. 1977).

Antonio Muntadas, *Wet and Dry Diplomacy*, 1980, Printed Matter Window, New York City. The Printed Matter windows change monthly and are designed as social outreach projects by artists who have books in the store. (Photo: Lucy R. Lippard)

ones. The artist's adaptation of the book format for works of art constitutes a criticism of criticism as well as of art-as-big-business. Its history, however, lies in the realm of literature and *editions de luxe*.

The ancestors of artists' books as we know them now were the products of friendships between avant-garde painters and poets in Europe and later in New York. It was not until the early 1960s, however, that a few artists began to ignore literary sources, forgo the collaborative aspect and make their own books—not illustrations or catalogs or portfolios of prints but books as visually and conceptually whole as paintings or sculptures. Among them were some of the Fluxus artists—George Brecht in particular, who produced curious little publications with roots in games or the Surrealist collage and box.

The new artists' books, however, have disavowed Surrealism's lyrical and romantic heritage and have been deadpan, antiliterary, often almost antiart. Ed Ruscha's *26 Gas Stations* (1962), followed by his *Various Small Fires* (1964), *Some Los Angeles Apartments* (1965), *Every Building on Sunset Strip* (1966) and so forth into the present with *Colored People,* initiated the "cool" approach that dominated the whole conception of artists' books for years. Ruscha's books were a major starting point for the as-yet-unnamed Conceptual Art, a so-called movement (actually a medium, or third stream) which made one of its most vital contributions by validating the book as a legitimate medium for visual art.

By 1966, if you were reading the signs, you noticed that the book was a coming thing. Dan Graham's and Robert Smithson's hybrid magazine articles— neither criticism nor art—were one of the signs; Mel Bochner's "Working Drawings" show at the School of Visual Arts, where drawings that were "not necessarily art" were Xeroxed and exhibited in notebooks, was another. The

point (having to do with a broader definition of art, among other things) was followed up in 1967 by the Museum of Normal Art's show called "Fifteen People Present Their Favorite Book"; the same year, Brian O'Doherty, as editor of a boxed issue of *Aspen Magazine,* included artworks (not reproductions) by Sol LeWitt, Tony Smith, Graham and Bochner; the 0–9 press, one of whose editors was Vito Acconci, then a poet, published single artworks in booklet format by Acconci himself, Rosemary Mayer, Adrian Piper and others; Sol LeWitt published the first of his many books; and in England, the first Art & Language publications appeared, promulgating an extreme and incommunicative use of texts as art.

By 1968, when dealer Seth Siegelaub began to publish his artists in lieu of exhibiting them, the art world took notice. Lawrence Weiner and Douglas Huebler had "no-space" shows; Hanne Darboven and the N.E. Thing Co. published their first independent books; *The Xerox Book* presented serial Xerox works by Andre, Barry, Huebler, Kosuth, LeWitt, Morris and Weiner; Siegelaub's "Summer 1969" exhibition took place in fragments all over the world and existed as a whole only in its catalog.

Since then, hundreds of artists' books have appeared. Yet they are never reviewed, not even in art magazines, either as books or as exhibitions. So far, artists' books have been dispersed (usually as gifts) to friends and colleagues, then left to languish in warehouses, studios and gallery back rooms. They are published by the artists themselves, by small underground presses or by a few galleries—the latter more often in Europe than in America. Art dealers are more interested in selling "real art," on which they can make a profit, and tend to see artists' books as handy handouts to potential buyers of expensive objects. Even art bookstores make so little profit on artists' books that they neglect them in favor of more elaborate tomes. Artists unaffiliated with galleries have no way to distribute their books widely and rarely recoup printing costs, which, though fairly low, many cannot afford in the first place.

It is difficult to find organizational funding for printing artists' books because the visual-arts sections of the various councils do not give money for publications. Subsidies exist for all the conventional visual arts—film, video, "mixed media" (which covers a multitude of sins, but rarely books)—as well as for plays, fiction and poetry. But the artist's book—a mutation clinging to the verbal underside of the visual-art world—tends to remain an economic pariah even in its own domain. (It *is* difficult to distinguish an artist's book consisting entirely of text from a book of "poetry," or one consisting of a series of "antiphotographs," whose importance lies in sequence rather than in individual composition, from a conventional photography book.)

With some luck and a lot of hard work, problems of distribution may be solved by Printed Matter, a New York collective of artists and artworkers which has just been set up both to publish a few books and to distribute and operate a bookstore for all artists' books.[1] This task was taken over from Martha Wilson, an artist whose nonprofit organization, Franklin Furnace, briefly distributed artists' books but now limits itself to an archive and exhibition service for them. Printed Matter hopes to maintain an effective liaison between an international audience and individual artists, galleries and small presses, such as Vipers Tongue, Out of London, and L.A. Women's Graphic Center.

At the moment, the artist's book is defined (and confined) by an art context,

where it still has a valuable function to serve. To an audience which is outside the major art centers and, for better or worse, heavily influenced by reproductions in magazines, the artist's book offers a first-hand experience of new art. For an artist, the book provides a more intimate communication than a conventional art object, and a chance for the viewer to take something home. An artist's book costs far less than any graphic or multiple and, unlike a poster, which may cost as much or more, it contains a whole series of images or ideas. The only danger is that, with an expanding audience and an increased popularity with collectors, the artist's book will fall back into its *edition de luxe* or coffee-table origins, as has already happened in the few cases when such books have been coopted by commercial publishers and transformed into glossy, pricey products.

Needless to say, there are good artists' books and bad ones—from anyone's point of view. They have in common neither style nor content—only medium. (Economically determined strictures, as much as a fairly ubiquitous Minimalist stylistic bent, can be blamed for the tendency toward the white, black or gray cover with stark type that until recently was the trademark of the artist's book.) They are being made everywhere: Printed Matter's first ten books came out of Oregon, Pennsylvania, Illinois, California and Massachusetts, as well as New York. They range from the hilarious to the bizarre, romantic, deadpan, decorative, scholarly and autobiographical; from treatises to comic books. Their po-

Anonymous, from *Red Herring,* January 1977, p. 45.

litical possibilities are just beginning to be recognized too. One of the basic mistakes made by early proponents of Conceptual Art's "democratic" stance (myself included) was a confusion of the characteristics of the medium (cheap, portable, accessible) with those of the actual contents (all too often wildly self-indulgent or so highly specialized that they appeal only to an elite audience). Yet the most important aspect of artists' books *is* their adaptability as instruments for extension to a far broader public than that currently enjoyed by contemporary art. There is no reason why the increased outlets and popularity of artists' books cannot be used with an enlightenment hitherto foreign to the "high" arts. One day I'd like to see artists' books ensconced in supermarkets, drugstores and airports and, not incidentally, to see artists able to profit economically from broad communication rather than from lack of it.

NOTE

1. Printed Matter is now located at 7 Lispenard Street, New York, N.Y. 10013, 212-925-0325. The 1983 catalog contains over 2,000 items and is available for $4.00 postpaid.

The Geography of Street Time: A Survey of Streetworks Downtown*

I should say at the outset that my decision to write about streetworks—ideally an ephemeral, rebellious, iconoclastic, outreaching and noncommercial medium—reflects my dissatisfaction with the "downtown scene" as it has developed since around 1971, when so-called SoHo (even the name is imitative) hit its carnival stride. The area was once called Hell's Hundred Acres because of its concentration of sweatshops; in its sometimes lively decadence it may re-earn the name.

A good many artists have been living illegally in SoHo lofts since the 1950s. In 1968 the artists' co-op buildings were under way, but Paula Cooper had the only gallery below Houston Street. She opened her new space that November with a handsome Minimal show organized as a benefit for the antiwar movement. Also in 1968, Ten Downtown—artists showing in their own lofts—provided an early example of extracommercial, artist-organized exhibitions; and the next year 55 Mercer Street, founded by members of the Art Workers' Coalition, became the first of a new wave of co-op galleries.

There was at this point a mood of exhilaration, a feeling that control over art was being returned to the artists' community. In opposition to the intellectually demanding, often hostile and cliquish atmosphere of the 1960s avant garde, the end of that decade saw a brief politicization of artists on a model set by Blacks and students. Resentment against the high style of the classy '60s, the domination of big money, the uptown galleries and audiences—all of this contributed to the process of "decentralization" into the downtown area, although in retro-

*Reprinted by permission from *SoHo,* Akademie der Künste, Berliner Festwochen (Sept.–Oct. 1976).

spect, it is ironic and somewhat cynical to talk about decentralization (presumably epitomized by streetworks) in the heart of the bastion of international art centralization and all the vices inherent therein. Many artists and artworkers around 1969 desired some measure of independence from the system, though it should be said that none of us at any time totally abandoned his or her marketplace for the freedom of open shows, picket lines, and streetworks. There was, however, much talk about such possibilities, culminating in the citywide Art Strike at the time of the murders at Jackson State and Kent State, and the U.S. bombing of Cambodia.

The second gallery to move downtown was O. K. Harris. With the legalization of loft living, the beatification of SoHo as a landmark area, and the resultant media attention, an unheard-of degree of commercialism replaced the initial community ideal. By 1971 the political excitement had died down. While the art basked in pluralism, the area slowly settled into a geography of boutiques, bars, and fancy food. When tourists began to appear on Saturdays (and later by the busload even during the week), it was clear that SoHo's fate was no longer in the hands of the original artists' community. Subsequent moves into "SoHo," "Tribeca," Brooklyn or the Flower District have simply expanded the reach of the "downtown scene." In the summer of 1975, a resident noted that the ratio of dogshit per block below Canal Street had doubled.

Since this new scene and the art it sponsored were the products less of esthetic than of political and commercial groupings, there developed a collage of unlikely networks: between artists and other artists, writers, poets, film-makers, and musicians on one hand, and between them and the marketplace and the social superstructure on the other hand. Streetworks should characterize this overall disjunction. They are by definition vignettes—temporary, rootless within the system, free to create their own structures, and experienced casually by a chance audience. The earlier streetworks, as well as works in public interior non-art spaces (subways, courthouses, etc.) constituted a dissatisfaction with what Robert Smithson called "cultural confinement," an attempt to move out of the gallery's enclosed and pristine environment and into the World. SoHo, with its mix of expensive restaurants and truck-clogged and factory-litter-strewn side streets, offered a perfect "land of contrasts." Yet most of the art shown in far-out SoHo is conventional painting and sculpture, and despite their possibilities for "novelty," there are amazingly few instances of bona fide streetworks over the last six years, even including those which are gallery-based. The following text does not claim to cover all the downtown streetworks, but I suspect it includes the large majority.

Although in the late 1950s artists like Claes Oldenburg, Jim Dine, Red Grooms and Allen Kaprow went to the Lower East Side gutters for their materials and their subject matter, little actually happened in the public domain. In March 1964, the Fluxus group and its motley affiliates did the first (and only) of what had been planned as a series of Saturday streetworks on Canal Street. There were pieces of Alison Knowles, Dick Higgins, Ben Vautier and others; Robert Watts' *2 Inches* (a ribbon across the street intended to be cut, which was instead torn by cars) was broken up by the police. In 1968, Anne Healy defied police and permits to rig her first billowing fabric sculpture on the exterior of a West Broadway loft building. It was, however, in March 1969 that Street Works were officially baptized with a series of events organized by poet and critic John Perreault, artist Marjorie Strider, and visual poet Hannah Weiner.

The first of these was on Saturday, March 15, lasted twenty-four hours, took place in Midtown (Forty-second to Fifty-second streets between Madison and Sixth avenues) and included twenty people—artists, writers, performers, among them Vito Hannibal Acconci, Gregory Battcock, Meredith Monk, Anne Waldman, Les Levine, Arakawa and myself. Street Works II was more concentrated, taking place on Friday, April 18, from 5 to 6 P.M., on one block (Thirteenth to Fourteenth streets, Fifth to Sixth avenues). This time around forty people participated. Where we had been freaks in Midtown, we were part of the carnival on Fourteenth Street. Poets handing out or reading their work had to compete with leafletters for fortune tellers and hawkers of dry goods, artists with the visual, auditory and odoriferous stew of high honky-tonk commerce. Thirteenth Street, on the other hand, was a factory area and offered a different atmosphere, as did each avenue.

Street Works III took place on May 25, a Sunday night, between Grand and Prince, Greene and Wooster, in what was not yet SoHo; this area was chosen because it was then so deserted. Seven hundred people were invited to join and the event was aptly and darkly documented by Perreault with a flashless camera. Street Works IV was an institutionalized insert into the series—sponsored by the Architectural League, with selected participants. Street Works V was "World Works," in which "artists and people everywhere are invited to do a street work in a street of their choice. A street work does not harm any person or thing." (The warning referred to John Giorno's Street Works III piece—sprinkling the street with nails, which resulted in flat tires not only for friends and the curious, but for the touring police, who stopped the event.) Among the 1969 streetworks:

● Perreault's *Street Music,* utilizing the public phone booths in the area for a bell-ringing piece; and his *Survey,* in which "the questionnaire is the script, I and the person being interviewed are the actors; the set is the location, the costumes are the clothes we are wearing, the audience is all the other people on the street, the music is the natural sound, the dance is how we move in relation to each other."

● Stephen Kaltenbach's offer of a package (contents unknown) for sale, starting cheap and mounting in "value" each time it was refused by a passerby.

● Arakawa's blueprint of a house and grass yard on the sidewalk.

● My *Contact Piece*—merging with the crowds and doing the following things one time per block: "Stare up at the tops of buildings until others do so too; turn now and then, look behind you, abruptly: look everyone coming toward you straight in the eye for as long as possible; when someone is coming at you and swerves to avoid collision, swerve in the same direction and keep it up as long as possible; speak to one person as though you knew him or her well; walk in step with people beside you."

● Eduardo Costa's *1000 Street Works*—"artworks" unidentifiable as such, placed on the street charged with the implications that art may have for the person who passes by and notices them as such.

Although most younger artists now working in these media are hardly aware of their predecessors, this Street Works Series, along with the Judson Dance Theater, was a major source of the current performance art. During a November 1970 panel at the School of Visual Arts, called "Performances Are Not Dance, Plays, Events," it became clear that it was easier to define, à la Reinhardt, what the new medium was *not* than what it was. Street performance was seen as a way of moving out of the art context, "turning *people* on, not artists," while taking note of the dangers of "doing things to people," exploiting an audience which had escaped art. Performance was also related to an autobiographical and body art just then emerging, in part as a result of the Women's Movement and consciousness raising; in part as a result of a politically defiant "don't tell me what I can do" attitude which faded after 1970; and in part as a result of input from visually oriented writers.

● Scott Burton, as part of his series of "Self Works," walked Fourteenth Street in Street Works II dressed as a woman, not "in drag," as he described it, "but in ordinary, unremarkable woman's clothing (raincoat, umbrella, shopping bags). Total anonymity—as self (to acquaintances); as male, as performer (to all). Achievement of 'invisibility'; immaterial piece. And 'costumes'; concealment and revelation."[1] Burton slept (and dreamed) at an exhibition opening and then walked nude on Lispenard Street at midnight in a reenactment of a "classic anxiety dream" ("inversion of disguise piece? Violation of legality. Imitation of madness; strong self-directed effect"). In Street Works III, Burton had intended to lie nude in the gutter, anticipating the direction later taken by Chris Burden, but decided against its masochism and did a "Deaf Piece" instead.

● Other sleep pieces have been performed by Colette, in the streets at dawn ("because of the associations attached to those particular hours of the day . . . those hours when everything that is real appears to be unreal"); and by Laurie Anderson, whose *Institutional Dream Series* took place in city government buildings such as Surrogate Court, Night Court, and the Immigration Bureau.

● Vito Acconci, in 1969 a poet just emerging into the visual arts, was at first influenced by the conceptual street "exchange" pieces of Douglas Huebler; during the spring and summer of that year he gradually evolved his own concerns with the "interaction between the art activity and the daily living," aiming at "no separation, though ultimately *showing* it in an art context . . . I find that kind of performance tends to clarify things for me, as a kind of model experience."[2] Acconci started out by roaming the streets either in accordance with preconceived patterns or guided by chance circumstances. He saw himself as a moving point; he paced out distances, picked out people to walk with or stare at. For Street Works IV he followed one person and stopped only when the subject "entered a private place." (Christine Kozlov had also projected a "following piece" but later "rejected" it as part of a rejection series.)

● The ultimate risks inherent in this sort of public interaction have probably been taken by Adrian Piper. She began her *Catalysis Pieces* in New York streets and public places in 1970. In different parts of the city, she drastically altered her ordinarily attractive appearance so as to become a pariah. First this was done with

"costume"—stuffing her clothes with balloons, her mouth with a towel, blowing gum bubbles all over her face, riding the D train from Grand Street with her clothes drenched in a noxious-smelling mixture. Then she began to work with a more subtle kind of behavioral "eccentricity," reenacting public events or conversations from her past, singing to herself and dancing to it, launching into long stories to amazed passersby she had stopped to ask the time. The most recent manifestation of this attempt to exorcise her past is the adoption of a male alter ego complete with Afro and shades called The Mythic Being—"a catalyst for the violences of our world, an alien presence in the artworld, but a familiar presence in the rest of the world." In his guise she has appeared in the streets and in newspaper ads, in posters, and on postcards.

All the while, Piper has totally avoided a confrontational art context, making no indication to her chance audience that this was art or performance, and thus making the separations and connections between art and madness painfully invisible. She was determined to preserve "the power and uncategorized nature of the confrontation," denying any connection with "preestablished theatrical categories." Although she would later convey her activities to the art world by means of written texts, Piper began these lonely and frightening operations to avoid the "prestandardized" responses characteristic of art situations, which "prepare the viewer to be catalyzed, thus making actual catalysis impossible."

Costume, makeup, and props—standard theatrical materials—have played a considerable part in performance-oriented streetworks. They provide: a way of attracting an audience; a disguise which protects the artist from reality; and a mode of self-transformation important to the identity search that often parallels the carefully created public image.

● "Witch Doctor" Stephen Varble, who has paraded SoHo on Saturdays in fifteen elegant "garbage costumes," sees streetworks as "freeing artists from the slavery of the galleries . . . I found my own audience and my own patrons there."

● Martha Wilson and Jacki Apple, with four friends, took on the composite identity of "Claudia"—"a fantasy self who is powerful, gorgeous, mobile . . . the result of the merging of the realized and idealized self"; one Saturday in 1973, "Claudia," dressed fit to kill, lunched at the Plaza and then took a limousine to the SoHo galleries, engendering admiration and hostility.

● Richard Hayman, after a sound performance at the 3 Mercer Street Store, rolled up the street dressed in bells and a mask.

● Laurie Anderson has one-upped the local Juilliard students and wandering musicians by playing her violin on street corners wearing a long white garment and ice skates with their blades embedded in huge blocks of ice; her music comes partly from her bowing and partly from a hidden tape recorder, thus the name *Duets on Ice* (and its effect on puzzled passersby).

● Izak Kleiner-Weinstock, seeing himself as a shaman and holy beggar, performed *Rite of Passage* daily on West Broadway in the fall of 1974. Accompanied by the

tape-recorded sound of walking in water, he "activated/transformed the space/ street by walking in continuous circles—as in Zen meditation" and hoped to communicate to the spectator his "mantra of walking in water." A hat for contributions indicated that "money-energy in exchange for the transformed space" was gratefully accepted and was "integral to the survival of the artwork."

● Donna Henes has done a series of mask events at the South Street Seaport, Battery Park, and on the Brooklyn Bridge. They arose from "an interest in free, public, non-elitist, de-mystified art." She and friends appear at a public place with plaster and materials and proceed to make free face masks of passersby, who then make masks of each other. The event on the Brooklyn Bridge (May 5, 1974) spread until there was "a community of a couple of hundred masked people suspended over the East River, sharing . . . interacting . . . then continuing back into their separate lives, taking with them something as concrete as a plaster mask . . . and as abstract as the ambiance of the experience."

● Minoru Yoshida, self-described "epicurean of space universe," began doing streetworks concerned with energy and "the theory of new relativity" in SoHo in 1975. Garbed in a futuristic costume-machine, as an extension of his body, he is attached by fine lines upward to architectural elements. Accompanying literature is transcendent in tone: "The earth is so turbulent. Is it because man has been jammed into space so small there that he is unable to foresee the fact that he lives in such a wide space of the universe? The earth is so turbulent. Is it because the civilization man has been controlling has begun to control man?"

Streetworks tend to take two forms: impermanent physical objects or remains, and performances which last only as long as the action and, ideally, leave no pollution behind. One of the major virtues of such work is that it requires no dealer or sponsor other than the artist himself or herself, and that it commands a ready-made audience when it takes place in a naturally crowded area; otherwise, it must be announced ahead of time to attract a more specialized audience, and the level of artificiality is raised considerably. All too often, however, no real alternative to the marketplace is offered. Tiptoeing out of the gallery and into the streets, then rushing back to exhibit documentation, only parodies the need to form a "dialectic" between the real and the art worlds. In *urban* outdoor art, esthetic interest cannot overwhelm communication. *If the art has no effect on the audience and the audience has no effect on the art, the streetwork is not successful, and is hardly deserving of the name.*

Today the SoHo Saturday is a freak show, a fashion parade; clowns, magicians, mimes and bagpipers vie with art performances. A streetwork done in this area, especially on the weekend, is obviously aimed at a moneyed and tourist art audience; it preaches to the converted, so that the initial validity and impact of working in the streets has virtually disappeared. In the early days of SoHo, however, there were many more laborers working in the area's small factories; the population was more varied in ethnic and economic background and knowledge of art, providing a more valid version of the "broad public."

This was the audience in the fall of 1970, when Charles Simonds moved out into the public domain with his migrating civilization of Little People, who live

in raw clay landscapes dotted with dwellings, ritual places, and ruins built of tiny bricks directly in the streets or walls of vacant lots. In 1972, when the art world had diffused SoHo's street life, Simonds and the Little People moved to the Lower East Side, where the street is the heart of the community. Here people identified personally with the fragility and the dreamlike spaces of the dwellings, entering into the fantasy without art as an intermediary. In turn, Simonds too has been energized by the spontaneity of the situation and by the continual interaction with passersby. Building the dwellings is not a performance; the viewer as well as the maker must lose his or her role as audience or artist in order to enter the other times and spaces of the Little People's world. The dwellings seem to belong in the niches and crannies of broken walls and sidewalks the way an organically evolved life architecture comes to belong to the land on which it has grown. They are rooted in several different levels of consciousness—the relationship between the earth and the artist's body, the earth and the city, the (often erotic) rituals of the imaginary civilization and the lives of the community which surrounds it; these levels have been articulated by the political and emotional needs of the audience. Working almost daily on the Lower East Side for four years has deeply affected Simonds' art: "The meaning of the dwellings comes more to *be* there If I have to 'show' them to somebody, the experience is completely altered. The whole notion of surprise, of stumbling on a civilization of Little People is lost."[3] Last summer, after three years of hurdling bureaucratic obstacles and stimulating local enthusiasm, he and the residents of

Charles Simonds, *Dwelling,* raw clay, 1975, Long Island City.

East Second Street completed a much needed sculpture/playlot called La Placita, and with the Lower East Side Coalition for Human Housing, he is working on the use and meaning of urban "open spaces"—or vacant lots in various stages of decay and destruction.

If all art teaches us how to see, streetworks incur a special responsibility to relate to or focus on their environment and/or their audience. This was the subject of some of the 1969 Street Works, such as:

● Marjorie Strider's picture frames left in the streets to pictorialize specific places, views, or objects, "to call the attention of passersby to their environment"; in Street Works III, she placed a large banner labeled "Picture Frame" in front of the Architectural League door, "forcing people to walk through the picture plane"; in Street Works V, she put taped frames on the sidewalk, creating more picture spaces to walk through.

● In Street Works II, Stephen Kaltenbach handed out a map with a "Guide to a Metropolitan Museum of Art," which listed forty-two exhibits, such as: "Floor collage. Anon. wrecking crew. Plasterboard and tile. After Robert Morris"; "Air ducts, 2. Shaped aluminum"; "Sky framed by buildings. Air, light, dust, concrete and steel." The last six exhibits were "to be created by you." In the process, Kaltenbach not only invited random passersby to look but created a neat satire on current art for the specialized audience.

● In the Whitney Annual that winter, Robert Huot posted the location each day of a different anonymous "painting" somewhere in the city.

● In February 1972, Robert Whitman, well-known for his early theatre works, made a radio/street piece which had the same focusing effect. While Whitman was at WBAI as the "receiver," thirty observers, each assigned to a different area of the city, phoned in to the station, reporting in a few seconds exactly what was happening outside the phone booths they occupied, thus providing "instant news," such as "It's beginning to rain; a man just walked by with a large brown paper bundle." Eyes and consciousnesses grew sharper as the half-hour piece progressed, and the observers found that in their last calls they were presenting "metaphors of themselves" as reflected in the environment. The result was an audio context which asserted itself in visual images of the life of the city.

Sometimes the chance audience happens upon mysterious "traces" of past activities, which may or may not be decipherable at a later date. Pavements provide a visible surface for graphic streetworks.

● In 1969, Rosemarie Castoro rode up Fifth Avenue at midnight with a leaking can of paint on the back of her bicycle, leaving a wobbly Pollockesque trail to counter the strict traffic markings; for Street Works II, she "cracked" the block with a thin line of silver tape.

● For Street Works I, Kaltenbach made "Trash Poems" dedicated to the city, composed of all words/phrases which appear face up on the sidewalk, to be read

in the order encountered, with no established beginning or end—a circular, changeable, perishable poem.

● In a similar, if less poetic, act, Les Levine littered Forty-second Street with Kleenexes stamped with "dirty words."

● Colette has made several sidewalk pieces in SoHo with a trail system of personalized "Morse code," which connects and simultaneously fragments the experience of walking.

● Two young artists named Jody Elbaum and Stan Dyke have recently made street floor "paintings" with tape as well as paint—the most interesting extending a triangular park at Duane and Hudson with an aerial view of trash baskets, light poles and walls.

● Several years ago Robert Huot left small piles of pornographic magazines in desolate downtown working areas; the next day they had all disappeared.

● Ralston Farina, who does his own offbeat performances in- and outdoors, is mainly concerned with time and its effects. Last spring he put sacks of flour at the intersection of Spring and West Broadway, creating clouds, or snowstorms, when cars ran over them; dogbiscuits were laid on the street and outlined in chalk (like accident victims) and he wrote: "When the truth vanishes from the arts, it's gone forever," which might serve as an epitaph for SoHo.

● A lower-profiled manner of attracting attention to the details of a place or a surface was suggested by Richard Artschwager with his "blips"—small oblong shapes that appeared spray-painted inside and outside the Paula Cooper Gallery in May 1969—in the stairwell, high on the wall of a facing building, on a mailbox, and on up the street, causing a disquieting "image return," a network of remembered forms for the observant resident.

● Daniel Buren has been papering the world with his vertically striped posters (always the same, though in different colors) for almost a decade now. They are primarily intended as theoretical expanders of the art context, but they also provide the visual jolt characteristic of streetworks. The first ones to appear in New York were on billboards, walls and storefronts in October 1970; they were put up independently, though the action was repeated in 1973 under the aegis of the John Weber Gallery. Buren's posters are an attempt to "demystify the artist, the act of painting, the object of art, the object and its dematerialization as subject of formal or esthetic interest." In May 1975, he animated his posters by having a group of five people carry them in a parade around seven different neighborhoods (Chinatown, East Village, Greenwich Village, Times Square, SoHo, Central Park and Wall Street). Each day several routes were traveled and the color combinations of the placards changed. Buren called this *Seven Ballets in Manhattan*. The "dancers" found that each area had its own character and its own way of dealing with unfamiliar phenomena; the least interesting was SoHo, where the audience was jaded and unimaginative. Buren's pieces exist both in their visual fragmentation and on a highly conceptual level, bolstered by written texts. As Eliza-

beth Baker has pointed out, he is "a mixture of theorist, idealist, unavowed formalist, polemicist and art provocateur."[4] The posters have an activist side (he has been arrested for nocturnal poster-pasting) and a contemplative side, which together constitute an effective criticism of art as it exists in this society.

● In the spring of 1976, Carol Kinne turned street activity into a vehicle for easel painting by stapling a series of circular color abstractions painted on clear plastic contact paper around the Broadway–Lafayette area, where they provide an unexpected counterpart to the neighborhood collage (which includes, incidentally, some extraordinary pencil drawings by a local street person).

● November 1974: Zadik Zadikian painted a large old billboard on Varick Street a brilliant yellow to brighten up the lives of commuters through the Holland Tunnel.

● Denise Green has recently been making "guerrilla" fresco paintings on the outsides of downtown buildings, despite persecution by managerial art-haters.

● Robert Janz's streetworks have usually been done in tandem with gallery shows, but the two pieces he made in downtown New York existed independently in the city—visible, if not comprehensible, to the passersby with certain powers of observation. *Six Sticks,* executed in March 1975, was clearly an important experience for the artist, who described their placement as "a ceremony that explored some of the features of the urban landscape." The rectangular rods, placed in doorways, shadows, across sidewalks, against walls, long enough to be photographed, had a small, perhaps nonexistent audience. Janz sees this sculpture as performance, the sticks as actors. In the second piece, a year later, he departed from the opening line of Paul Klee's *Pedagogical Sketchbook*—"a line on a walk . . . a walk for a walk's sake." Klee's S-curve was drawn with chalk on intersections, corners, angles in the city; the lines are impermanent enough to satisfy ecological ethics but unlike the sticks, they are there to be seen. The graceful and cryptic curve must invoke some curiosity from passersby.
 Janz's streetworks were part of an ongoing series of "New Urban Landscapes" sponsored by the Institute for Art and Urban Resources, a unique organization concerned in part with recycling city-owned spaces for art and artists. This series is supposed to represent "a wide variety of avant-garde disciplines to transmit through their art, images of Lower Manhattan to the people who live and work there." Yet most of their projects, interesting though some may be on esthetic levels, make virtually no contact with an audience.

● Peter Barton, for instance, placed an abstract metal sculpture in various locations and keyed it into a time structure determined by complex satellite reckonings, in order to achieve "a vast range of implications that transcend the merely visual product." Such a piece, however, is inaccessible to its audience and exists primarily as a trophy, to be carried back in the form of documentation to the elite.

● Equally invisible, but somewhat more sensitive to its purpose, was Bill Beirne's poignant *Why Are You Leaving Me?* one of a series of pieces in which he

"attempts to force the indigenous activities of a specific location to interact with his presence there." Interested in the emptying-out process of densely populated urban spaces at the end of the workday, and the "simultaneous convergence of thousands of pedestrians on a few points of departure," he stood at the entrance of the Port Authority Trans Hudson System and "attempted to communicate the need for someone to stay by simply assuming a posture in opposition to the activity taking place there."

● The roofs of downtown Manhattan provided an airy multilevel stage for a 1975 performance by Trisha Brown, and a viewing platform for a six-square-block performance by Joan Jonas in 1972, in which she incorporated the piers, the vacant lots, painted circles and lines in the streets, and obstructed traffic by rolling through in a hoop. The vacant lots temporarily abandoned by capitalism have also become "sculpture gardens" and stages.

● In 1969, Les Levine made his *Process of Elimination* in a lot on Houston Street, placing 300 sheets of polyexpandable foam there and removing a portion each day, subtracting rather than adding objects to the environment—an idea much in vogue at the time.

● Poppy Johnson's Earth Day action in 1970 proved that adding can beat subtracting; she and friends cleared a vacant lot on Greenwich and Duane streets and planted sunflowers. For the most part, however, community development groups have been more active and more imaginative than artists in this area.

● Around the same time, Gordon Matta was building "garbage walls" in empty lots from the debris mixed with plaster; they were left to disintegrate and return to their original states. In 1971, he did a performance called *Jacks,* which consisted of propping up abandoned cars in another lot, and in 1972 he rented a dumpster, parked it on Greene Street, built in it a single-story "house" with materials found in abandoned tenements, and activated it with a sound performance. The next year he got a larger dumpster and made a two-story "apartment" in it, celebrating the opening with a chicken barbecue in the street. Matta also took a "fresh-air cart" down to Wall Street one summer, offering oxygen to the workers at lunch hour.

● In 1973, on a landfill area near Battery Park, Mary Miss temporarily erected a multipartite wooden structure which through a descending circular aperture impressively focused the river, the view of New Jersey, and the lunar landscape surrounding it. It was hard to get to, but this was offset in the artist's mind by the fact that it was not vandalized, as an earlier public piece on Ward's Island had been.

● In February 1975, Jim Pavlicovic was permitted to make a plaster, arc-shaped relief on the outside of Trinity Church, Broadway and Wall Street; it drew people inside to see his drawings, but he was chagrined to find that their level of abstraction drove dignified businessmen to insulting graffiti.

● When Richard Serra was looking for a place to erect the "drawing" for a large

sculpture in 1974, he chose a lot on West Broadway below Canal and simply set to work, figuring that if he asked for permission he wouldn't get it. There was quite a bit of interest from neighborhood workers when they found it was a sculpture going up, and not another McDonald's. Holes were dug; posts were put in, and the general structure was built, though not filled in, when the landlord caught on and threatened to sue. He was held off for a few days with promises of money until Serra had got a pretty clear idea of what the finished piece could be. When the enraged owner finally brought in bulldozers at 7 A.M. and razed the piece, he was, by law, required to "improve the property once it had been bulldozed" and had to make his own sculpture by moving sixty piles of dirt around for seven weeks.

● A large-scale prototype for such activities (though officially condoned) was the exhibition organized by Alana Heiss on an old pier under the Brooklyn Bridge in 1971. It included Jene Highstein's huge wooden *Chute for Looking Up and Down,* Tina Girouard's whimsical houseplan laid out in the dirt, Matta's pig roast, and, temporarily, one of Anne Healy's sail sculptures, which had to be dismantled because the professional riggers were unable to cope with its delicate technology.

● The *real* prototype for this notion of appropriating public space as an outdoor gallery is of course the famous Washington Square Art Show, which Matta recently tried (and failed) to enter, setting up his own graffiti show around the corner. Following its premise, but not its sales techniques, Scott Burton placed a single heavy bronze cast of an ordinary chair on the sidewalk across from his show at Artists Space in 1975; since it was not for sale, someone came along with a dolly and simply tried to take it away.

The notion of using the exterior–interior window spaces, in galleries or elsewhere, has produced some provocative tensions between art and life contexts.

● In 1970, Strider's great gobs of colored polyurethane foam, oozing from the windows of an upper-story factory loft on Greene Street, gave the weird impression that the contents had outgrown the container.

● Simonds has twice built dwellings for the Little People on the window ledge at 112 Greene Street, in 1970 and then in 1974, with a piece that went "through" the glass to bring the outside in and the inside out.

● Stefan Eins' 3 Mercer Street Store has had several events taking place inside and outside, or visible through the large windows so the gallery became a display box—for instance, video pieces by Dieter Froese and Willoughby Sharp, which were pointed out the window.

● Farina held a treasure hunt around 1970 in which "clue sheets" were sold for fifty cents, and clues were presented through objects and performances in the windows of a tea shop, a barber shop, and a dress shop in SoHo; no one won, and a $100 bill has yet to be found.

• In 1974, Buren made *Within and Beyond the Frame*—a line of his striped posters on cloth, which hung the length of the Weber Gallery, went out the window, and continued across the street.

• Jan van Raay constructed her own wood and glass window structure for the corner of Broome and West Broadway in Fall 1975; in front of it she displayed a colorful dead octopus, and through it she photographed people's responses, pasting the polaroids up on both sides of the glass until the window was full.

• Bill Beirne, in a 1976 show at 112 Greene Street, wrote a complex text (almost illegibly) in white paint on the front window. In this case the inside–outside format had a particular reference to the "implications of inclusion/exclusion . . . as it applied to the selection process involved in the art context"; the text, dealing with the machinations involved in getting to show at the gallery, and keyed into a list of personalities, read, significantly, from *inside* the gallery, so one was lured in rather than out—perhaps an unconscious commentary on the purpose of the piece.

• Probably the most effective window piece yet has been Red and Mimi Grooms' *Ruckus Lower Manhattan,* constructed on the mostly glass-walled ground floor of 88 Pine Street, during the winter of 1975/76, in full view of the entire working population; when it was completed and opened to the public, most of the Wall Street community were familiar with and fond of every detail. A few months later, an expanded version of the piece was shown at the Marlborough Galleries, some of it visible from Fifty-seventh Street, all of it maintaining the lively illusion of freedom from all commercial contexts even in the heart of enemy territory.

• In 1976, at the time of his uptown show "What Can the Federal Government Do for You?", Les Levine plastered the streets of SoHo with a "campaign poster" for himself in which he looked Japanese ("Everybody has to go to the Orient now to get elected; the *real* power and mystery are in the East"). One response to this piece was that it defaced the beauty of SoHo—curious, since poster pasting is a local obsession, and a surface reflection of what SoHo is all about. (Around 1974, an unknown individual who became known as the "Poster Killer" protested the growing wall litter in SoHo by leaving hate messages on each new layer.)

• Jonathan Price, capitalizing on this activity, makes "Paste-Ups"—mounting single poster strips around a SoHo already crammed with pretentious absurdities, and then photographing them to print on linen and show in galleries, as his "answer to Photorealism." The strips pose questions like "How Remote Is This Site?" and "How Can Art Refer Only to Art?" or make trite statements like "Art Contrasts Idea with Vision," "Seeing Is Imagining."

• A more provocative manifestation, unintended as art, was "Professor George's" wall on Greene Street, covered by political messages in an obsessive white script. The bearded writer was a resident squatter in SoHo long before the shoppes moved in. George has a background in radical labor and also gives booming and articulate nocturnal monologues on the state of the world. His wall has now disappeared under a refurbished SoHo.

Streetworks are, or should be by nature, political acts of rejection or celebration. Some of the most effective events have been straightforward and imaginative propaganda:

● In the early 1960s Robert Nichols did guerrilla plays against the Lower Manhattan Expressway, and the Puerto Rican Teatro Ambulante continues this tradition on the Lower East Side.

● As a preliminary for Angry Arts Week Against the War in January 1967, a Poets Caravan served as mobile streetcorner platform for protest and performance; the same year six decorated "floats," one covered in "tombstones" (stuffed rubber gloves), started out from SoHo with artists and writers who performed at the Spring Mobilization Against the Vietnam War. Around 1969 some of the same artists joined a troupe marching down West Broadway to mail graphic protest "presents" to the War Chief, or Secretary of Defense.

● Yayoi Kusama did a "naked demonstration" at the Stock Exchange in 1968, utilizing the "anatomic explosion" to demand cessation of taxpaying, destruction of the stock system, and the end of the war.

● In 1970, the Judson Church, cradle of some of downtown's liveliest arts, housed the People's Flag Show, a protest against repressive laws on the use of the American flag, which culminated in the arrest of artists Jon Hendricks, Faith Ringgold, and Jean Toche.

● Ralph Ortiz, Richard Schechner and others gave guerrilla theatre events in front of NYU's Loeb Student Center against the U.S. bombings in Cambodia, an abomination which also inspired Yvonne Rainer's moving *Dead March* through SoHo.

● In the same period, the Art Workers' Coalition, meeting at the Museum for Living Artists on Broadway and Waverly Place, was invaded by the FBI after an invitation was sent out to come discuss how to "kidnap Kissinger." In 1970 they posted a series of Reinhardtian questions about the morality of the art world. The AWC and the Artists' and Writers' Protest were also responsible for a funeral procession, in another antiwar march, where black body bags, one for each year of the war, the same kind used to transport the dead in Vietnam, were carried up to Central Park, accompanied by a 100-foot-long banner listing the names of American and Vietnamese victims.

● In 1971, Tosun Bayrak staged a gigantic "undercover street theatre" on three blocks of Prince Street covered with white paper. Titled *Love America or Live,* it titillated and appalled a large audience with blood, guts, nudity, rape, snakes eating rats, people urinating, defecating and fucking, dogs, children, pig fetuses, and a staged fight between a black and a white man which was broken up by the police. Homeopathically intended to expose violence by violence, to "dramatize the so-called American way of life and love by projections, emissions and bursts from the underbelly of the city," it was probably the most controversial streetwork performed in New York.

● The Guerrilla Art Action Group has made several protest pieces in and around City Hall and the downtown court buildings, several of which centered on the flag desecration issue. To raise money for McGovern in 1972, they sold engraved copies of their letter to Nixon ("Eat What You Kill") on West Broadway and distributed the second version of the AWC's My-Lai massacre poster.

● In the fall of 1973, after the military takeover of Chile, a large group of artists and writers publicly mourned the demise of Allende's Marxist government by copying a work of the famous Chilean mural brigades on cardboard panels which were painted outdoors on West Broadway by protesters and passersby and later paraded up Fifth Avenue.

● On a rainy May Day 1976, the Artists Meeting for Cultural Change handed out roses in the street and plastered SoHo with posters reading "Celebrate May Day"; anonymous opponents of this action rubber-stamped over them so they read "We the Bourgeoisie Celebrate Pay Day on the Backs of the Proletariat."

Such protest against protest can be still more negative, such as the random vandalism that has taken place in SoHo over the last year; paint has been splashed on buildings, windows have been smashed, and "For Sale" was written across a painting in a West Broadway gallery. Nobody seems to know whether this is a berserk fringe of the same anonymous group who stamped the May Day posters, or of those who, with more eclat, squirted epoxy glue into the locks of all the SoHo galleries last summer and posted a broadside echoing earlier efforts by the AWC. It read in part:

> As long as art is controlled by the institution of private property, artists will have little control over what they make as art or what happens to that product once they make it. Isn't it possible that the elimination of private property would also eliminate this separation between artists and their work? Aren't galleries simply private property on display? Aren't artists simply on display as private property? . . . Artists! Closing the galleries is the best thing that could happen to us. Galleries isolate us. Galleries force us to compete against each other. Galleries give us the illusion of freedom without the reality of power. The Galleries Will Open Again! Why not use this time to reconsider our social practice? Of course we're all victims. But if we continue to ignore alternatives we will remain helpless as well.

NOTES

1. Scott Burton, *The Drama Review* (March 1972).
2. Vito Acconci, *A Space Bulletin* (1971).
3. Charles Simonds, *Artforum* (Feb. 1974).
4. *ARTnews* (March 1971).

Dada in Berlin:
Unfortunately Still Timely*

"Dada in Europe: Works and Documents" was one of the four huge shows that made up *Tendenzen der zwanziger Jahre*—the 15th Council of Europe Exhibition, held last fall in three Berlin museums, and accompanied by a mind-boggling 1,133-page catalog. The shows were "From Constructivism to Concrete Art"; "From the Futuristic to the Functional City—Planning and Building in Europe 1913-1933"; "The New Reality—Surrealism and the New Objectivity"; and Dada.

Passing before the thousands of beautiful and/or provocative and/or impressive objects in these four exhibitions, sensing the vast energy—both esthetic and social—that went into their making, was a depressing as well as a stimulating experience. Such past magnificence and the presence of so many hopeful artifacts can only recall the predicament of art in the present and raise questions of what the role and function of art can be in the future. To those problems, only the Dada show seemed wholly relevant. Such questions were at the core of a movement that could be described by its admirers as "cultural revolt," by its detractors as "nihilism" and "cultural bolshevism" and by its protagonists as everything from "soft-boiled happiness" to "a virgin microbe" to "chaos from which thousands of systems arise and are entangled again in Dada chaos."

Dada has been historicized, digested and evacuated many times over in the last six decades. Apparently it makes good fertilizer. It continues to be imitated effectively because it had no formal style of its own. As this show amply indicates, its spirit was unique rather than its visual ingredients, which consisted of: Expressionism (the reigning German style, which it eventually ridiculed), Cubism (the epitome of Parisian high art, which did not keep the Dadas from adopting its collage, fragmentation and layered shallow space) and Futurism (whose anarchic typography and emphasis on "events"—now seen as Dada trademarks—were swallowed whole).

It is dangerous to generalize about Dada. Not only was its program one of determined self-contradiction, but it wore a different mask, a different costume in each city where it flourished. In wartime New York, where the Dada spirit was first made manifest by Duchamp, Man Ray and Picabia, it was a refined instrument for elitist ridicule of the bourgeoisie. In neutral Zurich, where the name originated, it reflected the antipuritanical, pacifist alienation of a group of exiles from the war. In postwar Paris, it was a sophisticated comedy of iconoclasm that cleared the decks for Surrealism. In Holland it achieved a kinky marriage with de Stijl via van Doesburg, who named his dog Dada, and in Central Europe, Latin America, Spain, Portugal and Italy it could claim quasi-legitimate offspring.

Only in Germany, especially in Berlin, was Dada's innate capacity for protest applied to the politics of European culture as well as to an attack on its superficial symptoms. German Dadas, almost in spite of themselves, merged art and politics in a manner that might be envied by socially conscious artists today. George

*Reprinted by permission from *Art in America* (Mar.–Apr. 1978).

Grosz was a member of the Red Group and ARBKD *(Assoziation revolutionärer Bild Künstler Deutschlands)* as well as of Dada; in Cologne, Baargeld's *Der Ventilator* was distributed at factory gates and suppressed by the British Occupation Forces; Richard Hülsenbeck was named Commissar of Fine Arts during the brief "revolution" of 1917, and writer Franz Jung was an early political highjacker, having "confiscated" a steamer in mid-Baltic with the help of a sailor friend and delivered it to Leningrad. A giant banner that hung across the *"Erste Internationale Dada-Messe"* in 1920 read, "DADA STANDS ON THE SIDE OF THE REVOLUTIONARY PROLETARIAT." They weren't kidding, though in retrospect nostalgic Dadas (especially, for obvious reasons, those writing in the 1950s) insisted that nothing about Dada was serious. This may have been true of Paris, but not of Berlin—in 1917 "a city of tightened belts, of mounting, thundering hunger, where hidden rage was transformed into boundless money lust, and men's minds were concentrating more and more on questions of naked existence. . . . Fear was in everybody's bones."[1]

The motley Dada show straddled the other three, including the purism and desire for a revolutionary *tabula rasa* of the "Concrete Art" show and the bitter, sexualized, often decadent satire of the "New Reality" show. The Dada installation, however, was drastically different, its beguiling clutter due in part to the fact that the surviving works are mostly small, unpretentious or mass-produced and often restricted to reproductions or documentation, as many of the originals were destroyed or dismissed, denied the commodity value of the despised high art. ("The bourgeois must be deprived of the opportunity to 'buy up art for his justification,' " wrote Hülsenbeck in 1920.[2]) It was an appropriately fragmented installation—a chaotic maze of partitions with no imposed directional sense, glass cases full of publications, and a taped program of music and sound poems which contrasted with the explicit political commentary of some of the photo banners and murals hanging over and beside art that had made similarly gruesome points years before—notably the crude and monstrously effective prints and watercolors of George Grosz.

"Unfortunately Still Timely" was the title given to several of his own retrospective exhibitions by photomontagist John Heartfield, who, with his brother Wieland Herzfelde, was the only Dada to remain a Communist; he died in East Berlin in 1968, having been awarded the Fighter Against Fascism Medal, the Karl Marx Order, and the Peace Prize of the DDR. All too familiar indeed are statements like the following, from Grosz's and Herzfelde's satirically titled "Art Is in Danger":

> The demand for Tendency irritates the art world, today perhaps more than ever, to enraged and disdainful opposition. . . . The artist, whether he likes it or not, lives in continual correlation to the public, to society, and he cannot withdraw from its laws of evolution, even when, as today, they include class conflict. Anyone maintaining a sophisticated stance above or outside of things is also taking sides, for such indifference and aloofness is automatically a support of the class currently in power. . . . Moreover a great number of artists quite consciously support the bourgeois art system, since it is within that system that their work sells. . . . In November, 1918, as the tide seemed to be turning—the most sheltered simpleton suddenly discovered his sympathy for the working people, and for several months mass-produced red

John Heartfield, *Those Who Read Bourgeois Newspapers Will Become Blind and Deaf,* 1930, from *A-I-Z,* ix, 6 (February 9, 1930), p. 103.

and reddish allegories did well in the art market. Soon afterward, however, quiet and order returned; would you believe it, our artists returned with the greatest possible silence to the higher regions: "What do you mean? We remained revolutionary—but the workers, don't even mention them. They are all bourgeois. In this country one cannot make a revolution."[3]

Other aspects of the show are still timely as well. Heartfield called himself *Monteurdada* to identify with the workers, *Monteuranzüge* being overalls and *monteur* not yet associated with photos. Today, Marxist artists affect workers' clothing, but the Dadas wore monocles and dressed like nineteenth-century esthetes, hoping to "offend the stuffed shirts who claimed to be progressive."[4] In a repressive wartime Germany, things that could not be conveyed verbally could be said in pictures. Thus two of the origins of photomontage were Heartfield's ironic "gift packages" and his and Grosz's collaged postcards sent to soldiers at the front containing items and images to remind them what a lousy world they were fighting for.

Clothes were one of the few legal ways to register public protest. Looking different established distance from a despised society. Hausmann invented a shirt (and in Paris Sonia Delaunay-Terk was making her "poem-dresses," also in the Dada show). Max Ernst's 1920 collage *The Hat Makes the Man (Style Is the Tailor)* combines the sexual and political innuendoes of such a "getup" in its punning multilingual title and phallic stacks of hat advertisements. The machine esthetic—the "mechanomorphoses," the ubiquitous gears and wheels that provide the most obvious visual connection between all styles in the Berlin shows—has its sources in Duchamp, Picabia, Léger and de Chirico, each of whom used the faceless robot, doll or mannequin in a very different way.

De Chirico's ominous use of sexual symbolism most strongly affected Dada visual art. His mannequin and factory tower were also much in evidence in the realism show, most interestingly in Tanguy's *Girl with Red Hair* (1926), her nudity and wildly disheveled hair set against the rigid smokestack; and in an extraordinary Magritte, *The Master of Pleasure* (1928). This atypically primitive and brutal painting depicts a flaming and/or hairy grisaille doll and/or baby and/or cunt anxiously walking a tightrope which leads across a massive flight of steps from a bobbin-shaped bedpost to a factory smokestack through a window and/or picture frame and/or mirror. The image suggests Freud's famous example of a baby coming to terms with his mother's absences by repeatedly tossing away and pulling back a spool of thread. Dada was in fact a return to origins, its very name deriving from the French word for a child's hobby-horse. In 1916 Hugo Ball recommended "everything childlike and symbolic" including "the infantile, demaentia and paranoia . . in opposition to the senilities of the world of grownups"; and the Dadas were the first to exhibit children's art and the art of the psychically ill.

Dolls appear frequently in German art. Sophie Täuber-Arp's *Dada Heads* (modeled like Hans Richter's *Head-Fantasies* on Hans Arp's "classic oval" head and "triangular Cubist nose"), Hannah Höch's witty *Dadadolls* and Raoul Hausmann's famous *Mechanical Head, The Spirit of Our Time* (its money lust implied by the wallet stuck on the back), resemble in their deadpan humor Alexandra Exter's marionettes, Ivan Puni's "Marionette Men" pacing the street outside of his Der Sturm opening in 1921, and the many marvelous Russian and Bauhaus stage sets in the "Concrete Art" exhibition far more than they do the Expressionists' and Surrealists' erotic manipulation of female dolls in the realism show. (These included Kokoschka's self-portrait with doll "companion" and Rudolph Wacker's *Blind Doll,* who sits with legs open and the fly of her pretty pantaloons open[5]—though the exposed pubis is also the grotesque focus of Grosz's satirically intended *Daum Marries,* in which a fleshy whore looks askance at her robot lover.)

In Dada art, dolls and mannequins can be seen as representing rebellion both against the romanticized humanism of traditional art and against the helplessness of humanity in the clutches of dehumanized rulers. The famous "Dadandy-ism"—title of a Höch collage borrowed for Hanne Bergius' catalog essay—can be seen as a disguise behind which an "inner laughter" is hidden, or as an armor, arrogance veiling terror. The Dada dandy is also a doll—uncaring and therefore not emotionally responsible. However, when the dolls are rigid and faceless they are almost always male figures; when they are damaged, dismembered or collapsing (as in Man Ray's 1919 "paper-doll" watercolor, *La Fatigue des marionettes,* or his amputated half-human half-cutout *Portemanteau,* an object-photo of 1920), they are female—women being the perfect examples of objectified and manipulable humans. Because the ruling culture, the ruling class and the war itself were unmistakably products of patriarchy, of the "fatherland," Dada's disgust was often cast in a feminine mold—a revulsion against brutality and hypocritical morality. Dada's fragmentation and hysteria are elements in a kind of slave humor. (Hugo Ball wrote about the "dandyism of the poor.")

Yet Dada was the most exclusively male of the modern movements. Hannah Höch (whose twenty-eight works in the Dada show and later almost Rosenquistian oils in the realism show were a revelation[6]) was the only woman artist who was a full-time Dada.[7] Her view of dandyism in the collages *Dadandy, The Beau-*

tiful Girl and *Kokette* applied the term to women and to the effect of fashion on them and on their images, quite another attitude from that adopted by the Dada men, and perhaps inspired by the patronizing atmosphere reflected in Hans Richter's later description of her as

> the quiet, the able Hannah. She was still quite innocent when she entered Hausmann's demonic jowls. But just as Jonah, newly born from the whale, immediately went about his business, so Hannah went about her collages and succeeded in developing her own note of individuality. She was indispensable as manager of Hausmann's atelier evenings, because of her light grace. . . . And on such evenings she too was permitted to raise her small but precise voice in favor of art and Hannah Höch while Hausmann held forth on Anti-art.[8]

Her own recollections of the situation are somewhat different:

> Poor Raoul was always a restless spirit. He needed constant encouragement in order to be able to carry out his ideas and achieve anything at all lasting. If I hadn't devoted much of my time to looking after him and encouraging him I might have achieved more myself. Ever since we parted, Hausmann has found it very difficult to create or to compose himself as an artist.[9]

Another aspect of dandyism was, of course, the fact that the Dadas were exhibitionists par excellence. In its own perverse way, theirs was an outreaching, public art, its ideas best conveyed by "events," posters, advertisements, pamphlets, publications and the sloganed "Dadastickers" with which they plastered Berlin. It is no accident that performance was the major impetus of the movement as a whole. Dada in Berlin, where street fighting, agit-art and revolutionary theatre were unavoidable, reached the public as a diffused part of a broad social disillusionment rather than as an "art" experience. Rebellious workers in Berlin could not have cared less whether an artist or a streetcleaner made Heartfield's propaganda (like his *Brudergrüsse der SPD* of 1925 with its grisly photo of what I gather is Karl Liebknecht's corpse). Nor could passersby in Paris have identified Dada highjinks as art. Those who went to the performances to throw eggs and tomatoes participated for the most part unconsciously in the Dada catharsis, seeing themselves as adversaries rather than participants. It was here in the domain of surprise, this neutral ground between art and life, that Dada had its greatest effect. Within the art market it was just another movement, although seen in Berlin "not as a 'made movement,' but an organic product originating in reaction to the head-in-clouds tendency of so-called holy art, whose disciples brooded over cubes and Gothic art while the generals were painting in blood. Dada forced the devotees of art to show their colors."[10]

It is therefore interesting to examine briefly the *actual* rather than the projected social ramifications of Dada objects—for instance, of the Ready-made. "That's not art, that's just a urinal, or a bottle rack" is the anticipated response. Yet totally aside from the economic aspects, the whole notion of the Ready-made (and later of Pop Art), captivating to a jaded, overestheticized art market because of its unexpected banality, simultaneously provides a major classist barrier between the popular notion of what art should be (something beautiful, decorative

or uplifting) and the avant-garde notion of what art should be (responsible for going "beyond" such expectations). The barrier was, in the case of Dada, intentional, although the bourgeoisie quickly recovered from its dismay and began to spend good money even on reproductions of these ordinary objects and to gain status thereby, while the rest of the world, if they were exposed to it at all, continued to be insulted. Ironically, the concept of the Ready-made, initially intended as a raspberry to the art establishment, made art more incomprehensible to more people and *strengthened* the commodity role of art on which ruling-class culture depends.

Dada briefly epitomized better than any other modern movement the alienation of the public—*all* publics—from contemporary art. New York and Paris Dadas tended to be content with this achievement. But in a defeated and economically shattered Berlin, too desperate to play with despair, disgust was combined with hope, with a deep need for social revolution. There Dada was not so much an explosion as a dismemberment, a sacrifice of everything to the void that offered rebirth: "As young people who had never believed in the justice of the German cause in the war," recalled Höch in 1959, "we were still idealistic enough to found our hopes only on those doctrines which seemed to be entirely new, in no way responsible for the predicament in which we found ourselves, and to promise us with some sincerity a better future, with a more equitable distribution of wealth, of leisure, and of power."[11]

The German art in all of these shows, regardless of style, can be distinguished from other European art by the depth of its bitterness. It is therefore ironic that Berlin Dada art, for all its disorientation, appears more hopeful and positive than that of the other branches. The Dada artifacts from Paris and New York in this show looked quaint and esthetic while the surviving German ones were "unfortunately still timely." This point was underlined by seeing them in the present context of a Berlin divided between consumerism and unrealized dreams.

NOTES

 1. Richard Hülsenbeck, from *En Avant Dada: Eine Geschichte des Dadaismus* (Hannover: Steegmann, 1920), reprinted in my *Dadas on Art* (Englewood Cliffs, N.J.: Prentice-Hall, 1971), from which all the quotations by Dada artists in this essay have been taken.
 2. *Ibid.*
 3. Wieland Herzfelde and George Grosz, *Die Kunst ist in Gefahr* (Berlin: Malik Verlag, 1925).
 4. Hannah Höch, interviewed by Edouard Roditi, *Arts* (Dec. 1959).
 5. Blind female dolls, statues or mannequins appear frequently in Surrealist art and offer irresistible Freudian interpretations; Hans Bellmer for some reason was not included anywhere in these exhibitions, but his dolls are classic examples of the whole syndrome.
 6. I was particularly struck by Höch's *New York* (1921), with its dazzling combination of aerial, frontal and reversed views; her large photocollages; and two delicate pastel collages: *Weisse Form* (1919) and *Astronomie* (1922), utilizing lace, sewing patterns and sky-maps in a manner predicting Cornell. Two other less-known artists who were strongly and revealingly represented were Paul Joostens, with beautiful small abstract assemblages, and Johannes Baader, with obsessive collage diaries and documentation of a fantastic junkyard of a construction—*Das Plasto Dio Dada Drama* (1920).

7. Täuber-Arp and Delaunay-Terk were active elsewhere and never fully involved in the movement. Little is known about Angelika Hörle and a woman named Deetjen, who also participated.

8. Hans Richter, *Dada Art and Anti-Art* (New York: McGraw-Hill, 1965).

9. Höch, interview.

10. Herzfelde and Grosz, *Die Kunst ist in Gefahr.* For a riotous account of Dada and its public, see Hülsenbeck on the Dada tour to Leipzig, Bohemia and Czechoslovakia in 1920, *En Avant Dada.*

11. Höch, interview. Stephen Spender, in an article on these exhibitions that I received just as I was typing this up, makes several good points about Berlin in the 1920s, among them: "What really made Berlin extraordinary then was the extent . . . to which everything that happened there appeared as symptomatic of the crisis in modern civilization"; "Why did the movement in all the arts have no effect on real politics? The answer, I think, is that the politicization of art was a reflection of a political situation rather than the entering of artists and art into the realities of politics." He says that the German artist of the period looked upon himself as "someone who having shed the past, regards the future of art as empty space that he can fill with his unprecedented forms . . . waiting to be filled with their dynamic new environment, which would create, with the beauty of its pure disciplines, the new Communist man" (*The New York Times Magazine,* Oct. 30, 1977).

This Is Art?
The Alienation of the Avant Garde
from the Audience*[1]

A tall white room, high over lower Manhattan; it is empty, even of light fixtures and window frames; wind, air and sky fill the space. "You must be kidding. Where's the art?" "It's nothing, nothing at all." "I kind of like it—all that emptiness." "Is this a hoax?"

The empty room is a work of art by California artist Michael Asher. The quotes are some public responses to his 1976 exhibition. For me, Asher's show was moving and beautiful, articulating interior and exterior spaces, their boundaries, mergings, light and shadow into a particularly subtle experience. But I have been a contemporary art critic for over a decade. To a general public there is, indeed, nothing there.

The alienation of the avant garde from a broad audience and the contemporary artist's indifference to this situation are casualties of Modernism (the evolutionary theory of art which has dominated this century). The current art public is the rich and educated class attracted to status as often as to esthetics. A still smaller percentage of this group participates in the rituals of the "art world"—an incestuous network in which contemporary art is generated by other art, exposed, bought and sold, until it reaches the only available outlet to a somewhat

*Reprinted by permission from *Seven Days* (Feb. 14, 1977).

broader public—the museum. Once there, it is greeted by the laity with bafflement, outrage, intimidation, and occasionally with genuine excitement. For in the field of contemporary art, almost everybody is the laity—not just the mythical men and women in the street with their assumed preferences for lurid sunsets and bug-eyed ballerinas, but the great majority of every socioeconomic class.

Art for art's sake, concentrating on form and ignoring content, is an acquired taste. The entire history of modern art in Western civilization is that of an essentially intimate and private art, an art of "precious objects" on sale for those raised to "appreciate" them and privileged enough to acquire them. ("Let's face it. The public is imbecile in every country," wrote Futurist Umberto Boccioni in 1912.) Through that same history runs a parallel thread of the loftiest idealism, the desire expressed by artists themselves that art might recoup its ancient vitality in social life, that art might change perception and thereby the world. I count myself as part of this starry-eyed troupe, and it is a melancholy task to have to report that the history of Modernism is in fact the history of antagonism against the same bourgeois establishment which, in the process, has become its prime audience. Having no history of involvement with the "masses," new art has consistently ignored its own aspirations. There are chasms between the class that demands "culture," artists who are making "art," and the virtually unarticulated needs of everybody else.

A crowded concrete plaza in Manhattan's financial district, surrounded by skyscrapers, a few trees, four of which are white, four stories high, made of fiberglass, and patterned with heavy black lines.

The gawky *Four Trees* is a sculpture by Jean Dubuffet, sponsored by the

Robert Huot, *Billboard for Former Formalists,* 1977 (also in postcard form).

Chase Manhattan Bank. It is one of the few public artworks in New York which avoids a faceless decorator's appliance look. One day last January, fifty-one passersby were interviewed in the plaza by Williams College student Mike Glier—twenty-seven of them "professionals" and twenty-four "nonprofessionals." Half of them liked the sculpture and half didn't. Eight thought the trees looked like giant mushrooms; the man who sweeps the plaza was reminded of a cave or "something from way back before I was born." A "prancing courier" thought of cutout cookies. A new mother said, "It looks like the inside of a body and bones." Children loved it and saw it as "a sandwich with a bite taken out of it" and "blown-up live stuff with black lines on it." Two men described as "down and out" were angered by the $500,000 price tag and would have preferred a statue of General Grant.

Dubuffet himself—a wine merchant who became an artist late in life—plays a contradictory role; wealthy, literate and worldly, he presents an "anticultural" stance, attempting to achieve a childlike innocence by borrowing from the art of "primitive" peoples, of the "naïves," and of the insane. If *Four Trees* is a successful provocation, his painting *Beard of Uncertain Returns,* in the Museum of Modern Art, has in two surveys been the least popular work viewed, evoking comments like, "He doesn't take himself or his audience seriously; he doesn't believe in anything and his art is alienated." The degree of abstraction may explain this. Representational art is preferred by the public across the board unless, as in *Four Trees,* there is an imagistic handle that allows the viewer to enter by some other means, the most useful of which is association—free, and frequently pointed. (As Brian O'Doherty has remarked, "shrewd common sense is the unconsulted public's only remaining weapon when confronted with 'elitist' monuments"; he cites a smooth mound of black marble outside a San Francisco bank which was christened "the banker's heart.") But association is rejected and, if possible, suppressed by most avant-garde artists, who feel it is irrelevant to their formal intentions. Thereby, unconsciously or not, they raise a major obstacle to their work's reaching a broader audience.

Right now, "public art" means to most people blown-up private art outdoors—looming Calders and mountainous Moores—cultural weapons with which to bludgeon "improvement" into the unruly classes. Both big business and the avant garde are now aware that art seen in a familiar space has a communicative advantage over art seen in artificial cultural contexts, such as museums and galleries. A college class interviewing in New York streets last year found that outdoors, people are less concerned with value judgments and more with their own opinions, whereas in the more detached and loaded indoor situations, this confidence is undermined. It is not surprising, then, that the majority of those rare artists making an effort to reach out have gone to the streets, where the audience can be caught unawares.

For the most part, however, contemporary artists who have ventured "out there" and found sites and sights to revitalize their art have been more successful in bringing these awarenesses back in to the art world than in bringing art out to the world. For example, when so-called Conceptual Art emerged around 1968, it was welcomed as a blow at the "precious object," but none of us took into account that these Xeroxed texts or random snapshots documenting ideas or activities or works of art existing elsewhere would be of no interest whatsoever to a broader public. They were, in fact, smoothly absorbed into the art market and are

now only slightly less expensive than oils and marbles. The perversity (and failure) of offering unwanted avant-garde art for the price of wanted schlock bears out in retrospect art historian Linda Nochlin's depressing suggestion that, admirable as the move to get art out of the museums and into the streets may be, it can also be seen as "the ultimate act of avant-garde hubris."

"I know very few artists who can even imagine the possibility of an art which is both good and more widely social," says painter R. B. Kitaj. "The road ahead is blocked among us by so many failures of imagination." It is also blocked by the rationalization that it is reactionary to try and contact the proletariat, who must "make their own art"; and these failures are sustained by an underlying fear, well justified but rarely admitted, that "the masses" will reject us if we leave the ivory walls and go out there with our present baggage—our art, our criticism, even our attitudes to life.

A vacant ground-floor storefront right off Times Square. A sign in the window reads, "Work for the Unemployed." From time to time someone wanders in hopefully and finds a dim, abandoned space, empty except for a chair, a tape-recorder, and a supervisor who gently advises that this is not an employment office; it is art. If the visitor remains, s/he hears a long, disembodied monologue on tape about the artist's political convictions. A crumb is thrown to accessibility; near the door is a pile of small, crudely bold black-and-white linocut handouts; "Want to Get Your Boss Off Your Back? Stand Up"; "Everyone Who Is Employed Is Being Robbed"; "Wages a Form of Slavery."

Art like this perhaps courageous but singularly ineffective and even insulting piece by Saul Ostrow simply parodies the valid dialectic between the real and the art world, becoming a picturesque gesture rather than a commitment. Just as it is not a matter of jazzing up factories or city walls so that art improves the working environment without doing anything about fundamental social inequities, neither is it a matter of gratuitously provoking ideas without being willing to follow them through. It doesn't help that "serious" artists are terrified that their art might be seen as "entertainment"—an unfortunate situation originating in understandable opposition to the sixties' buying public's consumption of art as a "fun thing." The art world has come to mistrust accessibility. Art that communicates easily is often understood only on a playful or superficial level and appears to lack the profundity that makes other, more hermetic art endure.

Though art in general is something people would really like to like, contemporary art cannot meet the challenge because it isn't accessible, even physically. In its place are the flower paintings, Paris-in-the-rain scenes, cats on black velvet, Spanish dancers and moonlit harbors found in shopping malls, frame stores and art festivals all over America. "The art is counterfeit, but the need is authentic," as Baruch Kirschenbaum of the Rhode Island School of Design has pointed out. Workers in Minneapolis, interviewed about art by artist Don Celender's students, bore this out. The large majority felt that "People need art," "It brings us closer to what we really are," and "It makes the world seem brighter."

Sounds fine until taste again rears its ugly head. When asked what art the respondents had in their homes, their answers ranged from an occasional abstract painting to antique furniture, a ceramic duck, *Blue Boy, The End of the Trail,* a stuffed pheasant, a print of the Lord's Prayer, "optic art, lamps, couch and chairs," candles, driftwood, "bubblegum acrylics," finger paintings of

fishes, statues of saints, "oil paintings which I appreciate because they look hard to do," yarn paintings, "pictures of artificial flowers," and a great many reproductions of "scenery."

In 1967, according to the International Council on Museums (ICOM) report, people liked art that was relaxing, calming, comfortable, conservative and realistic, art that was already familiar to them through the media and reproduction. Animals and birds were liked, fish less so; deep space was preferred to two-dimensional decoration. Direct stares in portraits and emphatically sexual images were rejected, as were both drab colors and very hot, bright ones, vertiginous views, dazzling light, and "childishness" (the "my-six-year-old-could-do-that" syndrome). People tend to be lost when there is no recognizable subject matter or to confuse the subject matter with the painting itself. (A friend overheard one well-dressed woman in the Metropolitan Museum standing in front of a Degas ballet painting say to another, "Why, my *daughter* dances better than that!")

Anything the least bit radical was seen as a put-on by artists who "don't care if ordinary people understand them." The 507 ICOM respondents wholeheartedly rejected art that was in any way disturbing in subject, that referred to social problems or suggested any negative aspect of life. The report concluded that "What is common on television in the way of violence and other distortions is not, in their view, equally acceptable as subject matter for painting"—an indication as to how far art has been removed from life.

Where do people get this "average" taste? In most cases it is a product of the media, which are certainly to blame for spreading the word that contemporary art is "news" for its peculiarities rather than for its virtues. (One survey even discovered horizontal paintings were much preferred over verticals and suspected a connection with the shape of TV and movie screens, though the walls of a house are also suggested.) Taste is also—to a lesser extent—affected by what is seen in museums, and *how* it is seen. One of Celender's respondents liked "old artworks because they're more classy," and class and intimidation are certainly factors in the public image of museums; along, of course, with boredom and mystification.

A truck full of Puerto-Rican teenagers from New York's Lower East Side is going past the Metropolitan Museum; one kid asks the driver, "Hey, man, is that City Hall?"

The Met's pseudo-classical design is identical to that of law courts and government offices, hardly inspiring confidence or conveying a welcome to the underclasses. Once museums were free, at least. Now, though tax-exempt, most have "discretionary admission" fees. Prominently displayed signs "suggest" that you pay at least $1.50 a head. The less comfortable the visitor is in befountained, bedraped and bepillared halls, the more likely s/he is to pay the demanded fee than to hand over the penny that is equally legitimate. The richer you are and the more at ease in your society, the less humiliating it is to "play poor."

A Black family in their Sunday best hesitates before the cashier at the Met, reluctantly turns back and leaves, despite the protestations of a concerned middle-class visitor who tries to convince them they can pay a dime.

Another survey found that many more people would visit museums if there were no charge. At the same time that museums all over the country were patting themselves on the back for increased attendance figures, the ICOM report said

that these figures merely "mask facts of a more disquieting nature—namely, a
visit to a museum does not guarantee understanding or acceptance of the art in
it." Long lines formed for popular shows like Calder's mobiles or the Mona Lisa
actually lead to impossible viewing conditions and *increase* alienation. There
is little popular or "low art" in museums because if it *is* truly popular it is not
considered "high art"; it doesn't get into the art history books and it is not
given to the museums by the rich. (God forbid the rabble should choose its own
art.)

There is, however, one art with a large audience that cannot be accused of
going ignored, or of avoiding provocative subject matter. The inner-city mural
movement, on New York's Lower East Side, Chicago's South Side, L.A.'s, San
Francisco's and Santa Fe's barrios, has become an effective public art precisely by
dealing with local life and welcoming art as an arena in which to expose it. The
community murals, varying widely in style, subject and "quality," are on the
whole consciously opposed to art for art's sake, though they too have an art-
historical model to which they look—the Mexican mural movement of the '30s
and '40s. They can provide an outlet for destructive energies, a catalyst for action
to improve the quality of urban life, and they assert the presence of a politically
invisible population. At their best, they do so by the same means the avant garde
itself admires most: directness, simplicity, strength and personal commitment.

The audience for the murals is ready-made and ready to empathize and act.
In the Mexican tradition, pictures take the place of words. Content ranges from
bitter social comment (against drugs, inflation, absentee landlords, corrupt cops)
to pride in heritage, culture, race and sex. Some derive their power from convic-
tion alone, others from considerable artistry; the artists are frequently not pro-
fessionals and the apprentices are youths from the communities. The murals are
in some senses a regional art (cement roots instead of grass roots), their makers
uninterested in the kind of "universal quality" that reaches museums. They claim
their own context; their audience is basically alienated from ruling-class culture
and is unaware of most intellectual stereotypes and expectations about art.

A Watts Neighborhood Arts Council report on art and welfare from 1973
quotes a survey in which the vast majority of respondents identified "culture"
with a *total experience,* including "education, learning, life style, refinement,
anything uplifting, historical background, customs and traditions, progress and
development," in that order. When the Decentralization Committee of the
Art Workers' Coalition circulated a questionnaire in the South Bronx in 1970 to
determine what the community would like in a local art center, the replies in-
cluded basketball, sewing, and day care as often as anything conventionally con-
sidered art. At the same time, the art world, trying to bridge the gap between art
and life, has claimed for the art context aspects of and references to basketball,
sewing, and social systems, not to mention didactic display, unaltered objects
bought in stores, street actions, primitive rituals, boxing, toys, real estate and
ecology, physics, sociology, and so forth.

Context has become a much-depended-upon concept in visual esthetics
since the mid-'60s. It is used to defend the activities of the far-out artist against the
response, "But this isn't art." The argument goes that if "it" is seen in a museum,
gallery, or art magazine, then it is art, no matter how bad or antiart or nonart it
may appear. This simple solution to the no-longer-burning question "What is

Art?'' is a reasonable one and makes sense within the art world, though it is invisible and incomprehensible to most of the audience. Ironically, however, the "context" concept, in fact, serves to further confine art within the art world by fixing its validity there. If it communicates, and satisfies the esthetic needs of its immediate audience, who cares what it's called?

Yet, when doubts are expressed within the art world about the ability of contemporary art to communicate, the need for artists to choose their own audiences and be responsible to them, the reply is instant defensiveness on the order of "Artists are free; Artists work only for themselves; Artists don't make art to please anybody," and even "Art is not communication." Nevertheless, it is patently ridiculous for any of us—artists and critics—to work under the illusion that we are not making products for a specific consumer—the international art audience, for whom fashion plays a huge part in success and failure. Those artists who refuse to consider a new audience for their work are simply accepting the existing one.

NOTE

1. This essay was written early in 1976 as a much longer piece; a short version was published under the same title by *Seven Days* in its first preview issue (Feb. 14, 1977), and for this version, a few sections from the unpublished long version have been reinserted. The surveys consulted for this article were ICOM (A. Zacks, D. F. Cameron, and D. S. Abbey), "Public Attitudes Toward Modern Art," *Museum* 2, no. 3/4 (1969); Don Celender and students at Macalester College, *The Opinions of Working People Concerning the Arts* (New York: O. K. Harris Gallery, 1975); George Nash, "Art Museums as Perceived by the Public," *Curator* 18, no. 1 (1975); Williams College students directed by Lucy R. Lippard, *What Do You See? Think? Say? Private and Public Responses to Art* (Williamstown, Mass., 1976).

Raising Questions, Trying to Raise Hell: British Sociopolitical Art*

In the London art world, as in New York, "social" is a disease, not a priority. Those dissidents trying to do right by the Left are rarely awarded gold stripping. However, perhaps because the art market here is so feeble, perhaps because England is, after all, a fiercely self-critical semisocialist country with economic troubles and a growing fascist backlash, more seems to be happening in Battersea than in Bond Street. This has just been acknowledged by two large and very different sociopolitical shows in government-sponsored spaces: "Art for Whom?" organized by crusading *Studio International* editor Richard Cork to give exposure in depth to five artists and/or groups at the Serpentine Gallery in royally

*Reprinted by permission from *Seven Days* (Aug. 1978).

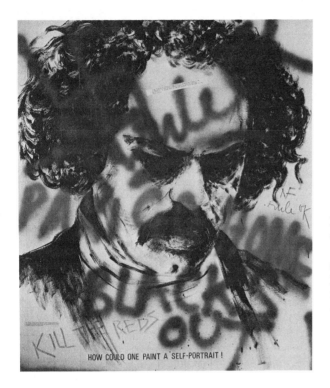

HOW COULD ONE PAINT A SELF-PORTRAIT !

Rasheed Araeen, *How Could One Paint a Self-Portrait!* 1978–79, acrylic polymer and aerosol paint with collage on hardboard, 48″ x 40″. Painted in response to an invitation to exhibit a self-portrait at a time of heightened racial tensions and police brutality toward people of color in London. (Photo: the artist)

owned Hyde Park; and "Art for Society," a motley, lively open-juried show of ninety-nine artists at the Whitechapel Art Gallery in the East End.

The first exhibition concentrates on work focused outside the art world, and the second covers a wide range of media and approaches. Both have been predictably patronized by establishment critics deploring the earnest rhetoric and emphasis on content over form—the general "poisoning of the wells of art" (Bernard Levin in the *London Times*). The taboo against "political art" holds firm.

I hesitate, though some don't, to describe the nucleus of British socialist art practice that emerges from these shows as a "movement"—with its implications of fad and rapid transition. But it certainly indicates an exemplary and growing number of possibilities for artists caught consciously or unconsciously in the several dilemmas it underlines. With great esthetic variety these artists are trying to reinvest "fine art" with social meaning, to raise political consciousness visually, and to broaden the base of art makers and art audience. Politically, most of them are on the Labour Left, are Communists, or are allied with the smaller revolutionary parties. (British artists seem more in touch with party politics than similarly inclined Americans.) While some few artists do make trade union banners for rallies, trade unions are not notorious for support of the visual arts. Thus the committed artist is caught between the middle-ruling-class conception of art as by nature an elitist commodity and the working-class unfamiliarity with and consequent suspicion of "fine art," along with wistful leanings toward what radicals avoid as "escapist" or "cosmetic" esthetics.

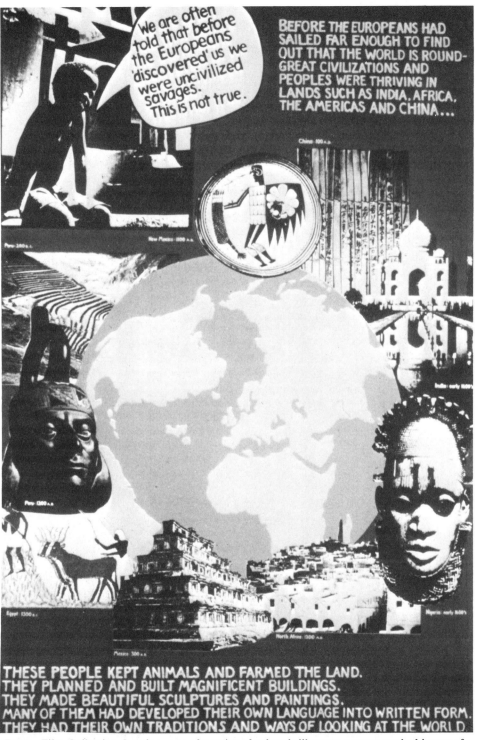

Poster-Film Collective, London, one of a series of colored silkscreen posters on the history of the Third World designed for (and successfully used in) elementary schools.

For instance, there is a British obsession with *work*—its history and process—common to all the media, with visual art no exception. The Dignity of Work and Worker, the Nobility of Factory and Machine is, however, an outworn socialist art cliché. Local response to a huge double mural on this theme by the Public Art Workshop indicates that the proletariat aren't really dying for "proletarian art." Recorded comments shown at the Serpentine emphasize "People want to get away from industrial work and things associated with daily living. Why not fantasize?" and "Paint a Beach." A more successful mural was designed by artists collaborating with Islington schoolchildren to conform to the brick-gridded façade of their building. It has no political content, but it works, which presents a dilemma for those artists committed to an overtly social public art but also opposed to esthetic colonialism. Conrad Atkinson was asked in Belfast in 1975 if his show there would be something "nice," like paintings of flowers. Knowing that instead it would focus on photos of the bloodstained banner from Derry's Bloody Sunday, he had to reply that "only when the soil bed of such issues is lain will it be possible for me to plant or paint flowers."

Conrad Atkinson, *Asbestos (The Lungs of Capitalism),* 1978, asbestos objects wrapped in plastic, red and pink typewritten sheets, photographed and printed documents, about 7′ x 12′. Atkinson calls this investigative work about the effects of asbestos poisoning and lack of compensation in the life and death of one man a "directly personal equation between the life of a working person and the balance of cost/profit." He cites the fact that in 1976 the asbestos industry spent £87,000 on research into the health hazards of their product and £500,000 on "an advertising campaign of breathtaking mendacity by omission, which was universally condemned." (Photo courtesy Ronald Feldman Fine Arts, New York)

It is significant that Atkinson, who continues to work from and with his working-class origins in a northern iron-mining town, is one of the more effective "modern" artists on the Left. His art and his writings tend to be free from theorhetoric; they are pragmatic, well researched and clear, and he usually manages to present reams of "boring" statistical and factual evidence with feeling, irony and visual interest. *Lungs of Capitalism* at the Serpentine was part of his present concentration on "the nature of the balance between profit and human life" and is intended to bring public attention to safety, health and compensation issues surrounding iron-ore and asbestos workers.

In one way or another, the majority of these artists are using documentary techniques and textual material, though often without the impact that the straight photography in the Whitechapel gains with such apparent ease. This situation raises the question of the *degree* of formal preoccupation and nonvisual packaging necessary to make social art. How detached can you get and still communicate the human necessity of your subject? How involved can you get and make something that still sparks the fundamentally detached experience that makes art thought-provoking? All too often the concern with a wider audience has led to "talking down"—a heavy-handed didacticism to the detriment of the communicative visual imagination. Such condescension, in turn, evokes justified complaints from artist-teachers that daily education is snobbishly neglected as a vehicle for cultural change, although it provides just the broad (and captive) audience others claim to be looking for.

Advanced educational techniques are at the core of Steve Willats' *Coded World,* an audience-participation project in Perivale (London) displayed at both shows. It is aimed at founding a perceptual "counter-consciousness" in a given community by evoking personal (theoretical) alternatives to extant authority patterns through diagrammed photo-problems and individual response sheets publicly displayed and progressing over a period of time. Willats' work makes good sense by assigning an active rather than a passive role to individuals in the community, though its obscure academic-bureaucratic language can only impede its progress.

Documentary information of another kind is the basis of Alexis Hunter's *Rape* at the Whitechapel—ten photos of a night street with double-exposed hands and knife blade and a handwritten dialogue below; it is an autobiographical account of the almost funny way the artist talked herself out of rape at knifepoint by political interaction with her attacker. Also on the subject of violence, from an extrapersonal, class-conscious viewpoint, Margaret Harrison included in her "Women's Work" show at the Battersea Art Center a large painted and collaged rape canvas including advertisements and newsclippings with such choice bits as a judge on an upper-class wifebeater: "If he had been a miner in South Wales, I might have overlooked it, but he was a cultured gentleman living in a respected community." The major part of Harrison's show was devoted to a vast amount of personal and official documents concerning the plight of the mercilessly exploited "homeworkers"—women doing piecework for wages averaging $11.22 for a forty-hour week.

By combining her own need to paint with the needs of these isolated women workers, Harrison pinpoints the tensions inherent in "social" art. So in another way does Tony Rickaby in his "Fascade" at Art Net—a deadpan show of forty-two deceptively conservative realist drawings of the facades of forty-two right-

wing organizations' headquarters in London, accompanied by a mimeographed checklist describing their functions. This curious hybrid blocks the viewer's temptation to look at the drawings as "art" (you can't quite say "Oh! I like the Institute for the Study of Conflict the best!"). The ordinariness of drawings and subjects is indeed a facade (a National Front?). The content is hidden, like the activities that take place within the suburban homes, storefronts and Victorian offices. In the end the blandness becomes downright ominous.

John Gorman observes in the Whitechapel catalog that "to sell the consumer dream, Capitalism employs more artists than at any time in history." A whole school of *un*employed British artists working in the footsteps of John Heartfield and Klaus Staeck analyze advertising and news media through sophisticated parody, photomontage, comic strips, and pointed contrasts between "found" images and added texts or vice versa (for example, Victor Burgin's *Saint Laurent Demands a Whole New Lifestyle* with a picture of a Pakistani woman on an assembly line).

Although often too easy a target, advertising, because it *is* in the public domain, provides a strong consciousness-raising technique, and as such is a highly seductive model. Yet these devices are best suited to posters homeopathically turning the mass media back on themselves (as in Peter Dunn's and Lorraine Leeson's very professional work to save the Bethnal Green Hospital from budget

East London Health Project (Lorraine Leeson and Peter Dunn), *Health Cuts Can Kill,* 1978, one of a series of colored street posters for East London, where hospitals were being closed and health programs slashed.

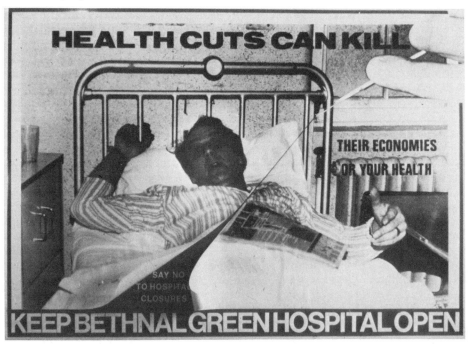

Cesarea, mid-1970s, an *arpillera,* or patchwork picture, made by anonymous Chilean women, many of them the mothers and relatives of political prisoners. The deceptively decorative images and symbols are politically pointed and the works are smuggled out of the country to convey the truth about life under the *junta.* This *arpillera* protests the closing of national health services.

cuts, at the Serpentine). Its simplest form has been one of its most effective—the sticker campaigns like "This Ad Insults Women" in the subway. The fact that many of the works in the Whitechapel show using advertising are not intended as posters but as gallery art gives me pause. It raises another question: When does "confrontation of the dominant ideology" become absorption by the opposition?

In contrast, some of the most moving art at the Whitechapel was the least sophisticated in avant-garde terms, and some of the best of it—Andrew Turner's viciously rhetorical *Black Friday Triptych* and Dan Jones' superb *Demonstration for the Release of Five Dockers Imprisoned in Pentonville*—is owned by trade unions. These works suggest that much sophisticated social art could use a shot of heart, which brings me in turn to the fact that very few women took part in these shows. I suspect this absence has something to do with the conceptual and practical means chosen by and available to women of all classes with which to consider and act upon the private/public dichotomy.

Not incidentally, the London show this year that most successfully and movingly integrated social concerns and traditional art was neither of the two

giants under discussion here but the exhibition at the AIR Gallery of the "patchwork" pictures made from factory remnants by anonymous Chilean barrio women. They protest the junta's repressions and offer methods of self-determination and economic survival. These women can't sit around and analyze their role; it has been handed to them on a bloodstained platter. By confronting it in a familiar medium that does not separate art and life, they are producing the most cohesive political art around.

III

TO THE THIRD POWER:
FEMINISM, ART
AND CLASS CONSCIOUSNESS

Prefatory Note

Concentrated time to write fiction always seems to expand my political horizons. My year in England (which I spent walking, reading and writing, instead of looking at art, talking and going to meetings) gave me time to think. I came back to New York refreshed and determined to try and integrate my major concerns—feminism and socialism; socialist and cultural feminism; art and politics; nature and culture.

In England I had spent some time with British socialist feminist artists whose theories on women and class seemed far in advance of most American artworld expositions. I had also become obsessed with the great prehistoric stone and earth monuments at Avebury, on the Dartmoor, and elsewhere, as well as with the landscape in which I had walked every day. I was willing to give up neither nature nor culture. However, "cultural feminists" (with their connective concept of women and nature) tend to perceive "socialist feminists" as male-identified, unfeeling intellectuals bound to an impersonal and finally antifemale economic overview; while "socialist feminists" tend to perceive "cultural feminists" as a woozy crowd of women in sheets taking refuge in a matriarchal "herstory" that is reactionary, escapist and possibly fascist in its suggestions of biological superiority. I still spend a lot of time in one camp making excuses for my commitment to the other, and vice versa.

In 1979 I organized a show at the Artemesia Gallery in Chicago called "Both Sides Now" which brought together women artists from both factions. I joined the New York Socialist Feminists which filled some large gaps in my self-education on Marxism. And the dialogue, feedback and support I received from the Heresies Collective for my own and collaborative work was crucial. It increased my intellectual security which in turn allowed me to write more openly, less self-protectively, about art and politics. In *Heresies,* for the first time, I was writing as *part of* a familiar and sympathetic fabric rather than being an isolated individual or dissident voice. Such nurturance in turn opened up new subject matter that I had previously felt "unqualified" to explore, such as class and broader cultural and media theory. The components of that still much-longed-

for integration became clearer, even if no solutions presented themselves. In the search for bridges, I found myself scrutinizing the imposed dichotomies between "high" (or fine) and "low" (or mass and popular) cultures.

As I type this, I have hanging over my desk two pictures of typewriters. In one the paper is replaced by a sheet of flames; in the other by a green-leafed plant. And as I write this I'm still trying to resolve all these contradictions, to participate in an agitprop art with the emotional and imaginative density of high art, and to encourage a high art with the immediacy, humanism and direct intensity of good propaganda.

(Photo: Jerry Kearns)

The Pink Glass Swan:
Upward and Downward Mobility
in the Art World*

The general alienation of contemporary avant-garde art from any broad audience has been crystallized in the Women's Movement. From the beginning, both liberal feminists concerned with changing women's personal lives and socialist feminists concerned with overthrowing the classist/racist/sexist foundations of society have agreed that "fine" art is more-or-less irrelevant, though holding out

*Reprinted by permission from *Heresies*, no. 1 (Jan. 1977).

the hope that feminist art could and should be different. The American women artists' movement has concentrated its efforts on gaining power within its own interest group—the art world, in itself an incestuous network of relationships between artists and art on the one hand and dealers, publishers, and buyers on the other. The public, the "masses," or the audience is hardly considered.

The art world has evolved its own curious class system. Externally this is a microcosm of capitalist society, but it maintains an internal dialectic (or just plain contradiction) that attempts to reverse or ignore that parallel. Fame may be a higher currency than mere money, but the two tend to go together. Since the buying and selling of art and artists are done by the ruling classes or by those chummy with them and their institutions, all artists or producers, no matter what their individual economic backgrounds, are dependent on the owners and forced into a proletarian role—just as women, in Engels' analysis, play proletarian to the male ruler across all class boundaries.

Looking at and "appreciating" art in this century has been understood as an instrument (or at best a result) of upward social mobility in which owning art is the ultimate step. Making art is at the bottom of the scale. This is the only legitimate reason to see artists as so many artists see themselves—as "workers." At the same time, artists/makers tend to feel misunderstood and, as *creators,* innately superior to the buyers/owners. The innermost circle of the artworld class system thereby replaces the rulers with the creators, and the contemporary artist in the big city (read New York) is a schizophrenic creature. S/he is persistently working "up" to be accepted, not only by other artists, but also by the hierarchy that exhibits, writes about, and buys her/his work. At the same time s/he is often ideologically working "down" in an attempt to identify with the workers outside of the art context and to overthrow the rulers in the name of art. This conflict is augmented by the fact that most artists are originally from the middle class, and their approach to the bourgeoisie includes a touch of adolescent rebellion against authority. Those few who have actually emerged from the working class sometimes use this—their very lack of background privilege—as privilege in itself, while playing the same schizophrenic foreground role as their solidly middle-class colleagues.

Artists, then, are workers or at least producers even when they don't know it. Yet artists dressed in work clothes (or expensive imitations thereof) and producing a commodity accessible only to the rich differ drastically from the real working class in that artists control their production and their product—or could if they realized it and if they had the strength to maintain that control. In the studio, at least, unlike the farm, the factory, and the mine, the unorganized worker is in superficial control and can, if s/he dares, talk down to or tell off the boss—the collector, the critic, the curator. For years now, with little effect, it has been pointed out to artists that the artworld superstructure cannot run without them. Art, after all, is the product on which all the money is made and the power based.

During the 1950s and 1960s most American artists were unaware that they did *not* control their art, that their art could be used not only for esthetic pleasure or decoration or status symbols, but also as an educational weapon. In the late 1960s, between the Black, the student, the antiwar, and the women's movements, the facts of the exploitation of art in and out of the art world emerged. Most artists and artworkers still ignore these issues because they make them feel too

uncomfortable and helpless. If there were a strike against museums and galleries to allow artists control of their work, the scabs would be out immediately in full force, with reasons ranging from self-interest to total lack of political awareness to a genuine belief that society would crumble without art, that art is "above it all." Or is it in fact *below* it all, as most political activists seem to think?

Another aspect of this conflict surfaces in discussions around who gets a "piece of the pie"—a phrase that has become the scornful designation for what is actually most people's goal. (Why shouldn't artists be able to make a living in this society like everybody else? Well, *almost* everybody else.) Those working for cultural change through political theorizing and occasional actions often appear to be opposed to *anybody* getting a piece of the pie, though politics is getting fashionable again in the art world, and may itself provide a vehicle for internal success; today one can refuse a piece of the pie and simultaneously be getting a chance at it. Still, the pie is very small, and there are a lot of hungry people circling it. Things were bad enough when only men were allowed to take a bite. Since "aggressive women" have gotten in there, too, competition, always at the heart of the artworld class system, has peaked.

Attendance at any large art school in the United States takes students from all classes and trains them for artists' schizophrenia. While being cool and chicly grubby (in the "uniform" of mass production), and knowing what's the latest in taste and what's the kind of art to make and the right names to drop, is clearly "upward mobility"—from school into teaching jobs and/or the art world—the lifestyle accompanying these habits is heavily weighted "downward." The working-class girl who has had to work for nice clothes must drop into frayed jeans to make it into the art middle class, which in turn considers itself both upper and lower class. Choosing poverty is a confusing experience for a child whose parents (or more likely mother) have tried desperately against great odds to keep a clean and pleasant home.[1]

The artist who feels superior to the rich because s/he is disguised as someone who is poor provides a puzzle for the truly deprived. A parallel notion, rarely admitted but pervasive, is that people can't understand "art" if their houses are full of pink glass swans or their lawns are inhabited by gnomes and flamingos, or if they even care about houses and clothes at all. This is particularly ridiculous now, when art itself uses so much of this paraphernalia (and not always satirically or condescendingly); or, from another angle, when even artists who have no visible means of professional support live in palatial lofts and sport beat-up $100 boots while looking down on the "tourists" who come to SoHo to see art on Saturdays. SoHo is, in fact, the new suburbia. One reason for such callousness is a hangover from the 1950s, when artists really were poor and proud of being poor because their art, the argument went, must be good if the bad guys—the rich *and* the masses—didn't like it.

In the 1960s the choice of poverty, often excused as anticonsumerism, even infiltrated the esthetics of art.[2] First there was Pop Art, modeled on kitsch, advertising, and consumerism, and equally successful on its own level. (Women, incidentally, participated little in Pop Art, partly because of its blatant sexism—sometimes presented as a parody of the image of woman in the media—and partly because the subject matter was often "women's work," ennobled and acceptable only when the artists were men.) Then came Process Art—a rebellion against the "precious object" traditionally desired and bought by the rich. Here

another kind of cooptation took place, when temporary piles of dirt, oil, rags, and filthy rubber began to grace carpeted living rooms. (The Italian branch was even called *Arte Povera*.) Then came the rise of a third-stream medium called Conceptual Art, which offered "antiobjects" in the form of ideas—books or simple Xeroxed texts and photographs with no inherent physical or monetary value (until they got on the market, that is). Conceptual Art seemed politically viable because of its notion that the use of ordinary, inexpensive, unbulky media would lead to a kind of socialization (or at least democratization) of art as opposed to gigantic canvases and huge chrome sculptures costing five figures and filling the world with more consumer fetishes.

Yet the trip from oil on canvas to ideas on Xerox was, in retrospect, yet another instance of "downward mobility" or middle-class guilt. It was no accident that Conceptual Art appeared at the height of the social movements of the late 1960s nor that the artists were sympathetic to those movements (with the qualified exception of the Women's Movement). All of the esthetic tendencies listed above were genuinely instigated as rebellions by the artists themselves, yet the fact remains that only rich people can afford to (1) spend money on art that won't last; (2) live with "ugly art" or art that is not decorative, because the rest of their surroundings are beautiful and comfortable; and (3) like "nonobject art," which is only handy if you already have too many possessions—when it becomes a reactionary commentary: art for the overprivileged in a consumer society.

As a child, I was accused by my parents of being an "antisnob snob" and I'm only beginning to see the limitations of such a rebellion. Years later I was an early supporter of and proselytizer for Conceptual Art as an escape from the commodity orientation of the art world, a way of communicating with a broader audience via inexpensive media. Though I was bitterly disappointed (with the social, not the esthetic, achievements) when I found that this work could be so easily absorbed into the system, it is only now that I've realized why the absorption took place. Conceptual Art's democratic efforts and physical vehicles were canceled out by its neutral, elitist content and its patronizing approach. From around 1967 to 1971, many of us involved in Conceptual Art saw that content as pretty revolutionary and thought of ourselves as rebels against the cool, hostile artifacts of the prevailing formalist and Minimal art. But we were so totally enveloped in the middle-class approach to everything we did and saw, we couldn't perceive how that pseudoacademic narrative piece or that artworld-oriented action in the streets was deprived of any revolutionary content by the fact that it was usually incomprehensible and alienating to the people "out there," no matter how fashionably downwardly mobile it might be in the art world. The idea that if art is subversive in the art world, it will automatically appeal to a general audience now seems absurd.

The whole evolutionary basis of modernist innovation, the idea of esthetic "progress," the "I-did-it-first" and "it's-been-done-already" syndromes that pervade contemporary avant-garde art and criticism, is also blatantly classist and has more to do with technology than with art. To be "avant-garde" is inevitably to be on top, or to become upper-middle-class, because such innovations take place in a context accessible only to the educated elite. Thus socially conscious artists working in or with community groups and muralists try to disassociate themselves from the art world, even though its values ("quality") remain to haunt them personally.

The value systems are different in and out of the art world, and anyone attempting to straddle the two develops another kind of schizophrenia. For instance, in the inner-city community murals, the images of woman are the traditional ones—a beautiful, noble mother and housewife or worker, and a rebellious young woman striving to change her world—both of them celebrated for their courage to be and to stay the way they are and to support their men in the face of horrendous odds. This is not the artworld or middle-class "radical" view of future feminism, nor is it one that radical feminists hoping to "reach out" across the classes can easily espouse. Here, in the realm of aspirations, is where upward and downward mobility and status quo clash, where the economic class barriers are established. As Michele Russell has noted,[3] the Third World woman is not attracted to the "Utopian experimentation" of the Left (in the art world, the would-be Marxist avant garde) or to the "pragmatic opportunism" of the Right (in the art world, those who reform and coopt the radicals).

Many of the subjects touched on here have their roots in Taste. To a poor woman, art, or a beautiful object, might be defined as something she cannot have. Beauty and art have been defined before as *the desirable.* In a consumer society, art, too, becomes a commodity rather than a life-enhancing experience. Yet the Van Gogh reproduction or the pink glass swan—the same beautiful objects that may be "below" a middle-class woman (because she has, in moving upward, acquired upper-class taste, or would like to think she has)—may be "above" or inaccessible to a welfare mother. The phrase "to dictate taste" has its own political connotations. A Minneapolis worker interviewed by students of artist Don Celender said he liked "old artworks because they're more classy,"[4] and class does seem to be what the traditional notion of art is all about. Yet contemporary avant-garde art, for all its attempts to break out of that gold frame, is equally class-bound, and even the artist aware of these contradictions in her/his own life and work is hard put to resolve them. It's a vicious circle. If the artist-producer is upper-middle-class, and our standards of art as taught in schools are persistently upper-middle-class, how do we escape making art only *for* the upper-middle-class?

The alternatives to "quality," to the "high" art shown in artworld galleries and magazines, have been few and for the most part unsatisfying, although well intended. Even when kitsch, politics, or housework are absorbed into art, contact with the real world is not necessarily made. At no time has the avant garde, though playing in the famous "gap between art and life," moved far enough out of the art context to attract a broad audience. That same broad audience has, ironically, been trained to think of art as something that has nothing to do with life and, at the same time, it tends only to like that art that means something in terms of its own life or fantasies. The dilemma for the leftist artist in the middle class is that her/his standards seem to have been set irremediably. No matter how much we know about what the broader public wants, or *needs,* it is very difficult to break social conditioning and cultural habits. Hopefully, a truly feminist art will provide other standards.

To understand the woman artist's position in this complex situation between the art world and the real world, class, and gender, it is necessary to know that in America artists are rarely respected unless they are stars or rich or mad or dead. Being an artist is not being "somebody." Middle-class families are happy to pay lip service to art but god forbid their own children take it so seriously as to con-

sider it a profession. Thus a man who becomes an artist is asked when he is going to "go to work," and he is not-so-covertly considered a child, a sissy (a woman), someone who has a hobby rather than a vocation, or someone who can't make money and therefore cannot hold his head up in the real world of men—at least until his work sells, at which point he may be welcomed back. Male artists, bending over backward to rid themselves of this stigma, tend to be particularly susceptible to insecurity and *machismo*. So women daring to insist on their place in the primary rank—as art makers rather than as art housekeepers (curators, critics, dealers, "patrons")—inherit a heavy burden of male fears in addition to the economic and psychological discrimination still rampant in a patriarchal, money-oriented society.

Most art being shown now has little to do with any woman's experience, in part because women (rich ones as "patrons," others as decorators and "home-makers") are in charge of the private sphere, while men identify more easily with public art—art that has become public through economic validation (the million-dollar Rembrandt). Private art is often seen as mere ornament; public art is associated with monuments and money, with "high" art and its containers, including unwelcoming white-walled galleries and museums with classical courthouse architecture Even the graffiti artists, whose work is unsuccessfully transferred from subways to art galleries, are mostly men, concerned with facades, with having their names in spray paint, in lights, in museums. . . .

Private art is visible only to intimates. I suspect the reason so few women "folk" artists work outdoors in large scale (like Simon Rodia's Watts Towers and other "naïves and visionaries" with their cement and bottles) is not only because men aspire to erections and know how to use the necessary tools, but because women can and must assuage these same creative urges *inside* the house, with the pink glass swan as an element in their own works of art—the living room or kitchen. In the art world, the situation is doubly paralleled. Women's art until recently was rarely seen in public, and all artists are voluntarily "women" because of the social attitudes mentioned above; the art world is so small that it is "private."

Just as the living room is enclosed by the building it is in, art and artist are firmly imprisoned by the culture that supports them. Artists claiming to work for themselves alone, and not for any audience at all, are passively accepting the upper-middle-class audience of the internal art world. This situation is compounded by the fact that to be middle class is to be passive, to live with the expectation of being taken care of and entertained. But art should be a consciousness raiser; it partakes of and should fuse the private and the public spheres. It should be able to reintegrate the personal without being satisfied by the *merely* personal. One good test is whether or not it communicates, and then, of course, what and how it communicates. If it doesn't communicate, it may just not be very good art from anyone's point of view, or it may be that the artist is not even aware of the needs of others, or simply doesn't care.

For there is a need out there, a need vaguely satisfied at the moment by "schlock."[5] And it seems that one of the basic tenets of the feminist arts should be a reaching out from the private sphere to transform that "artificial art" and to more fully satisfy that need. For the artworld artist has come to consider her/his private needs paramount and has too often forgotten about those of the audience, any audience. Work that communicates to a dangerous number of people is de-

rogatorily called a "crowd pleaser." This is a blatantly classist attitude, taking for granted that most people are by nature incapable of understanding good art (i.e., upper-class or quality art). At the same time, much ado is made about art-educational theories that claim to "teach people to see" (consider the political implications of this notion) and muffle all issues by stressing the "universality" of great art.

It may be that at the moment the possibilities are slim for a middle-class art world's understanding or criticism of the little art we see that reflects working-class cultural values. Perhaps our current responsibility lies in humanizing our own activities so that they will communicate more effectively with all women. I hope we aspire to more than women's art flooding the museum and gallery circuit. Perhaps a feminist art will emerge only when we become wholly responsible for our own work, for what becomes of it, who sees it, and who is nourished by it. For a feminist artist, whatever her style, the prime audience at this time is other women. So far, we have tended to be satisfied with communicating with those women whose social experience is close to ours. This is natural enough, since there is where we will get our greatest support, and we need support in taking this risk of trying to please *women,* knowing that we are almost certain to displease men in the process. In addition, it is embarrassing to talk openly about the class system that divides us, hard to do so without sounding more bourgeois than ever in the implications of superiority and inferiority inherent in such discussions (where the working class is as often considered superior to the middle class).

A book of essays called *Class and Feminism,* written by The Furies, a Lesbian feminist collective, makes clear that from the point of view of working-class women, class is a definite problem within the Women's Movement. As Nancy Myron observes, middle-class women:

> can intellectualize, politicize, accuse, abuse, and contribute money in order not to deal with their own classism. Even if they admit that class exists, they are not likely to admit that their behavior is a product of it. They will go through every painful detail of their lives to prove to me or another working-class woman that they really didn't have any privilege, that their family was exceptional, that they actually did have an uncle who worked in a factory. To ease anyone's guilt is not the point of talking about class. . . . You don't get rid of oppression just by talking about it.[6]

Women are more strenuously conditioned toward upward cultural mobility or "gentility" than men, which often results in the woman's consciously betraying her class origins as a matter of course. The hierarchies within the whole span of the middle class are most easily demarcated by lifestyle and dress. For instance, the much-scorned "Queens housewife" may have enough to eat, may have learned to consume the unnecessities, and may have made it to a desired social bracket in her community, but if she ventures to make art (not just own it), she will find herself back at the bottom in the art world, looking wistfully up to the plateau where the male, the young, the bejeaned seem so at ease.

For middle-class women in the art world not only dress "down," but dress like working-class *men.* They do so because housedresses, pedal pushers, polyester pantsuits, beehives, and the wrong accents are not such acceptable disguises for women as the boots-overalls-and-windbreaker syndrome is for men. Thus,

young middle-class women tend to deny their female counterparts and take on "male" (unisex) attire. It may at times have been chic to dress like a Native American or a Bedouin woman, but it has never been chic to dress like a working woman, even if she was trying to look like Jackie Kennedy. Young working-class women (and men) spend a large amount of available money on clothes; it's a way to forget the rats and roaches by which even the cleanest tenement dwellers are blessed, or the mortgages by which even the hardest working homeowners are blessed, and to present a classy facade. Artists dressing and talking "down" insult the hardhats much as rich kids in rags do; they insult people whose notion of art is something to work for—the pink glass swan.

Yet women, as evidenced by The Furies' publication and as pointed out elsewhere (most notably by August Bebel), have a unique chance to communicate with women across the boundaries of economic class because as a "vertical class" we share the majority of our most fundamental experiences—emotionally, even when economically we are divided. Thus an economic analysis does not adequately explore the psychological and esthetic ramifications of the need for change within a sexually oppressed group. Nor does it take into consideration how women's needs differ from men's—or so it seems at this still unequal point in history. The vertical class cuts across the horizontal economic classes in a column of injustices. While heightened class consciousness can only clarify the way we see the world, and all clarification is for the better, I can't bring myself to trust hard lines and categories where fledgling feminism is concerned.

Even in the art world, the issue of feminism has barely been raised in mixed political groups. In 1970, women took our rage and our energies to our own organizations or directly to the public by means of picketing and protests. While a few men supported these, and most politically conscious male artists now claim to be feminists to some degree, the political *and* apolitical art world goes on as though feminism didn't exist—the presence of a few vociferous feminist artists and critics notwithstanding. And in the art world, as in the real world, political commitment frequently means total disregard for feminist priorities. Even the increasingly Marxist group ironically calling itself Art-Language is unwilling to stop the exclusive use of the male pronoun in its theoretical publications.[7]

Experiences like this one and dissatisfaction with Marxism's lack of interest in "the woman question" make me wary of merging Marxism and feminism. The notion of the noneconomic or "vertical" class is anathema to Marxists, and confusion is rampant around the chicken-egg question of whether women can be equal before the establishment of a classless society or whether a classless society can be established before women are liberated. As Sheila Rowbotham says of her own Marxism and feminism:

> They are at once incompatible and in real need of one another. As a feminist and a Marxist, I carry their contradictions within me, and it is tempting to opt for one or the other in an effort to produce a tidy resolution of the commotion generated by the antagonism between them. But to do that would mean evading the social reality which gives rise to the antagonism.[8]

As women, therefore, we need to establish far more strongly our own sense of community, so that all our arts will be enjoyed by all women in all economic circumstances. This will happen only when women artists make conscious efforts

to cross class barriers, to consider their audience, to see, respect, and work with the women who create outside the art world—whether in suburban crafts guilds or in offices and factories or in community workshops. The current feminist passion for women's traditional arts, which influences a great many women artists, should make this road much easier, unless it too becomes another commercialized rip-off. Despite the very real class obstacles, I feel strongly that women are in a privileged position to satisfy the goal of an art that would communicate the needs of all classes and sexes to each other, and get rid of the we/they dichotomy to as great an extent as is possible in a capitalist framework. Our sex, our oppression, and our female experience—our female culture, just being explored—offer access to all of us by these common threads.

NOTES

1. Charlotte Bunch and Nancy Myron, eds., *Class and Feminism* (Baltimore: Diana Press, 1974). This book contains some excruciating insights for the middle-class feminist; it raised my consciousness and inspired this essay (along with other recent experiences and conversations).

2. Actually nothing new; the history of modern art demonstrates a constant longing for the primitive, the simple, the clear, the "poor," the noble naif, and the like.

3. Michele Russell, "Women and the Third World," in *New American Movement* (Oakland, Calif., June 1973).

4. Don Celender, ed., *Opinions of Working People Concerning the Arts* (St. Paul, Minn.: Macalester College, 1975).

5. Baruch Kirchenbaum, in correspondence. Celender, *Opinions of Working People,* offers proof of this need and of the huge (and amazing) interest in art expressed by the working class, though it should be said that much of what is called art in his book would not be called art by the taste dictators.

6. Bunch and Myron, *Class and Feminism.*

7. This despite their publication of and apparent endorsement of Carolee Schneemann's "The Pronoun Tyranny," in *The Fox,* 3 (New York, 1976).

8. Sheila Rowbotham, *Women: Resistance and Revolution* (London: Allen Lane, 1972; New York: Pantheon, 1972).

Making Something from Nothing (Toward a Definition of Women's "Hobby Art")*

In 1968 Rubye Mae Griffith and Frank B. Griffith published a "hobby" book called *How to Make Something from Nothing.* On the cover (where it would sell books) his name was listed before hers, while on the title page (where it could do no harm), hers appeared before his. It is tempting to think that it was she who wrote

*Reprinted by permission from *Heresies,* no. 4 (Winter 1978).

the cryptofeminist dedication: "To the nothings—with the courage to turn into somethings." The book itself is concerned with transformation—of tin cans, beef knuckle bones, old razor blades, breadbaskets and bottlecaps into more and less useful and decorative items. As "A Word in Parting," the authors state their modest credo:

> This book . . . is simply a collection of ideas intended to encourage your ideas. . . . We want you to do things your way. . . . Making nothings into somethings is a highly inventive sport but because it is inventive and spontaneous and original it releases tensions, unties knots of frustration, gives you a wonderful sense of pleasure and accomplishment. So experiment, dare, improvise—enjoy every minute—and maybe you'll discover, as we did, that once you start making something from nothing, you find you can't stop, and what's more you don't want to stop!

Despite the tone and the emphasis on enjoyment—unpopular in serious circles—this "sport" sounds very much like fine or "high" art. Why then are its products not art? "Lack of quality" will be the first answer offered, and "derivative" the second, even though both would equally apply to most of the more sophisticated works seen in galleries and museums. If art is popularly defined as a unique and provocative object of beauty and imagination, the work of many of the best contemporary "fine" artists must be disqualified along with that of many "craftspeople," and in the eyes of the broad audience, many of the talented hobbyist's works *would* qualify. Yet many of these, in turn, would not even be called "crafts" by the purists in that field. Although it is true that all this name calling is a red herring, it makes me wonder whether high art by another name might be less intimidating and more appealing. On the other hand, would high art by any other name look so impressive, be so respected and so commercially valued? I won't try to answer these weighted queries here, but simply offer them as other ways of thinking about some of the less obvious aspects of the art of making.

Much has been made of the need to erase false distinctions between art and craft, "fine" art and the "minor" arts, "high" art and "low" art—distinctions that particularly affect women's art. But there are also "high" crafts and "low" ones, and although women wield more power in the crafts world than in the fine art world, the same problems plague both. The crafts need only one more step up the esthetic and financial respectability ladder and they will be headed for the craft museums rather than for people's homes.

Perhaps until the character of the museums changes, anything ending up in one will remain a display of upper-class taste in expensive and doubtfully "useful" objects. For most of this century, the prevailing relationship between art and "the masses" has been one of paternalistic *noblesse oblige* along the lines of "we who are educated to *know* what's correct must pass our knowledge and good taste *down* to those who haven't the taste, the time, or the money to know what is Good." Artists and craftspeople, from William Morris to de Stijl and the Russian Constructivists, have dreamed of socialist Utopias where everyone's life is improved by cheap and beautiful objects and environments. Yet the path of the Museum of Modern Art's design department, also paved with good intentions, indicates the destination of such dreams in a capitalist consumer society. A

pioneer in bringing to the public the best available in commercial design, the museum's admirable display of such readymades as a handsome and durable thirty-nine-cent paring knife or a sixty-nine-cent coffee mug has mostly given way to installations more typical of Bonnier's, DR, or some chic Italian furniture showroom.

It is, as it so often is, a question of audience, as well as a question of categorization. (One always follows the other.) Who sees these objects at MOMA? Mostly people who buy three-dollar paring knives and eight-dollar coffee mugs which are often merely "elevated" examples of the cheaper versions, with unnecessary refinements or simplifications. Good Taste is once again an economic captive of the classes who rule the culture and govern its institutions.[1] Bad Taste is preferred by those ingrates who are uneducated enough to ignore or independent enough to reject the impositions from above. Their lack of enthusiasm provides an excuse for the esthetic philanthropists, their hands bitten, to stop feeding the masses. Class-determined good/bad taste patterns revert to type.

Such is the process by which both "design" objects and the "high" crafts have become precisely the consumer commodity that the rare socially conscious "fine" artist is struggling to avoid. Historically, craftspeople, whose work still exists in a less exalted equilibrium between function and commerce, have been most aware of the contradictions inherent in the distinction between art and crafts. The distinction between design and "high" crafts is a modern one. Both have their origins in the "low" crafts of earlier periods, sometimes elevated to the level of "folk art" because of their usefulness as sources for "fine" art. A "designer" is simply the craftsperson of the technological age, no longer forced to do her/his own *making*. The Bauhaus became the cradle of industrial design, but the tapestries, furniture, textiles and tea sets made there were still primarily works of art. Today, the most popular housewares all through the taste gamut of the American lower-middle to upper-middle class owe as much stylistically to the "primitive" or "low" crafts—Mexican, Asian, American Colonial—as to the streamlining of the International Style. In fact, popular design tends to combine the two, which meet at a point of (often spurious) "simplicity" to become "kitsch"—diluted examples of the Good Taste that is hidden away in museums, expensive stores, and the homes of the wealthy, inaccessible to everyone else.

The hobby books reflect the manner in which Good Taste is still unarguably set forth by the class system. Different books are clearly aimed at different tastes, aspirations, educational levels. For instance, Dot Aldrich's *Creating with Cattails, Cones and Pods* is not aimed at the inner-city working-class housewife or welfare mother (who couldn't afford the time or the materials) or at the farmer's wife (who sees enough weeds in her daily work) but at the suburban middle-class woman who thinks in terms of "creating," has time on her hands and access to the materials. Aldrich is described on the dust jacket as a garden club member, a naturalist, and an artist; the book is illustrated by her daughter. She very thoroughly details the construction of dollhouse furniture, corsages and "arrangements" from dried plants and an occasional orange peel. Her taste is firmly placed as "good" within her class, although it might be seen as gauche "homemade art" by the upper class and ugly and undecorative by the working class.

Hazel Pearson Williams' *Feather Flowers and Arrangements,* on the other hand, has the sleazy look of a mail-order catalog; it is one of a craft course series

and its fans, birdcages, butterflies and candles are all made from garishly colored, rather than natural, materials. The book is clearly aimed at a totally different audience, one that is presumed to respond to such colors and to have no esthetic appreciation of the "intrinsic" superiority of natural materials over artificial ones, not to mention an inability to afford them.

The objects illustrated in books like the Griffiths' are neither high art nor high craft nor design. Yet such books are myriad, and they are clearly aimed at women—the natural *bricoleurs,* as Deena Metzger has pointed out. The books are usually written by a woman, and if a man is coauthor he always seems to be a husband, which adds a certain familial coziness and gives him an excuse for being involved in such blatantly female fripperies (as well as dignifying the frippery by his participation). Necessity is the mother, not the father, of invention. The home *maker's* sense of care and touch focuses on sewing, cooking, interior decoration as often through conditioning as through necessity, providing a certain bond between middle-class and working-class housewives *and* career women. (I am talking about the making of the home, not just the keeping of it; "good housekeeping" is not a prerogative for creativity in the home. It might even be the opposite, since the "houseproud" woman is often prouder of her house, her container, than she is of herself.) Even these days women still tend to be raised with an exaggerated sense of detail and a need to be "busy," often engendered by isolation within a particular space, and by the emphasis on cleaning and service. A visually sensitive woman who spends day after day in the same rooms develops a compulsion to change, adorn, *expand* them, an impetus encouraged by the "hobby" books.

The "overdecoration" of the home and the fondness for bric-a-brac often attributed to female fussiness or plain Bad Taste can just as well be attributed to creative restlessness. Since most homemade hobby objects are geared toward home improvement, they inspire less fear in their makers of being "selfish" or "self-indulgent." There is no confusion about pretensions to Art, and the woman is freed to make anything she can imagine. (At the same time it is true that the imagination is often stimulated by exposure to other such work, just as "real" artists are similarly dependent on the art world and exposure to the works of their colleagues.) Making "conversation pieces" like deer antler salad tongs or a madonna in an abalone shell grotto, or a mailbox from an old breadbox, or vice versa, can be a prelude to breaking with the "functional" excuse and the making of wholly "useless" objects.

Now that the homebound woman has a little more leisure, thanks to so-called labor-saving devices, her pastimes are more likely to be cultural in character. The less privileged she is, the more likely she is to keep her interests *inside* the home with the focus of her art remaining the same as that of her work. The better off and better educated she is, the more likely she is to go *outside* of the home for influence or stimulus, to spend her time reading, going to concerts, theatre, dance, staying "well informed." If she is upwardly mobile, venturing from her own confirmed tastes into foreign realms where she must be cautious about opinions and actions, her insecurity is likely to lead to the classic docility of the middle-class audience, so receptive to what "experts" tell it to think about the arts. The term *culture vulture* is understood to apply mainly to upwardly mobile *women.* And culture, in the evangelical spirit of the work ethic, is often also inseparable from "good works."

OATMEAL RAZZLE DAZZLE IVORY LIQUID LADY

Oatmeal Razzle Dazzle, made from a Quaker Oats box, and *Ivory Liquid Lady,* made from a detergent bottle (illustrations from *How to Make Something from Nothing).*

Middle- and upper-class women, always stronger in their support of "culture" than any other group, seem to *need* esthetic experience in the broadest sense more than men—perhaps because the vital business of running the world, for which educated women have, to some extent, been prepared, has been denied them; and because they have the time and the background to think—but not the means to act. Despite the fact that middle-class women have frequently been strong (and anonymous) forces for social justice, the earnestness and amateur status of such activities have been consistently ridiculed, from the Marx Brothers' films to the cartoons of Helen Hokinson (whose captions were often written by male *New Yorker* editors).

Nevertheless, the League of Women Voters, the volunteer work for underfunded cultural organizations, the garden clubs, literary circles and discussion groups of the comfortable classes have been valid and sometimes courageous attempts to move out into the world while remaining sufficiently on the fringes of the system as not to challenge its male core. The working-class counterparts are, for obvious reasons, aimed less at improving the lot of others than at improving their own, and, like hobby art, are more locally and domestically focused in unions, day care, paid rather than volunteer social work, Tupperware parties—and the PTA, where all classes meet. In any case, the housewife learns to take derision in her stride whether she intends to be socially effective or merely wants to escape from the home now and then (families are jealous of time spent elsewhere).

Women's liberation has at last begun to erode the notion that woman's role is that of the applauding spectator for the men's creativity. Yet as makers of (rather than housekeepers for) art, we still trespass on male ground. No wonder, then, that all over the world, women privileged and/or desperate and/or daring enough to consider creation outside traditional limits are finding an outlet for these drives in an art that is not considered "art," an art that there is some excuse for making, an art that costs little or nothing and performs an ostensibly useful function in the bargain—the art of making something out of nothing.

If one's only known outlets are follow-the-number painting or the ready-made "kit art" offered by the supermarket magazines, books like the Griffiths' open up new territory. Suggestions in "ladies'" and handiwork magazines should not be undervalued either. After all, quilt patterns were published and passed along in the nineteenth century (just as fashionable art styles are in today's art world). The innovative quilt maker or group of makers would come up with a new idea that broke or enriched the rules, just as the Navajo rug maker might vary brilliantly within set patterns (and modern abstractionists innovate by sticking to the rules of innovation).

The shared or published pattern forms the same kind of armature for painstaking handwork and for freedom of expression within a framework as the underlying grid does in contemporary painting. Most modern women lack the skills, the motive and the discipline to do the kind of handwork their foremothers did by necessity, but the stitchlike "mark" Harmony Hammond has noted in so much recent abstract art by women often emerges from a feminist adoption of the positive aspects of women's history. It relates to the ancient, sensuously repetitive, Penelopean rhythms of seeding, hoeing, gathering, weaving, spinning, as well as to modern domestic routines.

In addition, crocheting, needlework, embroidery, rug-hooking and quilting are coming back into the middle- and upper-class fashion on the apron strings of feminism and fad. Ironically, these arts are now practiced by the well-off out of boredom and social pressure as often as out of emotional necessity to make connections with women in the past. What was once *work* has now become art or "high" craft—museum-worthy as well as commercially valid. In fact, when Navajo rugs and old quilts were first exhibited in New York fine arts museums in the early 1970s, they were eulogized as neutral, ungendered sources for big bold geometric abstractions by male artists like Frank Stella and Kenneth Noland. Had they been presented as exhibitions of women's art, they would have been seen quite differently and probably would not have been seen at all in a fine art context at that time.

When feminists pointed out that these much-admired and "strong" works were in fact women's "crafts," one might have expected traditional women's art to be taken more seriously, yet such borrowings from "below" must still be validated from "above." William C. Seitz's "Assemblage" show at the Museum of Modern Art in 1961 had acknowledged the generative role of popular objects for Cubism, Dada and Surrealism, and predicted Pop Art, but he never considered women's work as the classic *bricolage*. It took a man, Claes Oldenburg, to make fabric sculpture acceptable, though his wife, Patty, did the actual sewing. Sometimes men even dabble in women's spheres in the lowest of low arts—hobby art made from throwaways by amateurs at home. But when a man makes, say, a macaroni figure or a hand-tooled leather *Last Supper,* it tends to raise the sphere

rather than lower the man, and he is likely to be written up in the local newspaper. Women dabbling in men's spheres, on the other hand, are still either inferior or just freakishly amazing.

It is supposed to be men who are "handy around the house," men who "fix" things while women "make" the home. This is a myth, of course, and a popular one. There are certainly as many women who do domestic repairs as men, but perhaps the myth was devised by women to force men to invest *some* energy, to touch and to care about *some* aspect of the home. The fact remains that when a woman comes to make something, it more often than not has a particular character—whether this originates from role playing, the division of labor, or some deeper consciousness. The difference can often be defined as a kind of "positive fragmentation" or as the collage esthetic—the mixing and matching of fragments to provide a new whole. Thus the bootcleaner made of bottlecaps suggested by one hobby book might also be a Surrealist object.

But it is not. And this is not entirely a disadvantage. Not only does the amateur status of hobby art dispel the need for costly art lessons, but it subverts the intimidation process that takes place when the male domain of "high" art is approached. As it stands, women—and especially women—can make hobby art in a relaxed manner, isolated from the "real" world of commerce and the pressures of professional estheticism. During the actual creative process, this is an advantage, but when the creative ego's attendant need for an audience emerges, the next step is not the galleries, but "cottage industry." The gifte shoppe, the county or crafts fair and outdoor art show circuit is open to women where the high art world is not, or was not until it was pried open to some extent by the feminist art movement. For this reason, many professional women artists in the past made both "public art" (canvases and sculptures acceptable to galleries and museums, conforming to a combination of current artworld tastes) and "private" or "closet" art (made for "personal reasons" or "just for myself"—as if most art were not). With the advent of the new feminism, the private has either replaced or merged with the public in much women's art and the delicate, the intimate, the obsessive, even the "cute" and the "fussy" in certain guises have become more acceptable, especially in feminist art circles. A striking amount of the newly discovered "closet" art by amateur and professional women artists resembles the *chotchkas* so universally scorned as women's playthings and especially despised in recent decades during the heyday of the neo-Bauhaus functionalism. The objects illustrated in *Feather Flowers and Arrangements* bear marked resemblance to what is now called Women's Art, including a certainly unconscious bias toward the forms that have been called female imagery.

Today we are resurrecting our mothers', aunts' and grandmothers' activities—not only in the well-publicized areas of quilts and textiles, but also in the more random and freer area of transformational *rehabilitation*. On an emotional as well as on a practical level, rehabilitation has always been women's work. Patching, turning collars and cuffs, remaking old clothes, changing buttons, refinishing or recovering old furniture are all the traditional private resorts of the economically deprived woman to give her family public dignity. The syndrome continues today, even though in affluent Western societies cheap clothes fall apart before they can be rehabilitated and inventive patching is more acceptable (to the point where expensive new clothes are made to *look* rehabilitated and thrift shops are combed by the well-off). Thus "making something from

nothing'' is a brilliant title for a hobby book, appealing as it does both to house-wifely thrift and to the American spirit of free enterprise—a potential means of making a fast buck.

Finally, certain questions arise in regard to women's recent "traditionally oriented" fine art. Are the sources direct—from quilts and county-fair handiwork displays—or indirect—via Dada, Surrealism, West Coast funk, or from feminist art itself? Is the resemblance of women's artworld art to hobby art a result of co-incidence? Of influence, conditioning, or some inherent female sensibility? Or is it simply another instance of camp, or fashionable downward mobility? The problem extends from source to audience.

Feminist artists have become far more conscious of women's traditional arts than most artists, and feminist artists are also politically aware of the need to broaden their audience, or of the need to broaden the kind of social experience fine art reflects. Yet the means by which to fill these needs have barely been explored. The greatest lack in the feminist art movement may be for contact and dialogue with those "amateurs" whose work sometimes appears to be imitated by the professionals. Judy Chicago and her co-workers on *The Dinner Party* and their collaboration with china painters and needleworkers, Miriam Schapiro's handkerchief exchanges and the credit given the women who embroider for her, the "Mother Art" group in Los Angeles which performs in laundromats and similar public/domestic situations, the British "Postal Art Event," and a few other examples are exceptions rather than the rule. It seems all too likely that only in a feminist art world will there be a chance for the "fine" arts, the "minor" arts, "crafts," and hobby circuits to meet and to develop an *art of making* with a new

Kate Walker, Monica Ross, Sue Richardson, installation of *Feministo, A Portrait of the Artist as a Young Housewife,* ICA, London, 1977. Feministo began as a "postal event" early in 1975 with isolated women artists around England communicating by means of pictures and small objects. The first exhibition, in Manchester, May 1976, included nearly 300 works. Since then, Walker, Richardson and Ross have formed another art collective called Fenix. (Photo: Michael Ann Mullen)

and revitalized communicative function. It won't happen if the feminist art world continues to be absorbed by the patriarchal art world.

And if it does happen, the next question will be to what extent can this work be reconciled with all the varying criteria that determine esthetic "quality" in the different spheres, groups, and cultures? Visual consciousness-raising, concerned as it is now with female imagery and, increasingly, with female process, still has a long way to go before our visions are sufficiently cleared to see *all* the arts of making as equal products of a creative impulse which is as socially determined as it is personally necessary—before the idea is no longer to make nothings into somethings, but to transform and give meaning to all things. In this utopian realm, Good Taste will not be standardized in museums, but will vary from place to place, from home to home.

REFERENCES

The Griffiths' book was published by Castle Books, New York City; the Aldrich book by Hearthside Press, Great Neck, New York; the Williams book by Craft Course publishers, Temple City, California. I found all of them in the tiny local library in a Maine town with a population of about three hundred.

The Hammond article appeared in *Heresies*, no. 1 (Jan. 1977); her "Class Notes" in no. 3 (Sept. 1977) is also relevant. The Metzger appeared in *Heresies,* no. 2 (June 1977), and is an important contribution to the feminist dialogue on "high" and "low" art.

The British Postal Event, or "Portrait of the Artist as a Housewife," is a "visual conversation" between amateur and professional women artists isolated in different cities. They send each other art objects derived from "nonprestigious folk traditions," art that is "cooked and eaten, washed and worn" in an attempt to "sew a cloth of identity that other women may recognize." It is documented in *MAMA!* (a booklet published by a Birmingham collective and available from PDC, 27 Clerkenwell Close, London EC 1) and in *Heresies*, no. 9 (1980).

I have also been indebted to Don Celender's fascinating *Opinions of Working People Concerning the Arts,* 1975, available from Printed Matter, 7 Lispenard St., New York, N.Y. 10013.

Past Imperfect*

The Obstacle Race. By Germaine Greer. Farrar, Straus & Giroux. 373 pp. $25.
Women Artists of the Arts and Crafts Movement. By Anthea Callen. Pantheon Books. 232 pp. $20. Paper $10.95.

In an article on needlework published in 1815, Mary Lamb declared that women should embroider for money or not at all; only then would they see their work as "real business" and be able to afford "real leisure." Such painful distinctions between art and work, upper-, middle- and working-class labor and leisure, "fine

arts" and "minor arts," the amateur and the professional artist, lie at the core of these two books on the buried history of women's art. Germaine Greer's *The Obstacle Race* covers only the "fine art" of Western painting, but covers it from the Middle Ages through the mid-twentieth century. Anthea Callen's *Women Artists of the Arts and Crafts Movement* covers all the so-called minor arts in England and America from 1870 to 1914, with chapters on ceramics, embroidery and needlework, lace making, jewelry and metalwork, woodcarving, furniture and interior design, hand printing, bookbinding and illustration, as well as chapters on women's design education, feminism, politics and class structure.

If Greer stresses psychology and Callen economics, both define from a lively viewpoint the social contexts in which women have fought for creative dignity, and both deplore the damage done by centuries of male domination in even those arts considered "inherently female." Both are also sympathetic to the anonymous "amateur," Greer noting aptly that "amateur noblewomen may have more to do with art history than anyone is prepared to acknowledge." (Aptly, because she too is an amateur in art history, her training limited to student years of drawing and museum going; she attributes her decision to study women and the visual arts in part to the fact that she associates painting with sexual pleasure, and in part to a challenge issued by Norman Mailer in 1971.)

Callen is "mainly concerned to assess the role of middle-class women in their struggle for economic independence and an autonomous cultural identity." Lest that scare away those middle-class readers who are mainly interested in reading about the working class, I should say that she is equally perceptive about the relationship of art to the whole social structure. She weaves—appropriately—a new view of the Arts and Crafts Movement, a fascinating fabric of economics, ideology and esthetic evaluation in which William Morris and Edward Burne-Jones are no longer central figures. Starting from the breakdown of the family and of the rural lifestyle (and focusing on the crucial fact that by the mid-nineteenth century there were "too many women" in England), Callen traces the impetus for the crafts revival from the need to preserve the English countryside to the rather more pressing need to provide socially acceptable livelihoods for the increasing number of destitute gentlewomen, whose poverty was an embarrassment to their own class as well as to the state.

Art, like teaching, was seized upon as one of the few suitable professions for such women, complying as it did with the conventions of "woman's place." The constant reassurances that women artists would not compete in the male job market and art would not divert them from their hearths are reminiscent of right-wing arguments against the Equal Rights Amendment, not to mention the archaic but still flourishing notion that if a woman artist marries, she automatically becomes a "part-time artist." Both authors expose the crippling double standard by which women throughout history have been, in Greer's words, "led out of the race with false prizes, unaware of their defeat," and unaware that "the qualities men welcomed in women's art were the same that they reviled in their own."

Faced with such a large time span, Greer is inevitably less successful in making her points than is the more understated and better organized Callen. Nevertheless, her tone of irritable irony is a welcome addition to art-historical literature, and I suspect an editor should share the blame for her confusing organization, maddening and ubiquitous one-sentence paragraphs, weird punctua-

tion, dateless and often sappy captions, occasional typos and other inaccuracies. The book was originally intended as a dictionary, and its transformation to an integrated whole appears incomplete. The arrangement by theme rather than by chronology is a potentially good idea swept away on a flood of names and disconnected morsels of information. The early chapters—on "Family," "Love," "The Illusion of Success" and "Humiliation"—make a stronger case in Greer's class-action suit against the past than the more specifically art-historical chapters. Her intention is to show that "you cannot make great artists out of egos that have been damaged," so feminists waiting with bated breath for news of mythical Michelangelicas will have to settle for quantity over quality. She wants "to show women artists not as a string of overrated individuals, but as members of a group having much in common, tormented by the same conflicts of motivation and the same practical difficulties, the obstacles both external and surmountable, internal and insurmountable in the race for achievement." At the same time, she devotes a whole chapter to Artemisia Gentileschi as "The Magnificent Exception" and when she suggests that Mondrian owed a debt to the virtually unknown Marlow Moss, she admits to "a sensation of giddiness and fright," since with such claims "the well-known landmarks drop away." This is a basic problem for anyone rewriting art history so that it includes women. Struggling with the need to make more of what we find than what is there, we can feel justified to some extent by our role as David rolling back a Goliath of entrenched historical "knowledge."

Greer would have had a better book, however, had she chosen her examples more judiciously instead of listing every artist no matter how little she knew about her. Callen's far better book also occasionally degenerates into list making and she sometimes discusses women at length without reproducing their work. Nevertheless, both authors are making impressive moves to "repeople the historical artscape," as Greer puts it. And even as I make these complaints, I'm longing to hear the roll call continue, to read even more fragmented biographies, to see even more blurry pictures dredged up from museum basements. A mere name in print, however inconclusive and unsatisfying, is a name that has a chance at survival, and this is crucial to the future of feminist art history.

While most of the names in both books are little known, most of the issues are, alas, all too familiar. Greer quotes Boston artist William Morris Hunt saying to a tearful pupil in the 1860s: "You had better go and hem a handkerchief"; another female student is told to "go home and make puddings." Bemoaning the way modern women artists have "kept wandering away from fine art into the minor arts," Greer simultaneously applauds their realization that "art had to be emancipated from the prison of the picture frame and the charnel house of the museum," and quotes the Russian revolutionary painter Liubov Popova as saying, "No artistic success has given me as much pleasure as the sight of a peasant buying a length of material designed by me."

If from the "fine artist's" point of view, a woman's place was in the "minor arts," Callen makes it clear that sexual stereotyping was equally rampant and equally oppressive in the Arts and Crafts Movement. She is scathing about the reactionary core of the leaders' radical socialist philosophy, its perpetuation of the sexual division of labor, its hostility to female ambition—in short, the same bundle of issues that confronts socialist feminists today. She shows how the plight of impoverished middle-class women was not so different from that of peasant lace-makers whose work epitomized the evils of isolated "home work," and who

began at age five to work up to eight hours a day, graduating at age twelve to sixteen hours, ruining their very bone structure, not to mention their eyesight. Both groups were doomed to a drudgery dependent on fashion and exploitative philanthropy. Even Eleanor Marx in "The Woman Question" apparently reinforced the socialist craftsmen's relegation of "idle middle-class women" to their self- and socially imposed anonymity, an anonymity that only "speeded up their total disappearance" from the history of the movement.

Callen spends little time on the women of the "arts and crafts elite" aside from the considerable contribution of May Morris. Yet they, too, suffered from the familiar subject–object problem, or what Greer calls the "muse syndrome": "The young woman who gave evidence of talent was not an artist, but a muse. Her work was not evidence of what she could do, but of what she was." William Morris' wife, Jane, familiar to us as a mournful Pre-Raphaelite heroine, was such a sufferer. She and her sister and Lizzie Siddal married into the movement from working-class backgrounds. Callen points out that while "they were potentially more free from the moral restrictions of the period than their middle-class sisters, they were in fact encouraged to abandon their own culture for a bohemian no-man's land." The benevolent paternalism of these men marrying "down" reflected their attitude toward the revival of "lower-class" arts and crafts.

Both Callen and Greer encounter a difficulty familiar to feminist critics in other fields: how to reconcile our ambivalence about the interwoven strengths and weaknesses of women's art. All along we are aware of the extent to which our own educational conditioning affects how we see—just as women's art was/is historically forced into the uncongenial molds of male perception and male experience. I tend to prefer the work Callen reproduces here (even without color plates, the absence of which would have ruined a lesser book) to Greer's elegant canvases (which remind us of those by better-respected men). Does this mean I'm settling for less? For a cultural stereotype? That I'm unable even to visualize a heroic art history for women? We have mixed feelings about all definitions of "women's art" even as we make them. At the same time that Greer attacks the "rather Philistine concept" of Great Art and the "capitalist contempt for smallness," she is perfectly capable of condescending to women who did not aspire to male "norms," and of ridiculing "poor" Properzia de'Rossi's intricately carved cherrystones. We are angry about the way women's talents have been repressed, denigrated, wasted and "hidden from history." We are also proud of the intimacy and "humble" beauty of the art created under such grim circumstances by artists for whom an unobtainable Greatness was irrelevant.

Greer ironically notes that any scholar of women's work is "actually studying the female relatives of male artists." She bears this out by her detailing of the "art dynasties" from which most of the survivors emerged (a point also made in Ann Sutherland Harris and Linda Nochlin's pioneering book, *Women Artists: 1550-1950*, to which Greer owes much and gives too little credit). Callen confirms this when she is constantly forced to admit how often men designed and women only executed in the Arts and Crafts Movement. Should we then remake women into men, or should we rehabilitate, reclaim and elevate what women did, in fact, accomplish? We are often torn, and these contradictions don't always produce a dialectic.

Within the feminist art movement today there is a good deal of pressure to

break down the barriers between art and craft and thereby recognize the subject matters of both these books as a common history. In 1893, May Morris had already made a pertinent distinction between "pictorial" and "decorative" embroidery—a distinction that not only prescribed "truth to the nature of the medium" but rejected the notion that by imitating painting, embroidery would become a "higher" art. She insisted that such "intellectualism" simply alienated needlework from its roots—a timely comment, given the triumph of "pattern painting" in today's "fine" art world, which acknowledges the esthetic power of traditional women's arts.

Callen's book contains many such insights, always grounded in information about wages and working conditions. She emphasizes the ways in which women attempted to gain power by organizing and supporting one another in a system stacked against them. She offers us the happy history of Doulton's Lambeth Art Pottery as well as that of strong individuals like Kate Greenaway, who bucked the current alone. Greer, however, recommends "escape inward" over organization. She is convinced that "internalized psychological barriers" have damaged women's art more effectively than "poverty and disappointment," and fails to see them as two sides of the same coin. She equates politics and rhetoric, and then concludes that "the pressure of politics which drags the artist in another direction until her soul lies dismembered" is as bad as "the deadening pull of passivity." By perpetuating the notion that art is ineffectually "above it all," she reasserts the false dominance of criticism and convention over art without taking up the final challenge: to analyze what has been and is meant (and what she means herself) by the term *good art* in a context so colonized by men and by the ruling class that we have lost sight of what our own tastes might be. Despite the value of Greer's encyclopedic approach and the important uses to which her research will be put by students of art history, the real lessons for contemporary women in the arts lie in Callen's book.

Setting a New Place:
Judy Chicago's *Dinner Party**

An early meaning of the word *craft* was "power." Judy Chicago's cooperatively executed *The Dinner Party* (1973–79)—a multimedia sculpture, focused on china-painting and needlework—now at the San Francisco Museum of Modern Art—gives this interpretation a new life. *The Dinner Party* opened March 16 to a media fanfare not associated with feminist art and certainly not with an artist who, though known internationally, has never had a New York show. Chicago is the founder of the first feminist art program (in Fresno, 1970), cofounder of the

*This was originally published as "Dinner Party a Four-Star Treat" in *Seven Days* (Apr. 27, 1979) and is reprinted by permission of *Seven Days.* Many of the quotations from Chicago, Gelon and Hill came from an interview in *Chrysalis,* no. 4 (1977). I wrote a much longer piece on *The Dinner Party,* focusing more on the work than on its organizational politics, in *Art in America* (Apr. 1980).

first women's art space, the first women's art school, and the Los Angeles Woman's Building. She is a leading women's art theorist and activist. So it was no surprise, at least to the feminist community, when five years ago she initiated the *Dinner Party* project, conceived as no less than "a symbolic history of women in Western Civilization"—a project that became so overwhelming that even Chicago was occasionally daunted.

Briefly, *The Dinner Party* is a huge and elegant installation piece—an open-centered, triangular table (the inverted triangle being an ancient symbol of female power), 46½ feet on each side, set on a raised triangular platform. The three wings of the table contain place settings for 39 women from the mythical past through history to today, from the Primordial Goddess to Georgia O'Keeffe. They rest on a foundation of 999 women's names inscribed in gold in Chicago's Palmer-method script on the white, luster-tiled floor. Each place setting includes a gold-edged napkin, porcelain flatware and gold-lined chalice, and centers on a fourteen-inch, painted or sculpted porcelain plate and an elegantly ornamented needlework runner—image, style, and technique geared to the contribution and period of the woman honored. The plates all depart from a vaginally suggestive butterfly image which has been a symbol of rebirth since the beginning of time and Judy Chicago's trademark since 1972. As they move through the ages, from Ishtar and Amazon to Hatshepsut, Sappho, Boadicea, Queen Elizabeth I, Sacajawea, Sojourner Truth, Susan B. Anthony, and composer Ethyl Smyth (whose plate is a piano and runner, a tweed jacket), the plates gradually rise from flat to higher relief. After Mary Wollstonecraft, the images begin to struggle up off the plates into fully sculptured form, but even the last ones—Margaret Sanger, Natalie Barney, Virginia Woolf, and Georgia O'Keeffe—do not succeed in flying off the surface. Thus, Chicago notes, "All the women represented are still contained within their place setting."

It is Chicago's ambition to be one of the first women to break out of that containment. She fully intends *The Dinner Party* to be a monument—a feminist counterpart of the Sistine Chapel or the Matisse Chapel, consecrated instead to the resurrection of female energy—political and spiritual. (Funds are being raised to build a permanent installation for *The Dinner Party* so it can take its rightful place rather than disappearing like so much women's history to date.) She is not intimidated by those who feel that women should forgo the ego male artists enjoy. "Women *need* Big Egos," she insists. "And anyway, the Sistine Chapel is not a monument to any individual but to the human spirit."

Unlike the rest of the country's major museums, which could not be less interested, the San Francisco Museum, through its director, Henry Hopkins, has for years been immensely supportive of the project. But even Hopkins was not prepared for the excitement, size, and scope of the five-day celebration around the openings, which indicated just how far we have come from being babies. The openings were attended by thousands; lines formed around the block; the brochures were gone the first week; when Chicago spoke in the 900-seat Herbst auditorium, hundreds were turned away; reporters for TV, radio, the national magazines were much in evidence; every event—two lectures, a panel, a colloquium, films, concerts by Margie Adam, a local artists' studio tour—was filled to capacity; posters, buttons, and the expensive, profusely illustrated book published by Anchor/Doubleday were selling out, hopefully putting a dent in the project's $30,000 debt to the Los Angeles Women's Bank and even helping the museum out

of a financial bind. Aside from the sculpture itself, the exhibits included a sepa-
rate show of traditional china painting, a long hallway of handsomely designed
photodocumentation of technique and process with bios of all the women com-
memorated, a foyer of banners executed by the San Francisco Tapestry Work-
shop, and Suzanne Lacy's *International Dinner Party.*

The Dinner Party is notable on three levels. First, it is good art, though a
leading art magazine refused to cover the show because it was "merely sociol-
ogy." The more time I spent with *The Dinner Party,* with prolonged views across
the table where the brilliant color of the needlework is best seen and with
detailed scrutiny of the extraordinary ornament of each plate and runner, the
more immersed I became in the beauty of pattern, texture, form and the more I
was moved by the networks being revealed. Second, it offers an encyclopedic his-
tory of women's hidden history. I had never heard of many of the 1,038 women
the research team has resurrected, such as Wetamoo and Nancy Ward, respec-
tively, Native American chief and warrior; Elizabeth Talbot, an Elizabethan archi-
tect; Louyse Bourgeois, a seventeenth-century medical practitioner; Capillana,
an eighteenth-century Peruvian manuscript illuminator; or Henrietta Johnston,
"the first woman artist in North America." Third, and most powerful of all, *The
Dinner Party*'s vision extends to the future through the unique process and struc-
ture by which it was created.

During the five years of its gestation, some 200 women and men worked
cooperatively and voluntarily on *The Dinner Party* for periods of one month to
four years, donating in one documented *month* alone $15,000 worth of labor. The
turnover was large because few could afford to volunteer forever. No one was
paid, and students sometimes paid to participate in what was surely an educa-
tion far surpassing that offered by most art schools. The gradually developed core
staff fended for itself until toward the end a token salary was paid. (Art historian
Diane Gelon—indefatigable administrator, PR person, grant getter, and woman of
many more parts—drove a school bus in the mornings so she could continue to
work on the project.) Everyone gave what s/he had to give, and from those who
survived the grueling process there were few complaints. As Gelon said when
asked about being exploited, "I wasn't givin', I was gettin'." Needlework head
Susan Hill pointed out, "We encouraged support for powerful women; this is
new to most people. Women have a tendency to undermine a powerful woman;
the idea is to emulate her. In a work situation like ours the amount of respect, au-
thority, good stuff you get is in proportion to how much hanging in there and
producing you do."

This "benevolent hierarchy" (as one participant called it) is based on the
guild or atelier system. Chicago herself is clear about her own preference for a
cooperative-leadership structure over a collective one. *The Dinner Party* is in-
disputably her art and bears her personal stylistic stamp throughout. She con-
ceived it in 1973 as a private work—"a smaller project" than others she was then
contemplating. She was going to "combine images of *traditional* women
(symbolized by china painters) with *radical* women (those who were politically
active)." In what was to become a monumental understatement, she noted in her
diary on April 28, 1974: "There are a few aspects of the idea that are still unre-
solved." $250,000 and five years of solid work and frantic fund raising later, she
talked about something she had learned in the interim: "I think that the individ-
ual artist ethic has been very destructive to women, because when men are alone,

they aren't really alone—they are alone in their studios supported by systems. But women are *really* alone . . . isolated and powerless. The system of the individual artist has not worked for us, and yet women keep doing it and doing it. I think that one real contribution the piece will make will be to demonstrate another mode of art making for a woman artist."

The feminist purity and political correctness of *The Dinner Party*'s structure has been and will continue to be challenged. Chicago has indeed changed the rules, but then she made a lot of them, and feminism is committed to just such a dialectic of growth. Whoever heard of a male artist lecturing with two assistants (Gelon grinning, in baggy pants; Hill twiddling an iris) sharing the stage, the questions, and the limelight? Whoever saw a factory-fabricated "high art" sculpture accompanied by an exhibit of portraits and bios of some 100 workers? Such an amazing combination of accomplishment and professional intimacy cannot be credited merely to Chicago's charisma. For all her magnetic personality and organizational brilliance, she is not Jim Jones, nor is she easy to work with. The women and men who worked on *The Dinner Party* conquered internal and external conflict, doubt and exhaustion because they were convinced they were doing something important and participating in social change. Time and again they repeat how much they have learned and grown from the often difficult process; how the example of Chicago's own discipline could be oppressive but was finally inspiring; how they came to realize that they, too, could handle such a large commitment and responsibility and structure their lives around their art. They also noted that Chicago was inevitably working when they arrived at the studio in the morning and still working when they left at night and that every penny of her personal earnings from sales of work, royalties, lectures, tours, for over four-and-a-half years went into the project.

Chicago herself had no idea what she was getting into when she realized the project had outgrown the individual process. She found herself confronting "three fundamental problems that so far have prevented us women from making a real leap into the future": the need to change consciousness to the point where substantial cultural change can take place; the absence of financial, social, and emotional support for large-scale, ambitious projects by women; and "the way women's personalities have been damaged to the point where they cannot work" in the focused and automatically supported way in which men are trained by society itself. She believes, however, that there is no growth without conflict. The studio insisted on "no bullshit, no mystery, no fantasy" (and no personal problems were to be discussed on work time). While I personally prefer to work collectively, I have to admit that there is no way this over-$1,000,000 project would have been completed if the constant turnover of untrained people had participated in all decisions. At the same time, Chicago was immensely relieved when the whole process hit a turning point which showed that *The Dinner Party* had become common property and the burden of completing it a shared responsibility. Exhausted and discouraged, she was talking about giving up; the community said that if she quit, they would finish it without her.

Perhaps *The Dinner Party* (together with the Los Angeles Woman's Building and a few other such centers of cultural and political energy) represents a new stage of feminism. The California women's art movement has always operated on a scale and with a professionalism that is distasteful to New Yorkers, opposed and surrounded as we are by the dominant consumerist and "professional" male

art world. Yet as women's magazines, galleries, publishers, and other businesses get bigger and as our audiences continue to grow in spite of the backlash, there is an increasing realization of the frustration and wastefulness of planned inefficiency. We must learn to expand, to confront success as our earned right and to convert achievement into a triumph for feminist values that will affect both women and men. We are learning to respect structures like *The Dinner Party* that generate products as well as energize, while similarly refusing to abandon the consciousness-raising base and those aspects of working together which are unique and invaluable to the feminist movement.

For Judy Chicago, the Women's Movement is in an intermediary stage. In the past all women alike were on low levels of consciousness; in the future all women alike will be on high levels of consciousness. In the meantime, she proposes that we adopt a broad variety of strategies for working together, guided by the knowledge that we are not yet all in the same place. She and her *Dinner Party* colleagues are also committed to reintegrating men into feminist activities to offer them role models for another kind of existence. This will be one of the aims of the Through the Flower Corporation, which owns *The Dinner Party* and will administer and eventually house it, as well as found an educational program.

Finally, there is one last adjunct to *The Dinner Party* at the San Francisco Museum—*The International Dinner Party Event* initiated by Suzanne Lacy, a Los Angeles performance artist who concentrates on collaborative, politically focused art structures in public and media contexts. She and Linda Preuss contacted women all over the world to meet at the time of *The Dinner Party*'s opening in honor of living women. The visible part of Lacy's piece was a huge black-and-white world map dotted by red inverted triangles marking the sites of these celebrations.

I heard one complaint that the notion of a dinner party was itself middle class—and inappropriate to those parts of the world where people are starving. I wonder if the Last Supper was ever criticized on those grounds. In fact, both were meant for everyone, since they represented a feast, not of food, but of hope, commemorating the past time when the wealth was not yet in the hands of the few, and making a move toward the future time when a feminized society will more equally distribute the world's resources. The richness of color and texture, the gold and the glitter of *The Dinner Party* itself, refers not to ruling-class splendor, but to the rightful creative heritage of all the women to whom *The Dinner Party* is dedicated—most of whom saw little gold in their own lifetimes. Watching the telegrams pour in from Europe, Japan, Swaziland, Guyana, New Zealand, and seeing more and more red triangles dot the map, provided graphic affirmation of the kind of energy *The Dinner Party* has generated.

Some for

A picture is supposed to be worth a thousand words, but it turns out that a picture plus ten or a hundred words may be worthiest of all. With few exceptions, most effective social/political art being done today consists of a combination of words and images. I'm not just talking about "Conceptual Art" or paintings with words on them, but also about writing that integrates photographs (and vice versa), about comic strips, photonovels, slide shows, film, TV and posters—even about advertisements and fashion propaganda. In the last decade or so, visual artists have had to begin to think about problems of narrative, detachment, drama, rhetoric, involvement—*styles of communication*—which hitherto seemed to belong to other esthetic domains. And in order to deal with these issues, they have had to overcome the modernist taboo against "literary art," which encompasses virtually all art with political/social intentions.

"Literary art" either uses words or, through visual puns and other means, calls up content more specific and pointed than that promulgated by modernist doctrines. It is a short jump from *specific* to "obvious," "heavy-handed," "crowd-pleasing," "sloganeering," and other epithets most often aimed by the art-for-art's-sake establishment at Dada's and Surrealism's recent progeny: Pop Art, Conceptual Art, narrative art, performance and video art. Even the most conventional kinds of representational art come in for some sneers, as though *images* were by definition literary. God forbid, the taboo seems to be saying, that the content of art be accessible to its audience. And god forbid that content mean something in social terms. Because if it did, that audience might expand, and art itself might escape from the ivory tower, from the clutches of the ruling/corporate class that releases and interprets it to the rest of the world. Art might become "mere propaganda" for *us*, instead of for *them*.

Because we have to keep in the back of our minds at all times that we wouldn't have to use the denigrated word *propaganda* for what is, in fact, *edu-*

*Reprinted by permission from *Heresies*, no. 9 (1980).

cation, if it weren't consistently used against us. "Quality" in art, like "objectivity" and "neutrality," belongs to *them.* The only way to combat the "normal" taken-for-granted propaganda that surrounds us daily is to question *their* version of the truth as publicly and clearly as possible. Yet in the art world today, clarity is a taboo: "If you want to send a message, call Western Union" . . . but don't make art. This notion has become an implicit element of American art education and an effective barrier against artists' conscious communication, the reintegration of art into life.

After at least two decades in which the medium has been used primarily to subvert the message, the very word *message* has degenerated into a euphemism for commercial interruptions. So what's left of the avant garde, rather naturally, rejects the notion of a didactic or "utilitarian" or "political" art, and socialist artists working in a context dominated by various empty fads and formalisms tend to agonize about the relationship between their art and their politics. "Formalism" (in the Greenbergian, not the Russian sense) is denied them; it has been coopted by those invested in the idea that if art communicates at all, what it communicates had better be so vague as to be virtually incommunicable, or it won't be "good art." This leaves the disenfranchised formalist (or "socialist formalist," as one artist has called himself in an attempt to reclaim the term) on a tightrope between acceptance for her/his formal capacities alone and rejection for her/his need to "use" these capacities to convey social content.

Feminists, on the other hand, should be better equipped to cope with this dilemma. Women artists' historical isolation has prepared them to resist taboos. Our lives have not been separate from our arts, as they are in the dominant culture. "Utilitarian," after all, is what women's work has always been. For instance, many women artists today are rehabilitating the stitchlike mark, swaddling and wrapping, the techniques and materials of women's traditional art and work. Feminist art (and feminist propaganda) expands these sources to include what we learn from our own lived experience as women, from our sense of our bodies, from our subcultural lives as a "vertical class."

True, the feminist creed "the personal is the political" has been interpreted far too widely and self-indulgently in the liberal vein of "my art is my politics," "all art is political," "everything a woman artist does is feminist art," and so forth. The "I" is not necessarily universal. The personal is only political when the individual is also seen as a member of the social whole. There is a plethora of a certain kind of "feminist art" which, like other prevailing avant-garde styles, looks into the mirror without also focusing on the meaning of the mirror itself—on the perimeter, the periphery which forms the images (form as veil; form as barrier; form as diversionary tactic). Yet despite all this, feminism has potentially changed the terms of propaganda as art by being unashamed of its obsessions and political needs, and by confirming the bonds between individual and social experience.

Jacques Ellul[1] sees propaganda as totally dangerous, as a sop, a substitute for loftier appetites, a false cure for loneliness and alienation. He reduces to propaganda all of our needs for shared belief, for a community of values. Feminists may be able to see it differently. The dictionary definition of the word is "propagating, multiplying, disseminating principles by organized effort"; it acquired its negative connotation in a colonializing male culture (e.g., the Roman Catholic Church). In its positive sense the word *propaganda* can be connected to woman's classic role as synthesizer. Our culture of consumption draws women

to the market, which, as Batya Weinbaum and Amy Bridges have shown, "provides the setting for the reconciliation of private production and socially determined need."[2] Similarily, women artists, few of whom have escaped traditional women's roles, might understand and clarify a viewpoint rarely if ever expressed in the arts, and create new images to validate that viewpoint.

The goal of feminist propaganda is to spread the word and provide the organizational structures through which all women can resist the patriarchal propaganda that denigrates and controls us even when *we know* what we are doing. Since the role of the image has been instrumental in our exploitation (through advertising, pornography, etc.), feminist artists have a particular responsibility to create a new image vocabulary that conforms to our own interests. If, as Ellul says, "nonpropagandized" people are forced to live outside the community, then as feminists we must use our tools of consciousness raising, self-criticism, and nonhierarchical leadership to create a "good propaganda" that enables women of all races and classes to form a new, collective community. Such a "good propaganda" would be what art should be—a provocation, a new way of seeing and thinking about what goes on around us.

So far, the audience for feminist art has been, with a few exceptions, limited to the converted. The greatest political contribution of feminism to the visual arts has been a necessary first step—the introduction and expansion of the notion of autobiography and narrative, ritual and performance, women's history and women's work as ways to retrieve content without giving up form. This has involved the interweaving of photography and words and sometimes music, journal entries and imitations thereof, and the instigation of a dialogue that is particularly appropriate to video, film or performance art. For instance, while so much "narrative art" is simply a superficial and facetious juxtaposition of words and images, it can, when informed by a politically feminist consciousness, open a dialogue between the artist and the viewer: Look at my life. Now look at yours. What do you like/hate about me/my life? What do you hate/like about you/yours? Have you ever looked at your oppression or your accomplishments in quite this way? Is this what happened to you in a similar situation? And so forth, hopefully leading to: Why? What to do? How to organize to do it?

In a literate (but antiliterary) society, the words attached to art, even as mere titles, may have more effect on the way that art is perceived than some of the strongest images do. As a public we (but especially the docilely educated middle class) look to be told by the experts what we are seeing/thinking/feeling. We are told, taught or commanded mainly in words. Not just criticism, but written captions, titles, accompanying texts, soundtracks, taped dialogues, voice-overs all play major roles in clarifying the artist's intent—or in mystifying it. A title, for instance, can be the clue to the image, a hook pulling in a string of associations or providing a punch line. It can also be obfuscating, unrelated, contradictory or even a politically offensive publicity gimmick whereby the artist so vaguely identifies with some fashionable cause that the meaning is turned back on itself. (See *Heresies,* no. 8, for the Coalition Against Racism in the Arts' position on such a situation.)

At what point, then, does the word overwhelm the image, the combination become "just a political cartoon"? Still more important, at what point does visual or verbal rhetoric take over and either authoritarianism or an insidiously persuasive vacuity overwhelm dialogue? *This* is the point at which the image/word is no longer good propaganda (socially and esthetically aware provocation) but bad

propaganda (exploitative and oppressive economic control mechanism). Authoritarian written art is basically unpopular with all except the most invested and/or specialized audiences. Feminists, too, are more likely to be swayed and moved to tears or rage by music, novels, films and theatre than by visual art, which is still popularly associated with imposed duty and elitist good taste, with gold frames and marble pedestals. Yet the feminist influence on the art of the seventies is evident in the prevalence of art open to dialogue—performance, video, film, music, poetry readings, panels and even *meetings.* This tendency not only suggests a merger of art and entertainment (with Brechtian overtones) but also suggests that speaking is the best way we know to get the message across while offering at least the illusion of direct content and dialogue. It also implies that the combination of images and *spoken* words is often more effective than the combination of images and *written* words, especially in this day of planned obsolescence, instant recycling and antiobject art.

Although most of the propaganda that survives is written, it tends to get diluted by time, misunderstandings and objectification. The spoken word is realer to most people than the written word. Though more easily forgotten in its specifics, it is more easily absorbed psychologically. The spoken word is connected with the things most people focus on almost exclusively: the stuff of daily life and the kind of personal relationships everyone longs for in an alienated society. It takes place *between* people, with eye contact, human confusion and pictures (memory). It takes place in dialogues with friends, family, acquaintances, day after day. So one's intake of spoken propaganda is, in fact, the sum of daily communication.

This more intimate kind of propaganda seems to me to be inherently feminist. It might be seen as gossip, in the word's original sense: *Godsib* meant "godparent," then "sponsor and advocate"; then it became a relative, then a woman friend, then a woman "who delights in idle talk," "groundless rumor" and "tattle." Now it means malicious and unfounded tales told by women about other people. All this happened through the increased power of patriarchal prop-

aganda, through men gossiping about women and about each other on a grand scale (history). Thus, in the old sense, spoken propaganda, or gossip, means *relating*—a feminized style of communication either way.

Over my desk hangs a postcard showing a little Black girl holding an open book and grinning broadly. The caption reads: "Forge simple words that even the children can understand." This postcard nags at me daily. As a writer who makes her living mostly through talking (one-night stands, not full-time teaching), I am very much aware that writing and speaking are two entirely different mediums, and that they translate badly back and forth. For instance, you can imitate writing by speaking, as anyone knows who has dozed through the presentation of an academic "paper" spoken from a podium. Or you can imitate speaking by writing, as anyone knows who has read the self-conscious chitchat favored by many newspaper columnists. The best way of dealing with speaking seems to be to skip, suggest, associate, charm and perform with passion, while referring your audience back to the written word for more complex information and analysis.

Holding people's attention while they are reading is not so easy. Like "modern art," the thoughtful essay has had a bad press. Popular magazines imitate speech by avoiding intimidating or didactic authoritarian associations with the text-filled page and by breaking the page with pictures, anecdotes or intimate "asides." Right and Left depend equally on colloquialism to reach and convince a broad audience. Popular dislike of overtly superior or educated authority is reflected, for instance, in an antifeminist characterization of "most women's lib books" as "cumbersome university theses." The visual/verbal counterparts of long-running TV soap operas are the comic book and the photonovel, which, significantly, are the closest possible imitations of speaking in writing, as well as the cheapest way of combining "spoken" words with images.

As a middle-class college-educated propagandist, I rack my brain for ways to communicate with working-class women. I've had fantasies about peddling socialist feminist art comics on Lower East Side street corners, even of making it into the supermarkets (though it would be difficult to compete with the plastically slick and colorful prettiness of the propaganda already ensconced there). But this vision of "forging simple words" also has a matronizing aspect. I was taken aback at a recent meeting when a young working-class woman who did not go to college stood up for a difficult language and complex Marxist terminology. Her point was that this terminology had been forged to communicate difficult conceptions and there was no need to throw the baby out with the bathwater because of some notion that the working class wasn't capable of developing its minds. "We can look up the words we don't know," she said, "but people want to *grow*."

So are my comic book fantasies simply classist? Should I stick to the subtleties of four-syllable words? Both of us seemed to be leaning over backward to counteract our own class backgrounds. A similar conflict was expressed by Cuban Nelson Herrera Ysla in a poem called "Colloquialism":

Forgive me, defender of images and symbols.
I forgive you, too.
Forgive me, hermetic poets for whom I have boundless admiration,
but we have so many things left to say
in a way that everyone understands as clearly as possible,
the immense majority about to discover the miracle of language.

Forgive me, but I keep thinking that Fidel has taught us dialogue and
 that this, my dear poets,
has been a decisive literary influence.
Thank you.[3]

Such conflicts between high art and communication have recently been raised in the visual arts by public feminist performance art, by Judy Chicago's cooperatively executed *The Dinner Party* and by the community mural movement—the visual counterparts of verbal colloquialism in their clear images and outreach goals. But how much conventional visual art, in fact, has been successful as propaganda? From the twentieth century we think of a few posters: "Uncle Sam Wants You"; "War Is Not Good for Children and Other Growing Things"; "And Babies?" (this last one, protesting the My-Lai massacre, was actually designed collectively by a group of "fine artists" from the now defunct Art Workers' Coalition). And we think of a few modern artists—the Mexican muralists and, ironically, several Germans: the Berlin Dadas, Heartfield, Kollwitz, Staeck, Beuys, Haacke. Compare this lackluster record with the less brutal consciousness raised by songs (those in which the musical foreground doesn't overwhelm or neutralize the lyrics). And compare it with the kind of historical consciousness raising offered through oral history, accompanied by old photographs, letters, memories of one's own grandparents' stories. We keep coming back to words. And not just to words, but to words set in visual frameworks that are emotionally as well as intellectually stimulating.

My own preference is for an art that uses words and images so integrally interwoven that even narrative elements are not seen as "captions" and even realistic images are not seen as "illustrations." Yet I have to admit I'm constantly disheartened by the content of art using the "new mediums" as vehicles not for communication or social awareness, but simply for unfocused form and fashion.

Effective propaganda obviously has to be aimed at a specific audience, not just shot into the air to fall to earth we know not where. (This fact should hardly be anathema to an art already, if often unconsciously and involuntarily, aimed at a very limited audience of curators, critics, collectors and other artists.) Targeting one's audience is very different from finding one's audience—the former having to do with marketing and the latter with strategy. If we assume that moving a large and varied audience is at the heart of the matter, perhaps we should spend our energies making art for TV, where information can be communicated in a manner that is simultaneously intimate and detached, and where there might be some hope of turning that huge, passive, consuming audience into a huge, active, critical, potentially revolutionary audience. And *if* (a monstrous if) we were ever to succeed in wresting TV time from 100 percent corporate control, would this lead to solid alliances, or to a wishy-washy pluralism? And where would artists come in?

Most "art video" (as opposed to documentary, real-time political video) is still limited to art audiences and is, or would be, rejected by people accustomed to a kind of entertainment most avant-garde artists are not skillful enough to produce, even if they did decide to stop boring their audiences to death. Most artists prefer not to move out of the competitive, incestuous, but comprehensible art context into the unwelcoming Big Time of the real world. In the late sixties, a few Conceptual artists did make newspaper pieces, but they were usually artworld "in" jokes or rhetorical arguments plunked down with no attempt to adapt to the new medium, becoming in the process another kind of ineffectual cultural colonialism. (Ellul says that ineffective propaganda is simply *not* propaganda.) Despite its idealistic beginnings, most book art is now a pale imitation of gallery art, the page becoming a miniature wall instead of something to be *read* (i.e., understood). In turn, written art hung on gallery walls is difficult to read and arrogant in its enlargement from the book form it imitates. There have been some genuine and successful attempts to integrate art into street and community life, and others to analyze and compete with public advertising in the form of posters and rubber-stamp commentaries, but for all the theoretical acumen of some of this work, it tends to be visually indistinguishable from the mass media it parodies.

These issues open a can of worms about satires and "parodies" that aren't comprehensible if one isn't in the know. Ambiguity is chic *and* modernist, lending itself to esoteric theories that inflate the art and deflate any possible messages. A left-wing film, for instance, might be a "parody" of macho fantasy films of violence, but in fact uses parody as an excuse to wallow in just that "politicaly incorrect" imagery. This happens often in feminist art and performance, too. When women artists use their own nude bodies, made-up faces, "hooker costumes," etc., it is all too often difficult to tell which direction the art is coming from. Is this bare-breasted woman mugging in black stockings and garter belt a swipe at feminist "prudery" and in agreement with right-wing propaganda that feminism denies femininity? Is it a gesture of solidarity with prostitutes? Is it a parody of the ways in which fashion and media exploit and degrade women? Is it an angry satirical commentary on pornography? Or does it approve of pornography? Much so-called punk art (politically aware at one point in Britain, although almost never in the United States) raises these questions in a framework of neutral passivity masquerading as deadpan passion. Similarly, a work might cleverly pretend to espouse the opposite of what it does, in fact, believe, as a means of emphasizing the contradictions involved. But how are we to know? Are we just to be embarrassed when the artist says, "But I didn't mean it that way. How naïve, how paranoid and moralistic of you to see it that way. You must be really out of it"? Are we to back down because it is, after all, art, which isn't supposed to be comprehensible and isn't just about appearances? Or can we demand to know why the artist hasn't asked her/himself what kind of context this work needs to be seen "right" or "not taken seriously"—to be seen as the satire it really is?

Women are always assumed by the patriarchy to be suckers for propaganda—less educated, less worldly, more submissive, more emotional than men. Looking at it a different way, acknowledging the edge we have in empathy, feminist consciousness of communication, narrative, intimate scale and outreach networks, why aren't women artists taking the lead in inventing, say, a new kind of magazine art that transforms a legitimate avant-garde direction into propaganda with an esthetic character of its own? Why aren't many women artists making imaginative public art focused on feminist issues? Why do the Right-to-Lifers have more compelling demonstration skits, poster and pamphlet images than the Pro-Choice movement? (One reason, of course, is that the right wing has money and The Committee for Abortion Rights and Against Sterilization Abuse [CARASA] doesn't. But surely there are enough economically comfortable women artists to lend some time and talents and esthetic energy to causes they believe in?) Why does *Heresies* receive so few pertinent visual pieces? Why have the few artists committed to such work often found it easier to use words than images? And how can we get more visibility for those word and word/image pieces that do tackle this problem? Some crucial factor is lacking in our strategies for making memorable images or emblems that will move, affect and provoke a larger group of women. Some crucial breakdown in confidence or commitment, or caring energy, seems to occur when an artworld-trained artist is confronted with the possibility of making "useful" art. I could make a lot of psychological guesses why (fear of the real world, fear of being used by the powers that be, fear of being misunderstood and misperceived, fear of humiliation and lack of support) but I'm more interested in encouraging artists to move into such situations so we can see what happens then.

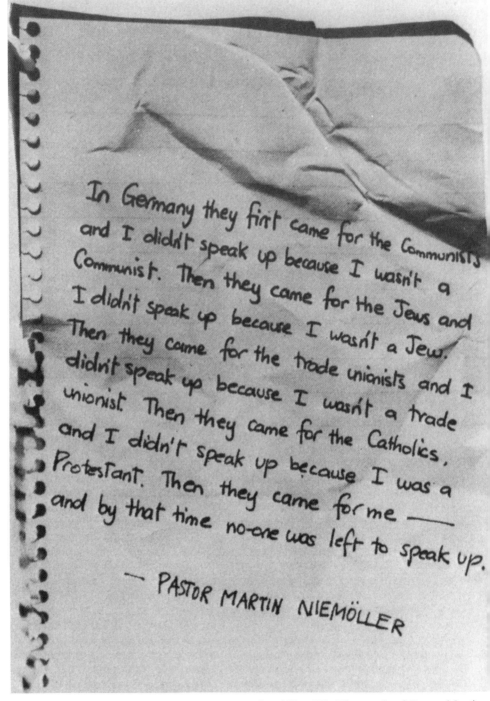

In Germany they first came for the Communists and I didn't speak up because I wasn't a Communist. Then they came for the Jews and I didn't speak up because I wasn't a Jew. Then they came for the trade unionists and I didn't speak up because I wasn't a trade unionist. Then they came for the Catholics, and I didn't speak up because I was a Protestant. Then they came for me ——— and by that time no-one was left to speak up.

— PASTOR MARTIN NIEMÖLLER

Annie Newmarch, *Quote,* 1980, photo screenprint, 22″ x 30″. The words of Pastor Martin Niemöller are presented as though scribbled on a piece of paper, then found later and read by candlelight. The print was made in response to the jailing of three unionists in Western Australia under old legislation that forbade the meeting of three or more people without permission. The screenprint was posted in the streets and elsewhere as a warning against rising fascism.

A lot of these questions and problems may be the result of our own misunderstanding of propaganda turning back on us. No one on the Left would deny the importance of propaganda. Yet it is a rare left-wing feminist who is interested in or even aware of the resources visual artists could bring to the struggle. The current lack of sparks between art and propaganda is due to a fundamental polarity that is in the best interests of those who decide these things for us. There are very effective pressures in the art world to keep the two separate, to make artists see political concern and esthetic quality as mutually exclusive and basically incompatible; to make us see our commitment to social change as a result of our own human weaknesses, our own lack of talent and success. This imposed polarity keeps people (artists) unsure and bewildered amid a chaos of "information" and conflicting signals produced by the media, the marketplace, and those who manipulate them and us. It keeps us desperate to be sophisticated, cool, plugged in, and competitively ahead of the game (other artists, that is). It makes us impatient with criticism and questions. It deprives us of tools with which to understand the way we exploit ourselves as artists. It makes us forget that words and images working together can create those sparks between daily life and the political world instead of hovering in a ghostly realm of their own, which is the predicament of the visual arts right now. It keeps us from forming the alliances we need to begin to make our own lives whole.

NOTES

This article owes a great deal to dialogues with the *Heresies* no. 9 collective and the New York Socialist Feminists, and especially to those with Joan Braderman in both groups.

1. *Propaganda* (New York: Knopf, 1965).
2. "The Other Side of the Paycheck," *Monthly Review* (July–Aug. 1976).
3. *Canto Libre* 3, no. 1 (1979).

Issue

"Issue and Taboo" was written for the catalog of the exhibition "Issue: Social Strategies by Women Artists" at the Institute for Contemporary Arts (ICA) in London, November 1980. I selected the show, but May Stevens initiated the idea and we worked with Margaret Harrison and Sandy Nairne to execute it. The source was "Caring: Five Political Artists," which I wrote for the Women's Issue of Studio International *(Fall 1977), which was, in fact, a brief introduction to five double spreads: "page art" by Mary Beth Edelson, Adrian Piper, Martha Rosler, Nancy Spero and May Stevens. What follows are a few paragraphs from "Caring" as an introduction to ideas more fully developed in "Issue and Taboo."*

Political art has a terrible reputation and may be the only taboo left in the art world. Perhaps it is taboo because it threatens the status quo which the avant

garde supports at the same time it thinks it's making "breakthroughs." In any case women's political art has a doubly passionate base from which to operate. The female experience is, of course, different (socially, sexually, politically) from the male experience, so the art, too, is different. This does not, as some would have it, exclude concern with all people; on the contrary, the female experience is profoundly radicalizing for those who survive its brutalization.

Good political art must raise questions as well as confirm convictions. Within the art world there is the danger of preaching to the superficially converted. Artists tend to come from the middle class and, even if they don't, their art— understandably, if regrettably—tends to serve the middle class. The work included here, therefore, is in some ways aimed as much at itself as at its audience. That is, it is projected through the artists' consciousness of conflict between art and the real world as much as it is actually aimed at the real world. (How many nonartists and nonartworkers read *Studio International?*) But it is also potentially on its way out of the art world. More than most artists, these women are aware of their predicament and are, perhaps, awaiting the left-open door, the unguarded cell.

For obvious reasons, since "magazine pieces" were requested, all the works here borrow vocabulary, stance, and/or medium from journalism. I think most of the artists would agree that both word and image are necessary for a politically effective art, even within the frame of a so-called *visual* art "world." They know, and I know, that such pieces would be all the more effective were they not confined to a single "article" or a single magazine in the single art context. I think we would all like to see this kind of work infiltrate the mass media, where it would puzzle, provoke, perhaps outrage a broader audience.

What it means to be *political* and to be a *feminist*, whether the terms are redundant, and the degrees of the interaction between the two would be variously interpreted by the artists represented here. I chose them because, whatever the interpretation, there can be no doubt about their caring—their allegiance to an active, outgoing use of art and an awareness of larger-than-esthetic issues. From an "art viewpoint," it is significant that while these five artists have very different styles and backgrounds, and work in New York, San Diego, and Boston, they all use or have used collage as a vehicle for their attempts reconcile art and politics. Because, for better or for worse, mixing art and politics today is like mixing water and oil. The two have seemed hopelessly incompatible to most would-be mixers. The reasons—too complicated to elaborate in an introduction— include the absorption of most "protest art" into the market-oriented maw of the art world (clearly exposed in the recent succumbing of *Artforum* to its advertisers); feminism's not-always-successful struggle against the sexism inherent in a male-dominated culture; the apparent futility of defining socialist programs in a capitalist society, and the reign of "quality," which derides all socially concerned art as "low," or "crowd-pleasing," or just plain "bad" art.

Issue and Taboo*

"Issue" is of course a pun on generation and topicality. It is about propagation, spreading the word that it is possible to think about art as a functioning element in society. While all art should to some extent act as provocation, as a jolt or interruption in the way social life and sensuous experience are conventionally perceived, the work shown here attempts to replace the illusion of neutral esthetic freedom with social responsibility by focusing—to a greater or lesser degree—on specific issues. It is all made by women because the contributions of feminist art to the full panorama of social-change art and the ways in which a politicized or topical art approaches, overlaps and diverges from the various notions of a feminist art are crucial to its further development. "Issue"'s concerns parallel on an art front those of Sheila Rowbotham's, Lynne Segal's and Hilary Wainright's important book *Beyond the Fragments*. While the fragments vary from field to field and from country to country, the fact that feminism has something to offer the Left that the Left badly needs is as unarguable in art as it is in political organization. The transformation of society, at the heart of both feminism and socialism, will not take place until feminist strategies are acknowledged and fully integrated into the struggle.

After the 1978 "Hayward Annual" (inaccurately called *the woman's show* and sometimes still more inaccurately seen as a feminist show), Griselda Pollock called for "an exhibition of feminist work which will present and encourage debate around the issues of feminism and art practice which have emerged within the women's movement . . . conceived and structured as a sustained political intervention."[1] I would like to think that "Issue" starts to provide such a framework for a transatlantic and cross-cultural dialogue. I want to make clear at the outset, however, that despite its stylistic diversity, "Issue" was conceived within a relatively narrow focus. It is concerned with what is being done in this specific activist area. It is in no way a general show of "feminist art" dealing with the politics of being female. Nor is it even a general "women's political art" show, since it does not include highly effective multi-issue artists like Toni Robertson or Annie Newmarch in Australia, nor community muralists like Judy Baca in Los Angeles, nor the many women who concentrate on video, film, performance, photography,[2] organizational slide shows, or realist painting and sculpture with political subject matter. Certainly "Issue" does not constitute a value judgment about what is the only effective feminist art, effective political art, or esthetically successful feminist art. In fact, such outreach art is no more a style or movement than feminist art is. If I am protesting too much about these distinctions, it is because I am sick and tired of the divisive categorizing that supports reactionary taboos against social-change art by stimulating the competition inherent in the present high-art system.

I hope it will also be clear that "Issue" sidesteps debates on stylistic assumptions about women's art. I still hold the opinion that women's art differs from that of men, but I have moved away from my earlier attempt to analyze these dif-

*Reprinted by permission from the catalog *Issue: Social Strategies by Women Artists* (London: Institute for Contemporary Arts, 1980).

ferences in formal terms alone. In ten years, the needs, contexts and developments have changed. In the early days of the feminist art movement we were looking for shared *images*—or rather they popped out at us and demanded to be dealt with. For some of us this preoccupation then led to a search for shared esthetic and political *approaches,* for a theoretical framework in which to set these ubiquitous images. Now we are in a stage where we tend to take that earlier data on image and approach for granted; the real challenges seem to lie in analyzing structures and effects. Thus the time seemed right to begin to break down the various kinds of feminist political art (all truly feminist art being political one way or another). "Issue" scrutinizes that branch which is "moving out" into the world, placing so-called women's issues in a broader perspective and/or utilizing mass production techniques to convey its messages about global traumas such as racism, imperialism, nuclear war, starvation and inflation to a broader audience.

There is, I know, a certain danger that when women's issues are expanded too far they will get swallowed up by an amorphous liberalism. Yet I have opted here for an ecumenical view rather than a strictly socialist feminist view because I am convinced that the cross-references made between all these works—even within the limiting context of an art show—add up to a denser, deeper statement. I hope the web of interconnections and disagreements will cross boundaries of medium, esthetic and ideology to facilitate a dialogue with the audience. The conference taking place in conjunction with "Issue" and her sister shows at the ICA—"Women's Images of Men" and "About Time"—will be a still more effective factor in this process.

One reason for placing a woman's show outside strictly women's issues is to provide a fresh look at feminist art from a different angle. Most of the work in "Issue" is urgent and explicit about its subject matter. It is *experimental art,* throwing itself into that notorious abyss between art and life of which so much has been ready-made since Duchamp and Dada. The artists have chosen different ways to slalom between the poles of isolation, separatism, struggle and autonomy within the male Left and assimilation that have been the choices open to feminists for the past decade or so. Yet all of them have worked collaboratively or collectively on some aspect of their art-related lives—whether in a coop gallery, a political collective, a woman's center, on a periodical, a school, artist-organized exhibitions and events, team-teaching, or in art-making itself—with other women or with politically sympathetic men. (Three of the twenty participants *are* collaboratives—Ariadne, Croiset/Yalter and Fenix—while Leeson and Holzer work regularly with male partners, several others do so irregularly, and Sherk works with a mixed group.)

The collaborative aspect is particularly significant because artists involved with outreach have to learn to work with others before they can hope to be effective in larger contexts. The women in "Issue" share an awareness of their capacity (and *responsibility*) as artists to raise consciousness, to forge intimate bonds between their perceptions and those of their audience. Some of them may feel that feminist art's most effective tactic is intervention *into* the mainstream so as to attack from within; others see the mainstream as irrelevant and seek alternative models for artists disillusioned with the role of art as handed down from above. They have all to some degree been exhibited and discussed within the current system, but each has also kept a wary eye outside of it. Their art gains from

the resulting tensions. For instance, a large number of them have chosen potentially populist, mass-produced mediums such as posters, books, magazine pieces and video as a means by which to extend control of their own art and its distribution, in the process choosing their own audience, or at least not letting their audience be chosen for them. The dominant culture tends to see such small, inexpensive, disposable objects as by-products, a watering down of the unique artifact for mass consumption. But, in fact, the reproductive works often represent a *culmination* in compact form that intends to compete (on however small a scale) with the mass media for cultural power. Such directness stems from the artists' desire to bring art out of its class and economic confinement, and it is integral to their strategies to such an extent that *direct*—as a verb and an adjective—seems to be a key word.

Jenny Holzer, for instance, uses direct mail and street leafleting to convey her provocative messages about thinking for oneself in the morass of conflicting propaganda that surrounds us. She does this by making her own carefully researched collections of aphorisms and essays whose messages sound ultra-positive and direct, but are often, on scrutiny, highly ambiguous. Holzer operates in a curious realm between belief and disbelief, cliché and fact, cynicism and hope. She sees her work as nonideological; it does not so much impose a fresh view as it criticizes all existing views. One of her recent works—a leaflet with a return-response coupon that is headlined "Jesus Will Come to New York November 4" (U.S. election day)—exposes right-wing and religious connections and warns its readers that 3,000,000 fundamentalists are newly registered to vote. The language is clear and nonrhetorical and the piece is potentially effective in that it could scare more liberals and leftists into voting.

Nancy Spero's delicate collaged scrolls are directed against brutality and violence. In a bold, irregular, oversized print, interspersed with twisted and attenuated figures, sharp tongues out or arms flailing, she catalogs humanity's current nightmares—the Vietnam war, the torture of women, the bomb, fascist coups. She often uses poetry (by Artaud or H. D. or from mythological sources) ironically to undermine the whole notion of poetry, or art, as something beautiful and soothing. In *Torture in Chile,* Spero uses fragmentation as a metaphor for the dismemberment of women and of a revolutionary motherland. The vast horizontal scroll is drawn out, strung up against the wall like a prolonged scream of rage. The images are less active than usual, as though the horror of the factual text, underscored by sharp geometric lines, has immobilized the figures.

In a very different way, Nicole Croiset and Nil Yalter also explore fragmentation in their extended video/text/drawing "oblique object" installations about the 14,000,000 working-class immigrants to urban centers and to the wealthier European nations. Yalter is herself Turkish and the piece in "Issue" focuses on Rahime, a Kurdish woman of nomadic background making the wrenching transition between her village and an industrial shantytown outside of Istanbul. Married at thirteen, a mother at fourteen, she is undergoing a forced triple consciousness raising (as a woman, a worker, and a rural alien), tragically heightened when her progressive daughter was murdered by a man she refused to marry. Rahime is very articulate about the injustices of her situation. She notes how the

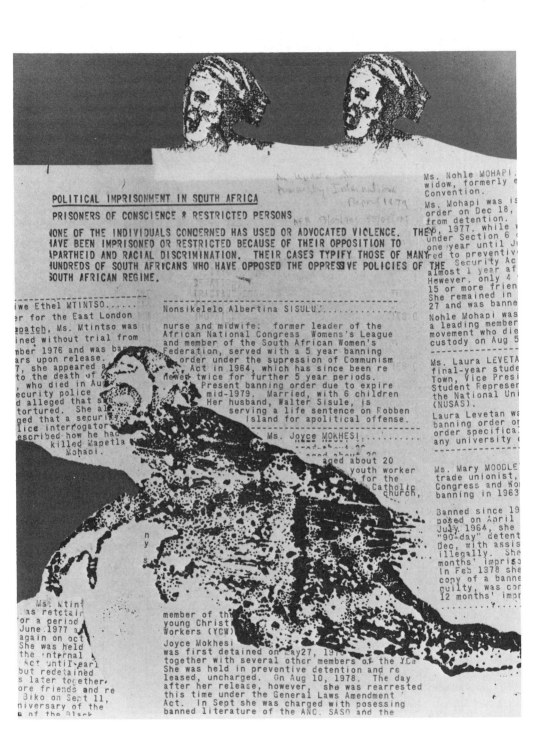

Nancy Spero, *South Africa,* 1981, 26″ x 40″, hand-printing and typewriter collage on paper. (Photo: David Reynolds)

Nicole Croiset and Nil Yalter, street poster at bus stops, exterior part of the multimedia installation *Women at Home, Women at Work,* in Mireuil, France, 1981. The work consisted of a portrait series from the lives of women living in the neighborhood where it was shown.

rich can't *do* anything—work in a factory or even fulfill their military service. Croiset and Yalter combine art, sympathetic anthropology and documentary approaches. As in their previous works on the city of Paris, a women's prison, and immigrant workers in France and Germany, they bring to rhythm and life the people who make up the statistics of Europe's new, reluctant melting-pot status.

Miriam Sharon is also involved in cross-cultural awareness. An Israeli, she has worked with the Bedouins in the Negev and Sinai deserts. Her earth-covered tents and costumes pay homage to their close relationship to nature. By performing rituals both in the desert and on the Tel Aviv waterfront (at Ashdod Harbor, appropriately named after an ancient goddess), Sharon uses her art as a vehicle of cultural exchange; she reminds the workers of the plight of the nomads who are being herded into cement villages and forced to abandon their traditional ways of life. She also shows her work in factories and has become a one-woman liaison organization between the "desert people" and their rulers.

Maria Karras also deals with dislocation in her phototext posters on the subject of "multicultural awareness." *Both Here and There* consists of fourteen posters in English and one of twelve different languages; each shows a relaxed portrait of a woman from a different ethnic origin and a statement excerpted from an interview about her experience as a woman and an immigrant in America. Conceived and marketed as teaching aids as well, the posters were seen by over a million people when they went up in Los Angeles public buses in 1979. They stem from Karras' earlier work on her own Greek heritage. What initially appears to be a bland, chamber-of-commerce format is ruffled by the casual poses and the controversial things some of her subjects have to say about women's roles in their communities. Each poster is a small and pointed political geography lesson. Karras offers positive images of women, new role models and new sources of confidence for women. She provides an exchange between Los Angeles' many and isolated ethnic communities, and makes connections between feminism and the anxiety, alienation and assimilation of the bi-cultural experience.

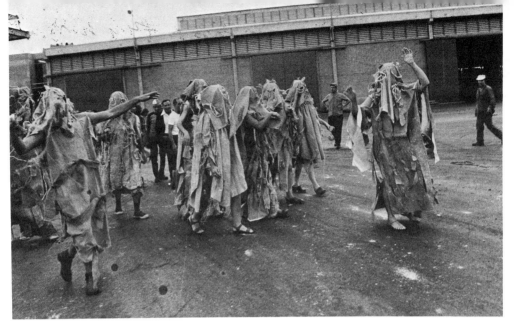

Miriam Sharon, *Ashdoda Harbor Project,* October–December 1978, Tel-Aviv, Israel. (Photo: Rachel Harpaz)

Maria Karras, *Both Here and There,* bus posters, 1979. One of a series of fourteen interviews with women of different bicultural backgrounds in Los Angeles, accompanied by a portrait of each and exhibited in 1,000 city buses. The posters are also used in schools as teaching aids, "designed to build bridges across cultures, and open communication about similarities and differences." They "make public what is private knowledge about the female experience of immigration to America."

Inspire multicultural awareness in your students,
read on,

Both Here and There is a

Multilingual

Multicultural

teaching aid designed to build bridges across cultures, and open communication about similarities and differences.

Posters, of course, are probably the most direct public art medium there is. Loraine Leeson and Peter Dunn have been collaborating for several years with the trade unions and local groups to produce a series protesting hospital shutdowns and health cutbacks for the East London Health Project. Because of their formal strength and visual interrelation, these campaigns lend themselves to art contexts as well as to the intended social function, although the artists make it clear they dislike using their audiences as "passive consumers," and don't think "gallery socialism" is enough. The series in "Issue" was made by Leeson with the Women's Health Information Centre Collective and deals with specific issues such as abortion, contraception, home care and women's work hazards, as well as more general questions such as women being driven back into the home as the result of health cuts, the social role of women and its indirect effects on health and why certain aspects of health care should be seen as women's issues. Like the earlier campaign, this is seen as social art for a "transitional period" between art based on the values of a consumer society and "something else" that will occur when that society is changed. Since she is acutely aware of the dangers of art colonization, Leeson's poster work is informed by a rigorous self-criticism which brings it to the edge of disappearance into social *work,* from which it is saved, paradoxically, by its visual and esthetic force.

For most of these artists, the international Women's Liberation Movement is a source of great theoretical vitality. However, they use it in very different styles, to very different degrees and operating from very different political assumptions. This could not be otherwise since they are also of different nationalities, different races, different class-and-esthetic backgrounds and foregrounds. The difficulty of generalizing about twenty-four such diverse artists is compounded by the fact that the discourses around feminist and sociopolitical art in the United States and the United Kingdom (where the majority of these artists live) are literally in such different places. The state of British art is not the state of American art. For example, this ICA series is the first establishment-approved women's show in London, while New York has had women's shows but has never had a "political art show" on the order of London's "Art for Whom," "Art for Society" and others.[3] In mainstream America, social art is basically ignored; in England, it enjoys the attention of a small but vocal (and often divided) group with a certain amount of visibility and media access. In America, artist-organized tentatives toward a socialist art movement are marginal and temporary, waxing and waning every five years or so with only a few tenacious recidivists providing the continuity. In England, there are actually Left political *parties* that artists can join and even work with—and the more advanced level of theoretical discussion reflects this availability of practice.

In England, feminist art is thought by some to be "utterly concerned with notions of what art is and only concerned with making strong, direct statements about the position of women in our culture"[4]—which certainly helps to explain the reluctance of some professional artists to be labeled as feminists. In America, on the other hand, it is the feminist Left that is reluctant to be associated with "bourgeois" or "radical" or "separatist" feminism, and the popular notion of feminist art is more oriented toward images than toward ideologies. There is also a firm resistance to the notion of defining feminist art at all, or accepting any "predetermined concepts of feminist art,"[5] because we have seen the enthusiasm

of those who would like to escape feminist energy by consigning all women's art to a temporary style or movement. In Israel, feminist art is still an oddity and Miriam Sharon is rare in welcoming the identification. In France, feminist art is more often defined according to American cultural feminist notions (autobiography, images of self, performance, traditional arts) than according to the more universalized psychopolitical theory for which French feminism is known. In any case, the sociological work of Croiset/Yalter does not seem typical of either country's clichés about feminist art.

All of these confusions can be partly attributed to the fact that, as Rowbotham has remarked in another context, the feminist tenets of organic growth— "many faceted and contradictory"—do not fit any current model of the vanguard.[6] In challenging the notions of genius, of greatness, of artist as necessary nuisance that are dear to the hearts of the institutional mainstream and of the general public, the artists in "Issue" have also challenged some fundamental assumptions about art. They are in a good position to do so because feminist art has had to exist for the most part outside of the boundaries imposed by the male-dominated art world. While these artists exhibit in that world, they also maintain support systems outside of it and many have established intimate connections with different audiences. Having watched so many politicized artists reach out, only to fall by the wayside or back onto acceptable modernism fringed with leftist rhetoric, I have the heartiest respect for those with the courage to persist in this nobody's land between esthetics, political activism and populism. The taboos against doing so, however, bear some looking into, along with the ways such artists have broken them.

Some are challenging the taboos against subject matter considered "unsuitable" for art—such as unemployment, work and domesticity, budget cutbacks or militarism. Some are aiming at the sense of imagined superiority that has so disastrously separated "high art" from "crafts" and "low art" and artists from "ordinary people." Margaret Harrison, for instance, is acting on both of these principles. Her collage paintings and documentation pieces have long focused on the theme of women and work, but rather than picture or objectively comment on her subject, she works from inside of it with the people it concerns. A work is finished only when it reflects and has had some effect on the selected field. Harrison has worked with isolated homeworkers and with rape groups. In "Issue," she takes on craft and class. The visual core of the piece consists of three versions of each craftwork: the actual object, a painting of it, and a photograph of it. The items belonged to her mother-in-law. They trace the "deskilling process" of working-class women since industrialization by moving from a handmade patchwork to a cheap doily, "made in the factory by working women and sold back to them." Like the "hookey mat"—once a shameful symbol of poverty and now enjoying the status of a desirable antique—they indicate the disappearance of crafts from the lives of working-class women to become the domain of the middle class. Harrison's theme has ramifications not only for the feminist insistence that the struggle is taking place in the home as well as in the workplace, but also as a comment on the "precious object" in current art practice.

Beverly Naidus also deals with planned obsolescence. Her title is *The Sky Is Falling, The Sky Is Falling, or Pre-Millennium Piece.* The audiotape talks about

Margaret Harrison, detail from *Homeworkers,* 1977, multimedia. This project employed photos, documentation and a large assemblage/canvas to investigate the problems faced by a pool of nonunionized, mostly female labor who do piecework at home for wages as low as 22¢ per hour. It follows the work of three individual women in detail and has been shown in schools and community centers in South London as part of an organizing process.

Beverly Naidus, *Stick It,* 1982, self-adhesive stickers for consumer intervention in stores, 7"x 7".

"selling life as it is," about unemployment and economic insecurity and the panaceas offered to cure them: consumerism and evangelical religion. She deals with issues blurred by media overkill by using cliché and collage—lists, asinine questionnaires, posters slapped up guerrilla-style over photos of people standing in lines and suffering bureaucratic banalities. This visual layering technique suggests that underneath the doom-saying is a groundswell of people' power.

There is a pervasive belief, in the United States at least, that art with political subject matter is *automatically* "bad art." To some extent, of course, such taboos can be attributed to the artists' intentional divergences from conventional audiences and goals, as well as to a formalist dislike of "literary art" that is much stronger in the United States than in the United Kingdom. But social art is also *perceived* differently. An organic shape readable, say, as a mushroom cloud, is judged on a completely different scale, no matter how forcefully it may be formed, from the same shape, similarly executed, that is illegible, or abstract. Timely subjects like those listed above are not publicly acknowledged to be threatening to the status quo but are simply dismissed as "boring" or "unesthetic." This dismissal is particularly weird coming after a decade in which the avant garde and the bourgeoisie cheerfully validated pieces involving pissing, masturbating, match throwing, body mutilation, self-imprisonment, etc. What, then, makes the appearance of an angry Black face, a war victim, or nuclear generators so firmly unacceptable?

Adrian Piper has addressed this issue in her *Aspects of the Liberal Dilemma.*

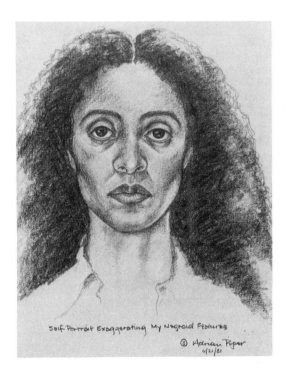

Adrian Piper, *Self-Portrait Exaggerating My Negroid Features,* June 1981, pencil on paper, 8" x 10". (Collection of the artist)

A photograph on the wall of a crowd of angry-looking Black people coming down a staircase is accompanied by an audiotape that discusses the image solely in formal terms and asks, "What exactly is the esthetic *content* of this work?" In another, similar pamphlet work, four identical photos of starving Boat People are captioned as follows: "Gosh, what a tragedy . . . / . . . / . . . (sigh)/Is that all? Where's the art?" In a 1977 letter she suggested that "the purpose of art may transcend the development of one's esthetic sensibilities in favor of the development of one's political sensibilities." Acknowledging the horror with which that statement would be generally received, she speculated: "Maybe nonpolitical messages are more acceptable because they tend to be more personal, hence less publicly accessible, hence more symbolic or mysterious, therefore more reducible to purely formalist interpretations; i.e., the more likely it is that people will understand what you're trying to convey, the less fashionable it is to try to convey it." As a Black woman who can "pass" and a professor of philosophy who leads a double life as an avant-garde artist, Piper has understandably focused on self-analysis and social boundaries. Over the years her work in performance, texts, newspaper, unannounced street events, tapes and photographs has developed an increasingly politicized and universalized image of what the self can mean. In the set of three *Political Self Portraits,* for example, she turns her autobiographical information inside out to provide devastating commentaries on American racism, sexism and classism.

Taboo subjects inevitably include a panoply of feminist preoccupations, such as rape, violence against women, incest, prostitution, agism and media distortion. All of these have been confronted by Suzanne Lacy and Leslie Labowitz, working together and with other women as Ariadne: A Social Network. Like Piper, they have used "the expanding self" as "a metaphor for the process of moving the borders of one's identity outward to encompass other women and eventually all people." Their collaborative performances are unique in their grand scale and detailed planning, and in the fact that they take place exclusively in the public domain, sometimes with casts/audiences of thousands (as in the Women Take Back the Night march in San Francisco in 1978). Lacy and Labowitz have evolved a "media strategy" for their campaigns and events, which often incorporate several different approaches to reach different sectors of the population.[7] They work with a broad variety of organizations and groups, focusing on specific feminist issues. Their pieces are carefully designed so as to subvert the usual media distortion of women's issues; to attract coverage, they depend on striking visual images (such as seven-foot-tall mourning women in black and one in red for rage bearing a banner reading WOMEN FIGHT BACK, in the piece *In Mourning and In Rage*, which commemorated the women murdered in Los Angeles by the Hillside Strangler). Ariadne was determined to control not only its production, but the way its images were perceived and understood. Lacy's and Labowitz's networking techniques gave them broader access to popular culture than is usual for art.

Most of the taboo subjects are, in fact, those covered (and mystified) extensively by the news media. I suspect one of the reasons they are palatable in that form of "entertainment," but not as fine art, is precisely because they are so ubiquitous in their more popular form. We are tired of them. Their focus on

Candace Hill-Montgomery, *Reflections on Vacancy,* 1979. Silver mylar installed in all 15 windows of an abandoned tenement on 121st Street, Harlem, New York City; inside and outside views. (Photos: Bill Stephens)

novelty deprives them of meaning even when they are the most meaningful issues of our time, and those it is most crucial for us to see clearly. The artists in "Issue" are acutely aware of this situation and confront it in various ways. Candace Hill-Montgomery, for example, in her angry photodrawings, uses images that have survived the media blitz to remain shocking reminders of the history of racism in America. Just to be sure, she heightens their immediacy by hanging the drawings, weighted down by plexiglass, with unexpected and often ungainly objects that bring them still more into our own world. Thick chains support a terrifying picture of a Black man chained to a tree, his back broken; a full-sized noose holds up a lynching picture; and army pants hold a piece on American military atrocities; a brass eagle holds the big, colorfully bitter *Teepee Town Is in Reserve.* By bringing relatively abstract and expressionist images into concrete space, Hill-Montgomery makes it clear that she is not talking about fictionalized history. With these almost monstrous objects mitigating the craft of her drawn surfaces, she juxtaposes the possibility of Black power against the historical fact of Black powerlessness, daring the viewer to enjoy her works as "just art."

Margia Kramer's *Secret* also deals with terrifying material and her use of black and white is based on a similar symbolism. Her raw material is the censored photocopies she obtained through the Freedom of Information Act on the FBI surveillance and harassment of Jean Seberg, which led eventually to the film star's suicide. In the 300-page file, the FBI referred to Seberg as "the alleged promiscuous and sex-perverted white actress" and stated its desire to "cause her embarrassment and cheapen her image with the public." Seberg's persecution arose from the fact that she was a supporter of the Black Panther party. The FBI leaked to the news media the false story that Seberg was pregnant by one of the Panthers; when the baby died at birth she took it in an open coffin to her hometown in Iowa to refute these stories, but the emotional toll had been taken. Kramer's art consists not of commentary but of strong visual presentation of the documents in video, book and huge blown-up negative and positive photostats; with their impersonal telegraphic style and brutally censored passages, they are the ideal vehicles for this chilling tale of governmental paranoia and manipulation. Her subject is not only constitutional rights, America's race wars, the media's willingness to exploit a woman at her most vulnerable point—her sex life—but, also, paradoxically, the democratic fact of the Freedom of Information Act that permitted this ghastly story to be exposed. In addition there is a curious reversal of the feminist search for public meaning in private life in Seberg's martyrdom through public invasion of privacy.

Alexis Hunter has concentrated on gesture in what might be taken as parodies of media photos of disembodied hands capably and prettily doing women's dirty work. She is not a documentary photographer, but sets up and acts out her own ideas like a photonovelist. For several years Hunter concentrated on themes of fear and violence, rape, domestic and sexual warfare. Despite often sensational subject matter, the work transmitted not moral outrage so much as bemused personal anger that found its outlet in highly physical or sensuous activities. There is an element of exorcism in these pieces and at the same time there is something decidedly threatening about the elegantly female hands going about their business with such aggressive determination. Surfaces—smeared, caressed, decorated or smashed—are dominant in Hunter's work, perhaps as a pictorial pun, since humor

Alexis Hunter, detail of *A Marxist's Wife (Still Does the Housework),* 1978. Color Xerox, 4 panels of 20 photographs, 15″ x 48″.

is rarely absent no matter how horrific the content. In *A Marxist's Wife (Still Does the Housework),* a ringed hand wipes off a portrait labeled "Karl Marx Revolutionary Man Thinker." The second piece in "Issue" is rare for Hunter in that the protagonist is neither generalized nor disembodied. *A Young Polynesian Considers Cultural Imperialism Before She Goes to the Disco* shows a Black woman trying on and then discarding a white woman's jewels (or chains). As a white New Zealander or "pakeha," the artist is implicated in this story not only as the executor of the work but as its surface. The young Polynesian becomes a mirror in which Hunter must see herself and her own race.

Marie Yates, in her phototexts *On the Way to Work,* also explores social preconceptions about images of women, the ways in which they are made and their meanings. By the materialist ploy of working "in the gaps of reality," she appears to pull the viewer into the interstices between cultural understanding and misunderstanding that are left when the representational cliché is emptied of its accepted content. She does this on the levels of "real life," fiction, and politically sophisticated analysis. In her earlier work (particularly the book *A Critical Re-Evaluation of a Proposed Publication* of 1978), Yates confronted the "display and/or consumption of landscape" by juxtaposing beautiful views of rural England with simple binary oppositions like "nature/culture, them/us." Now she applies a similar confusion of predictable romanticization and objectification devices in order to expose the codes of gender identification in this society.

Where most of the artists in "Issue" believe that art is about seeing clearly and teaching people how to see the world that surrounds them, they and others like them are sometimes attacked from the right for not sticking to formal "beauty" and from the left for having any formal preoccupations at all, as well as for being politically naïve. They are caught in a classic conflict between the "standards" of art taught in schools and the disillusionment that hits socially concerned artists when they begin to realize how little what they were taught can help them to get their most important ideas across. Once they have found their own ways, they may still be walking a tightrope, making art critical or neglectful of values they must accommodate to earn a living. Some such artists are eventually disarmed and assimilated into the mainstream while others are banished for

Marie Yates, detail from photo-essay: *The Time and the Energy—a Film,* 1982. "On the Left, pleasure and desire are issues largely unaddressed despite a growing recognition of their importance for the development of a number of diverse practices. The separation of the visual and the textual in art discourses finds echo in the separation of pleasure and desire from politics and theory in other perhaps more vocal discourses. Laura Mulvey suggested that 'desire born with language allows the possibility of transcending the instinctual and the imaginary' and maybe it is time to consider this.

"When watching moving images the visual codes manipulate the mechanisms of our pleasure to the perfect pitch of satisfaction by rapid shifts of emphasis of the look, from voyeuristic gaze to identification and back. The sound echoes the image to create a coherence which encloses us within these identifications and positionings.

"Current image production has developed counterpoint techniques to intervene in these mechanisms, and these practices are referred to in this work. It is therefore necessary to view the textual images as if they are moving across a screen with all the processes of pause, delay, repeat, relay and change implied."

uppity irrelevance to the dominant culture. Some have made a politically informed decision for this uncomfortable position, while others have moved into it organically. Either way, it is crucial for feminists to understand the ways these taboos operate and the reasons behind them, because even the least daring women's art is judged by criteria based on such antipathetic values. This situation can, in turn, lead to fear-inspired competition and factionalism and the diminution of a publicly powerful feminist art front.

Such factionalism also can result in (or is the result of) a reverse philistinism. The kind of feminist artist who does "care about art" can find herself isolated from those who have chosen direct action rather than working with them on tasks more suited to her own needs and effectiveness. She can also find herself reacting against reactions against feminist art, and thus being controlled by the opposition. New taboos arise from rebellions against the old ones: progressive and feminist art reacts against the notion that "high standards" are to be found only where form and content are seamlessly merged, where content "disappears" into form. In the process of this reaction, a new rhetoric emerges, and artists who refuse to throw the baby out with the bathwater (to replace form entirely with subject matter) may find themselves opposing their own politics and their natural allies. This double negation process may be inevitable if it is not analyzed and understood as highly destructive and divisive.

At the heart of the matter is what Walter Benjamin called "the precise nature of the relationship between quality and commitment."[8] The notion of "quality" (though I prefer the less classbound term *esthetic integrity*) is embedded in Western culture, along with various degrees of anarchism, individualism, and pluralism. We have, ironically, seen the results of their suppression in those Socialist countries where the power of art as a political force has been clearly recognized. Yet one reason why we can still not thoroughly discuss much of the work in "Issue" within a Socialist framework is that the Left itself has not expanded enough to include the options art must have—just as it has had trouble incorporating feminist values. May Stevens has defined philistinism as "fear of art."[9]

It is difficult not to be confused by all these taboos against any art that might be useful or even powerful. Several complex factors are operating. The most obvious is the tenor (or tenure) of Western art education and its insistence that high art is an instrument for the pleasure and entertainment of those in power. We are told in school that if art wants to be powerful, it must separate itself from power and from all events artists are powerless to control. This is the counterpart of telling women and children to step aside, "leave it to us: this is men's work." (And it has long been clear that artists are considered "women" by the men who don't dabble in culture but do "real work" and get their hands dirty in blood and oil.) If such attitudes stem from the ruling class's conscious or unconscious fear that art may be a powerful tool of communication and organization, what are the artists themselves afraid of?

For women artists in particular, the "real world" as an arena in which to make art can appear as a fearful, incomprehensible place. We know about our fears of taking hold of unfamiliar power. And for all its dog-eat-dog competitions, the art world is relatively secure in comparison. Finally, one's art is, after all, *oneself,* and its rejection—politicized or personalized or both—has to be dealt with emotionally. One of the most popular excuses given by mainstream artists

for rejecting social art is that "the masses" and the middle class *and* the corporate rich are all uneducated, insensitive, crass, vulgar, blind—leaving artists with a safe, specialized audience consisting primarily of themselves. Sometimes the frustration inherent in such limited communication leads to the international encouragement and provocation of a "fear of art." During the 1970s, much self-described political or Marxist art was watered down not only by stylistic plural-ism and academic aimlessness, but by the artists' own illusions of complexity and espousal of incomprehensible jargon. So-called advanced art tries to *épater le bourgeois* just as bourgeois art tries to tempt *its* chosen audience to consume it. These games are incompatible with social-change art, where reaching and mov-ing and educating an audience is all-important.

Yet this state of affairs is all too often only reluctantly recognized because of the pervasive taboos. And all the taboos are rooted in social expectations of art, and these in turn are rooted in class. As Piper remarked, artists concerned to communicate are often considered "bad artists" because their content is "untransformed"—that is, still comprehensible. The high-art milieu assumes that no one expects meaning from art; yet the societal cliché about "advanced art" is expressed in the question, "But what does it mean?" Laypeople are inev-itably disappointed when the answer is "nothing"—that is, only form and space and color and feelings, and so forth. The sophisticated assumption is that these experiences are of course open to anyone, so the audience too "dumb" to get it is not worth communicating with. One tends to forget that while the *experiences* may be open to anyone, the *meanings* are not, because we are educated to code them so they are available only to certain classes of viewer.

Even the expectations themselves can be broken down according to class. The ruling class expects "high" or fine art to be framed in gold—to be valuable, decorative and acceptable—and preferably old, except for the bland new outdoor furniture of "public art" considered suitable for banks, offices and lobbies. The middle class can't afford old art, so it tends to be more adventurous, preferring the new, the decorative and the potentially valuable. Working people are re-signed to expecting "beauty"—an old-fashioned, hand-me-down notion that usu-ally has little to do with their own taste. Supposedly the working person doesn't expect meaning from art but is happy with what s/he gets from gift shops and mail-order catalogs. Yet when artist Don Celender interviewed working people in Minneapolis and Saint Paul about art, he got answers such as: "art is good train-ing because it teaches us to look deeper into things" (a female bus driver); art is important "for appreciation of the environment" (truck driver); "art makes the world seem brighter" (housemaid); "life wouldn't be interesting if we didn't have art" (housemaid); "one of the better things in life [is] that people should be able to relate to his own type of art" (taxi driver); and "art is a way to convey and pre-serve a culture" (roofer).

Mary Kelly has set herself precisely this task: to preserve a culture hitherto virtually unexcavated in the first person: "The ways in which ideology functions in/by the material practices of childbirth and child-care."[10] These are among the taboo subjects, and Kelly has been exploring them for some eight years now in a multipartite work called *The Post Partum Document*. Each section consists of two forms: a series of framed collages that make refined and beautiful art objects ("fetishes" she calls them) out of stained diapers, infant clothes, her son's first

the Name

an institution, an author and a text.

Mary Kelly, *Post-Partum Document VI: Prewriting Alphabet, Exergue and Diary/Experimentum*

the Letter . . .

an anagram of the maternal body.

marks, drawings, discoveries; and a dense accompanying text that includes Lacanian diagrams, charts and a detailed analysis of "the ongoing debate of the relevance of psychoanalysis to the theory and practice of Marxism and Feminism." The section shown in "Issue" is, appropriately, the last one, in which mother and child enter the real world of writing and infant school. The "art objects" consist of chalklike inscriptions on slate, combining the mystery of the Rosetta Stone with the solemnity of the educational undertaking; the language of the alphabet books and learning stories is juxtaposed with diary entries and then in turn with the accompanying text, which dissects subjective and unconscious structures in linguistic frameworks. In one of the most complex explorations I know of the often distorted feminist credo—"the personal is political"—Kelly argues "against the supposed self sufficiency of lived experience and *for* a theoretical elaboration of the social relations in which 'femininity' is formed." The result is a poignant attempt to understand the mother's personal sense of less (loss of the phallus is her interpretation) when a child leaves the home, and an equally moving exposition of the predicament of the working-class mother when faced with schools, bureaucracies and all the other powers over her child that will leave her powerless again.

Fenix (Sue Richardson, Monica Ross and Kate Walker), though dealing with similar subject matter, prides itself on a raw, comfortable ("homemade, I'm afraid") approach that offers the process of *coping* as a direct challenge to the estheticization of high art. The three artists, who were also collaborators in the Feministo Postal Event ("Portrait of the Artist as a Housewife") see themselves as part of the first generation in which working-class women have had access to art education. Their theme is rising from the ashes to the occasion. They want to destroy boundaries between low, hobby and high art, motherhood and career. "It has been said many times by experts that women are not creative. They have a sentimental approach! Babies are not homemade! Flowers cannot be knitted! Reality is not a pussy cat!" They have set out to identify with and then deny the working-class suffragette Hannah Mitchell's statement: "We will never be able to make a revolution between dinner time and tea!" Fenix's installations reflect the creative chaos of the home. Richardson, Ross and Walker work on their art in public, and while the esthetic outcome of their collaborations is risky, it is less significant than the process itself and its effect on the audience.

Martha Rosler's conceptual and book works, mail pieces, photographs, performances and videos approach the issues of motherhood, domesticity, sex and career in a manner that is as theoretically stringent as Kelly's and as accessible as Fenix's. She avoids the vocabularies of the Marxism and feminism that inform all her work in favor of a "decoy"—a deadpan, easy-to-understand narrative style in which she demonstrates the most complex social contradictions and conflicts. For several years she concentrated on the uses and abuses of food—as fashion, as international political pawn, as a metaphor for a consumer society to which both culture and women seem to be just another mouthful in an endless meal. In the verbal/visual framework of her various mediums, she has examined anorexia nervosa, food adulteration, TV cooking lessons, the bourgeois cooptation of "foreign" cooking and starvation in those same "foreign" countries, the fate of the Mexican alien houseworkers, waitressing, and restaurant unionizing (as well

as The Bowery, Chile, the PLO and the Vietnam war). Rosler uses humor and a deadly familiarity to maintain her Brechtian distance from these subjects at the same time that she exhibits a thorough, and sometimes autobiographical, knowledge of them. Her acid intrusions into naturalism push reality up against idealism until neither has a chance. At that point, the skeleton of a demystified, but still estheticized, truth appears.

Yet another approach to the analysis of the female role in the total society is that of Mierle Laderman Ukeles. For some ten years now she has been making *Maintenance Art,* which emerged from "the real sourball . . . after the revolution, who's going to pick up the garbage on Monday morning?" It began in the home, when Ukeles realized that as a mother of small children she was not going to have time to make art. She decided she would have to make art out of what she spent her time doing. The work has since moved gradually out into the world—to the maintenance of art institutions, then collaborative pieces with the maintenance workers in offices and office buildings in which the structures of their tasks were examined both as work and as art, and finally two years ago to the grand scale of the New York Sanitation Department—to the 8,000 garbage men who are the pariahs of city government. The outward and visual performance aspect of *Touch Sanitation* was a dialogue and handshaking ritual with every man on the force. Its radical aspect reflects again on taboos. Ukeles' work has been called outrageous, trivial and condescending by those who have not stopped to think where these accusations come from. She has also evaded Marxist assumptions about production through a prototypical feminist strategy which uses men's productive but despised support work as a means to call attention to all service work—the most significant area of which is, of course, women's reproductive work in home and workplace. The most recent result of *Touch Sanitation* is that the sanitation men's wives are organizing.

Many or all these works are collages. And for a good reason. The Surrealists defined collage as the juxtaposition of two distant realities to form a new reality. Collage is born of interruption and the healing instinct to use political consciousness as a glue with which to get the pieces into some sort of new order (though not necessarily a new *whole,* since there is no single way out, nobody who's really "got it all together"; feminist art is still an art of separations). The socialist feminist identity is itself as yet a collage of disparate, not yet fully compatible parts. It is a collage experience to be a woman artist or a sociopolitical artist in a capitalist culture. "Issue" as an exhibition is itself a collage, a kind of newspaper.

The collage esthetic is at the heart of May Stevens' moving series "Ordinary Extraordinary." It has recently culminated in an artist's book that juxtaposes the lives of Rosa Luxemburg ("German revolutionary leader and theoretician, murder victim") and Alice Dick Stevens ("Housewife, mother, washer and ironer, inmate of hospitals and nursing homes"). Like Rosler and Kelly, Stevens analyzes language, but unlike them, she does it in an unashamedly affective manner. The book and the richly layered collages that led up to it are black and white—dark and light. They weave visual portraits and verbal self-portraits to bring out the underlying political insights. Sometimes a level of irony surfaces, which makes the roles of the intensely articulate and active Rosa and the pathologically silent and passive Alice almost seem to reverse, or overlap, offering generalized com-

Martha Rosler, *Watchwords of the Eighties,* performance, Elisabeth Irwin High School, New York City, February 27, 1981. (Photo: Richard Baron)

Mierle Laderman Ukeles, *Touch Sanitation,* July 24, 1979–June 26, 1980, performance, or ''maintenance ritual act,'' celebrating daily urban survival by shaking the hand of each of New York City's 8,500 sanitation men.

May Stevens, *Alice,* from *Ordinary. Extraordinary,* collage, 6″ x 9″, 1978, adapted for an artist's book of the same title, published 1980; the subject is the lives of two women: "Rosa Luxemburg, politician, revolutionary, theoretician and leader, murder victim (1871–1919)," and "Alice Stevens, mother, housewife, ironer and washer, inmate of hospitals and nursing homes (born 1895)."

Bonnie Sherk, *The Farm* (Crossroads Community), a freeway garden on state land, 1975. (Photo: the artist)

ments on class and gender. Stevens' mother became mute in middle age, "when what she wanted to say became, as she put it, much later, too big to put your tongue around." When she regained her ability to speak, "she had lost a life to speak of." Rosa, on the other hand, writes to her lover, "When I open your letters and see six sheets covered with debates about the Polish Socialist Party and not a word about . . . ordinary life, I feel faint."

The most ambitious collage in "Issue" is Bonnie Sherk's collaborative art-work/corporation/performance piece/site sculpture or "life frame" called *The Farm* (Crossroads Community). It consists of 5.5 acres of buildings, land and gardens under a looming freeway, at the vortex of four different ethnic communities (and three subterranean creeks) in San Francisco. *The Farm* is a collage of functions including community center, after-school and multinutritional health and nutrition programs, experimental agriculture, appropriate technology, zoo, theatre and park; and it is a collage of living styles or social options: an old-fashioned farm kitchen, suburban white-iron lawn furniture, an International living room to show that elegance is part of the natural life, and the latest project—"Crossroads Cafe," part of a scheme for international outreach that includes the projected import of an old Japanese farmhouse. Because of *The Farm*'s scope, it is virtually impossible to summarize in this context, but its most interesting aspect is its fusion of art with other functions. *The Raw Egg Animal Theatre* (TREAT), for example, could be called a stage set or an environmental installation piece as well as several other things. Sherk is concerned to integrate "the human creative process—art—with those of other life forms." She is fundamentally a visionary, albeit an earthy and practical one who managed six years ago to found and then maintain this huge-budget near-fantasy. *The Farm* emerged organically, so to speak, from Sherk's earlier art, which involved identification with animals, study of animal behavior and work with growing things, such as the creation of portable parks in the inner city and on the freeways.

Sherk's subject, like that of Ukeles and many other artists in the show, might be said to be nurturance and its meaning in an art context that sees it as a gender-related taboo. Yet like the notion of a female collage esthetic, this is also reducible to the dreaded "nature-nurture syndrome" which is a taboo within as well as outside the feminist movement. In some views, nature and culture are incompatible and any hint of female identification with the forms or processes of nature is greeted with jeers and even, perhaps, fears that parallel those of the bureaucratic patriarchy when they tried to censor Monica Sjoo's graphic depiction of *God Giving Birth* at the Swiss Cottage Library in 1973. Some of the artists in "Issue," however, refuse to separate their social activism and their involvement in the myths and energies of women's distant histories and earth connections.

It seems to me that to reject all of these aspects of women's experience as dangerous stereotypes often means simultaneous rejection of some of the more valuable aspects of our female identities. Though used against us now, their final disappearance would serve the dominant culture all too well. This is not the place to delve into the disagreements between socialist feminism and radical or cultural feminism (I, for one, am on "Both Sides Now"). But in regard to the issues raised in "Issue," I would insist that one of the reasons so many women artists have engaged so effectively in social-change and/or outreach art is

women's political identification with oppressed and disenfranchised peoples. This is not to say we have to approve the historic reasons for that identification. However, we should be questioning why we are discouraged from thinking about them. Because such identification is also a significant factor in the replacement of colonization and condescension with exchange and empathy that is so deeply important to the propagation of a feminist political consciousness in art."

NOTES

1. "Feminism, Femininity and the Hayward Annual Exhibition 1978," *Feminist Review,* no. 2 (1979), p. 54.

2. Another omission that will be obvious to British viewers is that of the Hackney Flashers; I should have loved to have them in the show but they had just stopped making new work when I asked, and I had decided not to exhibit anything previously shown in England. The German artist Mariane Wex was also invited, but she was in between homes and did not receive the letter in time.

3. A "Social Work" show was held at the Los Angeles Institute of Contemporary Art in 1979, but that was still an "alternate space." I organized "Some British Art from the Left" at Artists' Space in New York City in 1979, as well as "Both Sides Now" at Artemisia in Chicago; in 1980 "Vigilance"—a show of artists' books about social change, organized by Mike Glier and me—was at Franklin Furnace, and there have also been small "political" shows at institutions outside of New York as well as a number of artist-organized events over the years.

4. Roszika Parker, talking to Susan Hiller, though the view expressed was a prevailing one rather than that of either participant; *Spare Rib,* no. 72 (1978), p. 30.

5. Harmony Hammond covered this in her "Horseblinders," *Heresies,* no. 9 (1980).

6. Rowbotham, Segal and Wainright, *Beyond the Fragments: Feminism and the Making of Socialism* (London: Merlin Press, 1979), p.109.

7. See *Heresies,* no. 9 (1980) for Leslie Labowitz', "Developing a Feminist Media Strategy."

8. "The Author as Producer," *Understanding Brecht* (London: New Left Books, 1977), p. 86.

9. "Taking Art to the Revolution," *Heresies*, no. 9 (1980).

10. Mary Kelly, in the notes for and around *Post Partum Document*—the sources for all quotations here.

11. Adrian Piper raised the crucial distinction between condescension and empathy at a symposium on social-change art at the Cincinnati Contemporary Art Center in June 1980.

Sweeping Exchanges:
The Contribution of Feminism to
the Art of the 1970s*

By now most people—not just feminist people—will acknowledge that feminism has made a contribution to the avant-garde and/or modernist arts of the 1970s.[1] What exactly that contribution is and how important it has been is not so easily established. This is a difficult subject for a feminist to tackle because it seems unavoidably entangled in the art world's linear I-did-it-firstism, which radical feminists have rejected (not to mention our own, necessarily biased inside view). If one says—and one can—that around 1970 women artists introduced an element of real emotion and autobiographical content to performance, body art, video, and artists' books; or that they have brought over into high art the use of "low" traditional art forms such as embroidery, sewing, and china-painting; or that they have changed the face of central imagery and pattern painting, of layering, fragmentation, and collage—someone will inevitably and perhaps justifiably holler the names of various male artists. But these are simply *surface* phenomena. Feminism's major contribution has been too complex, subversive, and fundamentally *political* to lend itself to such internecine, hand-to-hand stylistic combat. I am, therefore, not going to mention names, but shall try instead to make my claims sweeping enough to clear the decks.

Feminism's greatest contribution to the future of art has probably been precisely its *lack* of contribution to modernism. Feminist methods and theories have instead offered a socially concerned alternative to the increasingly mechanical "evolution" of art about art. The 1970s might not have been "pluralist" at all if women artists had not emerged during that decade to introduce the multicolored threads of female experience into the male fabric of modern art. Or, to collage my metaphors—the feminist insistence that the personal (and thereby art itself) is political has, like a serious flood, interrupted the mainstream's flow, sending it off into hundreds of tributaries.

It is useless to try to pin down a specific formal contribution made by feminism because feminist and/or women's art is neither a style nor a movement, much as this idea may distress those who would like to see it safely ensconced in the categories and chronology of the past. It consists of many styles and individual expressions and for the most part succeeds in bypassing the star system. At its most provocative and constructive, feminism questions all the precepts of art as we know it. (It is no accident that "revisionist" art history also emerged around 1970, with feminists sharing its front line.) In this sense, then, focusing on feminism's contribution to 1970s art is a red herring. The goal of feminism is *to change the character of art.* "What has prevented women from being really great artists is the fact that we have been unable to transform our circumstances into our subject matter . . . to use them to reveal the whole nature of the human condition."[2] Thus, if our only contribution is to be the incorporation on a broader

*Reprinted by permission from *Art Journal* (Fall–Winter 1980).

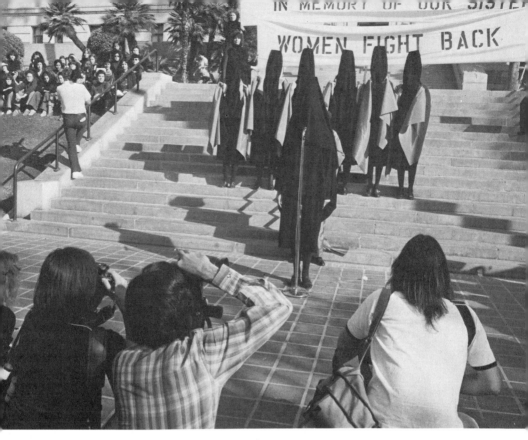

Ariadne (Suzanne Lacy and Leslie Labowitz), *In Mourning and in Rage,* media event and memorial social art performance to protest the murder of women by the "Hillside Strangler," Los Angeles City Hall, December 1977. (Photo: Susan Mogul)

scale of women's traditions of crafts, autobiography, narrative, overall collage, or any other technical or stylistic innovation—then we shall have failed.

Feminism is an ideology, a value system, a revolutionary strategy, a way of life.[3] (And for me it is inseparable from socialism, although neither all Marxists nor all feminists agree on this.) Therefore, feminist *art* is, of necessity, already a hybrid. It is far from fully realized, but we envision for it the same intensity that characterizes the Women's Movement at its best. Here, for example, are some descriptions of feminist art: "Feminist art raises consciousness, invites dialogue, and transforms culture."[4] "If one is a feminist, then one must be a feminist artist—that is, one must make art that reflects a political consciousness of what it means to be a woman in a patriarchal culture. The visual form this consciousness takes varies from artist to artist. Thus art and feminism are not totally separate, nor are they the same thing."[5] "The problem is not with people's taste (often called 'kitsch' by superior minds) but with defining art as one thing only. Art is that which functions as aesthetic experience for you. If a certain art works that way for enough people, there is consensus; that becomes art. . . . That which we feel is worth devoting one's life to and whose value cannot be proven, that is art."[6] Feminist art "is a political position, a set of ideas about the future of the world, which includes information about the history of women and our

struggles and recognition of women as a class. It is also developing new forms and a new sense of audience.''[7]

The conventional artworld response to these statements will be *what* new forms? And to hell with the rest of it. Descriptions like the above do not sound like definitions of art precisely because they are not, and because they exist in an atmosphere of outreach virtually abandoned by modernism. For years now, we have been told that male modernist art is superior because it is "self-critical." But from such a view self-criticism is in fact a narrow, highly mystified, and often egotistical *monologue*. The element of dialogue can be entirely lacking (though ironically it is *feminist* art that is accused of narcissism). Self-criticism that does not take place within or pass on out to its audience simply reinforces our culture's view of art as an absolutely isolated activity. Artists (like women) stay home (in self and studio) and pay for this "freedom" by having their products manipulated and undervalued by those who control the outside world.

A basic and painful conflict is set up when an artist wants to make art and at the same time wants to participate more broadly in the culture, even wants to integrate esthetic and social activities. Artists who work with groups, as do so many feminists, always seem to be looking wistfully over their shoulders at the studio. "I've got to get back to my own work" is a familiar refrain, because, as it stands now, art and life always seem to be in competition. And this situation produces an unusually schizophrenic artist. One of the feminist goals is to reintegrate the esthetic self and the social self and to make it possible for both to function without guilt or frustration. In the process, we have begun to see art as something subtly but significantly different from what it is in the dominant culture.

This is not said in a self-congratulatory tone. It remains to be seen whether different is indeed better. Success and failure in such unmapped enterprises are often blurred. Various feminists have already fallen into various traps along the way, among them: the adoption of certain clichés in images (fruit and shell, mirror and mound), materials (fabrics and papers), approaches ("nonelitist"), and emotions (nontransformative pain, rage, and mother love); a certain naïveté (also carrying with it a certain strength) that comes from the wholesale rejection of all other art, especially abstraction and painting; a dependence on "political correctness that can lead to exclusivity and snobbism; and, at the other extreme, an unthinking acceptance of literally anything done by a woman. Beneath these pitfalls is a need for language—visual and verbal—that will express the ways our art and ideas are developing without being sappy and without denying the powers of the individual within collective dialogue.

Nevertheless, feminist values have permeated the 1970s and are ready to flower in the 1980s, if militarism and socioeconomic backlash don't overwhelm us all. Often accepted unconsciously, these values support the opening up and out of eyes, mouths, minds, and doors—and sometimes the smashing of windows. They include collaboration, dialogue, a constant questioning of esthetic and social assumptions, and a new respect for audience. Feminism's contribution to the evolution of art reveals itself not in shapes but in structures. Only new structures bear the possibility of changing the vehicle itself, the meaning of art in society.

New? I hesitate to use the word in this context, since it, too, has been so distorted in the name of modernism: new reality, new realism, new abstraction,

and similarly, all the rigid posts: postmodernism, post-Minimalism, and post-beyond-postness. Feminism is new only in the sense that it isn't post-anything. Its formal precepts are not new at all. They are simply distributed differently from those entrenched since around 1950. Much or even most of the best art by women has turned its back on the "new," preferring to go deeper into visual forms that have been "done before" (mostly by men). When I began to write extensively about women's art, I was accused by friends and enemies of becoming a "retrograde" critic. And so long as I remained attached to the conditioning of my own art education, received primarily at the Museum of Modern Art and on Tenth and Fifty-seventh streets, I, too, was afraid of that stigma. However, the more women's work I saw, the more my respect grew for those artists who, having been forcibly cut off from the mainstream, persevered in exploring their own social realities, even—or especially—when such exploration did not coincide with the current fashions.

The more illuminating dialogues I had within ɪ ɪe Women's Movement, the clearer it became to me that the express toward the "true nature of art" had whisked us past any number of fertile valleys, paths to elsewhere, revelations, personal and social confrontations that might forever have been missed had it not been for such stubbornly "retrograde" artists, who insisted on taking the local. During this time I was constantly being told that some woman's work was derived from some far-better-known man's work. In fact, such similarities were usually demonstrably superficial, but the experience of searching for the differences proved invaluable because it undermined and finally invalidated that notion of "progress" so dear to the heart of the art market.

In endlessly different ways, the best women artists have resisted the treadmill to progress simply by disregarding a history that was not theirs. There *is* a difference, though not always an obvious one, between the real but superficial innovations of a feminist or women's art that has dissolved into mainstream concerns and the application of these same innovations to another set of values, where they may be seen as less "original." It was suggested several years ago that feminist art offered a new "vernacular" reality opposed to the "historical" reality that has informed modern art to date.[8] Given its air of condescension, *vernacular* may not be the right word (and certainly we don't want to be "hidden from history" again), but it is the right idea. The 1970s have, I hope, seen the last of the "movements" that have traipsed, like elephants trunk-to-tail, through the last century.

The notion that art neatly progresses has been under attack from all sides for years now; its absurdity became increasingly obvious with postmodernism in the early 1960s. By 1975, a not-always-delightful chaos of Conceptual Art, performance, photorealism, "new images," and what-have-you prevailed. The 1970s pluralism, decried for different reasons by both Left and Right, has at least produced a kind of compost heap where artists can sort out what is fertile and what is sterile. Bag ladies picking around in this heap find forms, colors, shapes, and materials that have been discarded by the folks on the hill. They take them home and recycle them, thriftily finding new uses for wornout concepts, changing not only the buttons and the trim but the functions as well. A literal example of this metaphor is the Chilean *arpillera,* or patchwork picture. Made by anonymous women and smuggled out into the world as images of political protest, social deprivation, crushed ideas and hopes, the *arpilleras* are the only valid indige-

nous Chilean art—now that the murals have been painted over, the poets and singers murdered and imprisoned.

You will have noticed by now that feminism (and by extension feminist art) is hugely ambitious.[9] A developed feminist consciousness brings with it an altered concept of reality and morality that is crucial to the art being made and to the lives lived with that art. We take for granted that making art is not simply "expressing oneself" but is a far broader and more important task: expressing oneself as a member of a larger unity, or comm/unity, so that in speaking for oneself one is also speaking for those who cannot speak. A populist definition of quality in art might be "that element that *moves* the viewer." A man probably can't decide what that is for a woman, nor a white for a person of color, nor an educated for an uneducated person, and so forth, which is where "taste" comes in. This in turn may explain why the "experts" have never been able to agree on which artists have this elusive "quality." Only when there are real channels of communication can artist and audience both change and mutually exchange their notions of art.

Feminists are asking themselves, as certain artists and critics and historians have asked themselves for generations, "Is this particular painting, sculpture, performance, text, photograph moving to me? If so, why? If not, why not?" In this intuitive/analytical task, the social conditioning we have undergone as women, as nurturers of children, men, homes, and customs, has its advantages. We are not bolstered by the conviction that whatever we do will be accepted by those in power. This lack can be psychologically detrimental, but it also carries with it an increased sensitivity to the needs of others which accounts to some extent for the roles that the audience, and communication, play in feminist art.

Similarly, because women's traditional arts have always been considered utilitarian, feminists are more willing than others to accept the notion that art can be esthetically *and* socially effective at the same time. Not that it's easy. The parameters for "good art" have been set; the illusion of stretching those boundaries that prevails in the avant garde is more exactly a restless thrashing around within the walls. Overtly feminist artists are always being accused of being "bad artists" simply by definition. That's not something I'm interested in responding to here, but it should be mentioned in the context of changing the character of art. Given the history of the avant garde, what on earth does "bad art" mean these days? But of course if someone isn't there to say what "good art" is—then art itself gets out of institutional hand.

Perhaps the single aspect of feminist art that makes it most foreign to the mainstream notion of art is that it is impossible to discuss it without referring to the social structures that support and often inspire it. These structures are grounded in the interaction techniques adapted (and feminized) from revolutionary socialist practice—techniques on which the Women's Movement itself is based: consciousness raising, going around the circle with equal time for all speakers, and criticism/self-criticism. From the resulting structures have evolved the models feminism offers for art. These models, I repeat, are not new ways of handling the picture plane, or new ways of rearranging space, or new ways of making figures, objects, or landscapes live; they are inclusive structures or social collages.

The history of the male avant garde has been one of reverse (or perverse) response to society, with the artist seen as the opposition or as out-of-touch

idealist. The feminist (and socialist) value system insists upon cultural workers supporting and responding to their constituencies. The three models of such interaction are (1) group and/or public ritual; (2) public consciousness raising and interaction through visual images, environments, and performances; and (3) cooperative/collaborative/collective or anonymous art-making. While it is true that they can more easily be applied to the mass-reproduced mediums such as posters, video, and publications, these models also appear as underlying esthetics in paintings, sculptures, drawings, and prints. Of course, no single artist incorporates all the models I am idealizing here, and certainly individual male artists have contributed to these notions. But since male consciousness (or lack thereof) dominates the art world, and since with some exceptions male artists are slow to accept or to acknowledge the influence of women, these models are being passed into the mainstream slowly and subtly and often under masculine guise—one of the factors that makes the pinning down of feminism's contribution so difficult. Yet all these structures are in the most fundamental sense collective, like feminism itself. And these three models are all characterized by an element of outreach, a need for connections beyond process or product, an element of *inclusiveness* which also takes the form of responsiveness and responsibility for one's own ideas and images—the outward and inward facets of the same impulse.

The word *ritual* has been used in connection with art frequently and loosely in the last decade, but it has raised the important issue of the relationship of belief to the forms that convey it. The popularity of the notion of ritual indicates a nostalgia for times when art had daily significance. However, good ritual art is not a matter of wishful fantasy, of skimming a few alien cultures for an exotic set of images. Useful as they may be as talismans for self-development, these images are only containers. They become ritual in the true sense only when they are filled by a communal impulse that connects the past (the last time we performed this act) and the present (the ritual we are performing now) and the future (will we ever perform it again?). When a ritual doesn't work, it becomes a self-conscious act, an exclusive object involving only the performer. When it does work, it leaves the viewer with a need to do or to participate in this act, or in something similar, again. (Here ritual art becomes propaganda in the good sense—that of spreading the word.) Only in repetition does an isolated act become ritualized, and this is where community comes in. The feminist development of ritual art has been in response to real personal needs and also to a communal need for a new history and a broader framework within which to make art.

Public consciousness raising and interaction through visual images, environments, and performances also insist on an inclusive and expansive structure that is inherent in these forms. This is in a sense the logical expansion of a notion that has popped up through the history of the avant garde: that of working "in the gap between art and life." Aside from an outreach branch of the "happening" esthetic in the early 1960s, this notion has remained firmly on art's side of the gap. But by 1970, feminists, especially on the West Coast, were closer to the edge of that gap than most artists; they were further from the power centers, and, out of desperation, more inclined to make the leap. Just as ritual art reaches out and gathers up archaeological, anthropological and religious data, the more overtly political art of public strategies reaches out to psychology, sociology and the life sciences. Its makers (*planners* might be a more accurate term)

work in time as well as in images, moving closer to film, books or mass media. Video and photography are often used not so much to stimulate a passive audience as to welcome an actively participating audience, to help people discover who they are, where their power lies, and how they can make their own exchanges between art and life.

Such work can take place in schools, streets, shopping malls, prisons, hospitals or neighborhoods. Among its main precepts is that it does not reject any subject, audience or context, and that it accepts the changes these may make in the art. To be more specific, a few examples: (1) A group of women of mixed nationalities living in Paris, who have done large documentary pieces including drawings, texts, photographs, and videotapes about women in prison and about Turkish and Portuguese workers at home and in economically imposed exile (see

Dan Higgins, *Pre-Renaissance Winooski, Vermont,* front and back of a postcard sent to residents, for them to comment on and thus elicit responses about the gentrification of a New England mill town. September 1981. (Original: *Winooski Diptych,* photo collage, 12" x 24", 1981.)

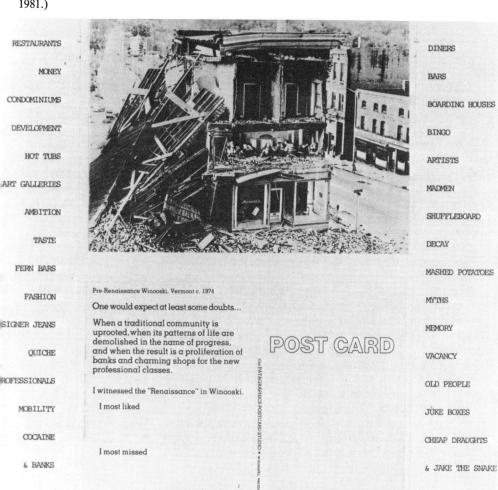

RESTAURANTS — DINERS

MONEY — BARS

CONDOMINIUMS — BOARDING HOUSES

DEVELOPMENT — BINGO

HOT TUBS — ARTISTS

ART GALLERIES — MADMEN

AMBITION — SHUFFLEBOARD

TASTE — DECAY

FERN BARS — MASHED POTATOES

FASHION — MYTHS

SIGNER JEANS — MEMORY

QUICHE — VACANCY

ROFESSIONALS — OLD PEOPLE

MOBILITY — JUKE BOXES

COCAINE — CHEAP DRAUGHTS

& BANKS — & JAKE THE SNAKE

Pre-Renaissance Winooski, Vermont c. 1974

One would expect at least some doubts...

When a traditional community is uprooted, when its patterns of life are demolished in the name of progress, and when the result is a proliferation of banks and charming shops for the new professional classes.

I witnessed the "Renaissance" in Winooski.

I most liked

I most missed

POST CARD

the PATAGRAPHICS POSTCARD STUDIO • winooski, vermont

signed September 1981

p. 129). (2) An Israeli woman trying to communicate to urban workers on the Tel Aviv waterfront the plight and beliefs of the Bedouin tribes through "desert people" costume rituals in urban workplaces (see p. 130). (3) A New York woman who made her "maintenance art" first in the home, then in office buildings, and has spent the last two years identifying with the men in the city's Sanitation Department (the "women" of the city government), recognizing their maintenance work as art by shaking hands with every member of the department (see p. 145). (4) Two women in Los Angeles who make public pieces strategically designed to change the image and media coverage of feminist issues such as rape and violence against women (see p. 150). (5) A mixed-gender group, led by a San Francisco woman, that has built a "life frame" which is simultaneously performance art, five acres of community outreach and an experimental agriculture station, making connections between animals, plants, people and art (see p. 146). (6) A group of women photographers in East London organizing child-care facilities and comparing pictures of real life with the mass-media images of women (see p. 207). (7) A man in a small economically devastated New England milltown who uses photography as a vehicle of continuing awareness to acquaint the inhabitants with their environment, with each other and with their possiblities (see p. 155). (8) Another man who mixes art and science and populism in a South Bronx storefront and calls it a "cultural concept" (see p. 181).

All these examples overlap. Much of the work mentioned above is being executed by various combinations of artists or of artists and nonartists, often anonymously or under the rubric of a collective or network or project. Some women work cooperatively—helping an individual artist to realize her vision on a monumental scale and in the process both giving to her work and getting input for their own work. Others work collaboratively, according to their own special skills, needs and concerns. And others work collectively in a more-or-less consciously structured manner aimed at equal participation, skill- and power-sharing. Each of these means helps to achieve an end result of breaking down the isolation of the artist's traditional work patterns. None precludes individual work. (I find from my own experience that the dialogue or critical/self-critical method stimulates new kinds of working methods and a new flexibility. By integrating feedback into the process, and not just as final response to the product, it also changes the individual work.)

The structures or patterns I've sketched out above are laid out on a grid of dialogue which is in turn related to the favorite feminist metaphor: the web, or network, or quilt as an image of connectiveness, *inclusiveness* and integration. The "collage esthetic" named by the Surrealists is a kind of dialectic exposing by juxtaposition the disguises of certain words and images and forms and thus also expressing the cultural and social myths on which they are based. The notion of connections is also a metaphor for the breakdown of race, class and gender barriers, because it moves out from its center in every direction. Though men are its progenitors in high art, collage seems to me to be a particularly female medium, not only because it offers a way of knitting the fragments of our lives together but also because it potentially leaves nothing out.

It is no accident that one ritual artist calls herself Spider Woman and another group calls itself Ariadne. As I was writing this essay, I read an article about the Native American ethos of total interrelationship between all things and creatures which says: "Thus, nothing existed in isolation. The intricately interrelated

Nancy Linn, *June and Avion,* from a series of color photographs made on a regular basis at the well-baby clinic of a New York City hospital; October 24, 1979; August 27, 1980; March 25, 1981.

threads of the spider's web was referred to . . . the world. . . . This is a profound
'symbol' when it is understood. The people obviously observed that the threads
of the web were drawn out from within the spider's very being. They also
recognized that the threads in concentric circles were sticky, whereas the threads
leading to the center were smooth!''[10] The author remembers his mother saying
that "in the Native American experience all things are possible and therefore all
things are acceptable" and he goes on to hope that "our societal structures and
attitudes become bold and large enough to affirm rather than to deny, to accept
rather than to reject."

I quote this not only because it expresses very clearly a conviction that lies at
the heart of feminism (and should lie at the heart of all art as well), but also be-
cause it comes from another subjugated culture to which some of us fleeing the
potential disasters of Western capitalism are sentimentally attracted. However,
the socialist feminist model does not stop at the point of escape or rejection as did
the counterculture of the 1960s. To change the character of art is not to retreat
from either society or art. This is the significance of the models I've outlined
above. They do not shrink from social reality no matter how painful it is, nor do
they shrink from the role art must play as fantasy, dream and imagination. They
contribute most to the avant garde by slowing it down. They locate a network of
minor roads that simply covers more territory than the so-called freeways. These
roads are not, however, dead ends. They simply pass more people's houses. And
are more likely to be invited in.

NOTES

1. Even *The New York Times* critic, though he fears it, is "lowering the art-
istic standards."

2. Judy Chicago, *Artforum* (Sept. 1974).

3. Surrealism was also self-described along these broad lines, and with Dada
has proved that it, too, was never a movement or a style, since it has continued to pervade
all movements and styles ever since.

4. Ruth Iskin, quoting Arlene Raven at panel on feminist art and social change ac-
companying the opening of *The Dinner Party,* March 1979.

5. Harmony Hammond, "Horseblinders," *Heresies,* no. 9 (1980).

6. May Stevens, "Taking Art to the Revolution," *Heresies,* no. 9 (1980). Many of the
ideas in this article emerged in discussions with the collective that edited this issue and
with Hammond and Stevens in particular.

7. Suzanne Lacy at panel accompanying *The Dinner Party.* See note 4.

8. Jack Burnham in the *New Art Examiner* (Summer 1977).

9. The distinction between ambition (doing one's best and taking one's art and ideas
as far as possible without abandoning the feminist support system) and competition (walk-
ing all over everybody to accomplish this) is a much discussed topic in the Women's Move-
ment.

10. Jamake Highwater, quoting Joseph Epes Brown, in an unpublished manuscript.

IV

HOT POTATOES

Prefatory Note

This part chronologically overlaps the previous one. At the same time that I was acquiring a stronger critical armature from progressive theory, I was getting increasingly angry at the art world, and at artists for perpetuating by passivity the system in which they were so powerless. A generation gap had also emerged. I was forty in 1977 and had to concede that I no longer always had the first word on the new. Twenty years of experience within an avant garde trying to exist in a system of alien values brings with it an unavoidable cynicism. Since 1975 I'd felt guiltily jaded. When I returned from England in the fall of 1978, I realized that for all my identification with and support of artists, I was sick of the art I saw in the galleries; no matter how good it was, the context was poisoning it. I was repelled by the games we were all forced to play to survive in the world we had chosen, but not chosen to control.

So the essays below are an odd combination of enthusiasm (for the steps toward activist art, for the young New Wave artists trying to break out of the system) and melancholy (for their compromises, for their futures as artists in or out of the art world, for all our futures anywhere as the Right rolled over us) and rage (at the way art is treated by the dominant classes, and the way art treats people, and the way the selfish system drains artists of their natural oppositional energies). The "Nigger Drawings" show in 1979 was a watershed for me because it split the art community (not quite down the middle), with the liberals standing up for art's right to be neutral, reactionary, offensive or dangerous, and the Left insisting that the lines be drawn in art as they are in the streets.

Charged by the socialist art I had seen in Britain, I sent out a postcard (announcing the show "Some British Art from the Left") stating the intention to begin an archive of international political art, to organize future manifestations if the interest was there. It was, and the result was PADD (Political Art Documentation/Distribution), which was officially founded in February 1980, and is treated more fully in Section VI below. At the same time I visited for the first time a socialist country—China—which was a revelation, if a confusing one. And boundaries between high and low culture began both to disappear and to take on new importance.

Hot Potatoes:
Art and Politics in 1980*

Every summer I sit down and try again to write about "art and politics." Every summer, the more the possibilities have expanded and the changes have been frustrated, the harder it gets. Despite years of "art activism" the two still crouch in separate corners of my life, teasing, sometimes sparring, coming to grips rarely, uneasily, and without conclusion or issue. Even now, when many more visual artists are informed about radical politics, when "political" or "socially concerned" art has even enjoyed a doubtful chic, artists still tend to think they're above it all and the Left still tends to think art's below it all. Within the feminist art movement as well, polarities reign, although because of its fundamental credo—"the personal is political"—they have different roots, and different blossoms.

I wrote the paragraph above in the summer of 1977, two years before the cusp of 1980, where I stand now. Things haven't changed much. Contrary to the popular image of the wild-eyed radical, artists are usually slow to sense and slower to respond to social currents. Yet perhaps in response to the anti-'60s economic backlash that has only recently reached the art world in the guise of punk and/or "retrochic," it does seem that an increasing number of young artists are becoming concerned with social issues—though often in peculiar and ambivalent ways. I tend to be overoptimistic, and at the moment am obsessed with the need to integrate ivory tower and grass roots, particularly within the "cultural" and "socialist" branches of feminism. So I could be wrong, as I was when I hoped for too much from the Conceptual third stream around 1970. But first, a little history.

A LITTLE HISTORY

Art and progressive politics as currently defined can't get together in America because they come from opposite sides of the tracks. Art values are seen by the Left as precisely bourgeois, even ruling-class, values, while even the most elitist artists often identify vaguely—very vaguely—with an idealized working class. Or perhaps painter Rudolf Baranik's way of putting it is fairer: "Art both serves and subverts the dominant class of every society. Even the most passive or subservient art is not the precise carrier of ruling class ideas, though in every way the ruling class makes an effort to make it so."[1] Art may feel trapped in the ivory tower, now and then complaining bitterly, now and then slumming for a while, but it lets its hair down selectively so only a chosen few can climb to its chamber. Politics has other things to think about and, aside from occasional attempts to knock down the tower, is little concerned with what goes on inside it. At financial crises, politics may solicit money and propaganda from art's liberal conscience, which also provides benefits, cocktails and imaginative bursts of energy until

*Reprinted by permission from *Block*, no. 4 (1981).

"too much time is taken away from the studio." Caught in the middle of all this is the socially conscious and sometimes even socially involved artist.

The American art world (aka "the art scene"), where most of these forays take place, is a curious barnacle on capitalist society that imagines itself an esthetic free agent. The art world has been wary of politics since the late '40s, when artists were in danger of being called before the House Un-American Activities Committee if their work was too comprehensibly "humanist." In 1948 a soon-to-be-famous painter and a critic jointly declared that "political commitment in our time means no art, no literature."[2] Variations on this position dominated the next twenty years, only a few holdouts insisting that "painting cannot be the only activity of the mature artist" (though continuing to support the separation between art and politics).[3]

American art subsequently became a world power precisely by severing itself from politics (read Left politics, since the center and Right status quo are just presumed to be "society" or "life"). By the late '50s, the New American Art—abstract and therefore, paradoxically, far more socially manipulable than representation—sidled forth from the tower to issue internationally impressive "breakthroughs." Those who had initially objected to its red range began to like warm colors when these could be paraded as testimony to the glories of esthetic freedom in a democracy. No one seemed to notice until the late '60s that artists had lost control of their art once it left the studio—perhaps because the whole experience was a new one. Some American artists were enjoying for the first time a general prestige. In the process of acknowledging that content in art was inseparable from form, many also fell for the next step (offered by critics who had been "political" themselves in the '40s)—that form alone was the only possible content for "important" or "quality" art. This recipe was swallowed whole in the period between Korea and Vietnam. How, after all, could pure form be political? How indeed. The problem seemed solved as the international Triumph of American Painting paralleled the triumph of American multinationals. Again, in all fairness, it should be noted that the artists themselves were rarely if ever aware of these implications, and when they were, their extraordinary esthetic achievements could be identified, as Irving Sandler has suggested, as a holding action on the threshold of resistance.[4]

All this time there was a good deal of banter about the superior "morality" of American art as compared to European art; yet political morality—ideas affecting culture from the depths rather than on the famous surface and at the famous edges—was all but invisible in the art world. For a while the yacht was too comfortable to rock, even though it was still too small to accommodate the majority of the artist population, not to mention the audience. By the mid-'60s, the small number of highly visible artists who had "made it" offered a false image of the future to all those art students rushing to New York to make their own marks, and to have nervous breakdowns if they didn't get a one-man show within the year (I say one-man advisedly, since the boys suffered more than the girls, who had been led to expect nothing and had to cultivate personal survival powers).

Throughout the '60s a good healthy capitalist dog-eat-dog competition flourished with the free-enterprise esthetic. More-or-less abruptly, at the end of the decade, reaction set in, taking the form of rebellion against the commodity the art object had involuntarily become. Conceptual Art was conceived as a democratic means of making art ideas cheap and accessible by replacing the con-

ventional "precious object" with "everyday" or "worthless" and/or ephemeral mediums such as typed sheets, Xeroxes, snapshots, booklets, streetworks. Conceptualism coincided for obvious reasons with the conscientious downward mobility of the counterculture and the theoretical focus of the often academic New Left. It was crowded in the streets in 1970, what with the Blacks, the students, the antiwar movement, the feminists, the gays. Art felt like one of the gang again, rubbing elbows with the masses, fighting a common enemy. After all, despite the elitist fate of their art, artists can all too easily identify with oppressed minorities whose civil rights are minimal.

But wait. The enemy looks familiar. It is The Hand That Feeds Us. We were picketing the people we drank with and lived off of. We were making art in a buyer's market but not a consumer's market. We were full of "mixed feelings," because we wanted to be considered workers like everyone else and at the same time we weren't happy when we saw our products being treated like everyone else's, because deep down we know as artists we *are* special. What we (artworkers) wanted, and still want, as much as control over our labor power and over the destiny of our products, was *feedback*. Because art is communication, and without contact with its audience it becomes the counterpart of a doorhandle made on a Detroit assembly line. (I have this vision of a '90s artist seeing a film of a SoHo gallery in the '70s and finding herself unable to recognize her own work—just as the factory worker would not be able to distinguish her doorhandle.)

A little dissent goes a long way in the art world. By 1972 the ranks were dissolving back into the white-walled rooms. Pluralism reigned and there was more room at the top. For the most part this pluralism was healthy, though attacked from the right as a fall from grace, too democratically open to mediocrity; and from the left as a bribe, too tolerant of anything marketable, a confusion of the issues. Dissent was patronized, patted on its ass and put in its place. Those who were too persistent were ghettoized or, more subtly, discredited on levels they were never concerned with. After a brief flurry of Women's Art and Black Art shows, the institutions subsided to prepare for a backlash campaign, like exhibiting the Rockefeller Collection to commemorate the Bicentennial. Yet one thing that the art activism of the late '60s and the increased (if intermittently applied) theoretical awareness of the '70s did accomplish was a fairly thorough purge of the "my art is my politics" copout, which encouraged Business as Usual and blocked all avenues (or alleys) to change. Many of us were aware by then that every move we made was political in the broad sense, and that our actions and our art were determined by who we were in the society we lived in. (This is not to say that most of us cared to think about these insights.) We were also beginning to realize that Conceptual Art (the so-called movement, not the third-stream medium) had, like the dress and lifestyles of the period, made superficial rather than fundamental changes, in form rather than in content. When we trooped back into the galleries, back to a SoHo already cluttered with boutiques and restaurants its residents couldn't afford (a far cry from the Artists Community envisioned around 1968), we bore this new burden of awareness. We could no longer seriously contend that because art tends to be only indirectly effective, artists should be exempt from all political responsibility and go bumbling on concerned only with their own needs. (Yet again, this is not to say that most of us cared to act on these insights.)

IF MY ART ISN'T MY POLITICS, WHAT IS?

One point at which art and politics meet is in their capacity to move people. Even though communication with nonbuying or nonwriting viewers is an unpopular or unconsidered goal in the high art world, art that has no one to communicate with has no place to go. Contemporary criticism has offered no solid analyses of the artist's exile status, nor any sophisticated notion of art's audience—either present or future/ideal. We might get further faster by asking ourselves as artists and artworkers: Who are we working for? The accepted avant-garde answer has long been "for myself," and "for other artists." These responses reflect the rugged individualist stance demanded of American (male) artists and the fundamental insecurity of an artist's existence in a society that tolerates but does not respect cultural activities and practically denies the existence of cultural *workers.* Reaching a broader public, aside from its populist correctness *and* aside from the dangers of esthetic imperialism, might revitalize contemporary art by forcing artists to see and think less narrowly and to accept ideological responsibility for their products. By necessity, the feminist art community has made important moves toward a different conception of audience. Perhaps this is what Jack Burnham meant when he saw feminism as offering a potentially "vernacular" art to replace the "historical" art that has dominated modernism.[5] (My dictionary's first definition of *vernacular* gave me pause: "belonging to homeborn slaves.") Although it was still possible in 1977 for *Studio International's* special issue on "Art and Social Purpose" to ignore feminism, this has been a central concern of the most original feminist artists and writers for some time. Feminist artists are luckier than most in that we have a constant dialogue between a network of intimate art support groups and the rest of the Women's Movement, which is dealing with nonart issues in the real world. (An example is the current campaign in New York of Women Against Pornography.)

Yet the "high" or commercial art world's lack of respect for a less than classy audience whose tastes differ from its own continues to be conveyed through its patronizing (and, alas, matronizing) accusations that any popular work is "rabble-rousing" and "crowd-pleasing." The institutional reception, or lack thereof, given Judy Chicago's monumental and cooperatively executed sculpture *The Dinner Party,* and the overwhelming enthusiasm it has sparked in nonartworld audiences, is a significant case in point, which I've treated at length elsewhere. Suffice it to say that the notion that elitism is necessary to the survival of Quality is tendered by the same liberals who deny all evidence of repression in America and continue to extoll the perfection of a capitalist democracy.

For all the global village internationalism supposedly characterizing the '70s, in 1979 most artists are still working for exactly the same economically provincial audience. "It's a free country." We are supposed to recognize that personal tastes differ. In the high art world, however, Quality *is* the status quo. It is imagined to be permanently defined by those controlling the institutions. While stylistic pluralism had been encouraged in the '70s, deeper divergences from the mainstream are still not tolerated. Given the reigning criteria by which lousy art cast in the proper mold or accompanied by the proper prose is consistently hung, bought, approved by the most knowledgeable professionals, the issue of Quality seems irrelevant. Since Quality comes from art, and not vice versa, the question is: How do we arrive at an art that makes sense and is available to more, and to

more varied people, while maintaining esthetic integrity and regaining the power that art must have to provoke, please, and mean something?

For better or for worse, most people go through life without even wanting to reach the inner sanctums where Art coyly lurks. What the ruling class considers "low art" or "bad art" plays a role in the lives of many more people than "high art" does, and it is this need that new art is trying to tap. Right now, only the lucky few get "good art" or are educated to recognize it, or decide what it is. (Recently feminists, Marxists and Third-World artists have been trying to reeducate ourselves in order to avoid seeing with the conditioned eyes of the white capitalist patriarchy.) But are we really so lucky? How much of the avant-garde high art we see gives us profound sensuous or intellectual pleasure? How often do we lie to ourselves about our involvement in the art we have convinced ourselves we should like? How many sensible middle-class people devoted to the survival of "good taste," as intoned by the powers that be, secretly pine for the gaudy flimsiness, the raucous gaiety of "lower-class" culture? Judging from the popularity of such art from other, more "primitive" or ancient cultures, of Pop Art, "camp" and the whole punk or New Wave phenomenon—quite a few.

IS THERE ART POST LIFE?

In the '70s it became critically fashionable to call art "post" anything that peaked in the '60s: "poststudio," "post-Conceptual," "postmodernist," "post-Minimalist," even "postmodern." (Where does *that* leave us?) Maybe in the '80s we'll just find out that "beyond" was nothing but a vacuum. Or a void—as in a *tabula rasa,* which is not a bad thing, especially when things need cleaning up as badly as they do now. For some of us who lived through the '60s and have spent the last ten years waiting for the '70s to stand up and identify itself, the '70s have been the vacuum. It was only in its last three years or so that the decade got it together to pinpoint an esthetic of its own, and this it did with a lot of help from its friends in the rock music scene, not to mention S & M fashion photography, TV and movie culture, *and* a lot of '60s art ideas conveniently forgotten, thus now eligible for parole. As we verge on the '80s, "retrochic"[6]—a reactionary wolf in countercultural sheep's clothing—has caught up with life and focuses increasingly on sexist, heterosexist, classist and racist violence, mirroring, perhaps unwittingly, the national economic backlash.

(Some parenthetical examples of retrochic, in case it hasn't spread as far as I'm afraid it has: An exhibition of abstract drawings by a first-name-only white artist gratuitously titled "The Nigger Drawings" for reasons so "personal" he is as reluctant to murmur them as he is to wear blackface in public; this was studiously defended as a "revolutionary" position by a young Jewish critic who has adopted a pen name associated with Prussian nobility. Or a male Canadian rock group called "Battered Wives," which sings a song called "Housewife"— "She's a housewife/Don't know what to do/So damn stupid/She should be in a zoo." Or a beautifully executed and minutely detailed "photorealist" painting called *The Sewing Room* dedicated to some poor soul named Barbara, which depicts a pretty middle-class sitting room in which a work-clothed man gorily stabs the lady of the house in the neck.)

While most of the hot potatoes seem to have cooled to an acceptable tem-

perature and been made into a nice salad, some still seem to see the retrochic trend as a kind of ecstatic but dangerous drug not everybody has the guts to try. It has been called a "DC current that some people pick up on and others don't," that combats "'60s tokenism" and is "too hot to handle."[7] Some retrograde punk artists share with the Right Wing an enthusiasm for the '50s, which are seen as the Good Old Days. They are either too young, too insensitive or too ill-informed to know that the '50s were in fact Very Bad Old Days for the Left, Blacks, unions, women (viz. the crippling and deforming fashions like stiletto heels, long tight skirts and vampire makeup) and for anyone else McCarthy cast his bleary eye on. The earth-shaking emergence of rock'n'roll notwithstanding, it was also a time of censorship in the arts, of fear and dirty secrets that paved the way for the assassinations, open scandals and quasi revolution of the '60s.

Punk artists—retro and radical—also trace their bloodline back to Pop Art and Warhol (though the latter epitomized the scorned '60s) and to Dada (though it's not fair to blame a partially socialist movement for its primarily reactionary offspring). The real source of retrochic is probably Futurism, which made no bones about its fundamental fascism and disdain for the masses. Violence and bigotry in art are simply violence and bigotry, just as they are in real life. They are socially dangerous, not toys, not neutralized formal devices comparable to the stripe and the cube. So I worry when a young artist whose heart and mind I respect tells me he's beginning to like the reactionary aspects of punk art because he sees them as a kind of catharsis to clear the decks and pave the way for change in the art world. At this point, as in the idealization of the '50s, I become painfully aware of a generation gap. The anticipated catharsis sounds like the one I was hoping for in 1969 from Conceptual Art and in the '70s from feminist art.

I hope retrochic is not the banner of the '80s, but merely the '70s going out on an appropriately ambiguous note, the New Wave rolling on and leaving behind an ooze primed for new emergences. I have nightmares about a dystopian decade dominated by retrograde fascist art which, while claiming on one hand to be "space age social realism"[8] manages on the other hand to be just Right for up-and-coming extremists, for those people who simultaneously get off on and morally condemn violence and bigotry. The living rooms of the powerful, however, will not be hung with blurry photos of gum-chewing, sock-hopping terrorists torturing each other. The establishment's taste in politics and art does not coincide any more than does that of the artists themselves. With a nod to upward mobility, one can probably expect to find hanging over these mantels the same good solid bluechip formalism associated with the '50s and '60s, which continued to be successfully promoted and sold throughout the '70s. Inflation encourages such acquisitions, and the SoHo boutique mentality will maintain its strongholds. Or perhaps the art of the '80s will be a hybrid of the '70s progeny: impressive acres of colored canvas and tons of wood and steel functioning as covers for safes full of money and dirty pictures, with giveaway titles like *Snuff, Blowupjob, Monument to a Rapist, Faggot Series, Kike I, Kike II, Kike III,* and so forth—a charming and all-too-familiar blend of the verbally sensational and the visually safe.

There is, I'm glad to report, another, more hopeful side to all of this, which is subtly entwined with the above. The pivot is an ambiguous notion of "distancing." We critics have been talking about "distancing" or "detachment" or good old "objectivity" with admiration since the early '60s, applying it in turn to Pop Art, Minimalism, Conceptual Art, and now to performance, video, photog-

raphy and film. Irony is usually an ingredient, and if we're seeking a *tabula rasa,* irony is a good abrasive. But irony alone, irony without underlying passion, becomes another empty formal device. Today *distancing* is used two ways, which might be called passive and active. Distinguishing them is perhaps the most puzzling aspect of today's esthetic and moral dilemma.

The passive artists tend toward the retrochic extreme. They are sufficiently "distanced" (or spaced out) to see offensive racist or sexist words and images as a neutralized and harmless outlet for any perverse whim; after all, it's only Art. (They are not usually so far gone, however, as to use such epithets outside of the art context—in the subway, for instance.) These artists would subscribe to the formalist maxim "If you want to send a message, call Western Union," and they tend to have great disdain for old-fashioned radicals (like me) who take such things seriously.

The active artists also use distancing as an esthetic strategy, but to channel social and personal rage, to think about values, to inject art with precisely that belittled didacticism. Instead of calling Western Union, these artists hope that they will be able to put their message across by themselves. They often use understated satire or deadpan black humor to reverse offensive material and give it a new slant. The younger they are, the rougher they get, and sometimes the cycle reverses itself and it's difficult to distinguish earnestness from insanity.

Passive or active, the crux of the matter is how do we know what's intended? We're offended or titillated or outraged; now we have to figure out whether it's satire, protest or bigotry, then whether the intended content has been coopted by its subject matter. These are questions that must be asked about much of the ambiguous new art. These are questions particularly important for feminists working against, say, pornography and the violent objectification of women, and Blacks working against racists in liberal clothing.

For example, when a woman artist satirizes pornography but uses the same grim images, is it still pornography? Is the split beaver just as prurient in a satirical context as it is in its original guise? What about an Aunt Jemima image, or a white artist imitating a Black's violent slurs against honkies?

Answers, though not solutions, have just been proffered by two leading and very different practitioners of social irony. Yvonne Rainer, who works from a Brechtian viewpoint, treated sex and female nudity with humor and "distance" in her films until she realized from audience responses that the strategy wasn't working. At that point she became convinced, according to Ruby Rich, "that no matter what techniques surrounded such a depiction, no matter what contradictions were embedded in the presentation, nothing could ever recoup the image of a woman's body or sexuality bared."[9] Similarly, Black stand-up comedian and pop hero Richard Pryor has just vowed publicly to give up a staple of his routines: the word *nigger.* "There was a time," he says, "when black people used it as a term of endearment because the more we said it, the less white people liked it, but now it seems the momentum has changed. . . . There's no way you can call a white person a nigger and make him feel like a black man." Asked why whites are getting so fond of the word, he replied, "I don't think enough of them have gotten punched in the mouth."[10]

Distancing, it seems to me, is effective only if it is one half of a dialectic— the other half being approaching, or intimacy, or optimism. You move away to get a good look but then you move back toward the center where the energy is.

"The Manifesto Show," 5 Bleecker Street, New York City, Spring 1979. (Photo: Vincent Falci)

This seems to be the position of a number of younger artists whose often para-punk work bears some superficial (and perhaps insidious) resemblance to retro-chic. An increasing number are disillusioned with what they have found in art and the art world (including the alternate spaces and the current dissenters): "Embrace fearlessness. Welcome change, the chance for new creation. . . . There is no space for reverence in this post-earthrise age. We are all on the merit system. The responsibility for validity is the individual artist's. The art critic is dead. Long live art."[11] To which I would holler Hallelujah, but not Amen.

Some young artists are working collectively, making art for specific installations, public places, or for their own breezy, often harsh little shows in flaky impermanent spaces (the model for which may have been Stefan Eins' idealistic if not always fascinating 3 Mercer Street Store, and now his more fully developed Fashion Moda in the South Bronx). One of the most talked-about exhibitions last season in New York was "The Manifesto Show," collaboratively organized and open to friends, invitees, and off-the-street participation, through which it organically almost doubled in size. There was no single, recognizable political line, but a "social and philosophical cacophony"[12] of specific statements, rhetoric straight and rhetoric satirized, complaints, fantasies, threats—some more and some less geared to current art attitudes. Distancing techniques were used against themselves in self-referential hooks into content from art, as in Barbara Kruger's contribution, which began: "We are reading this and deciding whether it is irony or passion/We think it is irony/We think it is exercising a distancing mechanism. . . . We are lucky this isn't passion because passion never forgets." There were also the unselfconscious, atypically straightforward works that said what they meant and meant what they said. And there were Jenny Holzer's dangerously

conventional collages of contradictory propaganda with lethal reminders built in for anyone who swallows them whole ("REJOICE! OUR TIMES ARE INTOLERABLE. TAKE COURAGE FOR THE WORST IS A HARBINGER OF THE BEST . . . DO NOT SUPPORT PALLIATIVE GESTURES: THEY CONFUSE THE PEOPLE AND DELAY THE INEVITABLE CONFRONTATION. . . . THE RECKONING WILL BE HASTENED BY THE STAGING OF SEED DISTURBANCES. THE APOCALYPSE WILL BLOSSOM"). The message seems to be Think for Yourself.

THIS UP AGAINST THAT

Those invested in a perpetual formal evolution in art protected from the germs of real life won't like my suspicion that the most meaningful work in the '80s may depend heavily on that still pumping heart of twentieth-century art alienation— the collage esthetic, or what Gene Swenson called "The Other Tradition." Perhaps it will be only the alienated and socially conscious minority that will pursue this, and perhaps (this demands insane heights of optimism) the need for collage will be transcended. Obviously I mean collage in the broadest sense, not pasted papers or any particular technique but the "juxtaposition of unlike realities to create a new reality." Collage as dialectic. Collage as revolution. "Collage of Indignation."[13] Collage as words and images exposing the cultural structure of a society in which art has been turned against itself and against the public.

For instance, the media strategies for public performance used by West Coast feminists Suzanne Lacy and Leslie Labowitz (with the "social network" Ariadne) juxtapose two kinds of image within the context of street, shopping mall or press conference.[14] The first is an image of social reality as we all know it through TV and newspapers. The second is that image seen through a feminist consciousness of a different reality—for instance, looking at the media coverage of the Hillside Strangler murders in Los Angeles, analyzing its sensationalism and demeaning accounts of the victims' lives, then offering an alternative in the form of a striking visual event (*In Mourning and in Rage,* see p. 150) and controlling the subsequent media interpretations. The public thus receives, through art, information contrary to that which it sees as "the truth" and receives it in a manner that is sufficiently provocative visually to encourage reconsideration of "the truth." Ariadne's media strategies obviously have limited means at their disposal, but their performances have played to audiences of thousands and have an imaginative impact only professional artists can bring to bear.

The attraction of a collage esthetic is obvious when we realize that most of us, on the most basic level, exist in a downright Surrealist situation.

Consider the position of any artist in a society that perceives art as decoration or status symbol, investment or entertainment.

Consider the position of a visionary artist in a society devoted solely to material well-being.

Consider the position of a person making impermanent objects of no fixed value in a time of inflation and hoarding.

Consider the position of an artist laboring under the delusion that individuality is respected in an age of bland, identical egos and homogenized culture.

Perhaps most Surrealist of all, consider the position of a feminist/ socialist/populist artist in a patriarchal capitalist marketplace.

NOW WHAT?

After the pluralism of the '70s, the '80s are going to have to make art that stands out in sharp relief against our society's expectations for art. Artists are just beginning to understand the flood of new mediums available, after a decade of enchantment with their novelty. Comprehension of "the nature of the medium" may sound like an echo of formalist dogma, but if the medium is one whose nature is *communication*—the video, the street performance, posters, comic strips, graffiti, the ecologically functional earthwork, even photography, film and that old but new-for-the-visual-artist medium, the book—then such comprehension may have more impact on audience and on art. We are supposed to have grown up absurd already. Yet through the '70s I've asked myself why the hell these new mediums were the vehicle for so little socially concerned art. If there is all this rebelliousness and unease among young artists about how the art world treats art (and there is), why are such appropriately outreaching mediums so little explored and exploited? Why is there such a dearth of meaningful/provocative and/or effective public art? Has distancing gone too far? Have we gotten Carried Away? Space Age objectivity over our heads? Over and out?

I hope we're not just doomed to follow the bouncing ball through endless cycles of romanticism/classicism, subjective/objective, feeling/intellect, etc. If the '60s proved that commitment didn't work, the '70s proved that lack of commitment didn't work either. The '80s decade is coming into a legacy of anxiety, of barely articulated challenges to boringly predictable mainstream art. It is going to have to restore the collective responsibility of the artist and create a new kind of community within, not apart from, the rest of the world. The danger on all esthetic fronts is the kind of factionalism that already divides the politicized minority within the art world. Too many of us spend our time attacking everyone else's attempts at relevance while paranoiacally guarding our own suburban territories. There is an appalling tendency to insist on the need for theoretical understanding of the artist's position in a capitalist society and simultaneously to destroy by "logic" every solution offered. It is all too easy for any intelligent observer to be devastatingly cynical about Marxists making abstractions, artists made vulnerable by working at the same time in communities and in museums, feminists riding the Women's Movement to commercial success and getting off there. The denial of support to an artist or a group who is trying to work out of this dilemma we all share, the kvetching about presentation, form, and motivation when it appears that communication *is* nevertheless taking place—all this merely recapitulates the competition that maintains the Quality-based "high-art" world.

Merely opportunist as some of it may be, art with overtly social content or effect still poses a threat to the status quo. And, ironically, no group is so dependent on the status quo as the avant garde, which must have an establishment to attack, reverse, and return to for validation. It is true that most politically aware artists and artworkers would sooner give up politics than give up art. Embedded in the whole question of why more visual artists aren't more committed to combining form and content in more interesting ways is the taboo against "literary" art. Artists emphasizing words and ideas over formal success have been seen since the '60s as traitors to the sacred modernist cause; just as the Dadas and Surrealists are not considered serious contributors to modernism even when their

contributions are considered serious. This sort of prejudice has been blurred by the mists of pluralism, but it remains as subtle conditioning. Because visual art *is* about *making* things (even if those things have no "pictures"). And this is what visual artists justifiably don't want to give up. In the late '60s we got sidetracked by the object/nonobject controversy. Sheets of paper and videotapes, though cheaper than paintings and sculptures, are still objects. Conceptualism, we know now, is no more *generically* radical than any other ism, but it's no less art.

Another major question we have to ask ourselves as we enter the '80s is: Why is it that culture today is only truly alive for those who make it, or make *something?* Because making Art, or whatever the product is called, is the most satisfying aspect of culture? Its subsequent use or delectation is effective only to the extent that it shares some of that intimacy with its audience? Even as a critic, I find that my own greatest pleasure comes from empathetic or almost kinesthetic insights into how and why a work was made, its *provocative* elements. So the necessary changes must broaden, not merely the audience, but the makers of art (again a fact the feminist art movement has been confronting for some time over the issue of "high," "low," craft and hobby arts). Maybe the ultimate collage is simply the juxtaposition of art and society, artist and audience. Maybe that's what a humanist art is: it comes in all styles and sizes, but it demands response and even imitation. It is alive.

John Fekner, from *Queensites,* stencil on city surfaces, 1980–81. Fekner "captions" the destruction of the urban environment with his giant hit-and-run stencil works. (Photo: John Fekner)

For the vast majority of the audience now, however, culture is something dead. In the '50s the upwardly mobile bourgeois art audience (mostly female) was called the *culture vultures*. They didn't kill art but they eagerly devoured it when they came upon its corpse. As Carl Andre has observed, art is what we do and culture is what is done to us. That fragile lifeline of vitality, the communication to the viewer of the ecstasy of the making process, the motive behind it and reasons for such a commitment, can all too easily be snapped by the circumstances under which most people see art: the stultifying classist atmosphere of most museums and galleries and, in the art world, the personal intimidation resulting from overinflated individual reputations.

What, then, can conscious artists and artworkers do in the coming decade to integrate our goals, to make our political opinions and our destinies fuse with our art? Any new kind of art practice is going to have to take place at least partially outside of the art world. And hard as it is to establish oneself in the art world, less circumscribed territories are all the more fraught with peril. Out there, most artists are neither welcome nor effective, but in here is a potentially suffocating cocoon in which artists are deluded into feeling important for doing only what is expected of them. We continue to talk about "new forms" because the new has been the fertilizing fetish of the avant garde since it detached itself from the infantry. But it may be that these new forms are only to be found buried in social energies not yet recognized as art.

NOTES

1. In conversation with the author. In this and other conversations and writings over the years, Baranik has been a rational/radical voice in my art-and-politics education.

2. Robert Motherwell and Harold Rosenberg in *Possibilities,* no. 1 (Winter 1947–1948).

3. Ad Reinhardt, *Arts and Architecture* (Jan. 1947). Many of the ideas in this article have their sources in Reinhardt's ideas and personal integrity.

4. Irving Sandler, *The Triumph of American Painting* (New York: Praeger, 1970). Max Kozloff, William Hauptman and Eva Cockcroft have illuminated the ways in which Abstract Expressionism was manipulated during the Cold War in *Artforum* (May 1973, Oct. 1973, and June 1974).

5. "Patriarchal Tendencies in the Feminist Art Movement," *The New Art Examiner* (Summer 1977).

6. I don't know who coined the term *retrochic,* but it was used frequently during the controversy over the "Nigger Drawings" show in March–April 1979.

7. Douglas Hessler, letter to the editor of the *SoHo News* (June 21, 1979) in response to a piece by Shelley Rice (June 7, 1979), which bemoaned the prevalence of "apolitical sophistication."

8. J. Hoberman, "No Wavelength: The Para-Punk Underground," *The Village Voice* (May 21, 1979).

9. Quoted in the *New Art Examiner's* special issue on "Sexuality" (Summer 1979).

10. Quoted by Richard Goldstein in *The Village Voice* (July 23, 1979).

11. Lauren Edmund, review (in the spirit of) "The Manifesto Show," *East Village Eye* (June 15, 1979).

12. Peter Frank, "Guerrilla Gallerizing," *The Village Voice* (May 7, 1979), p. 95.

13. "Collage of Indignation" I and II were the titles of two separate antiwar exhibitions in New York, in 1967 and 1970–1971; see p. 29.

14. For more on Ariadne, see *Heresies,* no. 6 (1978), and no. 9 (1980).

Rejecting Retrochic*

Visual artists in this culture tread a thin line, like drivers arrested after one martini. We have this myth that artists are wild, woolly and free—and politically radical. We have this reality that artists are isolated in studios and artworld bordellos and tend to be either unaware or downright conservative. The vectors meet in a middle ground occupied by the art audience. But the audience is invisible to most artists, and in that simple fact lies one of the great failures of modernist art. This basic alienation has, paradoxically, increased since art has entered the fringes of popular culture. These days the audience is being subjected not only to the usual indifference from the art majority, but also to a wave of hostility from an art minority which has been called *retrochic*.

Retrochic is not a style (though it is often associated with "punk art"). It is a subtle current of reactionary content filtering through various art forms. Its danger lies not so much in its direct effect on the art audience as in its acceptance by the art world itself. Too many artists and artworkers seem blissfully unaware of the social ramifications of the notion that art is so separate from life, so neutral in its impact, that Anything Goes in the Galleries because it's Only Art.

Retrochic offers a particularly overt example of how art is seen and manipulated in this society. In the process it becomes an unwitting tool of the very powers it seems to think it's repelling, part and parcel of the national economic backlash against reproductive rights, social welfare and human rights. Neutrality is just what the doctor ordered for the corporate classes controlling art (and the rest of the world). It keeps artists as safely ensconced in their small puddle as nonunionized workers are kept isolated on their assembly lines. As the product of a complex psychological current, retrochic was perfectly described by the punk rock group Devo: "The position of any artist is, in pop entertainment, really self-contempt. Hate what you like, like what you hate. It's a totally schizophrenic position, but that in itself is a principle that most people in the business and outside it don't understand."

So how did Art—popularly associated with communication, enlightenment and uplift—get into this predicament? Precisely by rejecting the "real" and distastefully "commercial" framework within which it operates and turning inward to the point where it no longer knows who its audience is, and by hating that audience it doesn't know for not knowing it.

Art has a kind of permanent innocence in this culture. We expect very little of it. We expect *nothing* of it. We expect *everything* of it. Depending on who we are. Who are we? Who is the art audience? I once called all the major museums in New York City to see if they had done audience profiles. They hadn't. But of course window-shopping—which is what art is about for most people—is not taken too seriously in the real world of Big Business that administers the museums and makes sure what is shown there is oriented to the right people—to the public, but not to the gum-chewing public. The art gallery audience, on the other hand, is in training to be able to swallow anything. And retrochic art is sufficiently

*First published as "Retrochic, Looking Back in Anger" by *The Village Voice,* Dec. 10, 1979, and reprinted by permission.

"distanced" (or spaced out) to see racism, sexism and fascism not as content, but as harmless outlets for a kind of disco destructiveness that feeds the art world's voracious appetite for anything consumable.

Sometimes it's the ad that's retro. What, for example, was the "Talking Legs" exhibition? I'll never know because I refused to go and see; the announcement featured a pair of high-heel-booted, garter-belted female legs cut just above the crotch and standing over a toilet seat. Sometimes it's the title that's retro, as in the now notorious "Nigger Drawings" show in which the racist title was the only provocative aspect of a group of pleasant abstract drawings. And sometimes it's the art. The item that made me maddest last season was not "punk" but its suburban cousin: photorealism. The announcement showed a lovingly executed painting of a pretty upper-middle-class living room in which a work-clothed man is stabbing the lady of the house in the neck. Beautiful little drops of blood and all. It is called *The Sewing Room,* is dedicated "to Barbara," and was described in the press release as "color-coordinating an erotically charged narrative situation." (This has to come to you from the people who have not read the extraordinary letter in the *Village Voice,* October 22, 1979, which once and for all destroys the association of sex with rape, and by extension, with murder.) This painting, the blurb continued, was intended to "keep us cool by perfectly orchestrating layers of surface and narrative." It didn't keep *me* cool. Nor did a letter from the dealer, who was surprised by my lack of cool, denying the press release's neutral tone by insisting that this painting was a "pro-feminist statement"!

She did, however, ask two interesting questions. First, wouldn't I go see this kind of scene in the movies? (Absolutely not; while I don't always know ahead of time what I'm getting in the movies, I was forewarned here, and boycotted the show.) Second, would it be "more agreeable" to me if it had been painted by a woman? (I thought about this one before answering no again, and also wondered what woman would be able to stand the emotional trauma of working for three years on such an image, as the male artist did.)

The climate is so foggy nowadays that any artist whose work incorporates a newspaper headline, or even a photograph—especially a sleazy, grainy one—is immediately considered "political." But what politics? Speaking to whom and to what end? Mostly to nobody and to no end. Because it's not politics. It's art. And art is above it all . . . isn't it? If it's okay to use racist slurs and sexist violence, then why are esthetic taboos still exerted against "political" images taken past the artist's personalized cocoon and into arenas such as inflation, housing, starvation or rape? Because we all supposedly know about all that stuff already?

That "look of concern" communicated by rough typography, banal advertising images, and blurry, pseudoporn photographs is blatantly ambivalent as well as highly ambiguous. Which is where the audience comes in—the audience as everybody not making the work in question. Since audience and artist have no contact, no dialogue is possible, and we are left with that familiar question: What does it Mean? I happen to be personally attracted to the nonslick "look of concern." I look more closely. I see a guy in leather pointing a gun at me. I see Black people running down a street. I see a half-nude woman cringing in a corner. What am I seeing? Is this parody? Feminist satire? Gimmicky advertising? Cinéma vérité? Is the artist a fascist or a Marxist or nothing? Is s/he shrewdly wallowing in "politically incorrect" imagery while claiming to be "politically correct" in some subtle (read incomprehensible) way?

Since it's art—not photojournalism—there are usually no captions to such images, and sometimes there are titles that sound like rock groups or boutiques which either neutralize or are neutralized by the image. Compare the "Nigger Drawings" episode with the recent banning of a phototext work from a General Services Administration (GSA) exhibition in Washington, D.C. The photos were acceptable but the text ("a narrative indictment of military government, unequal distribution of wealth, violations of human rights and U.S. business involvement in South America") was unacceptable. When it was suggested that the photos be shown without text, Isabel Letelier, widow of the murdered Chilean diplomat, protested that "without the explanation, they are just lovely colorful pieces of work that have no point. That is exactly what Latin America is for the tourists who have no explanation."

And that is exactly what art is supposed to be. When art is not seen as communication on any level, when art becomes a blunt weapon with which to beat people on the head for no reason but one's own enjoyment (as in retrochic) rather than a sharp instrument of perception, analysis and "eye-opening" of one kind or another, then it becomes almost inevitable that art will be coopted by the status quo and become a neutralized symbol divorced from life, work and human need. In a period when everybody had better be thinking quick about what to do next about the world, art has been backed into a corner where artists are "allowed not to think" (as opposed to "not being allowed to think," which we condemn in other societies). This taboo effectively keeps artists out of the way and at the same time allows the present single-class buying art audience to mold it and its uses. The retrochic artist, thrashing around in the nursery like a spoiled child, is the latest version of the artist as divine idiot, neither respected nor paid, but kept docile on a daily dose of Ego.

I'm enough of an old-fashioned moralist to think art should offer a critique of the society it rides on and through, that part of its responsibility is to do so in collaboration with its audience. The critique can be done in as many ways as there are individual imaginations. But it does demand that the maker think about where an artwork goes next, to whom it is meant to mean what, and for what it is to be used. If artists won't take responsibility for art, who will? (Three guesses.) If your art incorporates an exploitative photograph of a woman being murdered, can you really get away with saying "I don't know why I chose that image; it just *came* to me." (From where?) Or "I liked the diagonal her leg made. I liked the gesture. I was using the red of the blood to bring the illusionistic space up to the picture plane"? I know art speaks for itself. I know art says things you can't say in words. That's one of the things I like about art. On the other hand, I don't believe that visual language has hit such a poverty level no one is willing to admit it ever says *anything*. Even the most convinced formalist, Minimalist or post-whatsis should know what s/he really means on some fundamental level. And if what s/he means is fundamentally fascist, I'd like to see this recognized, questioned, and rejected by the art audience.

Martha Rosler, a West Coast Marxist feminist who makes narrative photo-text pieces, videos and performances—and is very clear about what they mean—sees them as "decoys" that "mimic some well-known cultural form so as to strip it of its mask of innocence." Ironically, this is the same esthetic ploy used by the retrochic artists whose work comes down on the far right. Sometimes the decoy is intentionally ineffective. Sometimes the decoy is too effective; the audience is

fooled and gets shot down. Rosler and a few others (mostly working on the West Coast) escape this kind of self-imposed backlash because they are aware of the crucial relationship between audience and art and of the way the audience is manipulated by the art that is available to it.

There is also a growing number of still younger artists who are concerned with this state of affairs. Some are working on the fringes of the art world, having been initially attracted to it by a notion of art they have since found to be a mirage. Others are even less visible as they try to make art in a different context altogether. They are responsible for posters like that showing the Pope before a firing squad as antidote to the mass hysteria of the papal visit. They are responsible for some street pieces, store windows, artists' books, performances, actions, open studios and scruffy artist-organized shows. And for Stefan Eins' Fashion Moda in the South Bronx, which is the only *alternate* space in town that deserves the name it rejects. They are responsible for outreach placement of relatively conventional art objects like John Ahearn's painted plaster heads of local residents in a South Bronx Con Edison office and for public works like Jenny Holzer's anonymous aphorisms, which I happen to think make good "political" art because I happen to think I get the point, though they, too, have a touch of the violence I fear. Like Nicole Gravier's very different media pieces recently shown at Franklin Furnace, Holzer's lists of slogans make me-the-audience *think,* about myths and clichés and propaganda and the slogans I use myself. What I like about this and other such work is that the irony is embedded in it. Here's the old formalist ideal of medium and message merged, rather than one tacked onto the other gratuitously to make a sensation, rather than the medium used to subvert the message.

Some of this art and some of these artists are seen as "punk," though *new wave* is a preferably woozier term. If so, punk comes in two guises: this harsh social commentary retaining an echo of Brechtian irony and of the original British music movement's working-class political force; and retrochic, which sees the audience as "parents"—authorities to be done in. The latter is most visible because it's out for power and because the social branch has for the most part (or for the time being) bowed out of that particular brawl. Retrochic, like its commercial counterpart in fashion advertising, gets shown and occasionally eulogized in the trade magazines and is, I assume, bought now and then by the beleathered hordes who wander through SoHo on weekends seeking a social jolt—otherwise it wouldn't *get* shown and written about.

Because I see retrochic as feeding neatly into the right wing's fury and as playing agent-provocateur to the working classes some retrochic artists claim to identify with, I'd like to see this kind of art rejected. I know some will holler "censorship" (and I'll mutter "selection"—which is another whole can of worms). I know that the intention of this art is to get parents like me to scream Bad Taste! Decadence! and other flattering epithets. I did just that when I read a pseudonymous critic called Peter "Blackhawk" von Brandenburg describing "The Nigger Drawings" as "revolutionary," though I had to laugh when I read they were also "a veil between a pulp-populist catalogue of nuance and a prodigal epicure's prosthetic interpretation of 'Social Lamarckianism.' " We've had this kind of language from the third-string academic Greenbergians, but it seems a bit more incongruous coming from a "movement" which is supposedly opposed to promulgating bullshit like the above. (Imagine any self-respecting punk artist

Jenny Holzer, *Truisms,* Spanish translation, colored photostats in window of Fashion Moda, South Bronx, New York, 1979, 96″ x 40″; a selection of alphabetically arranged "truisms" includes: "To disagree presupposes moral integrity; To volunteer is reactionary; Torture is barbaric; Trading a life for a life is fair enough; True freedom is frightful; Unique things must be the most valuable; Words tend to be inadequate; You get the face you deserve . . .; You must know where you stop and the world begins . . .; Your oldest fears are the worst ones." (Photo: the artist)

claiming to employ "a symbological and epistemological lexicon"; it's lucky critics are still around to do the dirty work, to alienate the thinking audience still more effectively.) Probably the last laugh is offered by a Canadian punk rock group called Battered Wives, whose logo is a fist and a bleeding mouth and who sing a song of the stupidity of housewives. They surely became "high artists" when they said, "The name's symbolic. It doesn't mean anything."

It used to be only abstract art that fostered this intense disregard of or even hostility toward and from the audience. In the heyday of Minimalism, I and others used to talk approvingly of "the cult of the difficult," in reaction against the instant cooptation of new art. In a curious way the retro sensibility represents another, more overt, wave of this attitude toward the public. Pop art, which was once the detestably accessible art, is the idolized ancestor of unacceptable art this time around. Today's costume militarism, violent porn, pseudoterrorism and ethnic-racial-and-gender-based slurs are seen by some as nose-thumbing counterparts of the cereal boxes, comic strips and washing machines of the early '60s. We've come a long way. The durable and adaptable Warhol is once again the epigon of Cool. He alone of the Pop artists shared some of the Minimalist sensibility, and he alone is now whooped up by post-Conceptualists who despise the rest of '60s art. Retrochic is envisioned as a kind of red-hot risktaking not everybody is man enough to try, "a DC current . . . too hot to handle," as one journalist put it.

But where are all those burned fingers? If symbols are meaningless, I shudder to think what art is. If Warhol is the godfather of punk, the real retrochic heroine is Valerie Solanas—the uninvited guest whose "Scum Manifesto" was too hot for *anyone* to handle, or maybe Norman Mailer, who has lauded such "existential acts" as murder. Retrochic is subversive in the sense that Reagan and the oil companies are subversive. It's part of a TV culture that offers Insult, Assault, Torture. Yawn.

Real Estate and Real Art
à la Fashion 時髦 Moda М О Д А *

The liveliest events in the art world always happen when artists take things into their own hands. This is happening more often now than it did in the 1970s. Two unique examples in New York are a "cultural concept" called Fashion Moda in the South Bronx, and a recent raid on public property called "The Real Estate Show" on the Lower East Side. These are the hopeful and angry products of a spreading artworld crisis of faith, and may mark the beginning of a new and noncondescending meeting of art with social concern.

The fires of the late '60s sparked a number of artist-run "alternate spaces," co-op galleries, and underground publications. Some of them survived the

*Reprinted by permission from *Seven Days* (April 1980).

cooled-out '70s by becoming as institutionalized as the institutions they resisted; others folded when artist organizers burnt out and retreated to their studios; others still maintain a degree of independence from artworld bureaucracies by not biting the hand that feeds them. Despite all this activity, young artists arriving in the Big Apple by the end of the '70s found it full of worms. The careerists, of course, go at it as they always have, and the ones who care only for art stay in their studios waiting for fate to agree with them. But more and more idealist/activist types are muttering on the street corners. They're artists. They make art. But what are they supposed to do with it?

These younger artists tend to be downright disillusioned with the way the art distribution system works (in and out of so-called alternatives), demoralized by high rents and inflation, disinclined to become as apolitical as is fashionable in the "high art world" while equally uninterested in the earnest theorizing that has been passing for "political art" in New York. Some fifty such artists have not been just sitting around complaining, or indulging in the infantile sensationalism that undermines the vitality of the New Wave arts. Instead, they have organized— *loosely* organized, but organized nonetheless. Often working anonymously and collaboratively—calling themselves Collaborative Projects Inc., or Co-Lab for short—they have put together a series of rough little open and issue-oriented shows in temporary spaces: "The Dog Show," "The Money Show," "The Doctors and Dentists Show," "The Manifesto Show," and now two current TV shows on Channel D: "Red Curtain" and "Potato Wolf."

The most recent effort along these lines—"The Real Estate Show"—opened on New Year's Eve as a unique combination of art exhibition and guerrilla action. A group of downtown artists simply broke in and took over a derelict city-owned storefront right on teeming Delancey Street on the Lower East Side of Manhattan, turned on the heat and light (also "extralegally"), and filled the space with art protesting absentee landlordism, eviction, developers, the city's waste of space, greed—the whole notion of property in a capitalist society. The show was dedicated to Elizabeth Mangum—"a middle-aged Black American killed by police and marshals as she resisted eviction in Flatbush last year."

I don't want to "review" this show so much as to cheer its existence and that of future such events, as well as the related posters and publications emerging from the same group. Suffice it to say that in what has come to be a recognizably chaotic installation—the artists filled their captive space with a vital, if uneven, mess of art, including wall drawings and graffiti by neighborhood kids as well as artists' drawings simulating that same harsh directness, a "process piece" of crumpled cigarette packs presumably found in the gutters, a series of color advertisements of classy real estate with ironic suggestions about what could and couldn't go on inside these places, and a lot of raucous New Wave word-and-image stuff that ranged from sizzling social denunciation to easy anarchism and ambiguity. The walls were not white or clean. The lights were not bright. The audience was not all white. The back door was the safest entrance. The Museum of Modern Art it was not. You could tell by the excitement.

The City's Housing, Preservation and Development Department closed down "The Real Estate Show" a day or so after it opened, but compromised by not arresting anybody and offering the artists other, less desirable, and less public spaces, which they have since used sporadically for video and performance. During the negotiations, famous artist Josef Beuys even showed up, and the

"Real Estate Show,"
Xeroxed handout,
New York City, 1980.

group also met with local organizations protesting the dismemberment of their neighborhood.

A "Real Estate Show" broadside stating the oppression of artists and expressing solidarity with the Third World mitigated its '6os sound by ending: "It is Important to Have Fun. It is Important to Learn." This is another generation. Ten years later, the hostility is more up front and the idealism is more laid back. A classic statement (by Iggy Pop) of the ambivalence toward politics and middle-class motivation was quoted in the February *Artforum* by Edit de Ak, founder of the proto–New Wave magazine *Art Rite:* "A good product has the ability to set forth true and false propositions. If someone comes on with only what's true, it's very boring, because nobody has that much truth in them."

One of "The Real Estate Show's" several Xeroxed handouts stressed the importance of bridging "the gap between artists and working people by putting art on a boulevard level." In a storefront on Third Avenue in the South Bronx, Stefan Eins has been calmly doing just that for over a year now. Fashion Moda (the logo is in English, Spanish, Chinese, and Russian) is an essentially indefinable place,

though Eins has called it "a cultural concept" and even a "museum." It is based on a Duchampian/populist mix of art and science that has nothing to do with what comes out of MIT. The opening show offered, bilingually, "Miracles of Science, Technology and Nature." All of Fashion Moda's shows feature art and what might not be called art by those who think they know: children's work, toys, puzzles, inventions, painted signs, manufactured objects, live animals, and you-name-it.

Fashion Moda is inventive, subjective, and people-oriented, devoted to communication between two cultures that rarely understand each other. *Only* an artist could have come up with Fashion Moda and made it work. Eins is a kind of matchmaker, the artist as synthesizer. An ex-Austrian, in New York since 1967, Eins operated his own downtown storefront space from 1971 to 1978 at 3 Mercer Street, where he hoped to make a place that connected with the hardware, secondhand-goods scene on Canal Street. Having gotten sick of the door-to-door self-salesmanship demanded of an artist in the art world, he showed his own inventions and other "applied physics" and sold them cheap to anybody off the street. Eventually his friends started to show, too, and 3 Mercer became an unconventional art space rather than the everyman's land its founder had originally envisaged.

In 1978 Eins closed up shop to find a more challenging field than the by-then-fully-colonized SoHo. He prowled the streets of the South Bronx until he found a large, airy storefront—or what was left of one—and on his own time and money began to renovate it. Gradually he made friends in the neighborhood who helped and also protected the space (the whole front is a plate glass window—and it is still intact). Fashion Moda acquired a codirector—Black artist, poet, musician Joe Lewis—and a participatory constituency that is split between South Bronx artists and residents and friends from the Co-Lab/Lower East Side/Tribeca contingent looking for an audience that is loose, enthused, and not art-world-weary. Although still struggling, Fashion Moda now receives funding from various state and private agencies.

Fashion Moda is indeed, as Eins claims, "something essentially new and different." It is defined neither by art nor by do-goodism. Its success stems from a genuine mesh of its own interests and those of its audience, and it avoids "cultural imperialism" by respecting itself as well as its audience. Eins is interested in *stretching* Fashion Moda as far as it will go, even worldwide, "combining a local sense with a planetary sense." Still in flux, Fashion Moda has recently initiated three new enterprises: an "Institute for Appropriate Technology" directed by Jamal Mecklai toward "cultural, environmental, and economic harmoniousness"; through Joe Lewis, a proposed publication and traveling show by Ray Ross of some 500,000 slides and photos documenting New York jazz; and a project on alien intelligence with a research student from New York University.

At the core of all Fashion Moda's ideas, however, is communication. "There is no art without audience," says Eins. "The bourgeoisie, like the courts and religious hierarchies that preceded it, is structured enough to take care of its art. It remains to be seen whether this subculture will be able to do this." He is constantly aware that he has entered a "different culture, with all the conflicting behavior patterns and wrong assumptions" that lead to misunderstanding and, too often, to hatred in the city's daily class struggle. Slowly he has developed "a sense for the common denominator" that can make the connections he seeks.

The governmentally funded South Bronx power structure is still not responsive to Fashion Moda and is probably threatened by its free-wheeling energy,
curiosity, and class mix. Eins also made local mistakes. For instance, after
announcing a meeting of South Bronx artists to which no one came, he realized
"you can't do anything here at a certain hour on a certain day." The current
show—"SOuth BROnx ART, PROJECTS, OTHERS"—had four different openings.

The show itself indicates how much Eins has learned since that unattended
meeting. It includes downtown and uptown, South Bronx and Lower Manhattan
art, but it's hard to tell which is which. There are "paintings in blood" by
"Satanic Sisters Jacquelyn and Carole" (a lavender room environment with
symbols, graffiti, a candle burning in a hole-in-the-wall shrine, exhortations to
worship the goat and to "Live Lust Laugh Levitate"); there is Elizabeth Clark's
mural project for the abandoned Elisa Clarke School nearby (a peak-roofed house
shape in line and dotted line labeled "reconstruction" and drawn in blueprint
form because "the blueprint means something to be done"); David Wells'
inventions; Willie Neal's array of high school pastels, professional color photos of
the city, and a series of painted and varnished sticks and clubs garnished with
color and an occasional marble; Wally Edwards' punk expressionist painting
juxtaposed with an anonymous painting of weird faces found in an abandoned
building: Fidel Rodriguez' landscape sign painting for a social club; and Louis
Badillo's amazing, obsessively scribbled notations of religious math—diagrams
for *La Destruccion del Mundo* incorporating *Cristo Rey* and *El Dragon de las
Estrellas*. There is a huge rose spray-painted directly on the wall "after a painting on a wall at 5th Ave. and 110th St. (to scale)," and the window is occupied by
Candace Hill-Montgomery's *Inner City Environment*—a white picket fence
around a patch of real, green grass with a battered found-metal frame hanging
over it.

The most popular art ever shown at Fashion Moda, which has become a kind
of permanent resident, is the *mascarillas* by John Ahearn (white, downtown artist, twenty-nine, punk haircut, BFA from Cornell). Ahearn has cast in plaster the
heads and torsos of over fifty South Bronx people flirting, grinning and joking,
lively as life. They are painted in brilliant, almost realistic skin-and-clothes
colors. People are constantly coming into Fashion Moda to watch him make
these and to ask if he'll do them, their kids, their boyfriends. After their first
showing at Fashion Moda, the masks were moved triumphantly around the corner to the Con Ed building at 149th and Courtlandt, where their wild colors and
odd shapes not only transformed the bleak and shabby space but also gave the
impression that Earl and Butch, Cosmic, Willy, Big City, and Sonny had liberated
Con Ed with the kind of frenetic life that epitomizes the hyped Up and the low
Down of the South Bronx.

For the current show, some of these masks are now back at Fashion Moda,
and they have, in the meantime, propagated. Hung next to Ahearn's heads are
two others by Rigoberto Torres. Although the technique is the same, there are esthetic differences that come from culture rather than skill. And across the room
are some wooden shelves with another exhibit—the painted and unpainted plaster "Hispanic statuary" mass-produced by the Fabrica del Carmen. Dimestore art,
folk art, or "real art," there is no question of these statues' formal power, especially in three of them: a matte, air-brushed bust of an impassive Jose Gregorio
Hernandez Cisnero; a white hand with a saint on the tip of each extended finger,

within a bulbous white cloud; and a small, flesh-surrounded glass eye in an ornate gold frame.

The conceptual triangle formed by these three groups—Ahearn's, Torres' and the "Hispanic statuary"—make one of the points Fashion Moda exists for, illuminating three arts and two cultures in open communication.

John Ahearn, *Big City,*
painted plaster cast from life,
hanging (temporarily) in Con
Edison, South Bronx, 1979,
sponsored by Fashion Moda.

Sex and Death
and Shock and Schlock:
A Long Review of "The Times Square Show"*
by Anne Ominous

Overheard in downtown art territory: "Have you seen The Times Square Show?" "Not yet, but I hear it's the best thing around." "That's not what I heard."

THE SHOW

Well, by now everybody's heard *something* about "The Times Square Show"—a sleazy, artist-organized extravaganza in a deteriorating former massage parlor on Forty-first Street and Seventh Avenue in New York City. Abundant press coverage

*Reprinted by permission from *Artforum* (Oct. 1980). Copyright © 1980 by *Artforum*.

has been as contradictory as the show itself. Word of mouth to mouth has often been tongue in cheek. What makes TTSS noteworthy, no matter what one thinks of the art in it, is the levels it offers. TTSS is an organizational feat—an object lesson in object organizing by artists. It is a weird kind of cultural colonization that worked because colonizers and colonized had something in common; an exhibition of "unsalable" works accompanied by a gifte shoppe that managed to sell just such works—cheap; a constantly changing panorama of esthetic neuroses; a performance and film festival; a throwback to the early '60s happenings-and-store-front syndrome; a sunny apotheosis of shady sexism; a cry of rage against current art-worldliness and a ghastly glance into the future of art. It's also a lot of knives and guns and money and dirt and cocks and cunts and blood and gore housed in four wrecked floors (plus basement) donated to the organizers by the landlord.

The extraordinary transformation of the space over two weeks was noticeable only to those who saw it both before and after, because after imitated before, littering the floors with sawdust, the corridors with broken glass, the walls with graffiti, despite preshow cleaning and repainting and putting in windows. Neat art was out, and those who risked it made art that stood out. Every inch of the space was tarted up with art or an unreasonable facsimile. Some of it was barely recognizable as such, which is how you knew it was avant garde. At the same time, works came and went and changed places and evolved. There were some 100 artists included, with the makers of the "Exotic Events" that took place several times a week. At the beginning the organizers (the artists' group Collaborative Projects, Inc., or Co-Lab, and friends and some enemies) asked for "proposals" like any self-respecting institution. Because of the success of their previous shows (including the "Manifesto Show," the "Doctors and Dentists Show," the "Money Show" and "The Real Estate Show"), they were swamped with would-be exhibitors. The result was the kind of chaos in which the group operates best anyway. Artists who persisted made work that existed—as far as I can tell from the experience of an Australian friend of mine, unknown to and not exactly well-received by the organizers, but with the self-confidence not to slink off rejected. I shudder to think about how the various spaces were appropriated, but people found their niches—in closets, dark halls, toilet stalls, ceilings and stairways. (No list of artists appeared, most of the work wasn't signed, and there were no nice typed labels.)

A huge banner on Seventh Avenue announced the show. Below it from a row of unglassed windows, taped music and laughter wafted in the Fashion Avenue breezes, mixing with the fast-food odors of the diner below them. Around the corner was a big store window and a bright yellow "naïve" mural by a Czech and German group called NORMAL on the walls of "The Gift Shop," which was in some ways TTSS's most innovative aspect. The average price was five dollars, and there was plenty to buy for a quarter or a dollar ninety-nine; the idea was that if something didn't sell in the first few days it would be disappeared; featured were chatchkas for the downwardly mobilized: a winged penis, a pornographic fan, pill capsules with messages, books, posters, etc. The usually silver lobby with its blasting jukebox, bandstand, shabby plastic couch and miscellaneous artworks, including a large montage drawing of a beaten Black man hung by chains, offered a certain casual reception. But dim stairs beckoned up and down.

THE ART

It would take longer to describe than to see. Here are some of the things I was moved by or involved by:

A red-painted stairway ending in a huge comic-graphic gun/arrow bent around a corner; phrases and photos (and deaf alphabet translations) on walls and stairs. Descending you got "We all lose in the end" on the wall; going up you got "But the loss is kept obscure" and on the steps "Quick with your lip bite your tongue."

The dark, low-ceilinged basement room totally covered with black-on-white handprints ("in touch with the space") inhabited by an ambiguously sexed, painted figure wielding a circular beam of light; vantage points marked in the room; the piece not an "alien" as some would have it, but an illusive/allusive statement about control by a male feminist. Back in the shadows, another artist's wax paper "ghost."

A room wallpapered with money and rats.

"Marginal Economy," a miniature board fence plastered with photos of Black people and vacant lots.

The "Portrait Gallery" containing, among other things, ceramic heads of the eight U.S. soldiers killed in the "rescue attempt" in Iran, the ubiquitous and exuberant painted plaster heads of South Bronx residents, and some conventional paintings that gained interest from their context.

Varnished and garnished with marbles, wooden clubs hanging overhead in a short corridor.

A room (most effective at night) with a chicken-wire woman on bed springs holding a prayer book, an ominously gleaming gold plaster bust of a Black man "seated" in a shoddy armchair; an altar to violence in the closet; a skillfully painted pink pig labeled "The pig is the only domestic animal raised exclusively for slaughter"; a videotape of the Panthers on TV and "Revolutionary People's Communications Networks Voodoo Comics" wallpaper.

A tawdry "nest" in an upstairs closet filled with cloth, tinsel, satin, leopard-skin smelling of stale perfume and makeup and of the loneliness and ugliness of a whore's fantasy and reality.

Christy Rupp, *City Wildlife,* at "The Times Square Show," New York City, June 1980.

Some quite traditional, or just the opposite, figure paintings not on black velvet but on large cowhides.

Ceramic snakes' heads jutting over a stairway door.

Black-and-white raw cartoon montages self-critically parodying Macho and festooned (coincidentally) with dainty blinking Xmas lights ("MACHO ME, ME ME ME"; "MACHO PLAY, BANG BANG BANG"; "MACHO WORK, BOOM BOOM BOOM"; "MACHO MACHO, HOT CHA CHA"—a message also echoed in a big "Stupid Victor" mural by the same artist).

A room of collage installation protesting the Virgin/Whore image of women and the violence promoted by porn, complete with mermaid, bride, witch, nurse, madonna and little girl stereotypes crudely daubed with paint and arrayed with pink plastic tits and accompanied by porn magazine collages.

A long funny sad narrative revealed sequentially between the black bars of a manually cranked "peep show" machine.

A punching bag hung before an open black wall labeled "Diletante Guerillas" *(sic)* and enthusiastically chalked with audience responses.

A fringed white "rug" (under the punching bag) with advertising images of money inscribed "Chase Man" and "publicity is the culture of the consumer society" and "when times are hard, capitalists display images of money to make self-determination by the poor appear impossible" and "Walk Over Capitalism." Behind it, out the window, is a view of Chase Manhattan itself, Times Square Branch (is its money dirtier than money elsewhere?).

And a hand sink overflowing with grimy salt crystals, and some terrific feminist comic-strip posters, and a room of painted clothes, and SAMO's critical graffiti, and "Take Back the Night" scrawled here and there, and a scab-picker's bathroom of peeling red paint I liked better than the work in it, and a garbage and rat fountain and the ubiquitous decorated machines and a lot of other Indescribable Things You get the picture?

THE ISSUES

TTSS was ostensibly about Times Square—that is, about sex and money and violence and human degradation. It was also about artists banding together as pseudoterrorists and identifying with the denizens of this chosen locale— envying them and imitating them at the same time as colonizing them, thus rebelling against the cleanliness and godlessness of the artworld institutions, "alternate" and otherwise. It was also about artists making a microcosmic strike for economic independence and control of their products through the store, and the more-or-less "open" exhibition. (It is an illusion that Co-Lab is some sort of pariah working "outside the funding structure" when in fact they have a persuasive touch for or on official funds and a talent for PR that Show World should envy.)[1] Most important, TTSS, like all the other Co-Lab "theme shows," was about art being about something other than art.

While the energy of the whole heady mixture was a much-needed antidote to the mechanical novelty of today's art world, I didn't admire the contents of TTSS as much as I enjoyed them. As a whole the show did successfully appeal to a fairly varied audience—locals as well as disillusioned sophisticates, cynical radicals and chic seekers. This accomplishment can't be underestimated. It is

very rare that even the best-intentioned artworld offspring communicate outside their own yards. What I worry about is the depth of commitment even in that work I got my kicks out of. (Maybe I shouldn't ask for more? Gift horses and all that?)

I know from TTSS's organizers' past activities that "politics" was a major impetus. (However, the word was not mentioned on the press release, which was all fun and games; it did appear on the jazzier street poster, listed generically with "art, performance, film, video, store and music.") By virtue of its location alone TTSS was "political." But even though the general issues were easily identifiable it was often impossible to tell where the artists stood on them. Many seem to have thought that pictures of guns, pictures of dollars, pictures of sex (actually pictures of *women,* since women and sex are interchangeable, right?) constitute a statement in themselves. This is a sort of reverse Magrittean situation ("This is not a pipe") in which the image carries all the weight no matter how fragile it may be. Or is this just the middle-class TV terrorism which, with S & M, is the dominant subject matter for so much new-no-nuwave art?

There's a lot of random violence—"I'm going to kill you" scrawled out of context on a wall; "How to Stop a Bullet and Live" on a poster—and a horrendous arsenal of weaponry aimed nowhere, unless it's at the spectator. Social criticism this is not, though it is a loud and clear expression of alienation. As far as I can tell, these images are rarely meant as satire or protest, but intend rather to focus if not on the object then on the act—of dancing on the razor's edge, coming down left or right with the risk of straddling the middle. A game of American roulette is being played with art as the itchy trigger finger. This is possible because art is supposed to be either above it all or below it all but not part of it all. Art, like pornography itself, is fantasy without action.[2] But TTSS—as a collaged whole—has managed to be very much a part of it all. Although more appropriately secretive than "The Real Estate Show," it is out of the white-walled isolation ward. Its madness is up front, upstairs and downstairs and in milady's chamber.

The studied crudity that is so much a part of TTSS is also a part of the pervasive level of political naïveté. Whether self-conscious or manipulative or innocent or consciously critical, it is the cutting edge these mostly young artists are looking for (in sex as well as art and politics, it seems; one participant suggested that the best review of this show might be from an informed psychosexual viewpoint). I keep coming back to the way "politics" floats so politely in this iconoclastic but still "art" context. I've complained before about the assumption that style alone (as opposed to image) can make a political statement—the idea that badly printed photos and harsh tabloid graphics attached to no matter what kind of irresponsible or undigested imagery is "political."[3] And after some three years of the "punk" posters that paper SoHo, Tribeca and the Lower East Side, I'm getting sick of all the guns and skulls and racist/sexist slurs. (The latest is something about "Japs" and was included in TTSS events; it is presumably by someone for whom World War II only existed in the comic strips.) Even though these posters are often witty and eye-catching and an improvement on the Hallmark variety, it doesn't seem to me that the world situation is such that games around war and killing and race hatred are very funny. (Maybe it's just gallows humor, or shallows, or callow humor?) I'm angered that the *urgency* of so much of this art, in and out of TTSS, is being wasted on superficial fantasies—which is why Times Square is a sadly apt location.[4]

Those artists with an image of themselves as the daring agents of an esthetic catharsis would do well to listen to a 1939 statement by René Magritte, himself soon to become the darling of the bourgeois collectors:

The very special value accorded to art by the bourgeoisie brutally unmasks the vanity of its esthetic concepts under the pressure of class interests totally foreign to cultural preoccupations. The artist does not practice the priesthood that bourgeois duplicity tries to attribute to him [*sic*]. Let him not lose sight of the fact that his effort, like that of every worker, is necessary to the dialectic development of the world.[5]

There are also plenty of lessons to be learned from the historical fate of Dada, which seems to be a rather unfamiliar but approved source of much new art. A warning from George Grosz in 1925:

Dada was the breakthrough, taking place with bawling and scornful laughter; it came out of a narrow, overbearing and overrated milieu and, floating in the air between classes, knew no responsibility to the general public. We saw the insane end products of the ruling order of society and burst into laughter. We had not yet seen the system behind this insanity.
 The impending revolution brought gradual understanding of this system. There were no more laughing matters, there were more important problems than those of art; if art was still to have a meaning it had to submit to those problems.[6]

"We're interested in taking up situations that activate people outside the art world," says one of TTSS's organizers. And Richard Goldstein of the *Village Voice* claims that TTSS "lets a certain class of artists in for the first time." Actually, Fashion Moda has been providing this model for two years, showing "nonart" and "street art" and mass-produced art in an open context and confusing the boundaries between high and low culture more consistently than any single situation can.[7] In fact, to go back further, TTSS might have been concocted in the early '60s, along with Oldenburg's storefront on the Lower East Side, the grungy early Happenings, French "neo-Dada" (an unclean Pop or dirty old man), the March Gallery group's "Doom Show," Sam Goodman's "Shit Show," some Fluxus events and, more recently, the Guerrilla Art Action Group, the "Flag Show" (which landed three artists under arrest), the feminists' tampons and eggs in the Whitney, the Art Workers' Coalition's break into the Metropolitan Museum's trustees' dinner and so forth. So it's been Done Before. So What? The illusion of the new, like that of obsolescence, is fostered by competitive commercial interests.
 That's what.
 But the inclusion of "disenfranchised art" in both Fashion Moda and TTSS raised some other interesting questions about class which I can only suggest here. Goldstein called TTSS "three chord art anyone can play."[8] Its ineptness, and the ramifications of that ineptness, were among its most endearing and significant attributes. It is becoming clearer daily to more and more people that rather than the lucky few making art so unsuccessfully for the unlucky many, the artists' role may be to open up the making and distribution of art to everyone

as an *exchange* rather than an imposition, with empathy rather than condescension as the bridge. Mass production *by* the masses instead of *for* the masses. The do-it-yourself esthetic extended to art-making makes especially good sense in the economically depressed '80s and it is one of the goals of progressive artists today.[9]

So if schlock art is as valuable as shock art and if supermarket and sidewalk art is not to be looked down on—then what proportion of shows like TTSS should be just that kind of so-called kitsch? How much interclass and interculture leavening is necessary to get across the message? Would TTSS have been twice as successful in "activating people outside the art world" if it had consisted primarily of street art? Of dimestore art? Of calendar art? Of hobby art? Of straight porn? A marvelously ugly abstract sculpture in TTSS was made, I believe, by someone who had never shown in art places before. S/he probably wasn't interested in "ugliness," and would I like it so much if the whole show were nothing else? How eclectic can you get without losing the provocative point? How far from political issues can you stray, even with the best intentions, before you are "apolitical" like you're supposed to be?

For instance, TTSS's focus on sex had to include consideration of gender—a ticklish subject in these days of right-wing backlash against feminist strengths (and feminist moralizing). With a few exceptions, it was in fact neglected, along with significant contradictions raised around pornography by Women Against Pornography and its opponents in and out of the Women's Movement. Significant issues of exploitation were also ignored—not merely that of the women who are made into disposable sex objects, but that of the men whose manipulated desires are also pretty pathetic. (One artist in the show wore a "sex for profit" T-shirt on opening night; his misogynous peep show had disappeared by the next time I was there.) Somewhere in the process, issues of censorship versus selection must have been confronted by the organizers, though as Richard Goldstein remarked, the solution was apparently to assure an antithesis for every thesis, rather than to reject "politically incorrect" art. But underlying such solutions is also the notion that any moral stance is uncool. Some disturbing aspects are illuminated by Deirdre English's definition of porn, which could double as a definition not only of "punk art" and of retrochic, but even of the valid goals of all avant-garde art:

> Pornography depends on shock value. It lives to violate taboos. Porn, by definition, undermines the norms, attacks our values, attacks respectability. Pornography is what you're ashamed of enjoying. Porn is the devil. Porn says, here is what I really think. You don't like it? So what?[10]

Artists with esthetic integrity usually get around such problems by using codes understandable to their audiences. But this dependence on context doesn't work when art, as in TTSS, moves out into the world; a socioeconomically mixed audience gets mixed signals. Take the evolution of the sexually exploited woman image. In the '60s (Pop Art), several male artists made bundles on nonsatirical blowups of soft-core porn. In the '70s, with the advent of feminism, it was safe to say that such an image was intended to be read one of two ways—as belligerent sexism or as satire/protest against that same sexism. With a little help from critics, curators and dealers, artworld audiences knew, more or less, where the

artists stood, and read the images more or less as they were intended. By the end of the '70s, however, backlash and retrochic had confused matters again, giving rise to more thoughtful analyses of how art uses life and where the lines should be drawn. (Viz. the reprehensibly titled "Nigger Drawings" exhibition, which brought a crucial issue to the surface of art dialogue: Is art by nature merely neutral or can and must it mean something and take responsibility for that meaning or lack thereof?)

TTSS's images of hard and soft porn may have seemed quite daring and "real life" to an art audience. To the street audience they were probably downright opaque. On opening night two feminist women periodically performed a horrifying off-the-cuff five-minute piece with one of those life-size inflatable female nudes one can buy around the corner. She has three useful orifices and the two performers, strapped onto huge dildos, used them in the most brutal ways possible, yelling things like "She likes it. She loves it. Don't you, dearie?" Two men kept muttering, "All you women ever think about is sex," and to the repeated question "Is This Turning You On?" one finally cried out, "NO. It's disgusting!" A woman in the audience yelled, "You got it, Baby." And the point of the performance was made.

Or was it? I could barely stand to watch it, even though my politics are those of the performers. A small boy watched the piece several times in rapt fascination. I don't know what the Times Square locals thought about it, but I do know that one of the performers, after thinking it over, decided they had made a terrible mistake in disregarding coding and context; they *were* turning men on. Similar conflicts haunted the otherwise lively virgin/whore room, made in collaboration by two young women. The stated message was the same: "Pornography Lies About Women." Women artists all over the country for a decade now have been making very similar collage and installation pieces, so the main interest of this room was the fact that it existed not in an art gallery or a woman's center but in the heart of "enemy territory." Parts of it were strong enough to make the most hardened viewer shudder: the little girl's party dress adorned with nipple-shaped colored candies, and the porn collage of split beavers labeled "Is This Sexy?" But again, I'm not at all sure that everyone who saw it answered with an unqualified "No." For those who don't share the artists' views, it had to be either scary, cute, obvious, or—yes, sexy. Men came in for some degradation, too. A pair of cleanly professional photographs show a man being tortured—into the image of a woman, pincers pulling up breasts, etc.; a dancing Black puppet recalls the minstrel stereotype Black (James Brown notwithstanding). The show included a larger percentage of Third World artists than usual (which isn't saying that much), and women were well represented among its organizers and exhibitors. Yet after ten years of outraged satire, impressive women's erotic art, performances and pieces in which women overtly and covertly exploit their own bodies in an effort to liberate certain notions of sexuality from the vise of the dominant culture, and a still unabated plethora of works about the image of women in the media, much of the art in TTSS seemed pretty ineffective. It seemed mainly to exorcise individual esthetic taboos and cultural constrictions, maybe to pave the way for a more directly powerful statement. The same thing can be said, alas, for a great deal of current American "political art." I, for one, am so encouraged that such things exist at all that I find it hard to be harsh on them. However, if we don't have enough respect for these attempts to question their success and to

urge them on to more expressive forms, then we so-called political artworkers are also failing at our tasks.

Speaking of which, I had planned to tape the responses of the various TTSS audiences and to use the comments as the basis of this "review." Life interfered and I didn't do it. Perhaps the analysis that could emerge from such raw material will come from the organizing group itself, which has, I hope, spent some time evaluating its own process and experience now that the show is down. What next? "The Death Of Equal Rights Show" at the Statue of Liberty? Or the "Inflation Unemployment Show," which could take place in hot air balloons over City Hall? Or "The Whole Earth Show" at the Mudd Club featuring the Great Goddess? Or another "Sex and Death Show" by Hooker at Love Canal? Or the "Marathon Show" at Three Mile Island? Or the "Terrorist Show" (at last) at your local railway station? "The WASP Show" at Artists' Space? "The Class Show" at P.S. 1? Or maybe even "The Art Show" as a collaboration between Exxon and Mobil?

NOTES

1. Richard Goldstein, "The First Radical Art Show of the '80s," *The Village Voice* (June 16, 1980); the sources acknowledged on TTSS's "Exotic Events" program are: New York State Council on the Arts, National Endowment for the Arts, Beard's Fund, Robert Burden, Anfour Corporation, National Video Industries, Department of Cultural Affairs, Spectacolor, Inc., Sandra Devlin, Richard Savitsky, and 112 Workshop, as well as Anonymous.

2. Deirdre English, "The Politics of Porn," *Mother Jones* (April 1980), p. 20.

3. Cf. Lucy R. Lippard, "Retrochic, Looking Back in Anger," *The Village Voice* (Dec. 1979); and "Some Propaganda for Propaganda," *Heresies,* no. 9 (1980).

4. Another bad pun on the locale emerges from the fact that some of these artists are, quite naturally, on the make and take. What about the embossed card I got admitting me to a "private reception" for TTSS, from 6 TO 9 P.M. on a Tuesday—traditional uptown gallery opening hours? How square are the times showing themselves to be? Note Rudy Burckhardt's 1967 film, *Square Times.* I understand this is already getting to be a problem for Co-Lab. It's a shame that artists have to take the brunt of a crisis of conscience that should be laid squarely on the lap of a society that has no idea what to do with artists and consequently dumps them in this no-person's land between a reasonable desire to support themselves by doing what they do best and "selling out." Nobody put this conflict better than Ad Reinhardt in his writings and cartoons. I hate to see this generation confronted with the same problem that has smothered previous political ardors in visions of sugarplums.

5. René Magritte and Jean Scutenaire, "L'Art Bourgeois," in *Surrealists on Art,* ed. Lucy R. Lippard (Englewood Cliffs, N.J.: Prentice-Hall, 1970), p. 156.

6. George Grosz, "Art Is in Danger," in Lucy R. Lippard, *Dadas on Art,* (Englewood Cliffs, N.J.: Prentice-Hall, 1971), p. 81.

7. See Lucy R. Lippard, "Real Estate and Real Art à la Fashion Moda," *Seven Days* (April 1980).

8. Richard Goldstein, "First Radical Art Show."

9. The notion of empathy's replacing condescension emerged from a symposium on social change art that took place in Cincinnati, June 1980.

10. Deirdre English, "Politics of Porn."

Propaganda Fictions*

I
BRINGING CRITICISM BACK HOME

We all know art is above it all, right? . . . Let's hear it. . . . RIGHT? RIGHT!

First situation: If you want to send a message, call Western Union.

Huh? Why can't I do it myself? After all, I'm an artist. And art is about communication, and I should be communicating things I want to say, right?

Wrong. Art is about medium, not message. Art is about being faithful to the canvas the rectangle the edge the surface the material the space the fashion the form the market. Art is about using the medium to *subvert* the message. See? OK. Now. Let's run through that again. If you want to send a message, call Western Union.

Hello. Western Union? I want to send a message. Art (that's *A* as in Assthetics *R* as in Ree-production *T* as in Trans-formation) Is Useless (that's *U* as in do-it-Yourself *S* as in Salesmanship *E* as in Elite *L* as in Lame *E* as in Excuse Double *S* as in SSSSSSSorry).

Second situation: Ummm. I, uh, I didn't have *time* to write to my Congressman. I was busy writing a poem against torture.

Are you ashamed of not being an activist?

No, not really. I'm an *artist,* you see. An artist can't be *political.*

So what was your poem about?

My poem was an individual emotional response to a terrible thing.

Propaganda?

Oh *no.* A *poem.*

You mean it can't be art and propaganda at the same time?

Of course not. *Propaganda* is a dirty word. And art is greater, deeper. Art is . . . ineffable. Propaganda is linear, simpleminded and totalitarian. Art is Freedom.

Says who?

What do you mean says who? That's what art *is* . . . isn't it?

From a press release for a book by Sam Hunter called *Art in Business: The*

*The following are unpublished sections from a slide and text performance described as "a fairly dramatic reading," first presented November 13, 1979, at Seattle and performed elsewhere in the United States and Canada, Winter–Spring 1979–1980. These pieces were preceded by a first "fictional" slide evening called "Trying to Decide," given at AIR Gallery, New York, late in 1978. Written to be read aloud with exaggerated "drama," they lose a lot in print, but they were an important watershed in my personal relationship to the art world. I see the "Propaganda Fictions" as an exorcism of some kind—harrowing to perform, sometimes hurtful, but ultimately healing.

Phillip Morris Story, published by Harry N. Abrams, Inc.: "Corporate supporters in the arts are critically influencing the arts in America. In 1978 they spent $250 million. Through Hunter's lively and sharp eye, we learn that one *unusual* aspect *(wink, wink)* of Phillip Morris' arts activities in the '60s was their *willingness* to support avant-garde exhibitions! *(wink, wink)* Phillip Morris' *corporate policy of esthetic involvement* includes the integration of art into their worldwide corporate facilities, attention to innovative package and product design and a *deep involvement (wink, wink)* with museums and major exhibitions in the US *and overseas.*"

"Investment in works of art is as dangerous as attempting to beat card sharps at their own game," said Andrew Faulds, a Labour Party member, about the fact that British Railways' pension fund has earmarked $2 billion over ten years for an art collection that already includes Picasso, Cézanne, Tiepolo, French furniture, Ming porcelain and medieval manuscripts.

The Veterans Administration and the NEA have announced a program that will place more than $500,000 in new artworks in fifteen VA facilities and create a pilot program for an artist-in-residence. "Artists love to work where they are needed and appreciated," said Mrs. Mondale. "And they are especially needed where people are trying to heal themselves, physically and spiritually."

Hey! Are you one of these artists?

New York Times, *Sunday, August 10, 1979: Mr. Oliveira, violinist, native of Connecticut, said, "Music and politics have nothing to do with each other." "Of course they do," countered Mr. Pletnyov, a twenty-two-year-old from the Moscow Conservatory. "There is a connection that lies very deeply. A man's politics are related to his attitudes toward the world and his attitudes to his ideas. Because music is made of ideas, this connection between music and politics is proper. Now, you ask me if I feel* free. *But what is freedom? In the United States, musicians' careers depend on their popularity with the audience. I saw a woman playing Bach violin sonatas on Fifth Avenue. She was very good. But why was she there? In the Soviet Union when you go to a conservatory, the government pays you. And when you finish, the Ministry of Culture finds you a job. Isn't part of artistic freedom having a place to practice your art?"*
If propaganda is conforming to value patterns that permit you to affect society, and art is conforming to market patterns that permit you to live, what's the difference? WHAT'S THE DIFFERENCE?

Montesquieu: "The dangerous fallacy of egalitarianism would lead only to incompetence and eventual mob despotism." De Tocqueville: "In aristocracies, a few great pictures are produced. In democratic countries, a vast number of insignificant ones." John Stuart Mill, reviewing De Tocqueville: "This can be traced to the omnipotence of commercialism, rather than to the effects of egalitarianism."

We can't change the world. We're only artists. I mean, you people in the schools, the unions, the mines, the factories, the farms, the ghettos—you really

should organize. Come on, get off your asses and Move it. Get out There. Do Something. Yayyyy. Let's hear it for *You! You* can change the world. Let's hear it for *you* changing the world. But us? We're just artists. Leave us alone in our studios. Feed us, clothe us, give us big white spaces, some luxury, good materials and a lot of attention. And when you get the world changed, we'll come out and decorate it for you!

New York Times, July 1979: Jorge Esquivel, Cuban ballet dancer raised in an orphanage: "I can't talk about ballet without talking about the revolution. The art is born from the politics. For example, we try to bring the ballet to everyone in Cuba. We give lecture demonstrations in factories and for farm workers. And we dancers don't feel we're part of an elite; we're the same as any other group of workers. In a socialist country, everybody is important. When there's work to be done in the fields, we help pick crops. People outside Cuba have asked me 'How can you cut cane? You're an artist!' *But I'm happy to do it. I'm no better than the next guy. We don't have different classes in Cuba, just different jobs. The idea of getting lots of credit for your particular job is, I know, very important here in the U.S. You have to be aware of it to get along. But it's not something we in Cuba think much about. When you have stars you also have a lot of envy. That's not something I want."*

The director of Musicians Unite for Safe Energy (MUSE) says people will assimilate antinuclear information best when it comes from their culture heroes. "Not only do I think it's okay for musicians to become involved in politics," said Bonnie Raitt, "I think it's a responsibility." Jackson Browne said, "I think it's important for people to realize that unless they themselves do something, it won't get done."

If these aren't *your* culture heroes, we can find you some others. But will they feel this way? Most artists don't. "Political activity and artmaking have never mixed to *art's advantage,* and my guess is that most artists are better off out of politics," said Walter Darby Bannard around 1970, of all times. Doowacka doo wacka Doo wacka doo. . . .

YOU LOUSY ARTISTS. You never think of anybody but yourselves. You think you're better than other workers. You think anything you do is art. You think every move you make is interesting. Real time. Real shit. Real snot. Real Interesting To Who? You don't care to who. YOU LOUSY ARTISTS. You sneer at the idea you work for any audience except the one you don't admit you work for. You protect yourselves from reality by pretending you only work for yourself. For Other Artists. For People Who *Understand.* I don't have to please nobody, you say, and you're lucky I'm making art for you. . . . (But I'm *not* making art for you and if you think I am, you're crazy.)

YOU LOUSY ARTISTS. You call people up and tell them to see your shows. You whine if they don't. You whine if they do and don't like it. You whine if they do like it but don't tell you why, don't *do* anything about it, don't write or buy or make a fuss that brings in some praise or some money. I mean art isn't exactly about giving *pleasure,* about *communicating,* anymore, is it? God forbid it *says* something, much less *means* anything. Art isn't done by the *hour.* Art isn't

like *other people's* work. That's why artists don't get paid, except in *ego*. You blame it on outside forces. You wonder why your audience says "It's nice, It's interesting, It's pretty, It matches my drapes." You say we obviously don't understand. We're not *artists,* after all. How can *we* aspire to understand?

YOU LOUSY ARTISTS. You've been ruined by the system that's made you a pawn for them—them that controls everything, including you. Including your *Art.* And you don't even know it. Why do you think there's so much trademarkism in the art world? This guy thinks he owns stripes. That one owns mirrors. That one owns the *earth,* yet. You trade in originality because you don't know where to find it outside of the market. You're scared to do anything if it's Been Done Before. You think art is individual. Ha! Individualism is what makes all the art in the system the *same.*

And what about regional art? Now how come there's no Great Art in the sticks? Because there's no Great Art promoters in the sticks. Because rich people in the sticks like to buy their art in New York. And if there are promoters and if they do promote you, chances are you're going to move here where you can pay five times the rent and go to the openings and the bar every night so you can make the right connections. So of *course* you don't have time for feminism, YOU LOUSY WOMEN ARTISTS. You're a token woman now. You're grateful that some other women have broken their asses to open up galleries, museums, teaching jobs for you. You maybe even attended a few meetings, a few demonstrations— back *then.* But now it's up to the *bad* artists, who aren't really serious, to carry the burden. How can you—a *good* artist—be expected to give up studio time to work for a political cause? Those *bad* artists joined the ugly, fat, unloved dykes to do the real work of the feminist movement. And *You* don't belong in that company, do you? "I don't even know what feminism is. I don't have to know. You older women did it for me. Thanks."

YOU LOUSY ARTISTS. Doors are open now to white women with some money so what do *you* care about anybody else? So what if there aren't any Third World women in the art world. It's because they don't want to be there. It's because they aren't good artists. It's because they have some other idea of what good art is, and it won't sell. It's not because we don't know any of them. It's not because we don't invite them to our houses or go see their shows or protest when they're insulted. (*That* might be censorship. Artists should be free to be bigots.) *Are* there any Black artists? If one of them makes it into the art world you put him down because he makes *white art.* That's right, Give it to 'em coming and going. We don't need any more competition in the art world anyway. Pie's too small as it is. Bad enough all these *women* coming in. Just means the standards are falling. What can you say—YOU LOUSY ARTISTS. . . . You . . . bleep bleep bleep. . . .

Did you think I *meant* all that?

What do I want from you—applause or response? Can I make an art audience angry?

That's something.

Can you make art about these things?

Why Not?

II
"I Don't Want to Think About It
Because There's Nothing I Can Do About It
So Please Don't Talk About It to Me."

A picture of bitterness, with revenge barely visible in the background. A picture of a Black woman who has just been told the job is taken. A picture of a white woman who's just been told they'd rather have a man because she might get pregnant.

A picture of a man with a family who has just been told there *are* no jobs. A picture of a woman by a window, waiting listlessly for the social worker to come.

A picture of a baby toppling out that window. A brightly colored picture of a young couple relaxing on their cabin cruiser. (A tape recording of the fights they have below decks because they haven't got *enough* yet.) Another brightly colored picture of a bearded man with his hands nailed to a cross. Next to it a picture of a flaming cross outside a house. (A tape recording of the cold sweat dripping off the family inside the house.) No money for analysis. Practice what you preach.

Hi. Come on in. Iced tea?
How's Joe? And the kids?
Did you see in the paper about . . .
Oh, God. Don't let's talk about it. Too awful.
MMMMmm.

(Silence.)

It's not *healthy not* to talk about these things. They fester.
We all have our own ways of dealing with them. Mine's not to think about them.
But don't you feel guilty? I mean us sitting here, with all *this?* And knowing . . .
No, I don't feel in the least bit guilty. I've worked for what I've got. Don't tell me you're off on one of your send-the-leftovers-to-the-poor-starving-children-in-Africa kicks.
I think I'm outgrowing that.

(Silence.)

Well, if that's the way you want to be . . .
Let's drop it.

A picture of someone dropping it. Dropping the incriminating letter in the toilet bowl. Dropping a hint that You People aren't wanted here. Dropping in and not being welcome. Dropping the gun and running. Dropping a line to someone it might rescue. Dropping out of the meetings because my husband says he will leave me if I don't. Dropping DDT because it began to kill the wrong creatures. Dropping napalm because it didn't. Dropping the Bomb. Dropping the whole idea because it doesn't make sense anymore, because I can't change the world with art, because I'm more mature now, because there's . . . nothing I can do about it.

What's the most awful thing you can imagine happening to you?
If one of the kids committed suicide.
No, to *you*.
Going mad.
No, *to* you.
Being told I have no home, no place to go, nobody to love.
That's too general.
And you?
Maybe being tortured past the bearable point by men in uniforms and knowing if you talk they'll kill the people you love most and everything you've worked for, and knowing you'll *have* to talk, the next time they . . .
Good lord. You've been reading too many thrillers.
No, the newspaper. Argentina, Chile, El Salvador.
That's probably just Communist propaganda.
I heard a woman speak the other night. She'd gotten out alive. Her husband's still missing. Disappeared, they say. As in "he was disappeared." Her small children were left to starve in the streets. When she got out, one of them had gone berserk. Still is. She raised her shirt to show the scars of cigarette burns on her belly.
That's just sensationalism.
It wasn't makeup.
Listen, sweetie. You shouldn't *worry* about all that. There's nothing *you* can do about it. Think of the positive things you can do with your time. Things so the kids will have a Better Life in this Best of All Possible Democracies. Fund raising for the old school. Volunteering at the Junior League Thrift Shop. Fishing for cancer in the local stream. Being sure your kids get good drugs and no angel dust. You don't help anybody by worrying all the time. I tell you what—don't fire your maid. That'll be a blow for the downtrodden!

A long, long, endlessly long ramp leading from where I am to where I'm going. Down. I'm alone. Behind me in a struggling reluctant line is my extended family. Before me is this huge distance, a thin triangular space, narrowing at the bottom because it's so far away. There is a pale red glow in the sky which terrifies me, but I keep walking down, one foot in front of the other. I am barefoot. I am, in fact, nude, I suddenly realize. But after a moment of automatic shame I forget it, drawn back into the funnel of space. Down, down. Now I can see the end, or rather the horizon, the vanishing point. And I see that the dark cloud around it is thousands of people, millions, billions—all of humanity. I look back in fear, hoping someone will take my hand, but my family has disappeared. The way back is closed. I am too tired to climb, but I can still descend. I do. I come closer and closer to the crowds. They are people of every color, size, race, and age, men and women and children and babies. And dogs and cats and pigs and cows and horses and lions and tigers and elephants, and underfoot are snakes and insects and worms and fish, and in the sky a great swarm of birds and flying creatures. Their voices are raised in a righteous glory of rage, but at the same time they call out, to me, asking me to bring food, water, warmth, shelter, dignity, respect. And I am nude and my hands are empty. Yet the closer I get the happier I feel. I realize I am about to become one of them. Then, just as I am about to arrive, just as I begin to run down at a dizzying speed, just as I reach out to be welcomed by the nearest of the crowd—I am grabbed from behind and very, very slowly, agonizingly, I am

dragged back up the rough wood of the ramp, the people diminish, fall away into the red sky, and I'm only aware of the pain in my body.

I have terrible dreams.
What does your shrink say?
Take a sleeping pill.
What does Al say?
Buy a new dress.
Well, what am *I* supposed to say?
You're supposed to say I'm *right* to have terrible dreams and I'm just lucky they're only dreams, because for many people they aren't. You're supposed to say that the more we know, the *better.* That I should stop dreaming and start act-ing. That if *we* can't do anything nobody can. Because we're the ones with the time, the money, the education to do something. That if we don't, *nobody* can. That if we don't nobody *can.*

You're trying to make me sick. You *make* me sick. I feel sick. I saw the cutest thing the other day and I think it really *inspired* me. You know the blue curtains in the guest room? Well, what do you think of pink fringe? Pretty jazzy, huh? Pretty fucking heartbreaking—you, my best friend, trying to get me to read the newspapers, to *do* something, when you know it would make my life *miserable.* Pretty funny, because you know I'm powerless, hedged in by do's and don'ts with sharp points on the tops, electrified barbwire bars on my hatchback Honda and an overdose of chlorine in my new swimming pool. Enough to finish me. Me and my beloved kids I love so much I've given them *everything* . . . and now they don't know about *Nothing.* Are you trying to make me puke? Cry? *Change?*

III
A Happy Ending. That's What We Need.
This One Is Called "Happy Ending."

Once upon a time . . . your husband was killed in a defective Ford Pinto. Your brother went crazy from Agent Orange. Your daughter had cancer because your doctor prescribed DES when you were pregnant. . . . And Corporate America lived Happily Ever After.

There! Are you happy with your Happy Ending?
No? Well, Think Positive. Think *Pink* and Blue, not *Black* and Blue.

.

How about this one?
Once upon a time you thought a political conviction was just as healthy as a religious conviction. And did more good, too. Then you went and got murdered protesting the Ku Klux Klan instead of being burned at the stake . . . but you couldn't go to heaven, so you hung around in the energy fields watching the rest of the World live Happily Ever After.

No? That doesn't grab you either? Don't worry, Those are false *starts,* not false *endings.*

It all has to do with growing. One thing leads to another. Out of the soup and into the nuts. A Navaho girl lies on the earth to inherit its fertility. My own pu-

berty rites were muffled in Dairy Freezes too thick to suck through the straw, strained by the fine lines good girls didn't cross, cuddled between backseat buns with freezing diaries, red leather lips, a gold keyhole worth its weight in protection money. And when I was young and agile even the *front* seat didn't faze me. A ketchup-smeared napkin, a stray onion ring on my fourth finger, the hot and anxious hand, mouthwaterin' fingerlickin' fastfood and frantic damp of Coming Undone and How Far to Go. But where's the plot? It just goes from birth to death. A some-excitement-and-some-decay sandwich. Your normal cycle. So what else is new?

Every ending is a new beginning. That's what. Hip hip hurray! Nothing replaces political consciousness. That's what. Hip hip hurray! Nothing replaces the dialogue. That's what. Hip hip hurray!

Nothing replaces organization. Nothing replaces the workers taking over the factory and the woman fighting off her would-be rapist. Work replaces greed. That's what.

(Pause.)

No. Don't bring anything. I can do it all by myself. (Whatsamatter? You think because I'm so smart I'm not a Real Woman? I'll show you . . . this and this and this. Like it? Come up for more. Help Yourself! Dig In! Dying for some more to eat? I sleep with all my stuffed animals. Can I give you a taste of body and blood? Cup of coffee? Tea? Wine? Whiskey? Rattlesnake pickle? Aunt Fanny's redroot home abortion remedy? Try one. . . . Because I can't *talk* till you've got something in your mouth. Now have another one. That's it. Doesn't hurt, does it? Not so bad, is it? Whaddaya mean you can't talk with your mouth full? That's *very* rude. You're not allergic. Good for you. Bad for you not to eat what's good for you. She eats like a bird, and In Many Cultures Birds Are Sex Symbols. Why? The soaring, or the soft breasts? The precarious nests or the little pointed beaks? Lark pie and fried chicken. Decoy à l'orange. The way to his heart is through his stomach. Take that. And that. And that. Eat shit. Eat *me*. Ah ha! You are what you *eeee*aaaat! The next course is Fascism? No, a surprise. Social Democratic Republican Anarchic Libertarianism with *just* a dash of Luxemburgianism Feminism. Under glass? So the public can't touch? Under Dirt. Six feet of it. Happy ReBirthday to You. Happy ReBirthday to you. Happy *Bir*thday dear Happy *End*-ing. Happy Birdsay to you.

Come in, Happy Ending. We were expecting you. There had to be an improvement eventually. Just give me some time to digest all these new ideas. I mean, my legs were raised to know my place. Out back in the garden, scaring off the evil spirits. Of *course* there's plenty for everybody. All we have to do is move Fatso there down below the salt, so there's room for the Cambodians. A very old recipe. Handed down over the generations. Friggassee of the Rich. A delicacy in the hovels of Hohokus, the caves of Katmandu, the barrios of Bulgaria. No, I'm sorry. I can't tell you just *how* it's made. I might want to write a cookbook someday, you see. . . . Or make art. *Open Wide.* Meal Art is the Happy Ending! Slurp Slurp Slurp—Meal Art replaces Me-art, replaces mealy-mouthed art. Replaces loafing on the bread lines and eating cake and birdseed because the food stamps were

locked in the top drawer of the bureaucrat. Dig In! Dig Deep! With the weight of the rats off the sinking ship it floats again. The last meal of the day is lust. Take what you need and share it with your sisters and your brothers.

Have a nice Happy Ending! We're graduating from sodomized monobicontaminated glucosities back to dirt. Organic Earth. Nontoxic Love. Equal Distribution of Wealth. Our Right to Choose. We're sneaking through the intestines of this rotting society to give forth a good omen. Phew, Who did that? Hey. This corpse is *preg*nant. It's gonna be twins this time. Only the cleanest and the best; mixed in toilet bowls flagrant with artificial body odors. We keep them wrapped in plastic till they can walk. Then—*into* the microwave oven they go! All the impurities blown into a mushroom soup. You say's there's Nobody *left* in the race we won? But we'll wring a Happy Ending out of this anyway. Because look at the funny way that bird is flying. With its engorged right wing and desperately flapping left. It's taken some seeds. Will dump them. Life goes on. Tweet tweet.

Happy Ending. So Here's what we did: We bought mace guns and took karate lessons. We told ourselves not to be afraid. And we were afraid enough to be careful. *Very* careful.

We talked to the others, and we found out their pain was like ours. So we did. We joined the Union. And we didn't. We didn't pay our rent. And we picketed the place. We refused to pay our taxes. We mothers got together and said No to the School Board. We put pressure on them. *We* put pressure on *Them*. We lay in the road! We climbed the fence! We occupied the office! We spoke out! We marched! We sent letters to the mayor! *I* sent a letter to the president! Me. *I* sent a letter to the president of the United States. . . . And I got back a letter addressing me as mister.

So now there are many of us. And it is still not easy. That is at least closer to a Happy Ending, no?

(Dramatically.) But how can we forget Bloody Monday? Bloody Tuesday? Bloody Wednesday? Bloody Thursday? Bloody Friday? Bloody Saturday? Bloody Sunday? Bloody Mon. . . .

You said that one already.

(Head in hands, long shrieking wail.) WHERE WILL IT ALL END?

(Flatly.) I don't know, but I want *us* to have something to *say* about it.

Print and Page as Battleground

*A Slide Lecture**

This melodramatic title is really more wishful thinking than cold fact. When artists' books came out as a recognized phenomenon in the late 1960s, a lot of us on the "art left" had great hopes for them. We saw them as a potential means of

*An unpublished slide lecture given at Franklin Furnace, New York City, January 1981.

TONIGHT:
Mostly cloudy

TOMORROW:
No silver lining

HERESIES

NEW
FORMAT

ISSUE 14 A FEMINIST PUBLICATION ON ART & POLITICS $4.25

WOMEN'S PAGES

SPARK

RIOT

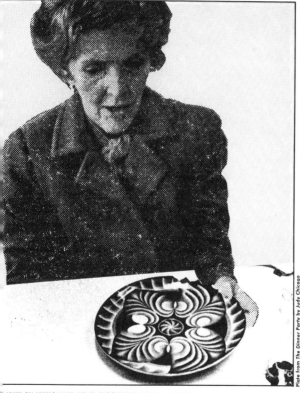

Plate from *The Dinner Party* by Judy Chicago

HIRED
TORCH
HELD

PLATTER SPLATTER! WHITE HOUSE CROCKERY SMASHED IN DOMESTIC SHAKE-UP. First Lady fondles "Hypatia," part of the new, feminist china to debut at the next White House Dinner Party.

The Women's Pages, cover of *Heresies* no. 14, Spring 1982, designed by Cynthia Carr with the Heresies Collective.

populist expansion and as an appropriately cheap, direct and intimate vehicle for social change. It seemed for a while as though artists' books—and pamphlets, broadsides, posters and little magazines—could bypass the art market and therefore say all the things the system preferred not to have said. Well, the printed art media proliferated in the 1970s but in 1981 they're still not in the supermarkets, even though they're now occasionally reviewed in the magazines. *Potential* is still the only way to describe the role of page art in oppositional culture.

Why? It's easy to blame it all on external factors, on the system itself and its effect on the artists trying to scrape a living off it. But one of the reasons for the slow start has been strictly internal, and that's lack of intense political analysis from within the art world about the place and role of art. For instance, I remember what a revelation it was when I finally figured out that the reason artists' books had not progressed was because the form had changed—not the content. Doesn't sound real bright now, but it does go to show how obsessed we in the art world are—especially in New York—with form and space, to the exclusion of meaning. The social expectations of art both for the specialized art audience *and* the general public are integrally linked to our attitudes toward mass-produced-and-distributed outreach art.

Since 1969, when the Art Workers' Coalition began to raise the consciousness of New York artists, the collaborative and collective urge to organize has had as much to do with what political artists have made as any esthetic "movement." In fact, it has been threatening enough so that the dominant culture has constantly tried to make manifestations like feminism, Black art, political art—even conceptual mediums—into temporary "movements" so they can be got over with quickly and we can go on to the next one. However, they all turned out to be *styleless* and thereby finally *un*cooptable by the style-obsessed mainstream. The fear of being consumed by radical chic still surfaces whenever the wind shifts slightly in the direction of social-change art, but I think it's safe to say that any genuinely gritty artist will find new ways of making her/himself indigestible.

The ways social-change artists have organized over the last decade have incorporated the use of print and page, from the Art Workers' Coalition to the AMCC to PADD. Community organizing, networking, and political organizing are extremely dependent on mass-produced communication, which is obviously where art comes in. I wish more artists were devoting more time to unexpected and visually effective ways of getting a message across. A message. Ah. But we've been raised to think that forms or images have to speak for themselves, that to demand a message from them is demeaning. You've probably heard the old purist saw "Wanna send a message? Call Western Union." Well, Western Union isn't exactly doing the job. Maybe artists should step in.

[. . . . *Periodically during the lecture, I showed groups of slides on specific issues, such as militarism and disarmament, racism, the environment, violence against women, etc. I suggested the audience think of them as photoessays in a magazine format. Unfortunately, most of this work is not reproduced in this book, as I usually show two carousels of eighty slides each at every lecture and I have about the same number of reproductions here for almost forty essays.*]

The social expectations of Western art are rooted in the class system, even though art is supposed to be classless. Two basic questions to ourselves—

honestly answered—can provide a lot of insights into this idea of a classless art. One is "Who are you working for?" The accepted avant-garde answer tends to be first "For myself," second "For other artists," and third a belligerent "Nobody tells *me* how to make my art" (even when the art market and media are, in fact, indirectly dictating esthetic decisions). The second question is "What does it mean?"—This is *the* commonest inquiry from *any* art public. It's a perfectly sensible question which no one is supposed to ask because it makes you sound powerless if you can't answer it, and god forbid that art should mean *Nothing*. Even in the late '60s, in the heyday of Minimalism, when many of us were concerned to empty objects of one kind of meaning so there would be room for another—even then *Nothing* was not the right answer. It had to be qualified, or mystified: In other words, it might be *Nothing* in the terms you're talking about because you know nothing—but it means *everything* to those of us in the know. If the public's too dumb to get it, then the public isn't worth communicating with, so back we go to the audience that has been educated to like what *we* like—the same people, in fact, who educated *us* to like what we like—and what they like, which turns out to be art that is safely meaningless except in its own captive context and framework.

Western art education insists that high art is an instrument for the pleasure and entertainment of those in power. We are told that only superior isolated geniuses make Great Art—upward mobility through art. We are told clearly in schools that if art wants to be powerful, it must separate itself from power, and from all events which artists are powerless to control. Our new leader has been

Greg Sholette, *The Citi Never Sleeps, But Your Neighborhood May Be Put to Rest,* artist's book made in vacuum-formed plastic and Xerox versions, 1980. At one point the book was placed uninvited in an artists' book show at a Citibank branch in New York City.

Klaus Staeck, *In the Beginning There Was Money,* 1973, street poster and postcard.

Chips McNolty and Toni Robertson, *Daddy, what did YOU do in the Nuclear War?,* 1977, street poster made at the Earthworks Collective, Sydney, Australia.

quoted as saying, "The arts should concentrate on what they do best, and leave the broader social problems to others." This is the counterpart of telling women and children to stand aside because this is *men's* work. The logical conclusion is that only politicians should concern themselves with social life, not artists, coal miners, housewives, etc. (This is *democracy?*) All these responses reflect the fundamental insecurity of an artist's existence in a society that tolerates but doesn't respect cultural activity and practically denies the existence of cultural *workers*. Work is what's respected in America above all else except having enough money *not* to have to work. The reasoning seems to go that art isn't work because the product is useless and therefore relegated to the role of *property* of those who have worked successfully.

Mass-produced art has one more strike against it. It's a truism of capitalism that if you give something away, nobody wants it. The more you charge the more desirable it is. Mass-produced art is seen as the cheap by-product of the real thing—like most so-called multiples really are, because they serve the same function as their more expensive counterparts, that function being functionlessness.

So what *does* art do best? What *is* art's function? Repressive societies don't lose sleep over this issue. In Chile and in the Soviet Union, images are feared, censored and controlled in more direct ways than in our own hegemoniacal country. Here the whole commercial art world is based precisely on art's uselessness and artists' powerlessness, not to mention the planned obsolescence of linear evolution that keeps the market afloat. The point I'm trying to make is that maybe art and artists shouldn't have to be socially useless. I know this is a *shocking* idea. Yet underlying the contradictions of this discussion is the fact— terrifying or exhilarating, depending on where you stand—that the image *is* powerful and that artists ghettoized into noncommunicative modes have allowed the image's power to be usurped by image-makers who know better than to call themselves artists.

I'm talking, of course, about the dread Mass Media. So-called fine artists tend to be highly ambivalent about it, envying it and imitating it and hoping to be covered by it (or on it)—*and* despising its shallowness and dishonesty. A good deal of contemporary art, both reactionary and progressive, imitates the media's techniques, which in turn often imitate art. (I wrote a book on Pop Art years ago, and later met an ad man who said his TV commercials were greatly influenced by the work in the book; I didn't know whether to laugh or cry.)

Though much oppositional art criticizes the media homeopathically, this desire to lure an audience into unexpected content by suggesting that the message will be as familiar as the image is not automatically effective. There's a subtle edge between being critical and being absorbed by the object of your criticism, or defined by the opposition. This edge in turn reflects the whole problem of "neutrality," of images so ambiguous that the message can be read either way— the problem of recognizable and unrecognizable satire, in which the artist gets off the hook and the art is depoliticized as effectively as if it had been apolitical from the beginning.

In the last twenty years, Pop Art temporarily blurred the distinctions between high and low art; Conceptual Art opened up the formal repertory and continues to sharpen the visual artist's verbal capacities; feminist art broke down the barriers between crafts, hobbies, and women's traditional arts. Nevertheless, taboos still exist against cross-class culture, and from on high still come

mystical invocations of "Quality." But all of these directions—Pop, Conceptual, feminist—question the "fine arts" and the genius-in-isolation mystique and have encouraged the interest in collective and collaborative and even anonymous art promulgated by organizations like CUD (Contemporary Urbicultural Documentation), Co-Lab, Group Material, or *Heresies*.

There are a lot of misconceptions going both ways between art and audience as a result of the divisions I've been talking about. They stem from class again. Working people are generally excluded from what most of us consider important art. The obvious point about making art in the streets and other public places is that one's work is seen by people who wouldn't be caught dead in a museum, as well as by those who would, but who might see it differently in a different context. For instance, store windows have become prime space for artists interested in outreach who aren't into or can't afford mass production. They function as laboratories for mass-production or other large-scale outreach pieces. The Printed Matter windows, now in their third season, are not meant as come-ons to come in, but are aimed at raising social issues for people passing by who probably wouldn't be interested in artists' books if they did come in. Local people, including workers from the telephone company and the Post Office, have come to expect the monthly changes and provocative subject matter; we get a fair amount of audience response, both approving and otherwise.

The other approach raised by outreach is that of coding, or of selecting audiences. There's been a lot of talk about context since the '60s, but it has been couched in primarily formal terms. (We don't know much about the effect, say, of the same image inside a museum, where it is sanctified by expertise, and out on the street, where the audience's own associations and opinions have freer rein.) The more politically sophisticated artists now consider the differences in their audiences and incorporate the different needs and interests into the different aspects of their work in a spirit of exchange. There is, of course, an element of market research in these strategies as well, aimed not at selling, but at feedback or education. One difference between art and advertising is that ads select an unthinking audience and tell it what to think or buy while art, ideally, tries to provoke people to perceive and think for themselves.

Nan Becker, title page of *Sterilization/Elimination,* 1980, artist's book in Spanish and English on forced sterilization of Hispanic women.

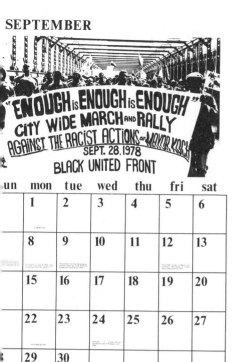

SEPTEMBER

un	mon	tue	wed	thu	fri	sat
	1	2	3	4	5	6
	8	9	10	11	12	13
	15	16	17	18	19	20
	22	23	24	25	26	27
	29	30				

Jerry Kearns, detail from *Calendar for the Black United Front,* Brooklyn, New York, 1980.

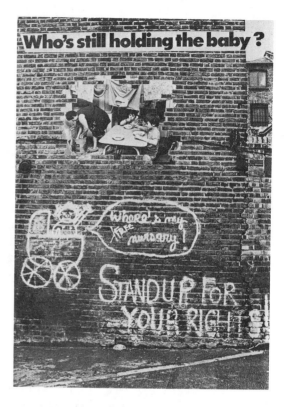

The Hackney Flashers, *Who's Still Holding the Baby?* from a slide packet/exhibition about day-care and local nurseries, Hackney, London, 1980.

All good art of any kind is on some level provocative and subversive. A culture of resistance specifically informs, rejects, protests and rebels. It questions authority and exposes sacred cows. For better or worse, this is an area where artists are particularly at home, since they themselves are considered social outsiders, even when they're doing their best to belong. Much of the art shown here is graffiti in one sense, an expression of self-identification scrawled on the surfaces of the dominant culture. Store windows, street posters, even community murals are "people's art," which is how one graffiti artist has described graffiti. Superimposed on predictable images, they also become collage—an ideal oppositional medium because of the way it wrenches things out of their contexts and forces people to see them differently. And an element of collage's unpredictability is humor, which many progressive artists have used with devastating accuracy.

The educational or didactic aspect of much print and page art is very important if it's recognized for its communicative abilities. For instance, the Poster Collective in London, focusing on Third World history, has made a colorful and concise series for schools. Jerry Kearns, working with the Black United Front in

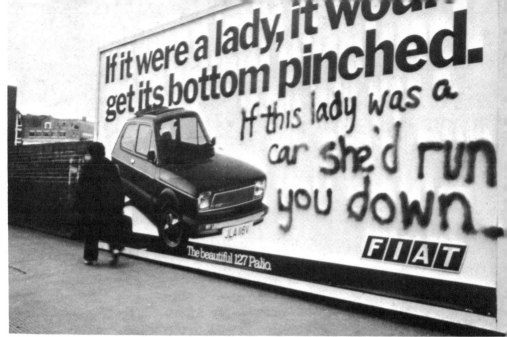

Jill Posener, postcard, Farringdon Road, London, December 1979 (Deviant Productions).

"Not 'til we pass the ERA!"

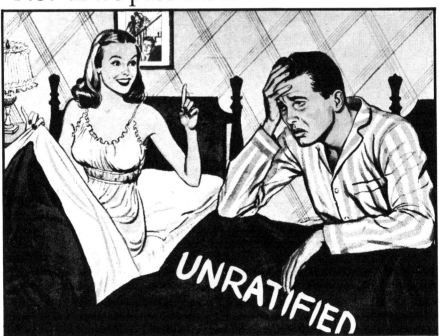

Cindy Schumock and Sharon Niemczyk, *"Not 'til we pass the ERA!,"* postcard, 1981, FeMail Art Productions, P.O. Box 10706, Portland, Oregon 97210.

It's more than a look. It's a feeling.

SUMMER ISSUE 99¢

Elizabeth Kulas, *"It's More Than a Look . . . ,* 1976–77, altered advertisement, cover of Xerox book by Northampton (Massachusetts) Artists Collective.

Brooklyn, made a photocalendar in which Black history is tied into current struggles against police brutality. One of the most intelligent and visually effective teaching aids I've seen is a little slide packet and booklet by the Hackney Flashers—a collective of British women photographers whose images of women and work, and women and child care, are based on a combination of community organizing and media analysis They are concerned with how the world is represented to those who are usually not educationally armed to understand it. They expose simply and clearly the discrepancies between media images and real life and the process of image construction "through a variety of professional and cultural practices and ideological positions . . . which benefit some social groups and may actively harm others." One of the Flashers' strongest works is about the fact that British middle- and working-class women are the most drugged women in the world—highly dependent on Librium and Valium—a chilling example of multinational control over the private lives of women and children for profit—equaled only by Nestlé's exploitation of Third World women and babies. (BOYCOTT NESTLÉ'S PRODUCTS!)

Sometimes there's a tendency in printed art to be more outrageous than

outraged. Women's art is where the real rage surfaces. Feminist analysis of media crimes against women has been particularly developed in the last decade. The Los Angeles Woman's Building sends out a continuous deluge of beautifully printed and designed mail pieces, artists' books, and postcards, like the attractive book by Margaret Cowley on the unattractive subject of incest and Mary Linn Hughes' series on sexual harassment. In New York, Ida Applebroog's violently understated little "performance" books are ironic takeoffs on soap opera situations and horrendous tales of all-too-common human damage. In France, Annette Messager's awful little book *Ma Collection de Proverbes* (an international compendium of traditional and totally misogynous "wisdom") proves, as she says in the preface, "that men fear women as much as they fear death—the two phenomena that must ineluctably be endured."

The violence that women face daily in the media, we must face in the streets as well. Women everywhere *have* been fighting back against pervasive victimization. There's an Australian Reclaim the Night mural in Adelaide.[1] A float for a 1978 Take Back the Night march in San Francisco by Ariadne—Suzanne Lacy and Leslie Labowitz—portrayed the double image of woman as virgin and whore. (During the same campaign, striking public bus placards by Mary Linn Hughes and Micki McGee used the phases of the moon as a vehicle for the same message.) Ariadne has concentrated on media abuse of feminist topics by doing extremely detailed and well-planned public performances in which they criticize and attempt to remedy sensationalized and distorted images of women. For instance, working with Women Against Violence Against Women (WAVAW), they've done media strategies around record-album covers *(Record Companies Drag Their Feet)* and rape *(Three Weeks in May).* The latter was a citywide rape campaign that included private and public performances, guerrilla actions, much-publicized meetings with city officials, liaisons with rape-crisis and other feminist groups, and a huge map in the City Hall Mall on which every rape was marked as it took place.

At the core of much social-change art is the familiar dialectic between personal and political—a feminist credo that is important to all oppositional culture, especially to the intimate medium of artists' books and magazines, which allow time and space for narrative hooks and visual seduction to work together. The emphasis can be on the private or the public. As Martha Rosler has pointed out (in reply to the question "*Is* the personal political?"):

> Yes, if it is understood to be so, and if one brings the consciousness of a larger collective struggle to bear on questions of personal life. . . . No, if attention narrows to the privatized tinkering with or attention to one's solely private sphere, if one simply regards this triumph of personal politics as a publicly emancipatory act. Yes, if one is sensitive to the different situations of people within society with respect to taking control of their private lives.[2]

NOTES

1. I saw this mural in the summer of 1982. The night before, it had been defaced with a huge red spray-painted penis and the inscription "Cock Rules."

2. She came up with this extemporaneously on a panel at the Institute of Contemporary Art in London in 1980.

The Ten Frustrations,
or, Waving and Smiling Across
the Great Cultural Abyss*

If much of China's art is lacking today, it is not lost, only sleeping. Some day we shall carry on a tradition that has made the world marvel.
—MADAME QUO TAI-CHI, *Queen* (October 9, 1935)

In retrospect, I'm not sure *what* I saw in the two-and-a-half weeks I was in the Peoples' Republic of China.[1] I do know that the things that most interested me had little or nothing to do with art. But since art is my field, it provides the most convenient framework in which to try to convey my excitement and confusion about China. The following is neither "my Chinese Diary," nor an expert's overview, but an attempt to make some sense of a baffling experience.

It was simultaneously just what we had expected and totally unimaginable. We knew the Cultural Revolution was over and we were prepared for the (by now diminishing) references to the Smashing of the Gang of Four. We knew that Mao's 1957 exhortation "Let one hundred flowers bloom, let one hundred schools of thought contend" had been the official arts line for some time. But we were unprepared for the billboards, the advertising for Sony, Lucky Cola, Swan Products, directed now at the Chinese, not just at foreigners; and for the persistent efforts to get us to spend money. ("We need the foreign currency," they ruthlessly explained, when we protested at being rushed away from interesting sights to the inevitable gifte shoppe attached to every factory, temple and exhibition.)

Our guide, Gu Yang, told us early in the trip: "The people are sick of politics." She laid this disenchantment squarely before the door of the four-headed serpent—attributing it to the Gang's lively but limited view of correct culture. I was greatly disappointed when I realized that in today's "normalizing" China, politics was out and tradition was in—tradition in the most banal and retrograde sense, at least to Western eyes. Gone are most of the "heroic revolutionary" and "Mao cult" billboards and posters, gone the "Red Detachment of Women" ballet; even the Peasant Painters and worker woodcuts are nowhere to be seen in the huge, crowded big-city bookstores, where the newest romantic novels are the best-sellers.

In their place is not a flourishing new art, but "fat babies" straddling fat carp, swirling atoms, rosy-cheeked children in space ships, kittens, goldfish, benign portraits of Zhou Enlai and Hua Guofeng, and the "lotus-faced ladies" who cross the graceful purity of ancient goddesses with a disturbingly bland and modern eroticism. Mao is to be found, but not in his previous profusion. We were not taken to see the famous *Rent Collection Courtyard* in Peking, though we did see a miniature version of it in the Shanghai National Art Museum (along with the only remaining major collection in China of the great ancient paintings, scrolls, bronzes and porcelains). The objects we saw in the factories, art galleries and de-

partment stores were either pallid imitations of the art of the past or banal schlock or handsome crafts, such as paper cuttings and bookmarks—all made with the utmost care and the most extraordinary degree of technical skill. As they say, Chinese society and politics are based on contradiction. In the lobby of the Shanghai Ballet Theatre there is a huge gold-on-red quotation from Mao: "In the world today all culture, all literature and art belong to definite classes and are geared to definite political lines." At a factory in the Mai Lu commune nearby we saw labels being sewn into men's shirts which read "Touch of Class."

While we may deplore this new socialist consumerism, it is hard not to enjoy what John Gittings has called "the very innocent sort of admiration with which many Chinese now regard the new advertisements appearing in the last year on hoardings that once bore heroic pictures or quotations from Chairman Mao." He copied down a poem in a glass-case street show of workers' art that read:

> Oh, multi-colored spread of advertisements
> Smilingly stretched along the ten league road
> Citizen quartz watches; Phoenix face cream
> Victory Song TV sets; Turtle shirts. . . .
> You are a set of bright medals on the chest of Shanghai!
> You are a branch of flowers hanging over our new road,
> In the colors of China's new spring of the 1980s![2]

The advertisements, like the brilliant patches of colorful clothes airing on bamboo poles over residential streets, do add life to often drab urban landscapes. They are also a bit quaint to Western eyes; one of our favorites was the dashing rider promoting the Chinese movie version of *Zorro*. The other prime urban decorations are the gigantic large-character poster billboards, white lettering on red grounds, that exhort workers to work harder and citizens to be better socialists.

I knew there would be a culture gap, but I had looked forward to meeting artists whose politics were up front in their art. In one sense that is what I found—though they weren't much interested in talking about it. The Chinese arts are still very political compared to those of the West. Propaganda and art are still frequently interchangeable. Socialism is still the all-pervasive ideological motive and force behind everything (even the new consumerism and incentive programs). The move in art from didacticism to entertainment may have something to do with the fact that the Gang emerged from the cultural domain, though culture is here defined in the broadest sense, including the whole superstructure: "the information media, statute-law and the judiciary, education, philosophy, literature, the arts, leisure activities, social conscience and the preferences of the intelligentsia."[3] (The "Four Modernizations"—agriculture, industry, defense and science/technology—do not include culture.)

Consequently art that looks limited and a bit decadent to us must be seen in the light of the fact that during the Cultural Revolution only eight operas were approved, and no matter how wonderful they might have been, this is something of a starvation diet for 800 million people over a ten-year period. Deng Xiaoping himself, in 1975, expressed the then "absurd view" that "Cultural life is monotonous . . . the model operas are not an example of a hundred flowers blooming but of one flower blossoming."[4] Jiang Jing's pride—the model operas—are now seen

as "too formalistic," and her "theory of the three emphases," aimed at the perfect socialist work of art, has been rejected in favor of Mao's vaguer, or more subtle, distinctions between subject matter (the "democratic essence" of his "Six Political Criteria for Art") and esthetics ("artistic technique"). At the same time, the Gang was always stressing "the new," and the ideological rejection of empiricism was also bound to affect the arts. All this may illuminate the terrible time we had defining or discussing "innovation" with our Chinese colleagues.

In developing his one-hundred-flowers theme, Mao had said that "it is harmful to the growths of arts and science if administrative measures are used to impose one particular style of art or school of thought and to ban another. Questions of right and wrong in arts and science should be settled through free discussion in artistic and scientific circles and through practical work in these fields."[5] One is now told constantly that during the Cultural Revolution writers were terrified to write, artists to paint, composers to compose, etc., since the strictures were so complex that virtually any "imperfect" attempt might end as the dreaded "poisonous weeds," to be rooted out by drastic means. According to playwright Tsao Yu, even now that the Cultural Revolution is over, "some people don't know what to do. They are like people who have been unbound but can't walk because their legs are numb."[6] Similarly, Zhang Yuanzhen, director of the Shanghai Art Gallery, said recently: "For ten years we were isolated. Now we are trying to understand what has been going on in the outside world. What are the new schools and how can we integrate their good points into Chinese art?"[7]

They are being justifiably cautious, however. Many agree with the composer Wu Zuqiang, who advocates "making foreign things serve China" while opposing "indiscriminate and wholesale adoption of anything Western," lest it sully the national spirit.[8] We often felt that for all the immense friendliness and enthusiasm, the older and more prestigious artists were less interested in what went on in the West than in how the West received the "new" Chinese art. At both the Shanghai Institute and the Shih Lin Seal Engraver's Society in Hangchou, our hosts were very disappointed to hear that we had no real "criticisms" to offer about their work, and that we had not seen their first overseas exhibition. We hastened to assure them it must not have come to New York, but the truth is that the art they were doing had so little to do with our own interests that most of us probably wouldn't have gone anyway. On the other hand, we were dying to try to explain what *we* did, and why, but nobody except Gu ever asked. At the stately Seal Society, during the formal introduction, the director said they had a question for us. We all perked up over our tea, but the question was, again, what did we think of Chinese art? I got stuck with answering and muttered something lame about how communication was important and we could learn a great deal from each other since we overemphasized innovation and they overemphasized tradition.

This *was* the crux of our misunderstandings. Goodwill could not overcome the basic fact that we were talking at cross-purposes, neither understanding the other's culture well enough to do more than wave and smile across the abyss. For instance, at a banquet in Peking with the staff of the Academy of Fine Arts and a few nonart professors from Tsinghua University, there was a painter at our table who had been to West Germany and had seen more contemporary Western art than we had Chinese contemporary art. He liked photorealism. But he frankly acknowledged that abstraction was culturally impossible for him to grasp.

"Where did it come from?" he asked us. "What does it mean? Why does it exist?" We drew a deep communal breath over our Mongolian hot pot and came up with a variety of off-the-wall replies—some theories that might have been recognized by the authors of the textbooks, and others that decidedly wouldn't have been. The Chinese artists were interested but sincerely baffled by our lack of a coherent theory on this important subject. There seemed no common point of departure into a "real discussion," especially since we ourselves didn't agree. Although we were told the Academy subscribed to *Art in America,* nothing of ours written or reproduced there seemed to ring a bell; their knowledge of Western art history usually seemed to stop with Impressionism, maybe Post-Impressionism, maybe a whiff of Cubism, and recently there was a Käthe Kollwitz woodcut exhibition in Peking. Even in these areas they seemed to be less familiar with theory than with pictures.

We, in turn, were always asking inappropriate questions about abstraction and innovation, and it took us an inordinately long and frustrating time to realize that their esthetic traditions are so different from ours that what we call innovation—that mad treadmill of progress that stimulates sales—has no application to Chinese art. The Chinese art people weren't being "inscrutable"; they just didn't know what we were talking about. They always agreed, in fact; they, too, were extremely interested in and dedicated to "innovation." And although we in the West think of Oriental art as "abstract" and have used it to inspire some of our most extreme nonobjectivism, the Chinese think of their traditional art as *realism.* (They proudly and often noted that Guilin, a town where karst peaks rise abruptly and fantastically from a flat plain, "proved to Westerners that Chinese painters weren't liars making things up.") We kept trying to explain how in the West change is constant, individual progress is expected, individuals work "freely" and competitively, how it is individual artists rather than schools who are credited with the greatest leaps forward.

We did not take time to recall, however, that within the Chinese tradition the audience's perceptive capacity is heightened and stimulated by minute changes and a poetically politicosymbolic vocabulary incomprehensible to us. One of our major frustrations was just that level of generalization on which the Chinese are accustomed to communicating. Our troubles stemmed partly from the language barrier and ignorance on our part and partly from the interpreters' not being artists. But it also had to do with the way the Chinese express themselves both verbally and visually in a thicket of metaphors, similes and parables that sound to us incredibly quaint and oblique. Even the documents of the Cultural Revolution, for instance, which affected the political future of the whole country, were couched in a language of flowers and bees and weeds. The Revolution itself was sparked by a historical play: *The Dismissal of Hai Jui* by Wu Han. We wasted a lot of our time trying to pin the Chinese down to specifics when they were probably being quite specific all along.

Chinese art education is divided into Traditional Chinese Art (paintings of landscape, birds and flowers, and figures; calligraphy; and chop carving) and Western Art (oil painting and sculpture). In Shanghai we visited the two sections of the Art Institute, where some of our misconceptions were clarified and others were heightened. This is one of the few such institutes in the country. All its members are graduates of the high art schools. They are there for life, some sixty of them in the Traditional section and thirty in Western art, ranging in age from

forty to ninety, doing "new creation" and "research" in their "own work." (A few promising amateurs are also given further training there.) They are among the thousand or so artists in all of China who are the real "professionals"—paid to make "fine" art full time. Their average salary is 100 Yuan monthly, whereas the average worker's salary is 60 Yuan a month. (We never met anyone who made over that, and we met many who made less.) In addition, the state pays for all materials and for framing and mounting. These special institutes exist only in a few cities and the one in Shanghai is the largest. Its members hold an annual exhibition and participate in the Shanghai Painting Association's and other nationwide shows. Every spring and autumn they travel to other parts of China (the countryside) to work from "grass-roots units."

The Traditional art section was housed in a lovely old foreign-built mansion with luxurious gardens. The artists who greeted us were mostly dressed in the gray suit of the upper echelon of the cadre. They were neat, dignified and quite formal. Their art was the best of its kind we saw in China. After the Brief Introduction, as we were admiring the scrolls hung in the main room, we had an exchange which epitomized our differences. Although stylistically much of the art was virtually indistinguishable to us from that in the museums, its "quality" was obvious. We unanimously focused on a particularly bold black-and-white brush painting of an eagle perched on a pine branch. We complimented the painter, and one of us took the bit in his teeth yet again and asked: "What distinguishes this from ancient art; what *are* the innovative elements?"

The artist replied that the traditional eagle is very brave, so to paint the eagle symbolizes bravery.[9] We tried again, and additional false starts increased his bafflement and our frustration. Finally, in desperation, the artist said, "New painters here, too, like to be different but they do it on the basis of the old." He pointed out that his work was based on a specific traditional painting as well as on an unchanging genre, and that in the older work "the leaf of the pine is very fine and exquisite, but here it is free and strong." I couldn't resist asking about the Ch'an Buddhist school, which had specialized in just such strong strokes, and one of the women said, "Oh yes, Liang Kai." So we got that far—but no further. The Ch'an Buddhist painters of several centuries ago look more "modern" to our eyes, but I couldn't tell if they heard me saying this, whether my ignorance embarrassed them, or whether the question simply made no sense at all.

This disputed eagle, which looked to us like a very skillful example of a tried-and-true style, may indeed have incorporated all kinds of personal innovation that were simply invisible to us. Equally possible, it may not have been innovative at all in our sense of the word. What *is* clear, at least, is that the degree of innovation is different in the Oriental tradition. Ad Reinhardt, who was an avid scholar of Chinese painting, loved it because nothing ever changed, because the Chinese were painting "the same painting, the same old thing, over and over again"—just as he claimed to be.[10] Anyone who has studied the history of Chinese art knows that the changes that did take place were very subtle and very gradual. Chinese innovation took place not so much within an individual's lifetime production as within a collectively evolved historical style (whereas our avant-garde tradition has abandoned connoisseurship in favor of novelty). Individual artists in China were revered, but their contributions were seen within the tradition itself, at that slow pace. This history sheds some light on Chinese Socialism as well as on Chinese art, and may to some extent answer questions as to why traditional im-

ages associated with the Bad Old Imperialist days continue to thrive in the New China. More specifically, the situation has of course also been attributed to the Cultural Revolution: "Chinese painters will now produce *guohua* [traditional painting] and nothing else for the next twenty years because they have been deprived of the chance for almost as long."[11]

I also found interesting another scroll in the same room. It was more "modern," less delicately expressionist, and showed a mountain landscape with an old house atypically large and centered, one window suffused by a brilliantly yellow light—an odd and incongruous suggestion of electricity in what appeared to be an "ancient" scene. It had the air of a nativity, and that, it turned out, is just what it was—a political nativity. It depicted the house in the Chingkangshan mountains where Mao had written a significant essay: "Why There Is Red Power."

At the Western painting section of the Shanghai Institute, we found the furthest-out art we were to see in China. This branch was established only in 1965, and a year later fell victim to the Cultural Revolution's distaste for elitist establishments and foreign culture. In contrast to the well-lit elegance of the Traditional section, it felt familiar to us. It was dimmer, shabbier; the artists were rather scruffily dressed and more relaxed. Over a couch hung a tightly painted oil, an industrial landscape with a band of bright pink cherry trees and a band of yellow flowers and a band of smokestacks and a band of sky, reminiscent of Childe Hassam or other provincial Impressionists.

"Painters here prefer the Impressionist style," we were told by the director (a sculptor, perhaps in his sixties, a follower of Rodin as all the sculptors seemed to be). He had studied in Paris and Belgium in the '30s and spoke French. He was a charming man, and his staff joined in, interrupting and laughing, during the Brief Introduction. They were disappointed that there was not a single oil painter in our group. (Our one specimen had skipped this session.) They obviously had anticipated great communication since they are, after all, specialists in *our* kind of art, and they were eager to hear about "the lives of painters in America." However, the avant garde since the '30s seemed to be absolutely unknown to them—except, again, for "photorealism": Duane Hansen, Andrew Wyeth, Norman Rockwell. It was very difficult to explain what we were and most of us lacked institutional affiliations. Free-lance art critics, like me, for instance, do not exist in China. We stumbled through, trying to exude as much good humor as they did. Then we went to see their work.

Painting by painting we went through the large exhibition, followed by a crowd. Every artist was dying to hear our every comment, though none of them spoke much English. The art was, for China, stylistically varied. There was a sort of Matissean still life done by the former director, who was "the teacher of Zao Wou Ki." There was the usual flock of well-executed socialist-realist documentation—Mao carrying pumpkins "like the peasant women," oil field workers, Zhou in the hospital, Zhou with kids on his knee, illustrations from Lu Hsun, Impressionist landscapes often executed with a certain flair and painterliness, and narratives that are moving despite their conventional execution. My favorite of these was the portrait of a young woman standing proudly in a snowy village street, all in cool grays and blacks. The subject is the revolutionary martyr Lu Hou Lan, dead at sixteen; the artist was, not surprisingly, a woman. We beamed at each other, but alas, she spoke only a few words of English, and I could communicate only my special interest in her work.[12]

Whenever we approved of something, the artist was called forward and shyly accepted our compliments. The works we liked best—those with outbreaks of expressionist brushwork or offbeat imagery—were inevitably by the very young men, which got embarrassing—though their elders seemed as pleased by their success as we were. Two stood out. The first made huge, bold and originally colored history scenes with powerful looming figures. The subjects were from China's distant past, and one big battlefield canvas had a kind of barbaric energy that reminded me of Malcolm Morley. The second—Chen Yifei—made a huge canvas about "modern young people thinking about history," in a style one could call romantic surrealist history painting. At right front an oversized self-portrait seen from the back surveys a background (or a painting within a painting) that is made up of myriad smaller scenes in washy grisaille and sepia, like ghostly old newspaper photos showing the history of China approaching the revolution. At the left, painted like the figure, in full color and concrete realism, is an oversized empty wooden armchair. It was an impressive painting and especially so in this context. When we went later to Chen's little studio, we found he painted unabashedly in several totally different styles, among them the romantic narrative (e.g., a canvas of the grandmother from a Lu Hsun story, dying of starvation in the snow, clutching the shoe of her grandson who had been eaten by wolves).

Like those at the Fine Arts Academy in Peking, where engrossed students turned out identical drawings of nude or "ethnically costumed" models, the studios here were straight out of nineteenth-century Paris; peeling plaster, dim light, centered around a small, black-piped coal or wood stove, a few life drawings and perhaps a reproduction of Ingres or Whistler pinned to the wall,

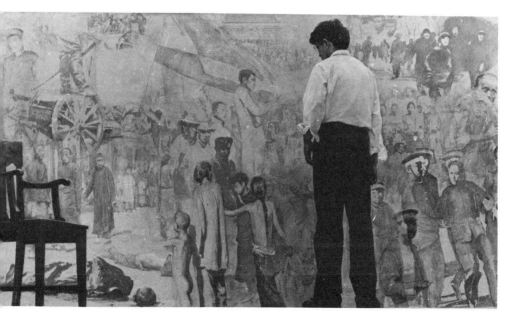

Chen Yifei, *Looking at History from My Studio,* 1979, Western Painting Institute, Shanghai.

Hsu A-da and others, *One Night in an Art Gallery*, artist's book after an animated film, Shanghai Film

no personal details at all. We also visited the sculptors: a woman making curvy, elongated Lohan-like traditional dancers and an equally stylized and emaciated twentiesish nude reaching daintily for the sky; a man working on a monumental bust of Zhou in gray clay, imitating chiseled stone, to be cast in bronze; another man making smaller portrait busts in plaster and bronze, the liveliest of which portrayed the composer of "The Yellow River Concerto." Art in China is mostly painting, or two-dimensional. Sculpture seems for the most part either monumental or figurine scale, destined for the plaza or the mantelpiece, perhaps because of the lack of a middle-class market and commercial galleries to buy anything in between. Although the Duchampian esthetic would surely be anathema to the Chinese, the only abstract sculpture we saw was, in fact, "found objects." In all the temple and palace gardens were huge natural rocks, pitted and carved by the elements, "chosen" by esthetes to be displayed as art.

The other high point of our art visits, and the other place we felt most at home, was the Shanghai Film Animation Studio. It wasn't on our itinerary, but someone knew some movie people who had been there; our request to visit was granted after a certain reluctance on the part of our local guide, who thought we were loafers and uninterested in China because so many of the group skipped official visits to wander around or shop. The studio turned out to be a kind of factory, and we immediately liked the people, who were relaxed and jovial and glad to see us. Altogether, 500 workers produce "thirty boxes of film per year": cartoons, puppet films and paper-cutting films. Since the Cultural Revolution they have produced some 200 films, all by hand. (A ten-minute film takes over 8,000 pictures and many of their films are features over an hour long.) Mr. Wong, the director, remarked that "working conditions are not so good. The buildings are old and the equipment is old." We could not disagree. The whole country is poor and the arts are no exception.

Workers at scarred, wooden school desks in open carrels were drawing from little plaster models of "Snowboy and the Rabbit"—heroes of a short directed by a cheerful woman. Under the glass of each desk were a few family photographs, scenic views, sometimes Mao or Zhou. Drawings made in one room were transferred to acetate in another. Here, as in every other factory or workshop we visited, the workers never missed a stroke of their extremely intricate work despite our breathing down their necks with curiosity and cameras, though they smiled up at us occasionally. The backgrounds for the animation are watercolor landscapes and Mr. Lei, one of the older directors, is proudly referred to as a "famous watercolorist." The tableaux for the puppet films are also constructed here; the one we saw was a beautiful miniature of the ornate temples we'd been visiting; the story was about a forced marriage in the bad old days. The lacy paper-cut figures were especially fascinating, extraordinarily complex and hinged at every conceivable joint for movement—wonderful works of art in themselves.

When we had seen each section, we were led back through the freezing hallways and open courtyards and shacklike buildings past the ubiquitous badminton nets and piles of wood and concrete. (Everything in China seems to be undergoing delayed construction; materials lie around like a museum of good intentions.) In a drafty screening room (no plush seats), we were offered four films, but to our guides' disgust saw only two because the sickest among us were about to die of the damp cold. The first was a feature we saw advertised on

billboards all over Shanghai: *Nor Tsah Troubles the Sea.* It was the story of a mythical boy hero born from an egg brought to his tyrannical father by a crane. At an early age he takes on the four evil dragons living under the sea—demons of flood, fire, snow and wind—who are persecuting the people. (We could recognize the Gang of Four but probably missed endless other political innuendoes in word and image.[13]) Although forced to kill himself to save the people in his first life, Nor Tsah is reborn, returns, and finally conquers. (Perhaps he represents Deng, also miraculously resurrected despite the four dragons?)

I am not a great fan of animated film but this one was exquisite, influenced by the early Disney and full of a uniquely oriental grace and vitality unknown to Walt. It incorporated the decorative styles of Tang and Indian art and even at his most cutesy, the boy hero had the appealing dash of Errol Flynn. The art, far more convincing than so much of the professional Traditional paintings we saw, made the old scroll paintings come to life. My favorite scenes were those in which the dragons were on the rampage, tearing around in fire and storm with virtuoso displays of movement like Ch'en Yung's famous thirteenth-century *Dragons of Mist and Torrent.*

The other film was called *Little Tadpoles Look for Mummy,* and was made by Mr. Lei and Hsu Ada in 1963 after the historical painter Chi Pai-Shih. It was one of the loveliest translations from painting to film I've seen. The brushed images, mostly blacks and grays with touches of brighter colors, floated on a white ground; the cast of frogs, ducks, crayfish, turtles, hens, et al., was, like the narrative, both witty and touching.

As usual, we had to leave before we could find a way into any meaningful conversation, but a few of us went on with Lei and Ada to an exhibition that turned out to be one of the most interesting of our Chinese art experiences. It was held in a big old stone second-floor hall, on a main commercial street, which turned out to be a sort of temporary "alternate space." Usually a Boy Scout hall, it had been rented by eleven artists from the animation studio for an independent exhibition (though the work itself did not seem very different from what we had seen officially displayed in the Modern Art Gallery). There was an entrance charge, and quite a few people were there in the late afternoon, some buying black-and-white souvenir snapshots of their favorite works. Nothing was for sale because the show would travel to Peking and Nanking. A critic was to write it up in the weekend paper, and the gate was to be divided between the artists after expenses were paid. The state, so far as I could make out, was not involved.

The art itself—lots of it—was small and varied, a hodgepodge of extremely skilled conventional water colors in both Chinese and Western styles (Mr. Lei's among the best), amateur imitations of same, popular decorative work with vaguely propagandistic subjects, calligraphies, prints, a few portraits. Landscape was the most popular theme and politics the least. One drawing seemed clearly Picassoid and almost abstract. A handsome landscape showed a cityful of smokestacks against a gorgeous display of polluted sky. My favorite (no photo available) was Hsu Ada's semiabstract black-on-white pattern of trees in the snow, which he said was seen from a train window; it stood out in its directness and geometric simplicity. Each artist displayed work in at least two styles. The lack of emphasis on the individual seems to leave the individual free to do whatever s/he wants, and there is certainly something to be said for that kind of freedom.

The fact that we were so amazed to find an artist-organized exhibition recalls our confusion about another "free" show. Before we left America we had read in *The New York Times* about a "dissidents' exhibition" in Peking which was closed down because it showed too much freedom of expression, including satirical treatments of party leaders. Our hosts at the academy in Peking laughed hilariously when we timidly asked if they had seen the "dissident show." They had not only seen it, but had helped find it an indoor space because "the side of the road is no place for art." They said it was a show of *amateur* artists, some of whom were their students, and that they had helped and advised the organizers.

After I got home, I read a fuller account of this episode.[14] Apparently the un-licensed outdoor show initiated by a group of young artists associated with the Democracy Movement had indeed been broken up, but then permission was given for a two-week show at the Museum of Art; it was titled "The Single Spark" (from Mao's "A single spark can start a prairie fire"). The group had published an unofficial magazine that featured such Western-sounding statements as: "The world provides the artistic explorer with limitless possibilities, and the artist should constantly be offering new surprises," and "We take Kollwitz as our model and Picasso as our pioneer." Gittings says that many of these young artists were Red Guards; while they are entirely disillusioned with the Cultural Revolu-tion, they continue to protest and satirize the bureaucracy, which has clamped down on freedom of expression even more since this show last November. I only wish we could have met with *these* artists. Among our frustrations was the knowledge that we knew so little and didn't know where to go for information, because so little seems to have been written on the visual arts.

Lei and Ada came to our hotel the next morning, and Ada brought me my first Chinese artists' book: 64 pages, 3½ by 10½ inches, horizontal format, consisting of full-color "frames" of a film called *One Night in an Art Gallery.* It is im-mensely inventive about how to transfer film to book medium, with each page edged at top and bottom in black so the pictures appear to be on a screen. The story is about censorship, good guys (schoolchildren who live in the gallery's pic-tures) versus bad guys (a hat and a club who represent the cigar-smoking bureaucrats; they drive up in a limousine and censor every picture). Kids and pic-tures fight back and the villains are vanquished along with their little green informer friend, after various chases and shenanigans. This is, then, a political artists' book, or propaganda, with a lesson to be learned amid the visual fun. It would seem to satisfy the criteria for literature and art offered in November 1979 by Deng: "Literary and artworkers who are responsible to the people should take into consideration the social effects of their works. All creative workers should give the people education and enlightenment and esthetic enjoyment . . . weeding through the old to bring forth the new."[15]

The mixture of "high" and "low" culture in China raises some fascinating issues for anyone who is dissatisfied with the way in which Western contempo-rary high art has cut itself off from the popular, or low, arts, and thereby from its audience. There are some parallels to be drawn between our Pop Art (in which exploitative mass media were incorporated into elitist esthetics) and the current Chinese notion that art's prime goal is to "give pleasure to the people" (in which elements of kitsch are also channeled into an aristocratic tradition). "The aim of Socialist production is to satisfy the needs of the people." But which needs? As in the West it is sometimes doubtful who has been consulted. "We have only a few

abstractions because the masses don't like it," we were told; then another person remarked sensibly that it was all right for an artist to do what s/he wanted since "everybody doesn't like everything anyway." We never had the sense that abstraction was being suppressed (although it certainly wasn't being taught) so much as that no one was particularly interested in it.

Larry Rosing reported from the last New York "artworkers" tour, in January 1978, that from their discussions with Chinese artists they gathered that abstraction was merely considered "decoration"—which sounds familiar. They were asked if the rise of photorealism in America "implied that American artists had come around to the Chinese way of thinking about subject matter." But when they met with four of the "professionals" from the Shanghai Institute, they were told that the difference between the Husian County Peasant Painters and their own work was that the institute painters "thought of form first while the Peasant Painters thought first about subject matter."[16]

The line between a would-be photorealism and pure academicism is not very clear. The "handicraft" embroideries which are photos transferred by grid into another medium could be the former, but perhaps the best example we saw was a "photorealist" portrait being executed in the street in Foshan by, I presume, an "amateur," though perhaps an amateur who had trained in the Western painting section of some art school; in every art school we visited, realistic portraiture in charcoal was a major focus. Then, of course, there is the Chinese view of modern photography, which is another essay in itself.[17]

Certainly the blurred distinctions between what we in the West see as "high" and "low" art would not encourage any apparent move away from accessibility and communication. Chinese professional artists are in the enviable position of seeing their art become public almost as a matter of course. It is true that the top-echelon painters at the Shanghai Art Institute did not make propaganda posters nor work in a factory, but the sculptors there were making official statues, and the "famous watercolorist" at the animation studio made propaganda . . . in the form of extremely popular cartoons carrying political messages, as well as his own "fine art." And there are other "masters" who are respected artists but still work either as commercial designers or skilled artisans or at some unrelated job during the day. In Guilin we even encountered the free art market: a number of young men squatting on the mountainside, trying to keep their perfectly competent brush paintings of the overwhelming landscape around them from blowing off the cliff. Their work was for sale, cheap by Western standards, although not so much cheaper than that at the Shanghai Institute.

When two Minneapolis artists were in Guilin last summer, they found "sixty paintings of incredible sensitivity, beauty and competence done by sixty amateur artists from a work brigade in a nearby towel factory." Yet when they tried to buy some rice paper to try the technique themselves, they found the materials were unavailable in Guilin; they were told that the "nonexistence of art materials was an effort on the part of the Communist government to stop the sale of paintings on the mountainside. When a medical doctor earns only two hundred dollars a month and a school teacher seventy dollars a month, an artist engaged in free enterprise selling drawings at ten dollars each constitutes a crime against the people."[18]

There may only be a "backdoor" market for independent artists, but there is definitely a huge market for chatchkas, or what we condescendingly call kitsch

or schlock art. These things are much cheaper than the "good art" being produced at the institute and therefore, just as in the West, more available to the masses. At the same time, the mixture of high and low culture is far less self-conscious than in the West. This could be seen in the exhibitions we visited and also in magazines. One, for instance, consisted mostly of revolutionary and historical comics, but also included an article on Leonardo's drawings; there was a cartoon on the front cover and Mona Lisa on the back.

At the Shanghai Art Gallery, where a vast span of contemporary art was hung, I kept noticing the introduction of the "feudal" goddess of mercy or "lotus-faced lady" into scenes of "modernization." For example, one gouache showed a laboratory/factory in which smiling young women in white coats extracted pearls from huge shells; each pearl was accompanied by a tiny "pearl goddess" aristocratically coiffed and dressed in flowing robes; several of these little goddesses were lined up like specimens in a glass case in the foreground. The figure appears to be a protectress of women workers; in another painting she was wafting around a microscope wielded by a healthy young woman on a mountainside. She seems both ubiquitous and anachronistic. (The sinuousness and elongation that often repelled us in the depiction of female and elderly sage figures is actually a hardy survivor from the history of Chinese art—what Roger Fry remarked in the '30s as "the emphatic continuity and flow of the contour"[19]—now exaggerated and cheapened by overuse or mass production.)

In Foshan, near Canton, we visited the Shihwan Fine Arts Ceramic Factory. It turns out endless exquisite replicas of gray-faced old sages, more of these lissome mythical females, water buffaloes and teensy-weensy boats and teensy-weensy sages playing Go with pieces the size of pinheads—all mass-produced by hand, though with division of labor. (No one person was responsible for every aspect of a figurine.) In the Handicrafts Research Institute in Shanghai—another dark, cold, formerly elegant mansion converted into a quasi sweatshop—we watched designers make the prototypes for the lurid tapestries reproducing Gainsborough and gamboling kittens we saw at the Industrial Trade Fair. They worked from postcards and color photographs cut from travel brochures. Some were making extremely skillful, if saccharine, figurines after ancient Buddhist sculptures by peering at blurry two-dimensional images. Others made needlework patterns from photographs of tourists' sights and of people—some commissioned by overseas visitors. (After seeing a Japanese businessman in blue serge and tie being transformed for woolly posterity, two of our group wanted their portraits done, but it turned out to be expensive—as well it should be, considering the time involved.)

At the same place we had a delightfully nonchalant demonstration of the art of paper cutting by the senior artist in that section. With a pair of rounded scissors he produced in midair a bird, and then a pig of astounding intricacy. Another man modeled for us a child doll from play-doughlike, colored plasticine. He, too, was amazingly skillful; tiny hands, button eyes, rosy cheeks and bright clothes rapidly and magically appeared. I was so impressed by the technical control that I'll never be able to look at these things the same way again. But the final image remained nauseatingly unconvincing in its confectionary cuteness. (Who am I to talk? I collect the "tasteless" creations of English ladies who stick shells in plaster over old plates and cold cream bottles, and I genuinely liked the Chinese computerized silk weavings in gray and black that imitate news-

paper photographs of important personages such as Stalin, Lenin, Marx, Engels, Mao, Zhou and sometimes Norman Bethune—but never Agnes Smedley.)

In any case, the notion of art as entertainment rather than as education alone, or political arousal, has penetrated the "high" traditional arts as well as the handicrafts. At the provincial but also prestigious and academic Seal Society on the famous West Lake in Hangchou, artists proudly displayed and demonstrated, along with marvelous calligraphy[20] and virtuoso landscapes, a kind of calendar art done, or overdone, in traditional styles. We saw the same kind of thing at the elegant Shanghai Institute of Traditional Painting. I don't know whether this is the influence of "modernization" or of Western art polluting the simplicity of Chinese watercolors, or whether it is simply the inevitable decay of a style weakened over centuries. Either way, one of the most appalling aspects of the mixture of aristocratic tradition, Madison Avenue, and the Rockettes, in which Chinese popular art seems to be wallowing at the moment, is the watered-down ethnic imagery we found. The numerous "National Minorities" incorporated by the predominantly Han population are used in Chinese art in a manner reminiscent of the "they-got-rhythm" brand of American racism. A great fuss is made over the minorities keeping their customs, diets, costumes—and racial stereotypes—intact. (One local guide told us that the Han race wanted to "stay pure.")

The murals in the foreigners' dining room at the newly opened Peking airport feature, as do many theatre presentations, the colorful Dai group, a quasi-Malaysian jungle culture that allows depiction of the women topless and nude. (Nudes are still rare in puritanical China, though we did see some curiously modest and dispirited Western realist ones in the academies.) Racism and sexism tend to go hand in hand. A woman artist at the Shanghai Institute and the man at the Hangchou Seal Society were both innocently painting what seemed to me to be tasteless hootchy-kootchy girls, far better endowed and more enthusiastically, if coyly, sexual than the academic nudes—while intending to eulogize the national minorities. This image was evident in all the arts, as well as in the handicrafts, in advertising and in public posters.

A similarly retrograde style of entertainment was found, to varying degrees, in the modern "singing and dancing" shows we attended. The ballet in Shanghai had a certain polyglot charm. It was actually some twenty different skits, each announced in the classic theatrical falsetto by a highly madeup, schoolgirlishly dressed actress. My favorites were a revolutionary romance (more romance than revolution) where the young couple is married and murdered on the battlefield; and an art piece where actresses in traditional costumes did astounding things with their twenty-foot-long scarves, simulating to perfection the popular depictions of those mythic goddesses swirling in cloudlike loops. Acrobatics (surely "low" art) was incorporated into some of the "ballets" (high art?).

In Guilin, on the other hand, the nightclub aspect took over completely. The acting was coy and mincing, the endlessly changed costumes sleazy and revealing, the image of woman as voluptuous slave girl or passive doll hideously contradictory to the relaxed and natural looks and behavior of the real Chinese women surrounding us. This particular shot of "normalization" seems to be introducing into Chinese culture all the worst the West can offer. I was enraged by it and told Gu vehemently that this was *false culture,* not worthy of the achievements of the Chinese people since the liberation, and so forth. Politics may be out, but does real life have to go, too? She also had a "criticism"—of the music: it

was a pastiche—but was clearly disappointed when all of us left at intermission. The 200-year-old Peking Opera was something else—robust and brilliant in movement, color and sound, utterly foreign, too long, and the best theatre I've seen for ages. We saw it three times in three very different settings, but the high point was in Shanghai, in a huge, dirty hall jammed with workers and their children—an audience quite different from the more genteel one at the ballet and in Guilin. As the Chinese themselves admit, China is not yet a classless society.

It is, however, the closest to one I have ever seen, and one can only admire the downright miraculous achievements of the Chinese people in the last thirty years. It was at the Worker's Cultural Palace in Shanghai that this was most strongly conveyed in regard to the arts. A huge multistoried building resplendently red and gold on the outside and worn and cavernous inside; its halls, workshops, exhibitions, game rooms and cafés were thronged with people. There is no night life in China—no bars except in the foreigners' hotels, a limited number of theatres and cinemas; restaurants are geared to the work shift ending at 5 P.M. and are empty by 9. So the cultural "palaces" are ironically where "the people" dally—or at least the men; the women were presumably home dealing with the second part of their double day.

After playing a doll hockey game and Ping-Pong, and seeing an exhibition on safety in the construction industry that included an intricate model of a tall building surrounded by the inevitable and picturesque bamboo scaffolding, we ascended to a warren of small rooms upstairs where people were studying and discussing, making and practicing their arts. I was immensely touched by the shabby little library filled with earnest blue-clad backs hunched over precious books[21]—an impressive microcosm of the struggles this country has had to educate and inspire in almost a billion people the respect for arts and learning. I was even more exhilarated by the time we had visited in rapid succession the practice sessions, or performances, of several different musical groups, ranging from an ebullient mixed chorus to a plaintive folk group; an ensemble playing ancient instruments was led by a beautiful and accomplished young woman who had risen from the Children's Palace to the Youth Palace to this apogee. A full orchestra played a symphonic version of "Oh Susannah" in our honor, and a team of nine acrobats—postpeople by day—did amazing things with a bicycle. Finally we got to the cartoonists' group, where disaster awaited us. They were mostly young and middle-aged, all men, very enthusiastic, crowding around to show us their work. It was the only art group we met in a wholly informal situation, without the benefit of a Brief Introduction, but we were too exhausted after a day of sightseeing to take advantage of it. They had no leader, and set to work collectively on the same sheet of paper, drawing effortlessly two tokens of Chinese–American friendship which they gave to us. When they insisted we make something in turn, our Shanghai guides shook their heads woefully. By now they didn't think we were proper artists at all. Aghast, we huddled to figure out what to do. Of our four genuine fine artists, two were absent and the others "don't draw." One nonartist could draw frogs and another volunteered to try a cartoon out of desperation. Then someone had the bright idea to do a collective "exquisite corpse"—folding the paper to make a composite figure Surrealist style. However, when faced with a huge piece of paper and a tiny fine-lined pen, we made such a mess of it that we had to cross it out and apologize. The cartoonists, disappointed, were nice about it, while our critical guide Chen snarled to

me under his breath, "That is not painting. That is a tourist game." The next day our absent draftsman made a small drawing and we sent it to the cartoonists through the guide.

SELF-CRITICISM

This humbling experience in some ways epitomized our Chinese tour. I think we learned a great deal from it, painful as it was. We met as a group that night for the first time, and discussed—also for the first time—our responsibilities to each other and to our hosts, especially to Gu. Our Shanghai guides were to some extent right in judging us "not serious" about art. I knew that I, for one, had not done enough homework. Frustrating fragments from a graduate-school minor in Oriental art kept floating to the surface, reminding me how little I remembered about Chinese traditional culture. We had not, of course, realized how important such an understanding would be because we had pictured the art as still more-or-less Culturally Revolutionary. (Since few of us would have shared the political convictions then, we probably would have been just as patronizing about this as we were about the traditional "kitsch.")

So we were not well prepared. We had done a good deal of reading in history and politics and neglected the arts, figuring that we could depend on our own skills and instincts. In fact, we should have pored over press clippings and four years of *China Reconstructs* and the *Beijing Review* before we left, rather than while we were there. At the same time, the Chinese, despite all the foreign books and catalogs we and surely other groups had brought, were equally unprepared to ask *us* "the right questions." Yet over this abyss of mutual ignorance I think we all managed to convey much goodwill and a longing to communicate. There was a lot of smiling and excitement to fill the intellectual lacunae.

It took us a long time to internalize the crucial differences between our culture and theirs, and by that time we had also internalized the rather condescending tone which I fear pervades this article despite my consciousness of it and my political sympathy for Chinese Socialism. Taste is taste, and insidious. Our conditioning as Western "high artists" was ineradicable. Our specialized group got more out of a weird breed of pig at a commune, the amazing street life of the old town in Shanghai, the visits to factories, schools, workers' homes and glimpses of private lives, than from the art itself. The Chinese are wise to introduce foreigners to all facets of their society.

Because I have spent a lot of time over the last few years thinking about populism and art, I probably felt guiltier than most about rejecting the "kitsch" (in itself a term that raises class barriers), about lacking the background to understand the traditional art, and being unable to respond to the mixtures—the same mixtures I hope for in my own art context. Accustomed to collective work and discussion, through techniques feminism has borrowed from the Chinese, I missed these in our own group and with the Chinese artists who were so professional, so warmly welcoming, so hungry for the same things. The fact that these dialogues never came off was nobody's fault, though at one point I tended to think it was ours. There was never enough time and it was very cold and we were sick a lot. Yet I have never seen and learned so much in such a short time. The

whole trip was hard work, physically and mentally exhausting, utterly fascinating—and above all, moving. I am convinced, like Liu Binyan, that "art and literature should interfere with life."[22] Now it remains to be seen what we can learn from the successes and failures of "people's art" in China.

NOTES

1. It was a vaguely specialized tour of "art types"—a motley crew of seventeen people, thirteen women and four men from New York, Chicago and Los Angeles, ranging in age from twenties to sixties: a painter, two sculptors, a "drawer," a photographer, a graphic designer, a textile designer, two dealers, three collectors/museum trustees (one a lawyer and builder as well), an art consultant, an art bookkeeper, two free-lance critic/curators and an art historian who had been to China before and organized the tour. We arrived in Peking January 10 and left through Hong Kong January 26 and in the interim went to Shanghai, Hangchou, Guilin and Kwangchou (Canton), as well as a few smaller towns along the way. In each city we visited places that had something to do with art in the broad sense and in Peking, Shanghai and Hangchou we talked to the "professional" artists at academies and societies. We were accompanied from the beginning by our "whole journey guide"—a twenty-eight-year-old woman named Gu Yang who, aside from working for Luxingshe (the government tourist bureau that provides all itineraries, guides and accommodations), had been a farm worker and a barefoot doctor, is a member of the Communist Party, and translates science fiction from English. Gu was intelligent, curious and relaxed, while never losing her authority. She answered our endless and often rather prying questions with patience and honesty and had many of her own in return. She pored over the books we had brought with us and used the trip as a quick course in Western modern art. She herself was the best advertisement we met for increased intellectual freedom in China.

2. John Gittings, "China's New Set of Plugs," *The Guardian* (London, April 12, 1980), p. 9.

3. Jean Esmein, *The Chinese Cultural Revolution* (New York: Anchor Books, 1973), p. 9.

4. Deng Xiaoping quoted in Chi Hsin, *The Case of the Gang of Four* (Hong Kong: Cosmos Books Ltd., 1978), p. 152.

5. Mao Zedong quoted in *ibid.*, p. 187.

6. Tsao Yu interviewed in "Playwright Discusses Modern Drama," *China Reconstructs* (Feb. 1979), p. 27.

7. Quoted by Seymour Topping in "China's Long March into the Future," *New York Times Magazine Section* (Feb. 3, 1980), p. 75. Topping also mentions a group called the "black painters," impressionists who were banned by Jiang Jing; perhaps these were the people we met at the Shanghai Painting Institute, but we never heard them called this.

8. Quoted by Ling Yang in "The Last Three Years: Discussion on Major Issues," *Beijing Review* (Dec. 28, 1979), p. 14.

9. As an example of how seriously such images are taken, Gittings (*op. cit.*) says that Jiang Jing during the Cultural Revolution denounced an old master who specialized in birds because he produced "a gloomy eagle."

10. This is not a direct quotation from Reinhardt, just what he said in various ways all along. In his writings, he also adopted his numbered lists and flowery titles from the Chinese, using them sometimes as satires on officialdom and sometimes approvingly, as in his writings about the "new academy."

11. An anonymous Chinese quoted by Gittings, *op. cit.*

12. I identified myself at each Brief Introduction as a critic particularly interested in the work of women; this was always greeted with mild amusement. Although women's roles and lives have obviously changed drastically since the liberation, the patriarchy is still alive and well in China. In all the places we visited only twice was a woman in charge of the

introductions and only once was she in a position of real power. The few women artists on the art school staffs were decidedly in the background; sometimes they served tea. Much of the work we saw by women seemed rather *sweet,* an all-too-recognizable symptom of conditioning equally common in the West. "Women's Lib" is considered a bourgeois phenomenon and my attempts to communicate the concerns of a socialist feminism were received politely but without much interest. I missed one session the whole trip—a bamboo factory—and in the introduction, I was told, the male director delivered a long feminist speech.

13. That is, we thought we recognized the Gang of Four; in correspondence later, I was told by one of the animators that they found this assumption hilarious and that their use of the old myth had no modern over- or under-tones.

14. Gittings, *op. cit.*

15. "Vice-Premier Deng on Literature and Art," *Beijing Review* (Nov. 9, 1979).

16. Larry Rosing, "China: Art & Artist," *Art in America* (March–April 1979), pp. 10–11. (See also brief articles by others on that tour in the same issue.)

17. Most of the photography we saw was either neutrally documentary or rather pallidly imitative of painting. Gittings (*op. cit.*) describes a photography show by Yuan Lianmin in a Shanghai park, which consisted of 100 pictures of the same famous mountain, all of which imitated, in various techniques, ink and oil paintings.

18. Julia Barkley, "A Trip to Asia," *WARM Newsletter,* WARM gallery, Minneapolis (Fall 1979), p. 3.

19. Roger Fry, "The Significance of Chinese Art," in *Chinese Art* (London: B.T. Batsford Ltd., n.d. second edition, c. 1945), p. 3. Fry also remarked that the Chinese handle figures differently (and without the Western interest in the human body) and: "when we Europeans refer to plasticity we talk, naturally, in terms of planes, but I doubt if the Chinese artist has ever conceived of this method of handling plastic forms. I do not know what language he uses, but I suspect he would, even in speaking, refer shapes to cylinders, spheres and ellipsoids," p. 4.

20. The calligraphy we saw demonstrated and exhibited in Hangchou at the Seal Society, and the exquisite books of the seals and chop marks in which they specialize there, were by far the most attractive art we saw to Western modernist eyes. Elsewhere we leapt on a Pollock-like black-and-white ink-on-paper work only to be told it was where the artist cleaned his brush.

21. Concerning the scarcity of books in China, see Lloyd Haft, "What the Chinese Are Reading," *The New York Times Book Review* (April 20, 1980), pp. 3, 32.

22. Quoted by Ling Yang, *Beijing Review*, *op. cit.*, p. 13.

V

VOICING OPPOSITION

Prefatory Note

I began to write a monthly page for the *Village Voice* in January 1981, just after returning from Cuba. It offers a much broader audience than my usual one and much faster feedback. I like the way I had to liven up, or "journalize," my style and the kind of continuity a monthly column provides. (I tend to assume people read the art section regularly so I can get on with my polemics without having to repeat myself all the time.) The *Voice* pieces here are the closest I've come to writing reviews for years (though I hate writing reviews and see them more as fragments of an ongoing dialogue with friends and readers about art, activism and my other obsessions). I took the job with the understanding that I'd write primarily about art and politics. I never suspected at the time that there would be so much activity in that area that once a month would be insufficient. That's heartening.

The following articles go up to February 1982, which is when the manuscript for this book was turned in. I've added, at the last minute, three more recent pieces and regret having to omit those in between.

Beyond Pleasure*

"I meet you today with love and fear." This was our official welcome to Cuba. The speaker was Alfredo Guevara, vice-minister of culture and director of the Cuban film institute. A revolutionary esthete. We were impressed. It was our second day in Havana, sixteen of us, mostly feminist and socialist visual artists from

*Reprinted by permission from *The Village Voice*, Feb. 11-17, 1981.

the United States. We had yet to see any Cuban art except what surrounded us in Alfredo's office—the modern "masters": Amelia Pelaez, Victor Manuel, Rene Portocarrero, in gold frames and velvet mats. We expected a brief formal greeting. Four hours of virtuoso monologue later, we left with our preconceptions shattered and a sense of the complexities awaiting us. Here is some of what Guevara said:

> Cultural relationships are always subjected to state relationships, so we should put our cards on the table. The relationship between American and Cuban intellectuals can never be the way it was before the revolution. There is a climate of distrust. The scars of North American imperialist culture are still evident in Cuba. Cuban culture was not formed by the healthy part of U.S. culture, but by an American *subculture*—commercialism, which coincided with the birth of the mass media. . . .
>
> We are beginning a long struggle in the direction of real cultural transformation. We must have the will to transform these past patterns of U.S.–Cuban relations into something constructive. We would be willing to accept a *rational* influence, but the frontiers must be questioned every day. North American society is so strong and so fascinating that the relationship has to be cautious in terms of quantity. All Cuban intellectuals don't agree. I am one of the most skeptical that the decolonization of Cuba has been accomplished.
>
> There are two ways to transform the North American culture left in Cuba: (1) The powerful can coerce. Selection is power. This is the superficial way. (2) Get rid of commercial subculture *critically*. This is the deep way. Making a hero revolutionary is only changing the sign. Deeper change will have to change the language. . . . The best revolutionary artists won't simplify, but complicate.

Two weeks later, after we had had more time in Havana and traveled through the interior, we gave the first public presentation of North American visual art in Cuba, at the Casa de las Americas.

In the meantime, we had met Cuban artists mostly in formal situations, which were informative and often moving but also frustrating in their lack of intimate dialogue. We had envied and been humbled by the combined political effectiveness and graphic power of the design team of *Organizacion de Solidaridad de los Pueblos de Africa Asia y America Latina* (OSPAAAL), who make the international solidarity posters for which Cuba is famous. We had been impressed by the people and by the network of the cultural *tallers*, or workshops, the *circulos de interes* and the Hermanos Saiz Brigades for young artists. We had admired the Cubans' energetic approach to mass culture and we had bemoaned the fact that there, as elsewhere, the visual arts are not so well supported as the more popular music, theatre, dance and literature. We had noticed the pervasive influence of the European modern art mainstream. We had been surprised by the breadth of styles and subjects, by the esthetic freedom that incorporated abstraction, expressionism, realism and up-to-date avant-garde styles that could have come out of SoHo. Perhaps most of all, we had been puzzled by what we perceived as almost a class distinction between "fine art" and "graphic art" in this classless society.

Installation of OSPAAL exhibition, Havana, Cuba, January 1981. (Photo: Suzanne Lacy)

It puzzled us particularly because most of our group was and is committed to making an art that responds to sociopolitical structures, one way or another. Our slide presentation was divided into three topics, a few of us speaking for each: African-American visual art and poetry; feminist art, much of it from the West Coast; and overtly political work from PADD (Political Art Documentation/Distribution)—a New York art group. We had worked long and collectively on our brief statements because we were anxious to communicate, and by this time we were aware enough of the cultural differences to know where the pitfalls lay. We focused on community outreach, public and performance art, and mass production. We knew that much of this work would be seen by Cuban artists as rather less than "fine art." So we tried to explain what a challenge it is to American artworld artists to wrench the best aspects of "high" art from the ruling-class institutions and the art market, and to distribute these new forms through "low-art" channels in order to affect broader audiences.

Ironically, but perhaps predictably, the more sophisticated Cuban artists seemed disappointed by our rejection of the international avant garde to which they, in their isolation, are attracted. The Cubans want to develop an independent nationalist culture which incorporates the best of their own African and Spanish colonial heritage as well as the best of modernism. They might subscribe to what Trotsky wrote in 1925: "Proletarian art should not be second-rate art. One has to learn, regardless of the fact that learning carries within itself certain dangers, because out of necessity one has to learn from one's enemies."

The Cubans are well aware that the cultural levels of the populace are varied and often low. (An intense literacy campaign over the twenty-two years since the revolution has raised virtually everyone at least to sixth-grade level; the next

goal is ninth grade.) "Raising the general cultural level" is a preoccupation of all the arts organizations, and they know the difficulties involved. "It is much easier to take over the means of production than to restructure the cultural conditioning," said Felix Beltran, an artist and official from the writers' and artists' union. "We are an underdeveloped country dragging a burden of colonialism behind us, not to mention the blockade, which affects art as well as technology. You can't expect a wholly new art of this gradual social process, but it has a different sense than it did before the revolution."

Beltran, who once studied at the School of Visual Arts in New York, also insisted that *all* art was political, including that of Warhol, de Kooning and Pollock. I spend a lot of time in the United States arguing against the classic "my-art-is-my-politics" copout, and this was where the differences between our situation and the Cubans' were clearest. When they make directly political art, it is supportive of their own and other national liberations. Those of us trying to make politicized art within capitalism, on the other hand, are marginal to our social system, and our work is necessarily oppositional. We're forced, at least temporarily, to reject much modernist art because of the uses to which it is put by the system we oppose. While we worry about restoring a communicative function to visual art, the Cubans feel free to make anything they want, resting assured that all art is revolutionary in a revolutionary context (at least within the relatively broad confines of Fidel's dictum: "Within the revolution, everything; against the revolution, nothing"—which means no effective counter-revolutionary propaganda is allowed).

As Nazario Salazar, a ceramic sculptor in the provincial city of Camaguey, said of his openwork pots based on a traditional artisans' technique: "Within a revolutionary context we don't have to worry about the uselessness of art because its *own* use is restored." Rafael Enriquez, director of the OSPAAAL design team, represented a different though not a contradictory viewpoint when he said: "All art has an objective. We don't believe in art for art's sake. Art communicates beyond pleasure." He distinguished between his own visually successful propaganda and the art in museums—"which transcends, and takes more time to make." Caught somewhere in the middle is Raul Martinez, the only well-known painter who has consciously attempted to break down the "fine/graphic" barriers by incorporating poster techniques into his "museum art." He said, "I thought the art of our time was posters. I wanted to do paintings departing from this principle, but many people don't see them as paintings, but posters."

Though we were often reminded how ill-equipped we were to judge Cuban reality, it seemed to us that the basic unpopularity of the visual arts could permit a disregard for mass audiences, and a drift toward a certain "untransformed" aristocratic and European orientation. This might be the source of the distinctions in value between mass-produced and unique arts. And what about the "unhealthy subcultures"? I didn't know whether to laugh or cry when a group of very young avant-garde artists told me that my fifteen-year-old book on Pop Art was their "ABC." A young artist doing his three-year work stint teaching elementary school art in the town of Trinidad told us he would like to do photorealism. I had heard the same thing from the Chinese, as they fell into the arms of Bloomingdale's. I can't help wondering, like Alfredo Guevara, how a fine art still not entirely able to cut across all cultural levels would cope with, transform, or reject the seductive imports and deceptive freedoms of West Broadway.

I left Cuba mulling these questions. Moved and enthused, I felt as cautious for this wonderful country as their own cultural leaders are. Guevara had had the last as well as the first word, gently mistrusting our passionate commitment to a nonsexist, nonracist, community-oriented socialist art. At the end of our Casa de las Americas presentation, he observed:

> Nearly all of your works reflect a very immediate will to communication. Are these demands of the time or do they reflect cultural and esthetic criteria? There is a difference between seeking universality or immediacy. These usually reflect positions related to historical events. When an artist reaches full realization, it is both immediate and universal. I hear from you a trend to the didactic . . . of that North American pragmatism which goes through all the history and culture we are fighting against. I know the consequences of its instruments beyond our borders, so I am forced, as is every citizen of a country like mine, to analyze it. A universalized culture is again being built and disseminated to destroy national cultures through mass communication. I ask myself if your struggle for community, race, sex, etc., is actually a counterpart of that tremendous work that tends to standardize and colonize.

Power Plays*

Who said "Art is energy in it most beautiful form"? Not Albert Einstein or the TVA, but an Austrian affiliate of the Mobil Corporation. And what in fact could be more uplifting than a fusion of art and energy? That is precisely the beauty of two recent art shows from the noncorporate opposition, but their energy is fueled by artists fighting back, by outward mobility—not quite the esthetic Big Business has in mind for the eyes of a public up to its ears in inflation and paying through the nose for oil. The collectively executed "New Energy Museum" was in store windows and Hans Haacke's show is in a SoHo gallery, but they have a common goal—to raise public consciousness about the power of utilities and the utility of art. In doing so, they make some connections between narrative, political outreach, media techniques, and performance crucial to the growth of an art that is not only socially aware but directly communicative.

"The New Energy Museum" was the last and most coherent of three lively exhibitions that took place over the last two months in the second-story windows over the Simply Elegant Boutique on the south side of Union Square. The more and less dissident artists, seeking a way to connect with a nongallery audience, sniped gaily at the looming towers of Con Ed, farther down Fourteenth Street. There were eight windows, nine artists—mostly young, mostly Black, mostly using words and/or photographs. A pointed humor prevailed, although the visual devices varied. I'd love to know what people who didn't know the windows were art thought they were. What, for example, was made of Anne Pitrone's boldly printed collection of words "Energy Riot, Final Days, Gas Electric

*Reprinted by permission from *The Village Voice*, Feb. 25–Mar. 3, 1981.

Girls, Dreams, Ups, Downs . . ."? (Though actually I preferred her handout text, which fantasized a takeover of Con Ed by "genius children with big hearts. . . . Now on the Con Ed bills it says, Con Edison, Con Juanita, Con Joey, Con Laura, Con You, Con Me, Con Us!")

Candace Hill-Montgomery's *His Family Still Pays Con Man* used electrocution as a metaphor to protest Koch's desire for capital punishment as well as police brutality. Bill Stephens' *Balance of Payments* about American import of oil and export of junk juxtaposed the Capitol and Coca Cola; no words. Mierle Laderman Ukeles, who has been made an Honorary Deputy Sanitation Commissioner, continued her ten-year association with the city's 8,500 San Men with a call for "completing the urban ecological cycle," using garbage for an energy source. Coreen Simpson's nude was literally having her mind blown. Nanette Carter used her space for a graphic warning against home heater fires. Lorna Simpson's window stood for "internal forms of energy"—people, community. Jules Allen and Joe Lewis simply advised "BLAST RAYGUN."

The "media look" of the Simply Elegant windows was intentional. A large

Hans Haacke, *Upstairs at Mobil: Creating Consent,* 1981, oil drum, TV antenna, 73" x 23" x 23". (Photo: John Abbot; courtesy John Weber Gallery)

number of artists have been employing homeopathic criticism to borrow immediacy from the powers that be. They sneak through the gates of public consciousness in a plastic Trojan horse, using familiar imagery to conceal an unfamiliarly oppositional message. The modern Aeneas is Hans Haacke, who, for almost a decade now, has made a habit of sniping at even bigger game. In 1971, his one-man show at the Guggenheim Museum was canceled because his investigative *Real Time Social System* piece on absentee landlords came a bit too close to the bone; the Guggenheim administration identified with the villains and declared the art potentially libelous—though all information was culled from public records. In 1974, another museum banned Haacke's *Manet-Projekt*—an apparently harmless work tracing the pedigree of a painting owned by the Wallraf-Richartz Museum in Cologne, which, just incidentally, examines in detail the owners' financial connections.

Since the mid-'70s, Haacke has focused his sights on Big Business, analyzing its public images and comparing them to its private machinations. In the past, his coolly rational approach to the multinational takeover of the consciousness industry bore little stylistic resemblance to the more rambunctious attacks of artists like those at Simply Elegant. But in his current show, "Upstairs at Mobil," the corporate elegance of his conceptual texts and plaques has given way to a more casual approach. In the show's centerpiece, the facts are now presented in a popular narrative style, still ironic but far less detached than before.

A silk-screened collage about the defeat of Senators Bayh, Church, Culver, and McGovern by the Moral Majority, which was in turn supported by Mobil money, remains straightforwardly simple; but an oil barrel topped by a TV antenna, titled *Creating Consent* and labeled "we spent $102 million last year in advertising. . . . We just want to be heard" is an almost kitsch one-liner. And the major piece in the show is a deceptively chatty and information-packed fictional monologue entitled *Musings of a Shareholder* (a takeoff on Mobil's Op-Ed page ads).

Colorful, decorative, hand-printed on ten panels of an enlarged and collaged stock certificate, *Musings* is a broad parody of utter capitalist satisfaction written, of course, by Haacke, although based on solid fact. Each section ends with "Mobil makes my money grow!" It is couched in a wide-eyed, "Who, me a fascist?" tone that indignantly denies suggestion of venality and proudly recalls Mobil's history from the 1973 oil glut ("happily solved by the Arab oil embargo") to Mobil's entrance into the wonderful world of culture, due to the resultant money glut ("In appreciation of the help from our Arab friends, Mobil produced a book entitled 'The Genius of Arab Civilization' "); it notes Mobil's South African subsidiary "allegedly" breaking the U.S. embargo to white Rhodesia ("nevertheless we are an equal opportunity employer and make tax-deductible contributions to the NAACP. . . . To blunt attacks and to preserve our interests in Nigeria, we sponsored a show of Nigerian art at the Metropolitan Museum"); it traces triumphs on PBS ("what our enemies call Petroleum Broadcasting Service") and gloats over other sellouts ("Museums now hesitate to exhibit works which conflict with our views and we need not cancel grants as we did at Columbia's Journalism School. The art world has earned our support.")

Haacke's technique is recognizable not only from narrative art but from the media strategies of Mobil itself. In a way, the broader humor of this piece is unnecessary. Taken straight, Mobil's actual pontifications are already pretty

funny—or would be if they weren't based on terrible truths. Haacke does his muckraking research with academic thoroughness, but he is at heart a Duchampian Dada, a fanatical underliner, subverting with found material. (How many of us noticed Allied Chemical's big brag in 1976: "The Road to Culture Is Paved with Profits"?) From the grab bag of public information he spotlights aspects of society we take for granted, thereby performing the classic artist's function of teaching people how to see.

I often wonder who buys this work. Rich leftists? Insensitive rightists? Probably the Neutral Art Majority. Haacke has always been clear as to the limitations of his artworld audience and his reasons for using the art system. He often cites his debt to Bertolt Brecht, who reminded social artists to make their "interests interesting" to their chosen audience. He has even done demographic surveys to determine exactly whom he's dealing with in galleries and museums and he makes his work as accessible to them as he can. Still I can't help dreaming about the *Musings* piece in *The New York Times;* the antielection poster on neighborhood walls; the oil barrel on the sidewalk outside Channel 13. Perhaps Haacke is moving toward a new approach to confrontation—almost that of the performer. I don't mean by this that he is about to take to the stage (not even in Masterpiece Theatre), but that in this new show he seems to be heating up his act.

Such a step on the part of our most respected and even respectable Marxist artist indicates a common urgency among many image makers today. Abandoning the neutral stance of powerless superiority to which they have been condemned by culture mobsters like Mobil, more and more artists are seeking alliances with each other and with broader political organizations. And of course the need to be heard, to communicate more directly, is not limited to social-change artists. It lies behind the whole last decade of narrative and performance art as well as the whole nonmodernist notion that the artist her/himself is part of the work—whether as autobiographer, fictional protagonist, "body artist," musician, performer—or just as speaker on the art-school lecture circuit. Haacke, too, seems to be entering his work, as the Simply Elegant artists are pushing theirs up front.

The basic function of all art is supposed to be communication. This may sound simpleminded, but you'd be surprised how many mainstream artists regard that function as defunct or negligible. Telling stories, imitating talk, speaking directly to an audience, engaging one's public in a dialogue rather than telling them what they are seeing and thinking and buying—these are the earmarks of an empathetic culture with a message to get across. The dangers are real. To those who, like our latest leader, claim that "the arts should concentrate on what they do best, and leave the broader social problems to others," most of these artists would undoubtedly reply that if oil companies can meddle in art, then artists can meddle in oil companies. (And what is it that art does best anyhow? Can't be worth much, given the proposed 50 percent cut in the federal arts budget.)

It's a healthy sign that a lot of young artists have followed Haacke into the fray and that Haacke himself—never afraid to speak out—is also doing so more colloquially. After a decade of C-R about how art is used, quite a number of artists seem ready to act on their own. The dialogue is important and energizing. But who are we trying to reach? And why? What are the real needs? What is the relation of all this energy to the masses? Tune in next month for more questions, still no answers.

Acting Up*

My hunch is that purely visual art is increasingly unable to communicate the complexities of the contemporary world. We might have to rely on hybrid forms of communication, mixtures of many media, including the context in which they are applied as signifier. —HANS HAACKE

March, coming in like a lion, was an appropriately stormy month for progressive performance art. Six artists participated in the "Acting Out" (AO) series I organized at Elisabeth Irwin High School, and some twenty were in Franklin Furnace's "We'll Think of a Title After We Meet" (FF)—the recent series of performances by women artists from London and Los Angeles. During an AO piece, one of the artists whispered to me, "We're all saying the same thing." What we were all saying was that the rampant retrogressions of the Reagan administration have got us terrified. Our angers and anxieties are readily expressed in performance art—the most immediate art form, which aspires to the immediacy of political action itself.

Like Conceptual Art and book art and other new mediums born in the strident '60s, performance art began as a political idea and was subsumed as form overwhelmed content during the slippery '70s. The "idea" was simply anti-isolation, direct communication. The new mediums in themselves seemed to offer a form of outreach. Only about halfway through the decade did it occur to many of us that outreach was failing because the content had not changed with the form. The ahistorical nature of the '70s "postmodernism" and "pluralism" is particularly visible in performance art, because its development spans roughly that decade.

Sixties performance art pioneers such as Carolee Schneemann, Lil Picard, Yvonne Rainer, Mike Kirby, and especially the Guerrilla Art Action Group were directly influenced by political events and activities. Some of the most effective works were designed collectively and took place within the context of mass demonstrations against the Vietnam war; for instance, in New York the Art Workers' Coalition carried banners bearing the names of thousands of Vietnamese and American dead, and numbered black body bags, as in a funeral procession; in Washington they distributed hundreds of Lieutenant Calley masks (the message: "We are all responsible for My-Lai"). This kind of action survived in left culture but was only revived in the context of art in the late '70s, primarily by Suzanne Lacy and Leslie Labowitz on the West Coast, with their float–performance in the "Women Take Back the Night" parade in 1978, and their large-scale, long-term outdoor "media strategies." Dealing with huge publics and the real world, their work might be seen as the ultimate in what used to be called "real-time art."

The mass media, or the Consciousness Industry, was omnipresent both as a target and a technique in most of the eight performances I'll talk about here. Performance art itself might be seen as a way of restoring the third dimension to images the media has flattened out for us. Stan Baker, the Human Television (AO),

*Reprinted by permission from *The Village Voice,* Mar. 25-31, 1981. Originally titled "The Angry Month of March."

does this quite literally. He wears a cardboard TV screen from waist up. Thus framed, he runs frenetically through a full day of programming on "WSEL," from subliminal cock-flashing to "Bob Dylan's Hits Rewritten for the Lord." Baker, a trained actor, is usually seen in the streets, schools, radio, and even on TV. His message is that "the media is a form of mind control more powerful than the police" and he treads a fine and very funny line between criticism and cooptation.

Most art performances are solos, reflecting art's aura of individual freedom (and for economic reasons as well). London artist Hannah O'Shea (FF) is, like Baker, a stand-up—but no comic. Dressed in a silver lamé gown, her solo prop a music stand, she intones in pseudo-Gregorian chant hundreds of names of known and forgotten women artists through the ages. Her classic *A Litany for Women Artists* is a moving and mesmerizing reminder of the invisible sisters lined up behind each woman making art. It also dispels the lonely genius myth in its own very feminist way.

Ilona Granet (AO), the only other artist of these eight who didn't use huge slides, did a chaotic cabaret act about disillusionment, violence, armament buildup, and militarism in relation to the alienated individual. In *Is It War or Is It Work,* she gave a virtuoso performance of "Little America" as a spoiled brat, screeching, caterwauling, and cooing her way through a parodic New Wave "opera," accompanied by a zany technology of out-of-control computerized toy oil rigs and missiles (by sculptor Barry Holden).

Ideally, performance means getting down to the bare bones of esthetic communication: artist/self confronting audience/society. As a medium, it has to compensate with more direct communication for audiences smaller than most objects have in their public life. Yet few performance artists use interaction with the audience, and many are open to accusations of being as manipulative as the media. Diane Torr's *The Right Thing To Do* (AO) effectively tackled this problem, resisting the weight of authority by humanizing it. She performed a violent abstract dance solo, to music by the Poison Girls, followed by a chatty, informal description and "conversation" with the people in slides she had taken in Washington during the Reagan inauguration; then came a correspondingly low-keyed dialogue with the audience itself, punctuated by a heckler who shouted right-wing vituperations and threw firecrackers at her. This was part of the performance, but I was surprised at how many people in the audience weren't quite sure it was. (As it turned out, their paranoia was justified; after the Saturday panel, the school's toilets were intentionally stuffed with paper towels by an unknown saboteur and resultant flooding did considerable damage; we got *that* message, too).

In Martha Rosler's *Watchwords for the '80s* (AO), the media blitz was made the vehicle of its own criticism. Against a flood of slides showing stores full of radios and TVs, ads, and up-to-the-minute news headlines about Reagan and El Salvador, Rosler appeared in a knit cap as a Latino kid bopping back and forth across the stage. Carrying a giant cardboard transistor radio and a magic marker, she gradually graffitied the wall with fragments of English and Spanish words that transformed their meanings in the process (e.g., quality to equality), superimposing "the people's art form" on the images of dominance. An audiotape mediated between the two arenas, playing Latin music and the artist's voice analyzing a recent trip to Cuba. The work as a whole personalized Americans' fears about the crisis in Central America while challenging official explanations of it.

Linda Nishio, *A Good House Is Hard to Find,* performance, sponsored by Franklin Furnace, March 1981.

Lorraine O'Grady, *Nefertiti/Devonia Evangeline,* performance, Elisabeth Irwin High School, New York City, March 6, 1981. (Photo: Freda Leinwand)

"Acting" as opposed to "passing" is taken to be a male prerogative, so it's interesting that performance art has been so deeply affected by the feminist movement and so many of its major proponents are women. (This has been trendily explained away as "narcissism"; women are better at being objects, see? Is this why Rosler had to be a boy?) I was out of town for most of the issue-oriented performances in the highly successful Franklin Furnace series, but I was struck by correlations between Linda Nishio's *A Good House Is Hard To Find* and Lorraine O'Grady's piece in "Acting Out." Both were bitterly beautiful, characterized by the striking imagery and layered meanings typical of much women's work, as well as by a direct political content that is unfortunately less typical.

Torso encased in a miniature house (reminiscent of Louise Bourgeois' famous drawings), Nishio recited her stylized text. Her figure cast a shadow on the slides and films and at times was echoed by small black cutouts of women being pinned up and taken down by an assistant. The subject was dislocation, racism and real estate, treated so that it flowed back and forth between personal and political, images of women and space, using "interior decoration" as a metaphor for cultural differences. O'Grady's *Nefertiti/Devonia Evangeline* focused on her sister's life, her resemblance to the Egyptian queen, and her death under tragic circumstances; along the way, in a lyrical, nondidactic style, it covered sibling rivalry, illegal abortion, racist views in academic Egyptology, "the power of elegance in Black art," and O'Grady's own need "as an upper-middle-class Black woman to insist on cultural equality." It ended with a futile resurrectional ritual about "the impossibility of reviving lost rituals" that included a memorable image of the artist in a long robe, trying repeatedly to step from one earth-filled vessel to another and failing . . . an image that could be read rather pessimistically as the futility of trying to cross cultures.

"Acting Out" ended with an equally angry but more optimistic view. *Communique: Wake Up New York* was directed by Jerry Kearns and performed by Serious Bizness (Jaribu and Ngoma Hill), who read poems and sang their own powerful, militant songs with guitar against a dissolving backdrop of black-and-white slides of demonstrations protesting police brutality. All three artists work with the Black United Front. The piece was dedicated to those murdered in "the Sowetos of Metropolitan New York" and "to those who are fighting back." Serious Bizness performs frequently on radio and in rallies, in the heart of the antiracism struggle. That night they became "performance artists" by virtue of the context, illuminating the precarious existence of political performance on the cusp between social and cultural worlds.

No sooner does art verge on the comprehensibly social than it gets called "simplistic" and "propaganda." Yet this sophisticated audience's enthusiastic and spontaneous responses to the issues raised by Kearns/Serious Bizness indicated that their force and emotion—more typical of politics than of art *about* politics—was getting across. As he began his poem, "Stop Killer Kops," Ngoma remarked, "If this poem sounds like a slogan, you're right, it is. Paint it on the walls of your consciousness." The word *action* was once used as a synonym for happenings or art performances, but it must have sounded too raw for "critical discourse," and was dropped. With the increased awareness of the '80s, maybe more progressive performers will reclaim it, returning to their sources in the '60s and getting back into the streets.

Faith Ringgold, *Atlanta,* 1981, mixed media, 30″ x 40″ x 16″. (Photo: Fred McDarrah)

Color Scheming*

Racism takes two main routes in the art world. The first is outright bigotry, as in the indefensible "Nigger Drawings" show. (I'm writing this on the anniversary of the lockout of Black and white protesters from Artists' Space, now happily under new management.) The second is a not-so-simple exclusion—as when museums don't consider Third World art "fine art," but ethnography. Both routes raise cries of censorship as well as complex questions about selection, boycott, and First Amendment rights.

Minority art groups over the years have been torn between responding to the antagonistic or the exclusive manifestations of racism—to hostility or to omission. One view holds that the exposure of any kind of art by minority artists is a political act. The other—not necessarily contradictory—holds that the art itself should be critical about the situation. Inherent in these choices are others: Should minority groups focus on art or on politics? Should minority exhibition spaces be separatist sanctuaries, tenderly nurturing endangered cultures? Or should they forgo "ghettoization" and risk demanding their share of the status-and-money pie—and of cooptation?

*Reprinted by permission from *The Village Voice*, Apr. 22–28, 1981.

These are, in fact, false options, imposed by the dichotomy that governs our cultural expectations. They prolong the competition fostered by the current system of getting art seen, which is grounded in fundamental racism. Rasheed Araeen, of London's *Black Phoenix* (in a broadside headed "No Liberal Sympathies, Please!"), observes angrily how in Britain, as in the U.S.:

> It is commonly believed that the predicament of the black artist is entirely due to the failure of the individual who is from a different socio-cultural background and who has not come to terms with the values of this industrial/capitalist society. But can one really explain this "failure" without considering the socioeconomic and in fact ideological context within which this "failure" occurs, and particularly when we don't even know what actually has been produced by the black artist?

Minority art has to be seen to be understood at all, and funding, of course, is a decisive factor. As artist Janet Henry has pointed out, minority art groups "have been asked to jump through hoop after hoop in the name of quality, cost efficiency, good management, accountability, and are still given peanuts with which they're supposed to accomplish" everything the white groups do with "twice the panache." Charles Mingus III's 1979 account of funding from the New York State Council on the Arts was an eyeopener. In 1978–1979, "three leading spaces for minority artists received $18,500 for exhibitions from NYSCA's Visual Arts Services budget; for its various programs Artists Space got $74,000." While these figures don't give the whole picture, they don't lie either, and the wounds will get deeper when Reagan's and Koch's cuts go into effect.

All this to provide a framework within which to look at a curious new genre of exhibition which is, actually, not new and should not be considered curious: the "mixed-but-mostly-Third-World" group show, which casually combines styles, levels of development, political consciousnesses, and skin colors. The function of such shows is simply integration, or perhaps reverse integration. The mainstream art world having failed to welcome Third World artists, some minority groups have taken up the challenge, along with a few mixed groups like the JAM (Just Above Midtown), Cayman, the Alternative Museum, Fashion Moda and ABC NoRio. The New Museum's "Events—Artists Invite Artists" last month paralleled the larger "Voices Expressing What Is" at Westbeth, organized by the AARA (Action Against Racism in the Arts). And currently, there is the Kenkeleba House's "Installations in the Five Elements," selected by Camille Billops.

The "Elements" show is not on the surface "political," though it is difficult even to get to the gallery without strong social emotions; Kenkeleba House is located deep in one of Manhattan's East Side war zones. On the other hand, the show is not apolitical either. The twenty-four participants are all women; the majority are women of color; and the theme is incorporative rather than neutralizing. Most of the artists made pieces specifically for the show, adapting personal styles to new content. Betty Blayton's *Zero Sum Game . . . Return* is a "black hole" of fabric striped with bursting rays of multicolored metallic type, garish and ferociously beautiful. Vivian Browne's double-vision drawing repeats lyrical imagery on three near-transparent fabric hangings in front of panels. Tomi Arai's *Winter/Spring,* modeled on the Japanese *tokonoma,* an alcove for scrolls

and flower arrangements, isolates architecture as sculpture. Zarina's tender brown abstraction is simply captioned "I whispered to the earth." Diane Hunt's *Written Falls* is a vertical, near-abstract photo scroll of a rocky riverbed, seen aerially to expose the female forms in nature. Camille Billops' photoseries, *The Ashing of a Bird,* combines urban violence with magic and chemical mystery. I also liked Sandra Payne's sharply graphic "black hand" collage, Jeannie Black's photos of childbirth, and Janey Washburn's scary *I Hate My Mother, I'm Afraid of My Rage.*

I hope this gives some sense of the variety involved. The three pieces that most moved me had nothing else in common. Virginia Jaramillo's abstract three-panel piece *On Metal* is quite literally that: hard, shiny, a powerful fusion of medium and metaphor. Kazuko gently energized her tiny room with an erratic border of twigs surrounding a circular floor piece of branches, bound together in a ritual process. Faith Ringgold's *Atlanta* is rows of stylized fabric dolls tagged to identify each one as a murdered child, overseen by a weeping couple, draped in green ribbons. ("Atlanta is more horrible than anything that's happened to us since slavery," she writes.) The heads are wrapped stones (earth); the bodies are metal cans filled with newspaper accounts of the deaths; they stand on a wood shelf; fire is represented by lighted candles on a windowsill altar. Ringgold has long dealt with this difficult synthesis of emotionally loaded subject matter and a style verging on cuteness; this piece particularly succeeds in making its contents *felt.*

Atlanta is not an easy subject. Howardena Pindell (in the AARA show), in her collage painting *The American Way,* made a formally forceful statement on violent disenfranchisement by scattering disembodied children's heads upside down on a white field. Out at State University of New York–Old Westbury last month, there was a devastating Atlanta installation by David Hammons, in "Spaces V" (Hammons, Charles Abramson, and Jorge Rodriguez)—one of the most dynamic shows I've seen in a long time, because the quite different artists struck a unique note between individual and collaborative work, flowing in and out of each other's territories with images and ideas that allowed each to be himself, as well as the others. Hammons' piece was a semiurban vacant lot in winter—dead leaves, branches, trash, and children's clothes tramped into the underbrush. It sounds obvious, but it was haunting, like a photograph come to life—real and unreal, distant and too close, subtle and unrelentingly critical.

During the "N——— Drawings" controversy, a group of white critics accused the protesters of "exploiting this sensitive issue as a means of attracting attention." Damn right. Another white critic said, "It's damaging to think about political issues and not the work." Damn wrong. A case in point being the press coverage of Mike Glier's passionately political show on the theme of White Male Power that just ended at Annina Nosei. It was seen in the context of apolitical New Wave art and thereby deprived of much of its impact. Even white male artists can suffer from the kind of "media insensitivity" that can totally whiteout a Third World artist's intent.

Art could be a decisive tool for unlearning racism, given its fusion of individual and social experience. Yet it is difficult to overcome cultural differences and form coalitions when white artists are still saying things like: "I don't think people won't show Blacks because they're Black, but because they don't do interesting work. It's like women. Women happen to be inferior artists to men and it's the same thing with Blacks. They happen to be better at peddling dope."[1]

Access to the media is a major issue. As Richie Perez of the Committee Against Fort Apache has observed about the lack of positive images of Third World people in the mass media, "they don't call it censorship, they call it 'nobody-is-interested.' Freedom of speech is meaningless unless you have the ability to have people hear you." Linda Bryant, director of JAM, talks about the "selective censorship" (usually called *curating*) that "prevents me as a minority from defining myself effectively and within the larger context of this society."

If the idea is to leave the selecting to those already in power, even boycotting becomes taboo. I can't get into the whole issue here, but I did want to make the point that while the manifestations of censorship-before-the-fact may be different in the mass media and in the "fine arts," the ramifications are the same. Lack of access to exhibition space or to the media is, in effect, a denial of freedom of speech which should be protected by the First Amendment. The Supreme Court outlawed segregated schools because they violated the Fourteenth Amendment by generating among children "a feeling of inferiority . . . that may affect their minds and hearts in a way unlikely ever to be undone." Art seems to fall between these two freedoms. Art is not separate from the rest of life, so this applies equally to artists' lives. As Nat Hentoff, who does not agree with me, said in these pages two weeks ago about the lack of press coverage of Third World concerns: "That we remain two nations is due at least as much to the press as to those in political power; . . . Even if some journalists wear a touch of green these days for the dead in Atlanta, it don't make no difference in what we print about where we are."

OK. Mea culpa. But you can't work politically out of guilt. And as Ad Reinhardt said, "Actions speak louder than voids." Go see Candace Hill-Montgomery's and Jerry Kearns' perfomance—*Teamwork the American Way*—at Franklin Furnace, Thursday, April 23, and continue the dialogue.

NOTE

1. Anonymous, quoted by Richard Goldstein in *The Village Voice* (March 31, 1980).

Who's on The First?*

New Yorkers may not be safe from much else these days, but we are being assiduously protected from "assault on our individual privacy" by public art. Shades of the '60s and the notorious "desecration of the flag" cases: In March a crucified coyote by Paulette Nenner was removed from the "Animals in the Arsenal" show in the Central Park Zoo and in April Michael Anderson's installation against taxes for military buildup was removed from the front of the Fourteenth Division State Armory in Brooklyn. Once again, the First Amendment's job is not being done, but this time from the opposite angle than the one I discussed last month in regard to racism and unequal access to media.

*Reprinted by permission from *The Village Voice*, June 3-9, 1981.

Paulette Nenner, *Crucified Coyote: He Died Because of Our Sins,* 1981, mixed media, 11′ x 5′ x 3′. (Photo: Steve Talaber)

Nenner went to court to uphold her right to freedom of expression and lost. Anderson (with two friends who were simply taking pictures) was arrested and thrown into jail for thirteen hours; his case comes up June 22. The two incidents differ in detail, but both are cut-and-dried violations of "freedom of conscience" (the First) and "equal protection under the law" (the Fourteenth). As such, both bode badly for artists working publicly with political content in the '80s.

The issue is protection—for whom, from whom. As lawyer Vernon Mason pointed out recently on WBAI, neither the First nor the Fourteenth "protected black people in the '60s. It took freedom rides, getting into the streets, *rebellion* to get the schools desegregated long after the law said it." Thus the KKK is "protected" from the very people it openly vows to exterminate, who in turn are not overly protected from the KKK. In the controversy over the film *Fort Apache: The Bronx,* the issue is whether or not the First adequately protects minorities from the multinational corporations who control the media and produce racist films that indirectly endanger the lives of people of color. The American Civil Liberties Union position simply upholds the right of everyone to say anything, but ignores the subtleties of hegemony and economic censorship.

This debate is an old one and continues heatedly today as consciousnesses are raised by cutbacks and the erosion of human rights. No sensible person on the Left is asking that the First be restricted, but there is plenty of discussion about how and whether it should be expanded to cover areas where it just doesn't work—one of which is obviously censorship of art by cops and bureaucrats.

The Anderson case will probably be argued both on grounds of freedom of expression and illegal, unnecessarily rough arrest of bystanders, and destruction of property by the police. The young artist was making a piece for the PADD (Political Art Documentation/Distribution) "Death and Taxes" project—a city-wide series of independent actions and works from April 1 through 15. Anderson impaled a skull-headed dead body dummy on the bayonet of a bronze World War I soldier in front of his local armory, over a shrine of plaster madonnas, votive candles, and plastic flowers. He had verbal permission from a security guard at the armory (who was not aware of the work's content).

Twenty minutes later the police arrived; confused discussions ensued; a passerby with an Instamatic was told to stop taking pictures, and the cops tried to grab the camera from one of Anderson's friends; when she refused they arrested all three and later exposed the film at the jail. Anderson makes the point that "the event took place a week or so after Reagan was shot, when nationalism was a strong emotional issue. It was obvious from the beginning that the cop was as angry and antagonistic as he was because of the piece's political message. His priority was the camera, not the installation or me climbing on the statue."

The Nenner case is more complicated and perhaps even more dangerous to artists preferring public to private outlets. Her sculpture was ordered out of the Arsenal exhibition by Parks Commissioner Gordon Davis on the day of the opening, superseding the free-lance curators of the show. The excuse was something legally called the *involuntary viewing problem,* in which unsuspecting captive audiences are "entrapped" into seeing things they don't want to see. Little children were frequently and piously invoked throughout the controversy, though for unexplained reasons. Davis claimed to have the right to approve all art shown, though by the day of the opening he had seen only some of the work, thereby giving tacit approval to the curators' choices. In addition, as Nenner's lawyer, Steven Eckhaus, argued, under Section 21-A of the Parks Department Rules the commissioner has "no power to suppress the publication of facts or opinions" in the parks, and such power had already been challenged and overthrown in the courts.

Nenner's coyote, crucified on an eleven-foot wooden cross labeled (in Latin) "he died because of our sins," and surrounded by documentation exposing "the inequities and brutality of predator damage control programs and predator harvests," was displayed in the Bird House, closed for remodeling and used as an annex to the Arsenal office gallery space. The text pinned to the cross blames the antinatural dualism of Judeo-Christianity for alienating humanity from animals and the rest of nature and for making "individual worth a major religious tradition." The message is that "our species can never survive without caring for all other life it shares the earth with"—and that message is powerfully conveyed.

The Bird House contained several other overtly political installations using the animal theme rather loosely indeed to comment on corporate abuses of the rights of human animals. Steve Appel's work also featured a stuffed beast—a snarling wolf on a hill of skulls and rubbish. So why pick on Paulette's coyote which, though dead, is endearingly furry and almost cute? Because, as a park employee told a caller from Friends of Animals, it might give little children nightmares. (In which case, the caller replied, "You might as well ban Bambi.") Yet even in this homocentric country, where men tend to be better protected by law than women, children, and animals, little children are constantly exposed to

the sight of a *man* gorily crucified; and right there in the Central Park Zoo they
can see live animals whose misery approaches that of their somewhat less fortu-
nate relatives caught, as coyotes are, in excruciating steel leg-traps.

Nenner is a longtime animal rights activist and her tender but impassioned
art consistently deals with the subject. Her sympathetic study of Huerfanita, a
young female lowland gorilla (an endangered species), was supported by the New
York Zoological Society. In another recent work—*Road Kills*—the remains of
wild animals killed by cars on a rural highway were brought to a rubbish-strewn
vacant lot in the South Bronx and exposed for several months on a "burial
mound" in memory of "fellow victims of silent environmental war." "This isn't
art for art's sake," she says. "It's art for all our sakes." Her stance has been sup-
ported by several animal rights groups, including the ASPCA. Michael Fox, di-
rector of the Institute for Study of Animal Problems in Washington, D.C., wrote
a letter protesting the censorship, saying that some of Nenner's art may be
"disconcerting" but that it "reflects the values and perceptions of society, which
some people might find offensive or deny," and Commissioner Davis is one of
those people.

This of course is the essence of the First Amendment. What rights do we have
not to be exposed to something? But that's the Committee Against Fort Apache's
argument, too, and I'm sure Mr. Davis would not support the censorship of Time-
Life Films, or even the grass-roots boycott. The way the First is interpreted now,
Nenner should have won her case hands down. Her lawyer made it clear that
(1) "The First Amendment does require that once the city has opened a forum for
artistic expression on public land, the city may not discriminate between artistic
expressions on the basis of content"; (2) "The park audience is there as a matter of
choice, not necessity" (therefore it is in no way a "captive audience"); and (3) the
coyote sculpture "is not obscene and no attempt has been made to fit it into any
other unprotected category."

This last seems obvious to a layperson reading the record. At no time in the
hoopla did Davis ever give any *reason* why this particular *object* should not be
shown in that location. In fact, he repeatedly reiterated that his "concern was not
with the work of art or the message, but rather its placement in this particular lo-
cation—the Central Park Zoo Bird House." At the same time, he dismissed all al-
ternatives offered by Nenner such as covering the animal with a black plastic bag
(with one paw sticking out) and showing it in the Arsenal gallery, where the audi-
ence is "preselected." She in turn rejected *his* only alternative—to show it in
the Arsenal's Xerox room "by appointment only"—which did not constitute a
public showing. Most sensibly, she suggested placing a "mature themes" sign and
information about the piece on the Bird House door. (The sign was, in fact, put
there, but the coyote wasn't.) In addition volunteer artist-sitters who were there
for the show's duration offered to "warn" all entrants at the door. This, too, was
refused by Davis, who claimed he couldn't control "the crowds." The beautiful,
sunny afternoon I saw the show the zoo was full, but I was the only person in the
Bird House, and the show was not even open on weekends.

Nenner sees Davis as ignoring the content of her work and "looking at it in
some psychosexual way." He, in turn, says she "admitted" wanting to shock peo-
ple, and she, in turn, is adamant about her intention to make the piece as dramatic
as possible and to have it seen by children, as "leaders of tomorrow." Davis, in
turn, was lauded by Judge Louis Okin (whose decision was the commissioner's

testimony almost verbatim) for his "extraordinary sensitivity" in calling around to find someplace else to show the coyote. In fact, Davis called the most unlikely list of places (including the New York Sierra Club and the American Museum of Natural History) and displayed a notable ignorance about the workings of the art world, implying at the same time that Nenner's art must be barely respectable because no one would change their schedules and publicly exhibit the piece immediately. (The only vaguely positive response came from the indispensable Ivan Karp, who said there was a possibility of putting it in a traveling show at some future time.)

Sadly but typically, some other artists in the Arsenal show felt threatened not by the censorship but by the way Nenner's actions might affect their own exposure, as when she and two others barricaded themselves in the Bird House and succeeded in keeping the piece up for the opening. Nevertheless, there is a growing number of artists like Anderson and Nenner whose social concern is leading them and their work into actual public involvement. They are in for some rude surprises. Censorship is on the upswing and the art world as usual is behind the times, rarely understanding the way hegemony works and the ways art itself is inseparable from the legal and social problems of all cultural fields, including the mass media. Feminist and political art is, as usual, always first in line. Carolee Schneemann, Anita Steckel, Judith Bernstein, and Chuck Close were all censored in the '70s for offering the public unfamiliarly female or radical views of sexuality. The new "Sex Issue" of *Heresies* magazine was refused by the printer. In Canada, avant-garde film and video is being run through a ludicrous gamut of bureaucratic censorship, and so it goes . . .

One final but fascinating art issue: When I saw the show, the coyote was, of course, gone. But pinned to the wall was a Xerox of a realistic pen-and-ink drawing of the piece and a text about its removal. This means that it was the *object,* but not the *idea* or even the *image,* that was objectionable—a curiously formal (or materialist) position for a man of Mr. Davis' delicacy. I wonder, if Nenner had leaned her eleven-foot crucifix against the bars of the cage in which a mangy haunted animal padded listlessly around a concrete pen, would she have got the same treatment Anderson did? And if you had stopped to take a picture, would you have been arrested? Maybe that's what Mr. Davis and Judge Okin are unwittingly protecting us "casual onlookers" from. This degree of protection should be available only to children watching TV, or to the casual passerby on Times Square, or to the casual browser in those classy East Side news stores near the zoo that sell hard-core porn next to juvenilia.

A Child's Garden of Horrors*

The image of the child in our childish culture is usually that of the bug-eyed waif or the wise-ass prodigy, and art about children is better left as unseen as it's unheard about. Icky little pictures inspire great big yawns. This month, though, two exhibitions recalled that our sentiments about children are political as well as per-

*Reprinted by permission from *The Village Voice*, June 24–30, 1981.

sonal. "Weeping in the Playtime of Others: An Exhibition on Child Abuse and Murdered and Missing Children" was organized by Karen Di Gia at the Gallery 345, and "Atlanta: An Emergency Exhibition" was organized by Tim Rollins at Group Material. Both shows are devastating comments on adult incompetence and malice; both incorporate children's own views, and both are models of what a caring, activist approach to art can offer.

If you went around the Gallery 345 clockwise, you began with birth photos by Jeannie Blake, and a casual series of paintings and photos of happy, ordinary children, highlighted by an Alice Neel portrait. As you moved on, the faces got sadder, the images and information more appalling: Anna Crowell's artist's book on child abuse and incest, published by the L.A. Woman's Building; Kenneth Wooden's books (from one of which the show's title was taken); some unspeakable photos by a child molester who documented his activities for sale; documentation and art about neglect, abuse, runaways, teenage prostitution, child porn, rape, murder, the Holocaust, Jonestown, Atlanta. In the back room—the wide screen: the international political abuse of children by warring, profiteering states *and* by nations struggling for liberation—images from Hiroshima, Vietnam, Cambodia, Nicaragua, El Salvador. In a handsome angry print, Florence Siegel quotes Gramsci: "The crisis consists precisely in the fact that the old is dying and the new cannot be born. In this interregnum a great variety of morbid symptoms appears."

There were classics from the Vietnam period (Jeff Shlanger's *Would You Burn a Child? If Necessary,* the Art Workers' Coalition's *And Babies?,* a Rudolf Baranik collage) and newer works by Anne Katz on El Salvador, Faith Ringgold on Atlanta, Joanna Vogelsang on Auschwitz—*They Died in Alphabetical Order;* on the brighter side, delightful ceramics by East Harlem schoolchildren—off the subject, but right on. These all vied with the practical data, such as police forms on runaways that made them sound like criminals, and heartbreaking documentation on missing children, especially Etan Patz, who disappeared from SoHo two years ago. (His mother helped coordinate this show.) I was particularly struck by Sylvia Sleigh's portrait of Etan, updated to suggest what he would look like today.

Karen Di Gia is a dedicated specialist in this kind of movement-oriented theme show, combining hard facts, a mass of resource information and analysis with artists' deeper insights. All her shows travel, accompanied by workshops on the issue. She did a powerful exhibition on aging earlier this year, and next fall will present one on world hunger. By taking on such awesome topics, she is breaking taboos against "useful art." Education goes hand in hand with esthetic provocation. If the art moves you to action you can pick up a pamphlet telling you which organizations to contact.

Is nothing sacred? Who needs it in an art gallery? Yet how many art shows can move you to tears? The books, pamphlets and posters provide both context and captions to the art, allowing it to refer to a broad view of global crisis that would be impossible to cope with otherwise. The art, in turn, expands the literature, giving life and individual vision to the statistics and generalizations detailed there. The Atlanta show is more purely visual, but it, too, combats the distortion of the deaths of twenty-eight young Black people into a series of random, "psychotic" murders unrelated to social conditions (as murders of women are inevitably seen—viz. the Yorkshire Ripper, the L.A. Hillside Stran-

gler—sensationalized by the media and denied their political framework in violence and misogyny).

Group Material (GM) is a collective of young artists whose storefront gallery is becoming a real participant in its rundown neighborhood. Like Gallery 345, they have concentrated all year on timely and lively theme shows for social change, beginning with "Alienation," moving on to "It's a Gender Show," "The Aesthetics of Consumption," and "Facere/Fascis." Each of these has been a conscious attempt to break down barriers between art and nonart, "high" and "low" culture, giving everything the advantages of a wider and analytical context. The Atlanta show is less chaotic than some of GM's other offerings, but the imaginative and stylistic range is as great as ever.

Its background is poignantly provided by John Fekner's collaged audiotape, made earlier this month in Atlanta—a rainstorm, gospel singing, news broadcasts; the recorder is framed by Don Leicht's steel tulips. Mundy McLaughlin's *A State of Civilization* is a grid of pointed quotations and reversed news photos from the mass media, made concrete by transfer onto ceramic plaques. Faith Ringgold's centerpiece—a stuffed woman in green brocade, her face a sequined mask of rage—holds a handkerchief in one hand and the artist's Atlanta poster in the other; she has stopped weeping and is calling for action. Candace Hill-Montgomery used her own family as a metaphor for Atlanta and the Third World,

Micki McGee, *White Guilt: Toward a Geography of Racism,* installation for Group Material Atlanta show, June 1981; a United States map chalked low on a black wall, a basin of dirty water, Ivory soap, and two dish towels—one an embroidered stereotype of a grinning Black chef, the other printed with a personal narrative tying the elements together and into an analysis of the murders of 28 Black children in Atlanta in two years, and American white racism. (Photo: the artist)

connecting her photos with red, white, and blue ribbons, "whiting out" some of the figures. Micki McGee's *White Guilt—Toward a Geography of Racism* is a disturbing installation of a white map chalked low on a black wall, a basin of dirty water, Ivory soap, and two dish towels—one an embroidered stereotype of a grinning Black chef, the other printed with a personal narrative tying the elements together and into Atlanta and American white racism.

Another group brings Atlanta into the international arena. Jerry Kearns' photoposter blowup does it with deadly simplicity. Bug-eyed gas-masked monsters with blade-like missiles labeled Atlanta and El Salvador loom out of our national foreground in a direct threat to the viewer, while in a ghostly backdrop the dead children smile happily. The Madame Binh Graphics Collective's double piece is layered in space, on plastic sheets, juxtaposing genocide and white supremacy with African liberation movements, moving from an Assata Shakur quote ("We are not citizens of America. . . . We need a nation") through the Atlanta parents and children and, up front, a Black Solidarity march surging into the gallery, accompanied by a Malcolm X quote: "If a white man wants to be an ally, ask him what does he think of John Brown. You know what John Brown did? He went to war."

The most moving part of the show was a group of pictures painted by educationally disadvantaged schoolchildren and collected by artist and schoolteacher Tim Rollins as *Who's Killing the Kids?* Their terrified responses recall one of McLaughlin's quotes, about how Black school kids in Atlanta "go all to pieces" if a book is dropped in the classroom. One young artist shows herself and her brother calling for help in their Harlem home (labeled "NYC"); a KKK figure is hiding there, too, and everything outside the house is labeled "Atlanta." Many of the kids showed the murderer as a Klansman, though one thought it was a cop (not surprising, given that until a few weeks ago the number of Atlanta murders was equaled by the number of Black and Hispanic youths killed by the police in New York City). In another picture, the clouds are weeping; in another, a tiny house containing two stick-figure children is isolated on a fearsome white expanse of emptiness. Another is an amazing gray-and-black expressionist abstraction; up in the corner is a cloud of insectlike children, helplessly swept away by the explosion below. One of the few whites in the class used an Indian to represent the Atlanta children. These kids' consciousness of the extent of their victimization is as painful as all the neglect, abuse, rape, and murder in the 345 show. Heaven help us. *Heaven* help us? God helps those who help themselves, so rumor has it. But the work ethic hasn't exactly done the job.

The fact that these two unique galleries (and, less systematically, ABC No Rio and Fashion Moda) concentrate on theme shows is significant. In many cases the shows themselves are more effective than the individual works. I'm not denigrating the "quality" of the art, which is comparable to that shown elsewhere, but saying that these organizers have found a context to make art support other art, rather than compete with it. Although the artists mostly work alone, the shows are collaborations between the participants who choose to focus on the issues. Thus the exhibition becomes a synthesis, a whole more effective than the parts could be—something like "The People United Will Never Be Defeated." This is a concept crucial to the development of responsible and activist art, and to the growth of alternative ways of analyzing the role art can play in society—as opposed to the role art *does* play in society.

Internationalist Art Show: Anti-WW 3, Parsons School of Design, New York City, July 1981.
(Photo: Leon Klayman)

The Collective Conscience*

My editor tells me I always end my pieces by waving the red flag. Well, this time, for a little variety, I'll do it at the beginning, because the ANTI-WW3 show at Parsons is sure as hell a red-flag-waving occasion. The San Francisco Poster Brigade (SFPB) has enveloped over 600 examples of "lyripolitical" agitprop from forty-five countries in a dynamic black and DayGlo installation that's more like a rally than an exhibition. Ubiquitously publicized (nobody in New York City can have missed the posters) as an "Internationalist Art Show, a collage of art and poetry from around the world," it is not antiwar so much as anti-imperialism; not about victimization so much as about fighting back. It recalls Gramsci's grim but determined prescription for change: "pessimism of the intellect, optimism of the will." "Internationalist art comes from the streets," says one pamphlet; "it looks the future straight in the face . . . it upholds the strength and courage of the worldwide resistance movements."

Before those who think "if it's politics it can't be interesting art" go away, let me recommend that you go see for yourself. If you liked Andy Warhol at his most lurid, if you liked or hated the Times Square Show, if you like abstract art from the Russian Revolution—you may like ANTI-WW3, too. (I'm using *like* in both senses in the most boundary-blurring way I can; it seems safe to make such pecu-

*Reprinted by permission from *The Village Voice*, July 22–28, 1981. Originally titled "The Conscious Collective."

liar comparisons here because the politics of the ANTI-WW3 show are so overt it can only be *esthetically* confusing, which is usually healthy.)

Take the poster, for instance. The idea is a little obvious: a noble Third World woman's face stares boldly and tragically out into space. But in the streets it's a striking and moving image because it's, yes, good art. Over the years the SFPB has developed a highly "personal" public poster style that modernizes without diluting the fundamental spirit of the revolutionary poster tradition. Their secret is an understanding of abstraction and a brilliant use of commercial graphic techniques turned upon themselves—light against dark, bold flat typefaces, diagonal lettering, and especially a refinement of those graded lines and dots familiar to every closet presstyper. The cover of their flyer for the open poetry reading superimposes oblique bands and rods of "modeled" metallic-looking parallel lines to enliven the flat surface just the way nonobjective Constructivism does. By introducing type and two small "dancing" (or grenade-throwing) figures, however, the image takes on the huge space and scale of girders, of a building under construction, of a stage set activated by human content. Formal convention is skillfully used to evoke political action.

The effect is alive, where so much high art using the same conventions is dead. This sense of drama is common to all of the SFPB's work, including a long "color Xerox in motion" filmstriplike piece in this show, and to the installation itself. Hundreds of posters, Xeroxes, poems are pinned up patchwork fashion against a continuous panel of black paper, set off by pink and orange fluorescent darts of color, accompanied by revolutionary music, overlooked by big banners and the words "we are internationalists" in different languages. The generally Latin flavor is a trademark of the Bay Area Left, epitomized by the Poster Brigade and Berkeley's La Peña Cultural Center. In fact, the attraction of Chicano and Low Rider culture (also the subject of a stunning videotape by Martha Rosler) raises some interesting questions about cultural colonialism and/or the reclamation of mass culture by the Left. As the Tabloid Collective from Providence, Rhode Island, has remarked, we need ways to consider "mass culture and everyday life as practices rather than as consumed or manipulated artifacts."

Last month I talked about how Group Material, Gallery 345, ABC No Rio, Co-Lab and Fashion Moda were evolving a theme-show concept in which the individual works contracted into a more effective whole. The ANTI-WW3 show epitomizes this idea, and yet the image of collectivism it presents is very different. For all its visual "spontaneity," there is nothing anarchistic about it. What the casual visitor to Parsons gets is a piece in itself, an "environment" of hot color, torn paper, slashing words, that conveys the anger and exhilaration of collective action. Since the SFPB's own works, featuring the same style and color scheme as the overall installation, dominate the ensemble; since the poster for the show appears repeatedly among the single contributions from elsewhere and the sales table also offers SFPB's own work, the whole business adds up to an ad for the show itself—and, of course, for what the show stands for.

ANTI-WW3 is committed to a single hard-driving political line, and one of its most provocative aspects is that this line is maintained while the show remains "open." Works were assiduously solicited from around the world. During previous showings in San Francisco, Los Angeles, and Tucson, the organizers occasionally removed one that was offensive to members of the audience or did not hang a contribution, but virtually everything sent in is included. Inevitably some

artists are unhappy about the placement of their work, but the hanging is basically egalitarian. At the same time the framework itself is strictly that of the Poster Brigade's own art and own politics. They have gone a long way toward every progressive cultural organization's goal: to rally the forces of individualism into a cohesive voice for change.

This is not the only way to do it. Other groups are groping toward other ways; the organization I work with—Political Art Documentation/Distribution (PADD)—is making issue-oriented public projects that are brought together as highly eclectic shows to provide varied models for non-art-world-centered, activist art. London's Poster Collective does it with powerful visual teaching devices. The dialogues springing up in the ANTI-WW3 show among members of such groups, to sift out the politics and esthetics of the individual works within the whole, are an important part of the process.

So is the work included, in its immense variety. While the influences of John Heartfield and Käthe Kollwitz are unashamedly celebrated, there is something for every conceivable taste (though not for every conceivable politics). I haven't room to name names and it's not that kind of a show anyway, but keep an eye out for the Japanese on the subject of nuclear war; for a pretty multicolored mushroom cloud with sort of a jump-rope rhyme ("WWI, WWII, please, be all through; WWIII, WWIV, no, please, no more"); for a scary and intimately communicative poster and note from a Vietnam vet: "Me! in the 70's . . . You! in the 80's?"; and for a photograph of a mounted cop chasing a man on foot across a field, inscribed "Which Side Are You On, My Friend, Which Side Are You On?"

Which side indeed. Maybe the real gift of this show is that it gets across how many of us are out there resisting, which is what internationalism is all about. Another crucial message for visual artists is that solidarity does not mean the suppression of the individual. And another is the multiple ways in which mass-reproductive techniques can combat the homogenized view of culture we are fed at the breasts of the mass media and the high-art system.

R_x-Rated Art*

All art isn't useless. In fact, confronted with the ills of society it can sometimes offer cures. This essay is about two of those times, very different ones, in Maine and California. In Portland, an unusual program called Spindleworks just showed its products in the lobby of the Nikolodeon Movie Theatre, and in Los Angeles, the Cowgirl Commandos of the Artists Coalition for Equality (ACE) stole the show from another one at the L.A. County Museum. Both events—the former a "conventional" exhibition of drawings and crafts, the latter an "avant-garde" public performance—were affirmative responses to negative situations.

Spindleworks is "a creative workshop for mentally handicapped adults" in the town of Brunswick. Its twelve artist-workers design and make their own

*Reprinted by permission from *The Village Voice*, Aug. 19–25, 1981.

craft objects with supervision, but no interference. They are learning "market-able skills" as well as self-confidence and self-sufficiency. I've been following their progress for several years. One summer I showed them slides of feminist art, connecting the images with women's experiences and complaints. A lot of the pictures included masks, for obvious reasons. After the slide show, John Joyce, one of the workers, got up and began to make a mask.

I mention this because watching some of the same Spindleworkers at the opening of their Portland show (not their first; they're becoming deservedly in demand), I realized how much they had in common with the California artists demanding equal space, who were using their art to convey their views of how their art gets used and misused. The Spindleworkers come from working-class small-town families and in most cases their lives have not been showcases for democratic possibility. Yet John Joyce knew just what masks were needed for. He wanted one, too.

"When people are around/No one pays attention to me./Quiet makes me feel lonely./I'd like a husband," wrote Jackie Helie in a poem published in the Spindleworks *Feather Collection.* "Sad/can't find a job yet./Mad at the bosses./I need a job./Important./Sad," wrote Rober Bernier. "You're slow learning/If you want to clean a window/People they go fast cleaning and cleaning/We take our time. We do it well./We can work and we do a good job/But Time/is/going/by," wrote Anne Marie Michaud. And, for me, most pointed of all, "Family Story" by Ellen Flewelling, who notes that for ordinary women life is: "you grow up, you get a job, you find a boyfriend, you get engaged, you get married, you have a house and little children," but "I'll never know where/I'll be/Because I am al-ready/Where I left off."

The Spindleworkers' visual art is much brighter and happier than their poems. A wonderful collaborative banner made for a local hospital (which they visited to see where the art would go, what the people were like) was executed predominantly in a sunny yellow (with a black border); one of three figures in wheelchairs is careening wildly out of control; the other two are wistful but calm, with expressions a lot like those of the artists who drew them. An abstract hang-ing of wool strips—tweeds, grays, blacks and orange with a touch of good Maine hunting-jacket black-and-red check—is as sophisticated as anything we see in New York galleries. Rita Langlois, who has been at the workshop since its in-ception, is a talented artist with a vital sense of form and color. Her great arched skies, masklike winking suns, raindrops like pearls on threads and subtle hierar-chical interiors are like Grandma Moses with expansiveness and deep feeling added.

At first, retarded people's work looks something like children's art, but there is a big difference. It is very carefully made, for the most part, and with that care comes an emotional commitment that communicates itself as a kind of maturity, an edge of sadness and hope. Nan Ross, the director and intelligent, caring force behind Spindleworks, wrote in her introduction to the Portland show: "The art of the handicapped . . . should not be looked down upon as the work of piti-ful people, nor looked up to as the work of 'special' people. It should be looked *at.* . . . Art is what is made by artists, and if an artist cannot speak, or walk, or cannot hold his/her hand still, or has a mental age below his/her chronological age, what that person wants to communicate is going to be affected but not nec-essarily diminished by these disabilities." She justifies such a "separatist show"

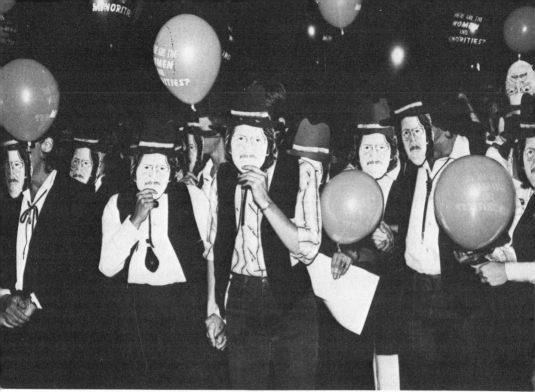

"Artists Missing in Action," media event at Los Angeles County Museum, July 1981; Maurice Tuchman masks. (Photo: Linda Eber)

precisely as I do women's shows, comparing the necessity for visibility of Blacks, women, Native Americans or the disabled "to emphasize the particular sensibility that group has to offer the larger, homogenous group."

This is not just pretty talk. I'm always immensely moved by what art means to the Spindleworkers and how much they in turn give back through it to all the people whose lives touch theirs. The usually taciturn Maine father of a severely retarded son told Nan Ross: "You've given Steve a new life." Then he paused and said, "No, you've given Steve a life."

I didn't see the "Artists Missing in Action" event at the L.A. County Museum on July 15, so the following comes from press releases and from highly revealing press coverage that it would be fun to analyze. ACE was protesting two shows: "Seventeen Artists of the '60s" (all white men) and fifteen site-art projects from the '70s (thirteen men, two women). This exclusionary policy ("no intentional discrimination," as the museum's PR man put it, because "art is basically blind"!) has a history. This is the tenth anniversary of the "Art and Technology" show (all men, all but one white), which sparked the first L.A. feminist art groups. Maurice Tuchman, curator of every disputed show, is therefore sort of an ill wind blowing good—a dependable reminder that art institutions, especially in the Reagan era, don't give a jellybean about affirmative action.

Led by veteran media/art activist Suzanne Lacy, the ACE event *was* art. The scenario centered around a Maurice Tuchman mask worn by some 100 demonstrators, captioned, pink-and-black balloons, and six "Cowgirl Commandos"—

masked and pink-costumed cheerleaders who announced they were looking for Tuchman, "wanted on three counts: rustlin' tax dollars from poor folks, falsifyin' history, and havin' the gall to invite youall here to watch it." Under a banner proclaiming "The LA County Museum of White Male Art" (and under hovering police helicopters), they also observed: "You're standin' knee deep in institutionalized racism and sexism, podner, and we think it's about time you scraped off those bootheels of yours." The myriad Maurices were then herded mooing and oinking up to the museum gates (where even those with invitations were refused entry), singing to the tune of "Git Along Little Dogies": "Yippy ai ai kai ay, white boys ain't the only ones makin' art in L.A."

A by-product of the event was a riotous postcard by "Thurmond, Margolies, Hughes" diagnosing Tuchman's "deadly curatorial disease" as "Visiona Narrowsa": "Sometimes it's hard to know what you're missing if it's never been there in the first place. . . . The next time you're in a museum and you notice your vision getting narrow, ask yourself what's missing and refer to the cure on the front of this card."

The cure, of course, is action of the kind ACE and Spindleworks are taking. A society in working order lets all its voices be heard. The Spindleworker who wrote: "I know how to sew/No/I can't read but/I know/how to sew," like the missing artists in L.A., is not reinforcing society's expectations of her—she's transcending them. That's how new art gets made and how it comes to communicate to more people.

(Photos: Marya Pollock, John Roca, Stephen Shanes)

Fringe heroes. Mothers' heroes. Nobody quite makes it today over life size. It's the squeeze, the sandwich, the board, that shrinks them. Step out of the frame and you're invisible. Hang in and you're all flattened out. Angels as devils, punks as stars, the musical middle-class schoolboy, the committed revolutionary or "hardened terrorist," the Horatio Algerian vigilante—full-blown, all dressed up for mass culture.

The one on the left playing the piano in a Police T-shirt is my hero, my son, Ethan Ryman. He loves New York, wants to be an actor, is witty, cosmologically inclined, and nearing draft age. The son in the middle is dead. Kevin Lynch starved to death in the midst of plenty of prison food, dying to prove that man cannot live by bread alone, that if the British are involved in a mere "police action," the IRA is fighting a war of independence. His mother fed him, raised him and watched him cut down like the ancient year king, grown from divine child to hero then killed and fed back to the earth to fertilize her and be born again. Tucked up cozily in his coffin/cradle, not as real as the photo over his head,

* (untitled collaboration with Jerry Kearns) Reprinted by permission from *The Village Voice*, Sept. 9–15, 1981.

Kevin Lynch died in the Maze, has worked his way out of the labyrinth of media half-life.

The one on the right belongs there. Curtis ("The Rock") Sliwa was 23 and managing a McDonald's when he cooked up the Guardian Angels—a three-year-old organization of 1,388 volunteer crime fighters with branches in twenty-two cities across America. It began underground, in the New York subways. Awarded a superpatriot prize by Nixon while still in high school, Sliwa was recently called back to Washington to testify for the SST. There, he decried youth crime and moral decay, was congratulated by terrifist Jeremiah Denton for being around to set things right, and was beaten up and thrown into the Potomac by (he implies) the police.

The bottom line of hegemony is control. The bottom line of control is violence. Drawing lines and bylines is culture's job. Remember Narrative Art? Comic strips and movies and street theatre? Posters and billboards and murals and artists' books? And TV serials designed to "solve moral perplexities"? Remember the popular notion that culture heroes are hard to reach, hard to frame, that they choose their own stripping, that art is so free that it seeps out of its containers, that art is art if an artist says it is and an artist is an artist if s/he says s/he is, no matter what the market and the media think?

This month's column is a mirror. It's usually a space for journalism about art, fact about fiction, and this time it's art about journalism, fiction about fact. It's still "criticism," though, because the pictures came first and the words have the last laugh. It's a distanced exchange between my partner, Jerry Kearns, an artist in the city where the news is produced, and me, a writer in the country where the news is a day late. JK sent me the picture panel above, and I'm responding in so many words. This is not a review of the poems the Maze prisoners write to the hunger strikers and shout across the H-Blocks, nor of the songs played for them over the radio, nor of the angry pictures drawn for them on the walls of Derry. It's not a review of the songs my kid writes, nor of the media theatre the Guardian Angels produce. But it's still culture.

We've spent a lot of time talking about heroes and looking at the way the media offer them up to us on silvered plates. I'll never be one of those mothers who proudly offers up her sons in exchange for a gold star. But I want Ethan on our side, back from Hollywood's outer space—my involuntary veteran of many marches. In a school play last year, he was born (I smiled), feebly rebelled (I sniffed), fell into line and kissed ass (I scowled), and died knowing he hadn't lived (I wept). I want to be both antiwar and anti-imperialist, but straddling the fence is beginning to hurt. The Celts were always big on sacrifice and self-inflicted punishment, according to the archaeologists. We eat our heroes, too, or find them at McDonald's. Christ still gets eaten at least once a week, so his friends and enemies can absorb his power. *Time* magazine on August 17 said of the IRA hunger strikers, amid many gory details and no political background, that they were practicing "an astounding kind of sacrifice—a brutal lingering death, full of hatred and martyrdom, so fanatical and Irish." So unlike the understated, democratic American way with just your ordinary white-hooded marchers and burning crosses and shotguns as shortcuts to law and order.

Fashion, ain't it grand? If I had anything to say about it, my kid would not run around in a Police T-shirt. I don't care if they are a "good" rock group; I do care that they sing a "bad" song called "My Girl Sally" about the total woman, but no

heroine even though she's inflatable, like she is bought and sold on Times Square. Eats nothing, like your middle-class anorexic, like Kevin Lynch. The Guardian Angels wear T-shirts showing a winged badge inscribed with an all-seeing eye in a pyramid, the sun's rays beaming behind it. They wear red berets so they'll "stand out in a crowd like lollipops." Time was, only sissy artists wore berets. Since then we've had Che and we've had them green for defoliators, purple for young lordship, black for the "urban jungle." My friend the professor wears a beret and his students call it his guerrilla outfit. If the hat fits . . . but what's the angle? The earliest art was body painting. T-shirts can be good propaganda for those of us who can't afford TV spots, pages of the *Times,* billboards, or cultural sponsorships, but at what point does the consumer become her own sandwich? What's the difference between wearing an antinuke symbol and advertising Adidas on your chest?

While the fogs roll and end-of-the-summer winds blow my papers around, I'm writing a book about prehistory and contemporary art. I'm reading about how the Christian church prefers lines to circles, light to dark, marches to dances, and how it absorbed all the pagan symbols it could, and turned the rest into evil. Patrick banished the snakes from Ireland. They went underground with the matriarchy, with the devil, the dark, the damp, and the dances. Does this have a familiar ring? Any connection with the fact that, in the United States, all revolutionaries are called terrorists, while all terrifying states are called policemen?

What does religion have to do with patriotism? With protection? A good guard is a guardian and a bad guardian is a guard. Last year the New York City police killed twenty-seven Black and Hispanic young men. Every time a hunger striker dies there are riots and others die, too. No one knows if subway crime is diminishing under the Guardians' eye. Ethan is labeled authority, but he won't listen to his mother. Lynch is labeled a rebel, but in fact, he just looks to another authority. Sliwa takes authority into his own hands.

Get the picture? It's both red and green like Christmas, and rough on the color-blind. Brecht recommended distance lest our vision blur. You want heroes? You get them, bigger than life. *Television* means "far-seeing." Don't look too close. You might get sucked in. You might get nothing but dots and bars, nothing but human interest, nothing to do with revolution, imperialism, economics, repression. But don't go too far away either. You might not see the background. You might mistake it all for culture.

Open Season*

You run into the damnedest people on the art circuit these days. Last week I hit Idi Amin, Teddy Kennedy, the Atlanta children, a harassed secretary, Prince Charles, Mademoiselle Bourgeoise Noire, Uncle Sam and Uncle Ron, Karen Silkwood, Martin Luther King, Mata Hari, Howdy Doody, some people from the

*Reprinted by permission from *The Village Voice,* Oct. 7–13, 1981.

South Bronx, Elvis, Andy, Santa Claus and half a million workers showing what they think of Bonzo's friend. I'm told "political issues" are hot this year. I'd say it isn't issues so much as images, or the varying degree of collusion with and opposition to the dominant culture.

What we have here are heroes (a few heroines), real stars, madeup ones, and "the masses." Mike Glier's Atlanta children (at Brooke Alexander) are boldly and sympathetically painted heads in grisaille, bigger than life, bigger unfortunately in death than they were in life. Warhol's blandly snazzy permutations of Day-Glo glitter and hype (at Ronald Feldman) offer fictional characters paradoxically presented in the authoritative, handless, head-and-bust shots favored for Our Leaders. They recommodify the commodified, including Andy himself, who is the only "real" person in the company of Dracula, the Wicked Witch of the West, et al. Judy Levy's large, candy-colored but oddly uncolorful portraits of international leaders ("Big Shots" at Schlesinger-Boisanté) also mix good guys and bad guys with impunity and no apparent rationale. These, too, are head–bust shots; only four of them have hands, and only Amin does anything much with them; he wields a big stick. These people are heads; others' hands do the work.

For all the talk about "new image" art, it's getting increasingly difficult to tell it from the "old image"—just plain figurative art, especially the post-Abstract Expressionist variety of spiritless drips and scumbles that flourished in the late '50s. Glier, for my money the strongest of those painting in a harsh, quasi-expressionist style today, is an admirer of the obstreperous portraitist Alice Neel, now in her eighties. The deadpan apolitical "iconic" portrait (like Al Leslie's of Moral Majority zealot Jesse Helms on a recent *Time* magazine cover) is at best giving way to a humanism that isn't new at all and doesn't need to be.

It's not just style that separates Warhol from Glier, nor levels of consciousness either (Warhol probably knows just where he is on the political spectrum). It's *intent,* within well-defined walls of artworld acceptability. The graffiti at Junior High School 22 on Avenue D at Houston Street exist outside those walls, but they share, to some extent, images with Warhol and style with Glier. Executed by street artists, some of whom attended the school, these anarchic surfaces include everything from ordinary "tags" to New Waver Keith Haring's lively frieze, to the flashy professionalism of master graffitist Lee, who has inscribed on a nearby handball court mural: "Grafitti [*sic*] is an art and if art is a crime let God forgive all" and "The only reason for art is to know you're alive."

The Lower East Side artists use a pop and mass culture vocabulary from TV cartoons and comic books not to introduce a jolt into high culture but, as a friend of mine remarked, because "it's their art history." The prime content is overt violence and alienation. The street provides its own tragic parallels. One wall shows a joyfully villainous figure touting the "Allen Boys" (it reads at first glance "Alien Boys"). On September 22, the *Daily News* front-paged a shoot-out in which two members of the Allen Street gang ended up in critical condition.

Young middle-class artists rebelling against the dominant culture while they are entering and perhaps expanding it aspire to outlaw status. Meanwhile the Allen Street gang acts in that overrated gap between art and life . . . or death. The J.H.S. 22 muralists magnify the desperate vitality of fear and poverty in *Daily News/Post* style; Warhol's figures from mass culture magnify a ruling-class stability, echoing the reassuring formality of *The New York Times*. The contrast is striking. Not so simple as "Warhol is passive because he's made it to the top, and the

'writers' are active because they have only a chance in hell of getting there," but that's not a bad place to start thinking.

Take Lorraine O'Grady's guerrilla "invasion" of the New Museum "Persona" opening, where, among the invited artists, at least Eleanor Antin and Lyn Hershman have their own histories of scrappiness. The fact that the show is called "Persona" indicates the way we re-create ourselves in relation to the "consumer model" offered by the media. Our artists create alter egos, disguises, masks because none of us are complete in ourselves.

There are no Third World artists in "Persona." O'Grady, who works like this herself, was only asked to do a workshop for schoolchildren on the subject, though the invitation was withdrawn after she had performed uninvited. She had gone beyond the esthetic pale, so to speak, by appearing at the opening in "debutante" garb—long white gloves, long white dress made of long white gloves, a tiara, and a banner across her chest proclaiming her Mademoiselle Bourgeoise Noire. She has used this persona before, but this was the biggest party Mademoiselle had crashed. Nothing could be further from the Black/Hispanic cartoon images at J.H.S. 22 than this elegant figure handing out white carnations and smiling regally at all comers. But the intent was similar. Her message was short and to the point:

> WAIT. Wait in your alternate/alternate spaces spitted on fishhooks of hope. Be polite. Wait to be discovered. Be proud to be independent, tongues cauterized at openings no one attends. Stay in your place. After all, art is only for art's sake. THAT's ENOUGH. Don't you know? Sleeping Beauty needs more than a kiss to awake. Now is the time for an Invasion!

Still another invasion took place in Washington on September 19, when the AFL-CIO summoned unprecedented numbers to protest administration cutbacks. (The *Times* reported 260,000; the British press 500,000.) A fellow PADD member had designed the yellow-and-blue flags and banners for District 1199; with the largely Black and Hispanic New York contingent, we followed a path of sunlight and exuberant anger past the Monument and up the Mall. Not art for art's sake, but a visual spectacle within the masses' culture that worked, raised spirits and "decoratively" got across its message—"Health Care for All." Back in New York, Karin Batten's paintings at 1199's gallery, right off Times Square, offered in turn an esthetic reflection of such real-life spectacles.

Batten is a forthright political painter with a robust style verging on "primitivism." Her show was subtitled "Humans: The Endangered Species. The Threat to Peace, The Danger of the Nuclear Holocaust," and it is a call to populist action. The atypical press material included encomiums from Alice Neel (underlining the importance of bringing "these threats to the attention of the world in pictures") and Machinists' Union president William Winpisinger (comparing Batten's exposure of nuclear madness with Dada, and suggesting that her work should "hang in corporate galleries across the land").

Vanalyne Green's performance to a crowd of financial-district office workers, whom she had solicited by leafleting the neighborhood, was about her secretarial job. Dressed primly in her business disguise, she sat at her desk, answered the phone, and gave a chilling account of life as a "high-paid dishwasher." Given its reception by secretaries in the audience, her calm, articulate, and humorous

narrative was also accurate. They particularly identified with the lines: "Sometimes when he asks me to bring him a cup of coffee, I do so. But I pour the coffee in a dirty cup that has a ring of dried coffee scum on the inside. And I smile as I hand it to him."

"This Is Where I Work" used formally powerful slides and a brief fantasy film passage to give another dimension to its message. In the process, Green deftly touched on several feminist and organizing issues, including sexual harassment, discrimination against qualified women with the "wrong image," the bosses' padded expense accounts, and pathetic "empire building" within the office. Afterward, information about clerical organizing was available, with coffee. Witty and unpretentious, this performance was a good example of imaginative activism. It combined several of the issues I expect to spend this year's columns investigating: outreach, activism, organization and collaboration; the degrees of effectiveness of oppositional art within the dominant culture; the relationship of high culture to media and mass culture . . . and how these are generating new art forms.

Vanalyne Green, *This Is Where I Work,* performance sponsored by the Downtown Whitney Museum, October 1981.

Margia Kramer, "Secret III" from *The Freedom of Information Act Work,* May 1980, Printed Matter windows, New York City, photostats on transparent film, 5' x 12'.

They've Got FBEyes for You*

It is the common fate of the indolent to see their rights become a prey to the active. The condition upon which God hath given liberty is eternal vigilance.

—JOHN PHILPOT CURRAN, 1790

Now that the dragnet is being spread again over the Left; now that the G-men are tromping again across our little silver screens, as well as across our lives; now that three bills to destroy the Freedom of Information Act (FOIA) are pending in Congress, in addition to the continuing litany of social-services-and-civil-rights mayhem, oppositional culture is rising like mushrooms after a hard rain. Artists are devising escapes from the house-arrested view of art as useless, impotent, and isolated. They have learned some lessons from popular culture, which has no such hang-ups. One effective wedge into high-art consciousness was offered last month at the Museum of Modern Art, which is not exactly famous for exposure of the status quo in which it so comfortably nestles.

*Reprinted by permission from *The Village Voice*, Nov. 4–10, 1981.

A lot of people were muttering and cursing under their breaths in the tiny basement video room as they took in Margia Kramer's installation: *Jean Seberg/ The FBI/The Media*. (Eavesdropping on the audience was, appropriately, an educational experience.) The room was filled with free-hanging black-and-white plastic panels, decorated with handsome type, calligraphic notations, and heavy black bars. Though visually striking, their informational density was the point. "Hanging in their glistening obscenity like dirty laundry" (as Kramer describes them), the panels are photoenlargements of FBI files on Seberg, on the Black Liberation and antiwar movements, obtained through the FOIA. The accompanying videotape is a collage of clips from Seberg's life and movies, and of the wide-eyed TV coverage of Cointelpro's crimes: "If the FBI was lying to us then, how are we asked to believe that they're telling the truth now?" one newscaster blandly asks another, who replies, "Well, we just have to take their word for it."

The *forms* by which political content is conveyed in the visual arts are increasingly under discussion in the activist cultural community. What works? How and why? Kramer's use of jagged black bars, for instance (they are the FBI's deletions before the material is declassified) become symbols of malignant censorship and secrecy, made meaningful by their juxtaposition with the brutal, illiterate prose of the bureaucracy. The words themselves also become bars. Something is being separated from something else. Something is held prisoner—in this case information, people's lives, and people's minds. In the hands of an artist with limited social awareness, the transparent black-and-white patterns might dissolve into estheticism. Kramer has avoided this pitfall with explanatory marginal annotations (credited to anonymous "FBI documents-interpreters who helped the artist understand . . . ").

Thus no one can miss Hoover's habit of lumping together Black organizations as "Black Nationalist Hate Groups," or the McCarthy language still used in 1971 ("communist infiltration of the motion-picture–radio–television industries"), or the gross idiocy of some of the harassment and ridicule plots, such as a raw, street-poster-style leaflet entering Dave Dellinger, Che Guevara, Mark Rudd and Herbert Marcuse in a "Gigantic 'Pick the Fag' Contest" with prizes including sexual favors and "seven full days in Hanoi, expenses paid." (The FBI is a lousy political artist on top of it all.)

Kramer is also aware of the need for more extensive propagation into the public domain. She has published several cheap "artists' books" on the subject and she organized a Seberg film series and a panel on "Freedom of Information and the Arts" at the Donnell Library that took place on October 15 (cosponsored by the Fund for Open Information and Accountability and Political Art Documentation/Distribution—PADD). Participants were Blanche Wiesen Cook, Emil de Antonio, Sol Yurick, Caryl Ratner, Jeffrey Halley, and Amiri Baraka, with Geoffrey Rips as a respondent. The quotes sprinkled through this article are from that panel, at which the level of outrage, information, and wit was high despite a legitimate degree of paranoia ("Someone in this room is an informer," began de Antonio) and filesmanship (as in "my file's bigger than your file"; those mentioned ranged from Ratner's 2 pages to Baraka's 4,000).

The streets have been another forum for this issue. Last spring Kramer and Vanalyne Green coordinated the cultural events for the No More Witch Hunts festival on Astor Place. As activist artists, they functioned as communica-

tive/esthetic bridges between the Left and sympathetic artists who might otherwise never have addressed the subject. The Group Material collective danced as "The Ghost of McCarthy Go-Go Dancers" in Joe M. masks; Mundy McLaughlin wore her half-camouflage, half-red "American/Unamerican" costume; Robert Grunberg's *Roving Camera* parodied the actual surveillance that was taking place (an agent was recognized and jeered); Stan Baker—The Human Television—did his well-known street act; Disband performed; Donna Henes made a (voluntary) scroll of fingerprints and handed out stickers saying something to the effect of "Don't bother; I've been printed already"; No More Nice Girls, pregnant and in chains, handed out their "No More Sexual McCarthyism" buttons.

The centerpiece was a full-scale sculpture of an ordinary living room (collectively designed by PADD people and primarily constructed by Tony Silvestrini). You peered into it through peepholes and the bare outside walls were decorated with catalog photos of the appalling range of surveillance devices available to poop-snoopers. (These, in turn, are responsible for the amazing range of counterdevices guaranteeing "phone privacy" that are advertised everywhere from airline catalogs to *The Village Voice.*)

The pioneers of cheap, esthetically sharp propaganda for freedom of expression and information are Jean Toche and Jon Hendricks of the Guerrilla Art Action Group (GAAG), founded in 1969, temporarily disbanded in 1976, and reborn soon afterward in our hour of need. Their mediums are the surprise street or museum performance and the outraged/outrageous red letter to authority. They were two thirds of the Judson Three in 1970 and in 1974, Belgian-born Toche was arrested by the FBI for sending out yet another of GAAG's bitterly humorous (and all too serious) epistles, calling for the kidnapping of all museums' trustees, directors, administrators, curators and benefactors "to be held as war hostages until a people's court is convened to deal specifically with the cultural crimes of the ruling class." C. Douglas Dillon, president of the Metropolitan Museum and ex-Secretary of the U.S. Treasury, apparently felt more vulnerable (or more powerful, as Carman Moore suggested at the time) than the rest of his colleagues and had Toche apprehended. The FBI was looking for a "professional troublemaker, foreign agitator, peacenik, dirty commie, flag-burner, big tall burly hairy man called Toche/Hendricks." Since Toche is a short plump man with a gentle, bearded baby face, and Hendricks is tall and beardless, their friends were quite taken by the FBI's creative GAAG hybrid.

GAAG was particularly active around S-1 and its progeny, and since 1975 has often done pieces on the theatre of the absurd arising from their attempts to obtain their FBI files through the FOIA. Last year they did an event at Printed Matter called "Curious," in which they handed out stamped, ready-to-mail requests for files, so the art community would know where it stood before the drawers slammed shut. Toche and Hendricks, in short, are public educators, satirists, heirs to Ad Reinhardt's unenviable role as "conscience of the art world." Only the leaden gumshoes could fall so heavily for their tactics.

In this tradition, art and media activists around the country have been preparing campaigns and protesting the latest mainlining of the status quo into our prime-time bloodstreams—the new TV show *Today's FBI,* which, as *The New York Times* reported, actively involved the FBI to the point of total creative control and "having agents suggest plot lines and approve all scripts." In Seattle, on September 27, a political artists' group called X-Change cosponsored with the

Political Rights Defense Fund "a little art action" directed against KOMO-TV, the local ABC affiliate. Doug Kahn's flyer invited everyone to attend in or out of "FBI drag"—suggesting that costumes might include "Third degree in the shades, legal briefs, long sleeves of the law, security breaches and 'hot on their' heels." Participants in trench coats slunk around and surveilled a skit called *Today's FIB,* sang songs and otherwise reflected on the high-art/low-media overlaps that go unrecognized by the dominant culture.

In view of the fact that the closers-down of democracy are always warning against state control and virtuously comparing our limitless freedom with the lack thereof in "totalitarian" states, this overt example of state propaganda in the guise of "entertainment" supports both de Antonio's contention that "U.S. TV is the most effective brainwashing going" and Sol Yurick's observation that "we've lived within a police state clearly since 1917," though a different kind than elsewhere, and that they want "possession of our minds in the magical sense, to change our sense of reality." Here's where art comes in. It can, as Baraka says, "make these things larger than life."

These are crucial issues for visual artists because those of us on the Left are always being accused of making "propaganda, not art." This situation reflects the fact that propaganda for the dominant culture is not called propaganda but simply "the truth." Both sides are trying to "propagate," multiply, spread the seeds or the word. ("Political warfare is about words," said Blanche Wiesen Cook.) Oppositional propaganda is, of course, drastically limited by inequality of access to the electronic media. Baraka compares IBM's budget with his "pocketful of nickels" for the Xerox machine. It's the same access and First Amendment issue that was raised by the Committee Against Fort Apache last year, that will be raised again when that racist extravaganza hits TV this winter, and is being raised in the interim by *Hill Street Blues*—another version of the heroic cops protecting us civilized folk from the jungle.

At the end of the panel at Donnell, a gray-haired woman wildly waved her hand to ask the last question: "Are you people trying to overthrow the government?" The panel responded without missing a beat. De Antonio quoted a version of the Curran line that opens this article. Blanche Cook said, "Do you mean the government of the Bill of Rights? The government of the Constitution? The government of the Freedom of Information Act?" And Geoffrey Rips said, "Maybe the government is already overthrown."

All Fired Up*

My neighbors were gone, scattered by the winds of arson, federal urban renewal and civic neglect. The media painted a portrait of my home town as a perilous "no-man's land," an urban jungle, and yet, this was America they were talking about. —LUIS CANCEL, DIRECTOR, BRONX MUSEUM

It happened so slowly and it happened to such an extent that I wasn't even aware of change until one day I decided to walk around the block and found that we had no block. Then I decided to walk around the neighborhood and found that we had no neighborhood. —VICTOR GEORGE MAIR, RESIDENT OF THE SOUTH BRONX

A year ago the Bronx Museum of the Arts mounted an exhibition that through its 116-page catalog has become a model for visualizing social change. "Devastation/Resurrection: The South Bronx," curated by Robert Jensen, offered a truly devastating (and healthily partisan) picture of what can happen to a community when it is attacked by the powers that be. I refer to it here as a starting point for examining the South Bronx's appeal for white avant-garde artists.

Noncommunity art activities in the ghetto, arising from genuine concern and also from varying degrees of consciousness, ignorance, and at worst opportunism, involve the most complex questions of cultural imperialism and good intentions, progressive and naïve politics, work with or "for" the community. Far be it from me to make it more difficult for anyone to make activist art anywhere outside the dominant culture, but in this particularly touchy cross-cultural, cross-class area of interaction, the relationships between privilege and exploitation, empathy and condescension are crucial.

The degree to which the visiting artists are inspired by the people and future of the South Bronx rather than by its picturesque landscape and desperate tenor, the degree to which their work is part of a considered political strategy formed with those people, the degree to which identification with the oppressed leads to passive exposition or active opposition, and what are the social roots of that identification—these are only a few of the questions that have to be asked. I don't pretend to have the answers, but will try in these columns to map out some of the art ground between Fordham Road and the Harlem and Bronx rivers. Eventually I'd like to get together a panel on the subject and hear the artists themselves talk about their motives for working in that area.

To begin on the bright side (perhaps a little too bright), Mel Rosenthal's exhibition of photographs from the South Bronx recently at Gallery 1199 offered moving portraits of the people who hang out on the streets there, emphasizing life among the ruins rather than the reasons for the ruins. Not that Rosenthal is unaware of the causes. He was raised in the Bronx when it was a working- and middle-class neighborhood, and now teaches local health workers and people who work in community organizations there. When he returned, he felt queasy at first about taking pictures, "partly because I didn't feel I belonged there, partly

*Reprinted by permission from *The Village Voice*, Dec. 2–8, 1981.

Mel Rosenthal, *Bathgate Avenue, South Bronx, 1978.*

Justen Ladda, *The Thing,* 1981. (Photo: Martha Cooper; © Marvel Comics Group 1981)

because I was overwhelmed by the devastation and pain, and partly because I couldn't even begin to figure out ways of documenting what was going on up there and my relationship to it."

The relationship evolved from his discovery that the people he met on Bathgate Avenue had no pictures of themselves aside from "the demeaning, distorting, and demoralizing photographs on their identification cards." He decided to provide the positive images that are also lacking in the public domain of movies, TV, and newspapers. Rosenthal's portraits belong in the "humanist" tradition of art/documentary photography. They are beautiful, caring, often striking. The show's pervasive emotions were courage and sadness. Some of my favorite pictures were those of young people and kids hamming it up in front of Super Kool cigarette ads, turning somersaults on burned-out mattresses or leaping for a basketball, caught in midair as though rising above the patch of earth they're stuck on by sheer willpower and exuberance. One senses the artist's seriousness, his constant sense of his responsibility to his subjects.

But Rosenthal's enterprise is a risky one, given the delicate line between the idealization of victims, pretending all is well if people can still smile, and ghoulishly dramatizing the victim, crying over spilt blood without suggesting some antidote. His subjects are nameless, continuing the anonymity graffiti artists are combating; there are no images of people working, of Tremont Trades, Banana Kelly, and other sweat equity groups, of organization and resistance. Rosenthal knows these pitfalls. He worries about the extent to which he "might also be contributing to the objectification and exploitation" of his subjects. His modest campaign for visibility is part of a larger one to counteract the image of the South Bronx in movies like *Fort Apache,* in which its cop-protectors describe the area as "70,000 people packed in like sardines, smelling each other's farts, living like cockroaches," out of whom there are "50,000 potential cop killers." The press continued the numbers game, *New York Magazine* imagining "the hellhole that is the South Bronx, 10,000 addicts on some blocks, arsonists common as rats, rubble where grass should grow" (Dec. 1, 1980).

The film's final solution was "bulldozers . . . that's the only way. Just tear it down and push it into the river." Marc Blane opposes this with his plans for parks constructed of the rubble left by arsonists, landlords and redlining bankers. Working in the tradition of Charles Simonds and Alan Sonfist, he proposes that his "Rubble Reconstruction Company" reclaim the land through recycling, for which he has the support of the South Bronx Development Organization. With the guidance of a local alcoholic he calls Don Jose, Blane dreams of making "reconstruction art," because Reconstruction was "the process of restoring to the states that had seceded, the rights and privileges of the Union." Unfortunately, this misguided parallel works, but not as intended, given what the post–Civil War Reconstruction did for southern Blacks.

Blane's best work is metaphorical, represented in two artist's books: *Cycles* and *Grounds/Greens, Graves, Ruins, Mines,* which suggest ironic ties between ancient culture and ours, abandoning the South Bronx to history. His gallery work (recently seen at Franklin Furnace) includes photographs of the Charlotte Street barrens, burned at the edges or juxtaposed with burned money, or inserted as the "message" in green Night Train Express bottles found in the gutters. This connection of whiskey, fires, and anonymous residents verges dangerously on the blame-the-victim syndrome, contributing to the media image of the area as

the habitat of "animals" and "inhuman creatures" who burn their homes down around them in drunken or drugged impotence; it ignores the "planned shrinkage" gentrification strategies of the developers who own the South Bronx.

John Fekner is always showing in the South Bronx. His "Falsas Promesas/Broken Promises" on Charlotte Street is a huge stencil of the 1980 People's Convention slogan. It provided a satirical backdrop for Reagan's and other politicians' obligatory preelection visits to the area that summer. Fekner and his stencil are, in scale and intention, an offshoot of the graffiti impulse. He simply states truths in giant letters on the surfaces of reality. "Industrial Fossil," he writes across an abandoned truck; "Decay," he writes in a deteriorating doorway; "Mortal Wound" inside a ruined church; "Indian Trails" on a freeway; "De-Emphasize Ads," "No TV," "Save Our Schools." Fekner is essentially a caption writer to the urban environment, adman for the opposition. He is a three-dimensional photographer who also works in other mediums, though this is his most effective. Reproductions of his work only palely reflect the experience of coming upon them on site. He does in public what a lot of artworld artists don't even do in galleries: he dispels ambiguity by naming his visions, his viewpoint.

Other young white artists, mostly of the Lower East Side/Tribeca/New Wave persuasion, work and show in the South Bronx through Fashion Moda—a "cultural concept" on Third Avenue and 147th Street. Founded and run by Stefan Eins, an Austrian who makes his art in an expanded, administrative version of Fekner's identification process, Fashion Moda shows weird amalgams of local, downtown, and international culture. They blur boundaries between high and low art, trained and untrained artists, education, science and culture. In the basement for a year or so was an installation by another white group called CUD (Contemporary Urbicultural Documentation). The goal of its systematic archaeology of very recent ruins (in this case the Bronx County Criminal Court House) is "to exchange information about the site/society we live in." CUD involves the neighborhood in research into the social artifacts, documents, and structures that control it, plumbs the bureaucratic depths of fallout shelters, psychiatric institutions, religious missions. It, too, represents a new kind of site-specific art, unearthing forms of alienation, fragments of lives, putting them together into a cohesive visual experience.

The artists I've discussed so far have used the found materials and realities of the South Bronx to comment on the societal/emotional surfaces and/or the underlying processes. Justen ("Houston") Ladda's *The Thing*, buried deep in the bowels of a huge, abandoned high school near Fashion Moda, is a picture from elsewhere, a pop-science-fiction fantasy familiar to the local audience, wrenched from the media to convey a message different from the intended one in much the same way the master graffiti artists often subvert their cartoon heritage. *The Thing* is a vision rather than a prescription. It is a two- and three-dimensional painted picture of Stone Man—*Hombre de Piedra*—a grotesque but benign superhero who hurls himself from the wall of a ruined auditorium onto the backs of the vast array of seats, which the artist has painted white. The painting is a complex, divided-perspective image, seen whole from a single vantage point, disintegrating before your eyes as you move away from it. To reach the work, one takes a postcataclysmic journey down dark, broken and obstacle-strewn stairways into a pitch-black hole, guided by Ladda's lantern. When one finally enters the auditorium, *The Thing* leaps out of the shadows. On a nearby stage is another

piece—a haloed pyre of burning books done in the same perceptual technique. The books are not fuel for the Moral Majority, but perhaps despair itself going up in flames, hope smoldering beneath the ruins, as Stone Man might be history bursting its bounds, a symbol of the South Bronx community organizing and breaking out of the tomb the dominant culture has built for it.

A monumental visual feat in itself, *The Thing* suggests other metaphors about archaeology, ruins and resurrection. On the poster was a quotation from Jung: "Our times have demonstrated what it means for the gates of the underworld to be opened. . . . Things whose enormity nobody could have imagined . . . turned our world upside down." The Bronx Museum catalog ends with a chapter called "Resurrection: The People Are Doing it Themselves." Culture in and coming into the South Bronx has a role to play. But what exactly, and how, and whose?

HAPPY NEWSYEAR FROM LUCY LIPPARD AND JERRY KEARNS

ART

Welcome to the image war being waged behind representational lines and in them. It's on your heads and boxes. There's fighting in the streets. This is about pictorial repression and pictorial resistance, about demonstrating our imaginations.

Close up, you see the New Right kept at a distance. They write us out of the picture, but we pale them by comparison. They appear in *The New York Times*, telling us it's okay, don't worry, don't think, don't act, the world's in good hands, in bad hands, in empty hands, in the wrong hands, but don't worry your little heads. Big strong white men got it all under control. (Help! We're being helped!)

They give us another message in the *New York Post*, where we're assailed by random violence, titillated by second-hand sexuality. Nobody's in control here, much less you, m'dear. No use feeling responsible, no use organizing. It's all out of your hands. It all *just happens* to you poor folk. Bricks fall from roofs, bombs fall from buttons. Don't watch the news, there's nothin' you can do. Read the papers and scare yourself to death. It's cheaper than the movies.

In these times not fit to print, see with your own eyes. See through words. Wonder whose reality they reflect, who owns the mirror. Wonder why it looks like it's us wearing masks, wearing gags. In fact, everybody's in disguise. Bloodthirsty maniacs wear the costumes of reason, authority, and decency—white shirts and ties, and

neat or disappearing hair. They cast us as the commie pinko queers demonstrating in the gutter while the good folk stay home and get off on teenage chastity and capital punishment for homosexuals, cozy in the knowledge that domestic surveillance—snuck in last month undercover of Libyan darkness—stops at the familiar center. (All the more reason not to let your art out of the room.)

Is art around to tell the time? Look at these faces. What time *is* it, anyway? Time for active resistance to the deaths/headlines offered by the nuclear powers: The Black United Front defying the draft, another crowning blow in Crown Heights; N.Y.P.A.D. in Washington canceling guns and bombs and warriors with black, white, and red, images alone; No More Nice Girls in New York marching tall, big-bellied, black-robed, chained, gagged in shocking pink, demanding reproductive freedom, a halt to Sexual McCarthyism and Forced Labor. But is it art? Yes, as a matter of fact, it is.

What do you show and where do you show? they ask in the art world. We show and tell what we believe wherever we can be seen. Why does political art have to use words? they ask in the art world. Whose political art—ours or theirs? How come we get asked suspiciously what we're doing when we join words and images to criticize? How come I get asked Are you still a critic? If art can be words, why can't criticism be images? When artists write, they don't stop being artists. You can get your head blown off in no man's land, but isn't modernism all about risk?

It looks like 1980 too: 1980 not won. 1980 for what? I dreamed the other night that the top of a rocky island blew off in a luscious cloud against a bright blue sky while boulders clattered to the ground killing many, because sculptors had been careless. Are we making art while Reagan fiddles? Why do we have to wake at night and worry, not about the bomb, the wars, the bodies of our sons and daughters, but about the next day's meals, the next week's work, the next month's rent? Can artists afford to look ahead? If we behave we get *Masterpiece Theatre* for one more year. They're dreaming the nicest little dreams for us. They don't include consciousness, concern, involvement, or action.

A happy newsyear would mean more news to fit the pages that be, more art fit to demonstrate what the media don't, more active resistance to the guardians of our immorality. How to resolve our new-year revolutions? In ancient winter solstice rituals, a fiery wheel was rolled downhill and people danced in circles to encourage the sun and moon to keep on turning. We've gone around in enough circles, gone far enough downhill. This time of year the sun's on the rise again. If only every cloud didn't have a plutonium lining. It's going to take more than a star in the East this time around. It's going to take both action and passion. Aren't they still in this domain?

Welcome to the image war being waged behind representational lines and in them. It's on your heads and boxes. There's fighting in the streets. This is about pictorial repression and pictorial resistance, about demonstrating our imaginations.

Close up, you see the New Right kept at a distance. They write us out of the picture, but we pale them by comparison. They appear in *The New York Times,* telling us it's okay, don't worry, don't think, don't act, the world's in good hands, in bad hands, in empty hands, in the wrong hands, but don't worry your little heads. Big strong white men got it all under control. (Help! We're being helped!)

They give us another message in the *New York Post,* where we're assailed by random violence, titillated by secondhand sexuality. Nobody's in control here, much less you, m'dear. No use feeling responsible, no use organizing. It's all out of your hands. It all *just happens* to you poor folk. Bricks fall from roofs, bombs fall from buttons. Don't watch the news, there's nothin' you can do. Read the papers and scare yourself to death. It's cheaper than the movies.

In these times not fit to print, see with your own eyes. See through words. Wonder whose reality they reflect, who owns the mirror. Wonder why it looks like it's us wearing masks, wearing gags. In fact, everybody's in disguise. Bloodthirsty maniacs wear the costumes of reason, authority, and decency: white shirts and ties, and neat or disappearing hair. They cast us as the commie pinko queers demonstrating in the gutter while the good folk stay home and get off on teenage chastity and capital punishment for homosexuals, cozy in the knowledge that domestic surveillance—snuck in last month under cover of Libyan darkness—stops at the familiar center. (All the more reason not to let your art out of the room, not to join groups, despite the loneliness of the short-sighted expressionist and the deadpanhandler.)

Is art around to tell the time? Look at these faces. What time *is* it, anyway? Time for active resistance to the deathsheadlines offered by the nuclear powers: The Black United Front defying the draft, another crowning blow in Crown Heights; PADD in Washington canceling guns and bombs and warriors with black, white, and red, images alone; No More Nice Girls in New York marching tall, big-bellied, black-robed, chained, gagged in shocking pink, demanding reproductive freedom, a halt to Sexual McCarthyism and Forced Labor.

In November, the women went to the Pentagon with patchwork banners and giant puppets to mourn, defy, rage and resist the clouds of war. We wove a multicolored web of fragile yarn and fabrics around the five faces and across its entrances, caught generals in our net. We demanded the toys be taken away from the boys. Blood spattered the pillars of militarism while we passed out fresh bread and willed the people within to work for peace and not for war. But is it art? Yes, as a matter of fact, it is.

What do you show and where do you show? they ask in the art world. We show and tell what we believe wherever we can be seen. "Why does political art have to use words?" they ask in the art world. Whose political art—ours or theirs? How come we get asked suspiciously what we're doing when we join words and images to criticize? How come I get asked, "Are you still a critic?" If

*Reprinted by permission from *The Village Voice*, Dec. 30, 1981–Jan. 5, 1982.

art can be words, why can't criticism be images? When artists write, they don't stop being artists. (A little justice here, please!) You can get your head blown off in no-man's-land, but isn't modernism all about risk? Maybe that's why some esthetic resisters wear masks. Maybe everything has to be unmasked before it can be rendered effective instead of safely contained in cultural anxiety.

It looks like 1980, too. 1980 not won. 1980 for what? I dreamed the other night that the top of a rocky island blew off in a luscious cloud against a bright blue sky while boulders clattered to the ground killing many, because sculptors had been careless. We hid in a basement as the cataclysm raged and I thought that was a dumb idea. Are we making art while Reagan fiddles? Why do we have to wake at night and worry, not about the bomb, the wars, the bodies of our sons and daughters, but about the next day's meals, the next week's work, the next month's rent? Can artists afford to look ahead? If we behave we get *Masterpiece Theatre* for one more year. They're dreaming the nicest little dreams for us. They don't include consciousness, concern, involvement, or action.

A happy newsyear would mean more news to fit the pages that be, more art fit to demonstrate what the media don't, more active resistance to the guardians of our immorality. How to resolve our newsyear revolutions? In ancient winter solstice rituals, a fiery wheel was rolled downhill and people danced in circles to encourage the sun and moon to keep on turning. We've gone around in enough circles, gone far enough downhill. This time of year the sun's on the rise again. If only every cloud didn't have a plutonium lining. It's going to take more than a star in the East this time around. It's going to take both action and passion. Aren't they still in art's domain?

Making Manifest*

I've never written much about "realist" art, maybe because I've always found reality itself more compelling. Some things can't be heightened; I'll always prefer a rock to a picture of a rock. But social-change art *has* to be concerned with realism, or at least with all our contradictory perceptions of reality—in the media, in mass and high culture. Realism means simply "the way it is, the way it looks." But looks to whom? And whose interpretation of what *is?* And how do we distinguish between individual and socialized visions? Or is there a distinction? A work of art with content is like a person. Some people look like what they are; others fool the eye and mind, for a while, with their picture planes. Art, like people, comes on differently in different situations.

I wrote a couple of months ago about white artists working in the South Bronx, wondering about their motives and effect. Bill Stephens is best and internationally known as a documentary video artist and photojournalist whose work now centers on Harlem. When I saw his collaborative video installation *Fire Walls Four* nestled among the blue chips at the Whitney Museum earlier this month, I began to wonder how the reversal works. It's an ambitious piece, a room within a darkened room, its outside walls painted with full-scale scenes of a firehouse, a burned-out building, Black urban street life and the landlord's white

*Reprinted by permission from *The Village Voice*, Jan. 27–Feb. 2, 1982.

suburban street life (respectively made by Ozzie Simmons, Chris Cumberback, Lavon Leak, and Richard Leonard). Inside, an almost-clutter of objects, images, and sound conveyed an atmosphere of urgency and emergency. Four color monitors on high red pedestals framed a ladder sculpture above and a flashing revolving red light below. Two of the screens showed crackling flames; the other two, documentaries of fires and fire victims. A small fifth TV set added a quasi-Surrealist touch with a mysterious and blurry (or blue) view of a white fireman performing an explicit striptease for a mostly Black audience.

One inside wall was painted by Freida Jones as a tenement exterior against the sky; it merged two tableaux: a shabby but comfortable living room with TV, hot plate, worn pink plastic toy, a pair of high-heeled white men's shoes, a woodcut by Charles White, an ashtray on the couch with two cigarettes having burned holes next to it: and the aftermath, a pile of burned-out furniture with ghastly photos of silhouettes of burned bodies. A third wall was the firehouse, with clothes and equipment (a handful of money and jewels dripping from the pocket of one bemedaled slicker); the fourth was a strongly designed documentation of "The Men Who Are Burning New York" with portraits and red graffiti reading "Arson for Profit," striped by canvas fire hoses. A can of kerosene and old business ledgers laid the blame on greed.

Stephens' details were well and pointedly chosen with just the right amount of esthetic confusion for the subject at hand. (Your eardrums weren't split; you could tell what the message was; and the presence of viewers didn't upset the visual impact.) When I saw the piece, it was full of participants, mostly young people, all white. Some appeared to know, some didn't, that areas of this city are systematically destroyed by their owners. Either way a certain reality was brought home. Maybe brought home is the wrong term. The Upper East Side abuts on Harlem, but it is also, no doubt, the home of many of those who profit from the destruction of others' homes. The distancing was a social as well as a formal device.

Some would question whether *Fire Walls Four* at the Whitney was a case of "preaching to the converted" (would that it were!), while others would question its appearance in an art museum. Stephens, however, wasn't preaching; he was stating facts in a dramatic but nonrhetorical manner. Some would in turn dispute his "realism" and argue with his interpretation of those facts. This group of dissenters would not be the people who live in Harlem, Bed-Stuy, the South Bronx, the people in union halls, public schools, and other less affluent enclaves. These people *know* the facts. They *are* the converted, not the Whitney audience, which is perhaps more highly educated and "better informed" about some things, but rarely aware emotionally of what goes down so near, and yet so far from their own more secure homes.

Across the street at the Lerner-Heller Gallery was a puzzling but provocative four-artist show called "Manifesto," which by my dictionary means "an open statement" or "a public declaration . . . making known past actions and explaining the motives for actions announced as forthcoming." The two works not made specifically for the show simply "made known past actions": a 1974 blackboard piece by Joseph Beuys from the time when it seemed he might indeed be manifesting something important and a large photograph of one of Ana Mendieta's "rupestrian sculptures," made on site in a Cuban cave last summer—a powerfully crude and moving image of female/earth connections.

The other two pieces, Vito Acconci's *Three Manifestos* and Rudolf Baranik's

Rudolf Baranik, *Napalm Elegy 2,* 1973, rustoleum and photostat collage on masonite with black lucite, 2 panels, each 102″ x 50¼″; piece revised for War Games exhibition at Ronald Feldman Gallery, Spring 1982, by addition of the following text:

"WAR GAMES, an obsolete combination of the archaic word WAR and the contemporary word GAMES. 1. WAR, the physical mass annihilation of human beings, usually organized and conducted by national states and carried out by parts of the population known as ARMED FORCES (obsolete). 2. The preparation of mass annihilation carried out by groups of retarded people known as MILITARY LEADERSHIP (military-obsolete). Groups of these retardees, known as GENERALS (archaic), had their headquarters in a five-faceted building near the Potomac River in the pre-civilization North American Empire. 3. WAR GAMES, used in the pre-civilization era to describe maneuvers of mass-killing forces. 4. A name of an exhibition held near the end of the twentieth century at the RONALD FELDMAN Fine Arts, New York, believed to be a gallery (obsolete). The exhibition, as reconstructed through the archaic recording means of video and microfilm, is believed to have been of sardonic nature. Dictionary of the English language, 24th century (*excerpted* by Rudolf Baranik)."

Words for One, are both clear statements of not entirely clear positions by two artists who occupy quite different places in the spectrum of New York "political art." Acconci's three-panel colored photography work was primarily bright, cheerful, at home in the gallery of 1982. Its punch lines were delivered, with a characteristic combination of frustration and vague sexual/political innuendos, on window shades that intentionally wouldn't stay down, so incur-

ious viewers never got punched at all. Over a picture of a luscious cloudy blue sky, a white shade read "An Art Should Last Only So Long As People Keep It Up"; over a reflective mylar panel, a black shade read "An Art Should Last Longer than People Can Hold It Down"; over a picture of the acting president of the United States, a transparent shade read "An Art Should Last Only So Long As People See Through It." I'll leave you to enjoy the ways in which this piece does not exactly "explain the motives for actions." Acconci has said that he sees the viewer of art as "a puppet or a victim of culture," and art as a way to "thicken the plot," to deal with "politics as a multisided thing."

Baranik's large black painting, almost covered with pale lines of delicate gibberish, offers a more complex view of where the needs and functions of art and politics converge and conflict. His "script" is almost legible; he somehow transcends decoration by the intensity of his *desire* to say something. I feel meaning pulsing just below the surface of these works, like an idea on the tip of my tongue. This is not an art that is easily seen through. The signs are there but the language is neither Baranik's native Lithuanian nor the English, German, French, and Russian he also speaks. In its simultaneous urge to communicate and remain silent, *Words for One* might be a polyglot tribute to internationalism.

Baranık calls himself, a bit ruefully, a "socialist formalist," refusing to let "them" own the depths of artistic clarity to which he is as committed as he is to the Left. His "dark paintings" series is inevitably comparable to that of Ad Reinhardt (ironically also a Lithuanian "socialist formalist"). Yet they differ in the fact that Baranik's hermeticism is a more poignant, less belligerent means of establishing art's moral role. Both demand of the viewer a commitment closer to that of the artist himself than is expected of the in-one-eye-out-the-other experience that much contemporary art has become. What is made real, or manifested, in this single glowing canvas is the part of politics that the noncultural Left has difficulty recognizing: the spiritual element, for lack of a less pompous term.

Leon Golub's "Mercenaries and Interrogations" show at Susan Caldwell is an open statement that manages to be both formally impressive and intensely critical of the world it clarifies. It's the hardest-hitting "realism" I've seen. The fact that its subject matter is overtly political is one reason. The other is esthetic and, as I keep muttering in these columns and elsewhere, the two are not mutually exclusive, much as the folks on the podium would like us to think they are. When esthetics and politics meet with equal strength, the result is a double whammy.

Golub's six large (ten to twenty feet) paintings are of a scale commensurate with their historical intent. Most of them have harsh, blood-red backgrounds. The foregrounds of three show hired killers lounging around with guns in a chilling buddy-buddyism that carries over to the other three pictures—of similar types torturing nude, faceless victims. A sign on the gallery door recommends children be admitted with discretion, indicating the work's effectiveness, since so much art, political or otherwise, tends to involuntarily beautify or obscure its content.

Golub's art is expressionist without being anarchic. A painful control parallels his subject matter. Both personal and public violence are held in check, as though all the evil of fascist militarism were inherent in these male figures. (This is a man's view of men, and all the more scary in that it suggests a knot of murderous rage on the generally social level, too.) Golub said on a recent panel,

Leon Golub, *Interrogation (I)*, 1981, acrylic on canvas, 120″ x 176″. (Photo: Diana Church; courtesy Susan Caldwell Gallery)

"I make my paintings as blatant, as vulgarly obvious, as raunchy and gross as I know how." But oddly the final impression is the opposite of these words. Hung like an obscene piece of meat, or seated black-hooded and helpless or (in the case of the woman) cringing blindfolded and gagged by tape, the victims are less than people. The real horror of these paintings is the very *casualness* with which the uniformed men go about their business—whether goofing off with their guns or administering unimaginable pain to other human beings.

The tensions in these paintings, the sense of time passing unbearably slowly, is integrally interwoven with their use of space. Human geometry—the bends of knees and elbows—is occasionally echoed by inorganic shapes like guns or gallows. In *Gigantomachy* of 1966, an earlier large canvas shown in a separate room, heroic nude figures flow across the surface and in their motion are truly monumental. The new works, however, are more so, heightened by their eerie sense of arrest and containment, their cruel, almost balletic, stopped-time gestures. The inherent violence is all the more appalling because it hasn't happened yet, or yet again. Similarly the paint surface itself is very dry, as though the pain of the victims were literally drawn out, bled through the brush, scraped across the canvas. (The pencil studies in another room are far more human; only in paint do these men become wholly evil.)

The distance that transmits that agonizing sense of time exists not only in the spaces between the painted figures themselves, which is crucial, but also in the spaces between "us" and "them," between a SoHo art gallery and the Latin American prisons or African villages where these scenes take place with a secrecy

and frequency no art can fully convey. Finally, there is also the space between a New York artist whose conscience is as sorely troubled by his own powerlessness to affect these events as by the events themselves—between him and the unknown victims who hold the same beliefs but who are asked so much more to support them. What results is an excruciating sense of personal anxiety made political. In two of the (nontorture) paintings there is an overt self-portrait, suggesting that perhaps we're all mercenaries and victims, working in a state that condones these tortures and has devised its own subtler ones.

Golub's portraits of power are finally portraits of impotence, an ultimate statement of any lone artist's powerlessness. At the same time they are moving and memorable. They will raise consciousness, provide models for other artists and actions. They make manifest a reality submerged by our own society, by a racist administration that figures those hot-headed Latin authoritarians just have a different view of human rights (i.e., victims *and* torturers are not quite human).

An acute anxiety connects all the work discussed here. It also connects modernism and social activism. Golub's new paintings achieve grandeur, maybe even "greatness"—a notion so abused by patriarchy and commercialism that I heartily mistrust it. He uses the extremes of military degradation—hired killers, torture—to comment on "the motives for actions announced as forthcoming." In other words, our future. Do you feel the draft?

Visual Problematics*

About thirteen years ago, antiwar activist Ron Wolin and I asked a number of artists we respected to design posters opposing the Vietnam war. The artists, many of whom were downright famous, took the idea seriously. But the results, while often decorative and/or clever, were disappointing. At the time I didn't understand why, or what we were demanding.

I've since realized it takes years to develop a formally effective way to express social outrage, and there are few models, since activist art isn't exactly taught in schools. You can't just drop in and make a good oppositional artwork, no matter how good you are. It's a highly specialized task, like the development of any other art form. And you've got to find time and energy for political organizing and education, because in this field, to be out of touch is to be out of steam.

Moreover, "political art" has never been defined and is still in its infant stages. Many still labor under the delusion that it is a creature of the Left, that establishmentarian neutrality is not "political." Others see no middleground between propaganda and prettifying. Now and then the artworld tolerance for "political art" expands a bit and topicality briefly becomes popular, because of pressures from the outside world. At the same time, alas, the term itself veers toward meaninglessness.

*Revised summary of three pieces in *The Village Voice*, 1982: "Icons of Need and Greed" (May 25), "A Small Slice of Whose Pie?" (June 8) and "How Cool Is the Freeze?" (June 15); published in *In These Times* as "The Outrage of the Artist," July 28–Aug. 10, 1982. Reprinted by permission of *The Village Voice* and *In These Times*.

I can recall two such periods—1968 and 1975—and now we seem to be into an-
other one. The time seems ripe to air a few related issues, to avoid divisiveness
and also to sharpen our analyses as we approach the inevitable peak of atten-
tion during the nuclear freeze campaign.

I have mixed feelings about this phenomenon. On the one hand, I'd like
(ideally) all artists to be socially responsible people, whatever their art is. I'd like
a healthy portion of them to be involved in both professional and grass-roots
productions that deal with specific issues and work directly with activist groups.
On that hand, I'm really happy to see more and more visual artists jumping on
the anti-Reagan and pro-disarmament bandwagon, because the support is always
great to have and I know from past experience that a few will stay with us for the
long haul, once the band stops playing.

On the other hand, it can be hard for those who have worked steadily for
years to watch newcomers (a few of them dilettantes and opportunists) get a
modest share of the too-small pie reserved for "political art," especially when the
newcomers' politics are naïve, nonexistent or even hostile to the Left. And on the
third hand, nobody wants to discourage anyone from joining up, so any such
dog-in-the-mangerism has to be scrutinized not only with guilt but also with
honesty and a certain pragmatism.

In the mid-'70s there was a tendency among progressive art groups to criti-
cize everyone who wasn't correcter than correct. Since nobody knew what that
was, everybody got criticized, severely limiting the possibility for any strong
theory or praxis to emerge before it got shot down. If you ventured into the art
world to educate and to make your alternatives visible, somebody would say
you'd been assimilated, ripped off or sold out. If you stayed in your studio and
worked because it had become important to prove that the Left had "quality"
too, that diverted your energies from collective work and somebody said you'd
opted out.

There has also been a tendency to cry Stalinist at anyone who has done their
homework and tried to develop a political analysis of their own. Then there's the
avant-garde anarchism that holds out for the "freedom" of art to be caring, but
disconnected from any structures formed with an eye to change.

There are also cries of careerism and cooptation, in which the most difficult
of our contradictions are exposed. One kind of cooptation is when you or your
work get used by the dominant culture differently than you had intended, or it
gets neutralized by the wrong context. But as Jerry Kearns has pointed out,
there's another kind of cooptation—when you censor yourself because of fear,
defeatism or rage, when you let go of the notions of beauty, scale, complexity and
visionary grandeur, when you get backed up against the copying machine forever.
It's not easy to figure out one's individual options between the extremes—total
immersion in the queasy ethics of the art commodity system or furious rejection
of all it stands for, which can lead to the wrong noses getting cut off to spite the
wrong faces.

As the disarmament movement swells and trembles, visual artists are mobilizing
in numbers unseen since the invasion of Cambodia sparked the intense, if short-
lived, Art Strike. Our image-makers—grass-roots and avant-garde—are once again
struggling to elevate slogans to symbols, to provide, literally, the banners beneath
which the people will march to doom or defiance. The present political situation,

with its demand for fast answers, is not only sending conscious artists into the streets, but into their studios as well, where they are taking a deeper look at their long-term needs and goals.

So it's a good time to consider distinctions between activist art and a progressive high art—that is, an art designed to participate directly in structural change and one that criticizes existing structures from more of a distance— always bearing in mind that the two are often made by the same artists for different contexts. With a little luck, all this activity will also defuse the terror many artworld artists have of being "used" by the Left, and reveal the ways orders from the Right somehow escape this onus.

I've seen a batch of "political" shows in the last month or two, some in unexpected places. When I expressed frustration with their unevenness, a friend pointed out that most of the high art we see in galleries represents a year's or several years' work. "Timely" shows, on the other hand, are reactive; they have to tackle one issue after another—a scattershot technique partially forced on us by previous invisibility and lack of support or communication.

This leaves little time to analyze and comprehend form and content when the content, at least, keeps changing. But the urgency also engenders a growing political consciousness and a spontaneous immediacy lacking in much "high art." Few progressive artists have been able to put all their energy into development of a formal vocabulary for political analysis, and fewer still have not frequently dropped their individual research to support this or that demo, issue or theme show. At the social core of the contradictions in progressive artists' work is the relationship between individual and collective artmaking. At the esthetic core is the relationship between form and politics.

Both in the galleries and in the streets, we are seeing a lot of skulls, bombs, missiles, suggestions for Raygun control, bloody dollar signs and TMI reactors, top hats and rags, peasants and generals, mutants and mushrooms, flames and fists. Extremes. I'm not making fun of these images. As emblems they can be used with force and directness, sometimes with subtlety and freshness. June 12—when almost a million people flooded New York to protest the nuclear buildup— proved that. What finally counts, though, is how deeply they reach, whether they are merely provocative or provoke thought and action as well.

The art on June 12 had three basic mandates: to make people terrified of nuclear war, *not* to make people feel helpless before their terror, and to help them understand its roots in domestic and foreign policy, or state terrorism. Clearly you can't reach out to a million people, no matter how brilliant your talents and good your intentions, unless you know what you think about the issues on a level more complex than basic ban-the-bomb black.

At "The Fate of the Art"—a recent Political Art Documentation/Distribution-sponsored evening of slides and discussion to evaluate the visual contributions to June 12—there were several passionate pleas for political clarity as well as esthetic integrity. The issue of words (any? how many?) in visual art came up, as it always does. For instance, one woman raised the interesting problem of cross-rhetoric, such as the parallels between the antiwar "Choose Life" and the antiabortion "Pro-Life" slogans.

If there's a plethora of extremes—of victims and enemies—in oppositional art, it's not the artists' fault. The art isn't going to go beyond the politics, just as on an individual basis it can't go beyond the artist's own politics. For this reason,

Juan Sanchez, *Viva Puerto Rico Libre,* 1982, oil and mixed media, 66″ x 52″. (Photo: Fred MacDarrah)

Peter Gourfain, *Chain Gang,* 1981, pen and ink, 22″ x 32½″.

the compromised notion of a nuclear freeze looks cool to artists whose liberalism turns reactionary when they perceive the strings attached—the vital cords of nonintervention, antiracism and -sexism, redirection of funds to social needs, and unilateral U.S. disarmament.

At one point during the June 12 evaluation, someone summed up the steps toward a strategic marriage of political clarity and imaginative form: Decide what image to make, where and how best to display it, and *why you made it.* The answer to this last part can't be simply, I wanted to participate, I had to express my outrage, I had a good idea, it sounded like a challenge, it was okay to visit but I wouldn't want to live there. Complex and effective activist art evolves, almost organically, from deep-seated political conviction, usually rooted in one's own life experience.

Take the work of Juan Sanchez, seen in May at the Intar Latin American Gallery. Sanchez' art is so much more effective than most not only because he is a damn good painter, but also because of his passionate and unconflicting commitment to the cause of Puerto Rican independence. He skillfully fuses experimental oil-painting techniques, which he uses as a frame or background with an inventive span of patterns, colors, images and words, with more urgent street mediums through his own photos. He integrates photographs, graffiti, slogans, collaged leaflets, a drawing by his mother, poetry, quotations from Puerto Rican culture heroes and activists (many of them women) and archaeological motifs from the Taino Indians. Each painting represents and communicates an entire culture as well as a directed outrage. I'm told that in the barrio, Sanchez' work has inspired and organized for years now. In the art world, it opens us up to new ways of seeing what surrounds us.

Like street demonstrations, "political art shows" sometimes seem primarily to reinforce the commitments of the artists and other converted participants. This is no small thing, much as we also pursue a broader effectiveness. Yet such shows also demonstrate that subjects like race, class, sex, militarism and unemployment can fit into the same art molds as any other subject. This fact in turn combats taboos but can be depressing, because we work in a context in which form dominates and content continues to be submerged. It is therefore exhilarating to find artists who are getting it all together, usually after long, hard work both in and out of both art and political domains.

A year ago, a friend showed me slides of a banner he'd photographed at an El Salvador demonstration. It was a fierce, brilliantly colored frieze of helmeted heads over a mass of smaller figures divided by a river of knifelike flames. He didn't know the artist's name. It turned out to be Peter Gourfain, whose abstract sculpture I'd admired since the mid-'60s. In May he had a show at the MOA Gallery in New York.

In the drawings and raucous clay reliefs shown there, and in the demo banners and big cartooned pots and monumental sculptures not seen there, Gourfain's dominant motif is a double frieze of wild-eyed "Romanesque" heads in profile, toothy mouths gaping open to swallow or to spew out grasping hands and various object-symbols—coins, nails, a fish, a wrench, pliers, paintbrushes. The impact of this iconography of need and greed is almost physiological. I felt a kind of visual gag reflex.

Gourfain's subject matter might be a ferocious impatience with what people do to each other. Grimacing with anxiety and anguish, unable to shut up, heads and legs imprisoned in chairs, or boating desperately on a sea of fire, his repeated figures make physical such social emotions as despair and anger about corruption or war, and the possible incompatibility of humanism and human beings.

A former Minimalist, Gourfain uses repetition and cross-reference, fertilized by a red-diaper baby's complex political consciousness, to produce an unexpected explosion of serial art. Rather than looking to specific issues and then trying to find a form in which to best express his opinions, he has found his form in the history of art itself. Romanesque relief, Celtic illumination, and the Coptic *élan* of Ethiopian "primitivism" are fused with a raw energy resembling the powerful alienation of a few New Wave artists.

I don't know if Gourfain calls himself a Marxist, but he is certainly a materialist in the grandest sense. His use of the Romanesque style reminds us how ancient the struggle is. His figures convey The People without resorting to proletarian clichés. They tug and haul at each other, upside down and rightside up, entwined in desperate contact, never at rest, humanity caught in serpentine human-made coils. Some seem to be giving and some taking away, some building and some betraying. Consumption competes with communication.

The gaunt, bearded figures (virtually all men and apparent self-portraits) talk in objects and body parts, suggesting the Celtic urge to transformation through hybrids of form and action. The determined oralism of Gourfain's imagery might be about the contemporary artist's hunger for the love, respect, dignity and power denied him in this society. Visual artists are not supposed to know how to talk—one way of keeping them in the infantile pattern of unfocused anger and dependence appropriate to the artworld playpen. Actually, not many people are given a voice in this word-riddled society, and what *is* said often resembles the crap pouring from the mouths of Gourfain's protagonists.

In his banners, in his monumental terra-cotta relief doors commemorating the Kent State murders, and in the giant *Roundabout*, a nine-foot by twenty-two-foot wooden tower depicting a whole history of political struggle . . . in all of these, Gourfain does what left artists are supposed to do. He makes our dissatisfaction tangible and urges us on to criticism and resistance. His subjects are often not explicit, and his iconography is often ambiguous. His art is straining at its bonds, trying to do what art can't do yet.

A silkscreen in the show—brasher than the drawings—does include words. It says "Much has been said. Now much must be done."

Out of Control: Australian Art on the Left*

On November 11, 1975, the Governor General of Australia—the Queen's commonwealth representative—dismissed the popularly elected Labor government of

*Reprinted by permission from *The Village Voice*, Oct. 19, 1982.

prime minister Gough Whitlam in what has since been described as a legal and an illegal parliamentary coup. Preceded by a CIA-instigated period of destabilization, resulting in a constitutional crisis comparable in some respects to what occurred in Chile between 1970 and 1973, this event was a watershed not only in Australian history but in Australian progressive art. It provides an implicit or explicit framework, particularly for those urban artists whose long-term goals reach beyond the art world.

Australian artists are obsessed with their national identity, and it offers a fascinating field of speculation for foreigners as well. I've just come back from two and one-half months spent mostly in Brisbane (capital of the neo-Fascist state of Queensland in the "deep north," ruled by a peanut-farming premier who specializes in handing over Aboriginal homelands to multinational mining interests). Because Australia is roughly the size of the United States, with a population the size of New York City's concentrated on the southeast coasts, it offers a visitor the illusion of political comprehensibility. The art world too is small and comfortably incestuous, which has obvious disadvantages, but also fosters a sense of community. There is a relaxed interaction between fine art and media activists impossible in the United States, where each "world" is so huge it's hard to keep up with both. Artists in Australia move often among the eight major cities, only three of which play major cultural roles (not including the artificial capital of Canberra, which has yet to develop a strong art community, though the recent opening of the new National Gallery may change that).

Since I was in Australia last, just before the 1975 coup, both artists and art world have "grown up" considerably. I got a sense of increased cultural and political confidence despite the rightwing government and recession that have undermined other aspects of the national ego. There are now two good new liberal art magazines—the more often progressive *Art Network* and the *October*-like *Art & Text,* published in Sydney and Melbourne respectively. With the annual *Lip* (a feminist journal of art and politics from Melbourne), the smaller *Art Link* (coming out of Adelaide), and *Art in Q* (a new publication in its birth throes in Brisbane), they are changing the tempo of communications among the state capitals.

The limited power of the limited art market, geographic isolation from the West and cultural isolation from Asia, resultant dependence on government support and the diminution of "cringe mentality" paranoia in the face of foreign art influences have all led Australian activists into some profound questioning of cross-cultural identities that eludes us New Yorkers in our frenetic and (for some) more immediately gratifying art scene. The current debate on regionalism, as Bernice Murphy has written, "generally involves not a psychological retreat within earlier confines of monocultural nationalism, but a more informed and complex consciousness of regional distinctness and cultural pluralism."

Australia is in fact becoming a curious cultural hybrid. Its components, in varying unequal parts, are: the rugged-individual Aussie, or at worst the "Ocker" in the macho pioneer tradition of beerswilling and "footie" (Rugby); British colonialism (the "Poms") divided by class, though nowhere near as visibly as in England; multinational Americanization and increasing Japanization, bitterly resented by many; recent immigrants from Asia, Europe and the Middle East, mostly postwar, which makes the "migrant problem" a generational one as well (many official signs are now in English, Italian, Greek and Japanese); and finally

the vast land itself, inextricably entwined with the 40,000-year-old "Dreamtime" of the remaining Aboriginal peoples, who now make up only 1 percent of the population.

Among the many contradictions inherent in this mixture is the way traditional Aboriginal knowledge and culture are paid such respectful lip service while the people themselves are universally shunned, degraded and economically enslaved. Innumerable places sacred to the native population are, alas, equally sacred to the desacralizers, since the central and northern deserts have the largest discovered uranium deposits in the world. At this very moment, in Brisbane, the Commonwealth Games are providing an international media showcase for the Black Protest Committee's exposure of these issues in the face of Queensland's notoriously brutal and corrupt police force.

Land rights and compensation to the Aboriginal owners when mining companies grab their sacred places are a major concern for artists, since native landscape is one of the focal issues of the regionalist debate. Coming from the fragmented United States situation, where similar events are obscured by so many other problems, I quite envy Australia's concentrated vortex, where colonialism, multinational control, Aboriginal liberation, antimilitarism and antinuke, unemployment and labor struggles against the highly automated mining industries all overlap. Perhaps because of this conjunction of issues, Australian artists on the left, "community artists," and "high" artists are often the same people. The level of red-baiting and polarization between "artworld" and "political artists" is minimal. Thus the paranoia that fuels much social artmaking in New York is aimed primarily at the opposition rather than focusing on intramural struggles.

In fact, there is no such thing as a "political artist" in Australia, in name anyway. Those anywhere on the left spectrum have assiduously avoided that obsolete label that plagues us here by ignoring the "political art" from the right posing as "neutral." Many Australian left intellectuals insist that the country has no avant garde either. However, Paul Taylor, editor of *Art & Text,* notes that the coordinates of an Australian art "concern our theories of the avant garde, the relationship between the categories of nature and culture . . . and the pervasive though unacknowledged influence of photographic representation."

It seems to me that the most impressive contributions to current progressive art, and not only in Australia, are those which provide not only a new image or even a new form language but delve down and move out into social life itself through long-term projects. These works tend to be intricately structural, the results of years of thought and labor—not autonomous series for exhibition, but ongoing sequences of learning, communication, integration and then learning from the responses of the chosen audience. Such works concern themselves with systems critically, from within, not just as commentaries. Such artists tend to be asked when they are going to "start some new work," because innovation in the international art world is understood as stylistic and *short-term,* geared to the market. Artists aren't supposed to go so far beneath the surface to provoke change, but are merely supposed to embellish, observe and reflect the sights, sites and systems of the status quo. (This is also a danger for much oppositional art today—that its necessary immediacy becomes reactive rather than radically alternative in the long run.)

Some Australian progressive artists have focused on strategic outreach into the public domain through an impressive body of murals and posters I can only mention here: Geoff Hogg in Melbourne with his delightfully decorative social history murals on all the buildings of the Turana Boys Home, a reform school in Melbourne, and his complex Building Laborers mural there; Michiel Dolk's and Merilyn Fairskye's ten striking "permanent billboards" (plus seven changing ones) on bridge pylons which document the often violent resistance to development in Sydney's working-class Wooloomooloo community; the witty and ruthless posters of the now-defunct Earthworks Collective and their union-oriented successor—Redback Graphics in Wollangong; and the independent productions of the master poster artists Toni Robertson and Chips Mackinolty.

Others have focused on strategic theoretical analysis in "scriptovisual" form or moved entirely into the real world, like Ian Burn, Ian Milliss and Leslie Pearson—"ex-conceptual artists" whose Union Media Service is ensconced in Sydney's Trades Hall, designing and publicizing a wide variety of union publications and campaigns. Still others interact with and against advertising, as B.U.G.A.U.P.'s (Billboards Utilizing Graffitists Against Unhealthy Productions) ongoing and hilarious program of altered billboards and a gay collective's appropriation and formal copyright of the Moral Majority trademark in Australia, on the eve of Jerry Falwell's visit.

All of these approaches specifically confront the uses and perceptions of mass, popular, folk or hobby culture, the issues of presentation and representation, production and reproduction that are at the core of social-change art all over the world. In Australia, crass commercialism in high as well as mass culture is totally equated with the United States. The special bitterness with which Australian artists regard our influence is a major factor in their examinations of their own cultural bases. It has become clear that a first step toward national independence, to which many would subscribe implicitly if not explicitly, would be to support local capitalism in the struggle against multinational control. The issue of sovereignty obviously poses specific tactical problems for socialist artists balancing "reform" and "revolution" from a realistic viewpoint.

On the one hand, Australian socialist art is historically invisible, dependent on institutions for visibility both locally and abroad. On the other hand, the weight of a repressive dominant history is not so embedded in this relatively young culture that the possibility of change seems out of reach. This generates a kind of optimism that contrasts with the situation of British activist artists who are trapped in a formalization of earlier Labor struggles and an increasing pessimism. Content is uppermost in many Australian artists' minds and their forms, if not "new" in terms of the international avant garde, are integrated with and specific to that content. The forms themselves "have politics." Realism is used as a tool rather than as a style, often in formally interesting ways; conceptual mediums are reversed back to their own origins in dialogue, away from the philosophical obscurities of the once-powerful Art & Language group. The "long-term" artists tend to avoid the parochialism of social art forms in the '30s and '40s because their own experience is rooted in the specifics of local environments and campaigns *and* placed within the general experience of a country struggling like so many others for freedom from cultural imperialism.

Peter Kennedy's project is titled *November Eleven* and consists, after four

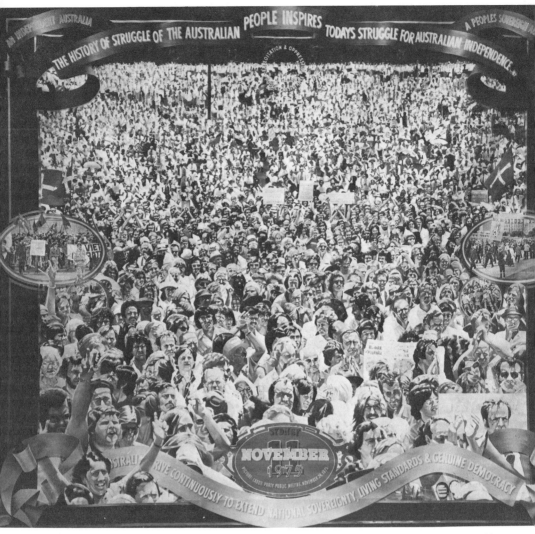

Peter Kennedy, *November Eleven,* 1980–81, painted and embroidered banner, 10′ x 9′.

years work, of two of a projected set of six ten-foot by nine-foot painted and embroidered banners and two videotapes made with John Hughes, studies for a collaborative feature film in progress. Apologizing for "how quaint this must sound," Kennedy says he wants his art to "have an influence on our destiny"—a position recalling that of exiled Salvadoran artists optimistically developing culture for an uncertain future. Kennedy's two completed banners depict massive rallies against the 1975 coup with the brilliant colors and ornate flourishes of their traditional trade union models. Each includes a field of hundreds of extraordinary realistic portraits in a brushy watercolor style that is both photographic and "impressionist" in effect.

These portraits might be said to be the community from which Kennedy works. In his search for an authentic expression of the popular historical expe-

rience, he spent several years in the early '70s making another "long-term" piece called *Introductions,* which consisted of watercolor portraits and video interviews with the members of four national "institutions": a Bushwalkers' Club, an Embroiderers' Guild, a Hot Rodders Club and a Marching Girls Club. Through this work he became aware of an unexpected social consciousness within each group, emanating from its own political concerns. For instance, the bushwalkers were worried about the Japanese woodchip industry that is decimating Australia's forests; the hot rodders had a clear perception of the effect of foreign car imports on local industry and labor.

However, Kennedy's role in *Introductions* was that of a mediator, and he was frustrated by the feeling that he lacked political control over his own work. With *November Eleven,* he resolved to present his *own* political attitudes. The banners represent, in a material sense, Australian history as well as art history— or rather the history of an art not included in the ahistorical art histories of the dominant culture. The banners represent a traditional popular art form and the videotapes a modern popular art form; the banners are static, the two videos are rapid-fire—one a very moving synopsis of the events around the coup; the other a witty montage of those events and an analysis of the Australian left. The banner form is declamatory by nature and allows for political forthrightness, where the tapes are more layered and complex, both experientially and intellectually. Together they combine populism and avant-gardism and become two different kinds of history book.

Since each banner takes about 1000 hours to complete, they are made for interior installation—the art context and occasional labor rallies. (Kennedy has made smaller, less elaborate banners for outdoor demos.) However, he feels that the content of both tapes and banners is so explicitly assertive that they cannot be contained or demonstrably altered by the crudest of institutional environments. Thus in a sense they coopt cooptation. *November Eleven* is intended as a wedge into the art context. There is nothing ambiguous about the intricate beauty of its banners nor the media blitz of its tapes. They can be read no way except that in which they are intended. At the moment Kennedy is working on the third banner, around the issue of land rights and multinational control, centered on a subtle alteration of certain talismanic Australian nineteenth-century history paintings.

Vivienne Binns' "softer" intervention into Australian history is concentrated in the personal realm. Though both she and Kennedy are highly respected in the art world and involved with the Community Arts Board, she works in the field. She describes herself as "a visual artist who has opted to work for the most part in community situations rather than in isolation in a studio, though I also do that. The contexts, the venues and the audience vary a great deal." Binns is "primarily interested in breaking down the distinction between the art of artists and art institutions on the one hand and the art expression of people in general on the other." Initially a painter who became involved in vitreous enameling and developed an industrial photo-silk-screening process in enamel, she is currently responsible as Community Artist for a staggering 60,000-square-mile territory in western central New South Wales.

Binns' art is particularly concerned with women's lives. Her preoccupation with Australian history is therefore similar to Kennedy's; the history of

women is also invisible, a microcosm in Australia of Australia's invisibility in the world. Her approach to the community attempts to undermine the Australian inferiority complex, as well as to develop simultaneously a sense of self-esteem and artistic skills for untrained people. Her best known work is a three-year project called *Mothers' Memories/Others' Memories (MMOM)*, executed with thirty-eight suburban women in Blacktown, N.S.W. It began when Binns and a friend had the idea of "swapping mums"—making duty calls on each others' mothers as a way of breaking out of the stereotyped and unsatisfactory mother-daughter relationship. Aware that while children's creativity is temporarily encouraged, adults learn to abandon it in favor of more practical pursuits and to leave art to the professionals, she is trying to reestablish the chain between creativity, expression, power and art in people's lives. ("If we are unable to express ourselves at all, we're likely to be either dead or catatonic.") *MMOM* included two rotating towerlike postcard stands with photoenameled cards drawn from the experiences of some of the women who participated in the exhibition.

Binns is a charismatic character, whether bursting into music-hall ditties at the drop of a hat, driving hundreds of miles through the wilderness in her red diesel truck, or enthusiastically sharing a cup of tea with elderly ladies at a "day care" home. I stayed for a few days in her Community Arts Committee trailer, parked in a noisy elementary-schoolyard in the country town of Lake Cargelligo. (In Australia the country really means the country; there are only some fifty towns in the 60,000-mile area where Binns works.) Watching her in action is in fact watching her in integration. Not too much seems to be going on, since she prefers to work through existing social forms—afternoon teas, sports events, fetes and other "understood gatherings." This is in addition to her art classes, mural project, crafts work on an Aboriginal reserve and float-making for a parade with an Aboriginal youth group.

Among the problems she has had to overcome while working into Australian history through people's lives is the sense of privacy around family conflict and touchy questions of sex and politics. The strategies devised by local women to protect themselves and their secrets, however, are precisely those used by professional artists: withdrawal, uncaptioned photographs, concentration on a single experience to exclude more sensitive material, indication of conflict only obliquely or ambiguously. In Lake Cargelligo we visited women in their farm homes as well as attending scheduled classes and local events. One such visit revealed the heart of Binns' long-term project far better than anything she could say.

Lila is the wife and active partner of a pig-farmer; she is also a painter and craftsperson, local social force, and mother. Looking at some 100 slides she had taken of her family, we learned not only an amazing amount of communal history but learned it through the eye of an artist. The conventional figures and scenes from Lila's life were framed and envisioned with an unerring formal accuracy that monumentalized a personal into an esthetic experience.

Binns is battling on two fronts. She is standing up for the individual's right to express herself and she is denying the generally false separation between art and work. In a paper given at the time of the "Arts and Working Life" conference in Sydney in 1981, she talked about her own experience in factories, developing her photoenamel process, about commercial art ("one place where art is integrated with work, when that means a paid job"), and about how the arts are seen as fe-

male and work as male. She is looking for a union of the two—"something that will transform the work experience and change the nature of art. . . . a situation where the creative ability and need for expression are recognized and allowed to operate in the work processes themselves, thus freeing the power of those engaged in work to shape and organize their lives according to their needs and abilities. . . . "

At the moment Binns is concocting ways to bring the breadth of shared experience she gets from her community work into the more coherent framework of her own art. Particularly interested in the relationship of lives to the environments in which they are lived, she is developing new work about landscape, community and history.

In Adelaide, South Australia, Ann Newmarch and the Prospect Mural Group also explore local and national history. Their black-and-white mural, *History of Australia,* subtly documents the colonial invasion and the decay of capitalism. A lateral motif of the Aboriginal rainbow snake as subterranean earth strata tunnels beneath the rising, then falling cities of white Australia and emerges in concert with symbols for feminism and Australian independence (the "Eureka Flag" of the Southern Cross, originated at a 1854 miners' rebellion in Victoria). Newmarch, a founding member of the group, whose photoscreen prints and posters are nationally known and shown, was community artist in residence in Prospect this year. With community arts officer Kathie Muir she has organized "Where We Are"—an exhibition of all kinds of art solicited from the neighborhood. It coincides with two related projects: schoolchildren making "one-off" books about their environment, and a book of recollections by Prospect's elder citizens. Here again "history" becomes an ongoing process including individuals' lives and coalescing into new views of national identity.

Newmarch's own prints are far more politically targeted, tackling the uranium issue as related to congenital birth defects and children's futures, militarism and war toys, entwined with images of her own two sons and baby daughter and of Australian independence from Americanization. (One of her most biting works shows the facades of Colonel Sanders, McDonald's, etc., laid over a ghostly backdrop of primal Australian landscape, ironically titled "Our Fathers Cleared the Bush, Boys.") Her hallmark is a fusion of unabashedly domestic emotion and an utterly unequivocal socialism. In her double book (for children and adults) *This Is the House that Peg Built,* she celebrates the life of her aunt who has eight children, twenty-three grandchildren and seven great-grandchildren; who at the age of thirty built a cement-block house in her spare time between a factory job and home duties; who in her late sixties is rebuilding another house and working as dressmaker, toymaker, electrician and carpenter. Along with this pioneer-type model the book also introduces an ideal of beauty for women differing rather broadly from that of mass culture.

I've run out of space and haven't talked about some of my favorite murals and posters, the Women's Art Movement, the national Artworkers' Union, or the immensely impressive group of social films I saw at the Sydney Filmmakers Co-Op. Not to mention the range of art being made within the trade union movement and the varied approaches to landscape and native flora and fauna. (Wild kangaroos really are visible at roadsides.) In any case, one of the most heartening

aspects of Australia for me was the realization of how broad a base the international progressive art movement is becoming, how well we can understand each other despite the conflicts set up by our various governments. My experiences in Australia were locally reinforced three weeks after I returned by the NAPNOC conference in Omaha, Nebraska, a meeting of some fifty committed veterans of grass-roots cultural groups from all over North America. NAPNOC stands for Neighborhood Arts Programs National Organizing Committee. [The name has since been changed to the Alliance for Cultural Democracy.] It represents around 200 groups and publishes *Cultural Democracy*—a pithy newsletter devoted to redefining United States cultural policy and engendering a national movement in which the political and emotional centrality of culture is acknowledged. As Arlene Goldbard and Don Adams (ACD's former staff *extraordinaire*) have written:

> The United States is a multicultural society with each person free to participate in many cultural forms and traditions; each person and each community has the right to culture; all cultures are entitled to coexist in freedom and equality; and government has no more right to favor one of these cultures above the other than it does to institute a state religion. . . . Cultural democracy means that cultural values should be open to debate—that the values of the big, established arts institutions shouldn't be swallowed whole.

Hotter Than July*

In June, when I quoted friends just returned from Nicaragua, I didn't know that within two weeks I'd be there myself. From July 12 to 20, I attended the interAmerican "Conference on Central America" in Managua, went to the fourth anniversary celebration in Leon of the Sandinist revolution, and traveled to Jalapa and Ocotal in the Honduran border war zone. There, a Stevie Wonder "Hotter than July" poster hanging in the army's Frontier Motel office ominously predicted a threatened August invasion by U.S.-backed "contras."

It was quite a week, intensified by the fact that when we arrived back in the Miami airport, newspapers carried reports of a fleet of warships headed for a possible "military quarantine" of Nicaragua, to protect other Central American countries from an epidemic of social justice (known in Pentagonese as "exporting revolution") and to exacerbate the already devastating effects of our economic blockade of this small, suffering, wartorn, bankrupt, beautiful and exhilarating country.

I've been back two days. Nothing's boiled down yet. The information and experience some 200 of us North Americans received in Nicaragua (firsthand, through reading, and through the conference lectures) were so much at odds with what's fed to us by the media here, it's difficult to register the fury and anguish many of us felt. How can I convey the concreteness of the Nicaraguan experience

*Reprinted by permission from *The Village Voice*, Aug. 9, 1983.

of courage and hardship, almost inconceivable from a distance, even from a sympathetic one? I know how corny all this will sound, but maybe our future depends in part on allowing such feelings to surface and to affect our actions. Nothing else seems to be working.

Having let that steam off, and because I can't indulge myself here in a synopsis of all I learned—three points, fast: (1) The Sandinist revolution is not perfect, nor is its perfection or lack thereof any of our business. It demands from the United States the simple right of sovereignty, of self-determination and defense within its own borders and the right to carry out its three basic principles: pluralism, a mixed economy and nonalignment. (2) The Sandinist revolution is not "communist" and did not emerge from the East-West struggle that so preoccupies Reagan, but is deeply rooted in local history and necessity. (3) It has achieved amazing things in its brief lifespan, among them the greatest improvements in this hemisphere, from mid-'70s to early '80s, of the "physical quality of life"—an index including life expectancy, infant mortality and literacy.

So what about art? If we accept the fact that art can't be isolated from its context, all of the above is about art. The conference itself was sponsored by the Sandinist Association of Cultural Workers (ASTC). Banners around town welcomed foreign "intellectuals." Most of those attending from North, Central and South America were not artists or scholars specifically (with a lot of exceptions, most notably Adrienne Rich and Julio Cortázar). Our goal was to strategize about affecting (or reversing) U.S. public opinion. As Comandante Bayardo Arce has written, "Revolutionaries can take economic power with relative ease, that is the material power of a society. But the most difficult task, that which takes much longer, is the taking of a society's ideological power—the intangible power expressed in the human mentality, in a society's mentality." From our very diverse viewpoints, this was applicable to most of our situations.

Personally, I was frustrated by the fact that time, conference logistics and my lousy Spanish drastically limited access to individual Nicaraguan artists. As a group, we got some good doses of culture ranging from two fine art shows, the murals, billboards, posters, stencils and graffiti in the streets, to dance, music and the most marvelous circus I've ever seen (circus arts are uniquely included in the ASTC's roster of cultural categories). But the photographers I wanted to interview in depth—Margarita Montealegre, with whom I spent a tantalizing three minutes in a Chinese restaurant, and Claudia Gordillo, whose tough and sensitive pictures of peasants and troops moving out of the Costa Rican border I particularly liked—were, respectively, on assignment for the newspaper *Barricada* and out of the country. I talked too briefly with some of the older painters from the ASTC and with Margaret Randall, who is a photographer as well as a poet and chronicler *extraordinaire* of the revolution (her book *Sandino's Daughters* brings the Sandinist experience to life like nothing else I've read).

The major Sandinist cultural principle is that revolutionary art can come only from revolutionary *experience*, and that it need not reflect that experience superficially if it has absorbed it profoundly: "When we talk about revolutionary art we are not talking about pamphlets—the clenched fist or the raised gun. We are talking about art of quality, which expresses insights into the reality of life" (Rosario Murillo, director of the ASTC).

The two spokespeople who have most clearly illuminated the role of culture in the new Nicaragua are Murillo and Junta member Sergio Ramirez. Both are

young and are poets (so are most of the members of the government). Both are virtually *pregnant* with the notion of the new forms that will emerge from art "created by artists who make rather than just observe the revolution." Ramirez noted that these new forms being released from historical restraints would open up changes of language and of conduct, in a new sense of the possibilities of *mutual* creativity between artist and "audience." They are to be produced not only by "the rich talent of individual creators with their own profiles," but also in the Popular Culture Centers by the hitherto silenced majority.

Though advocating the repossession of indigenous culture and resources and, simultaneously, broadening the definition of culture to include the mass diffusion of ideas, Ramirez is wise enough to acknowledge that so far "the process is too young to have created a single model, which cannot yet be stated or prescribed." He is on dangerous ground, however, when he suggests that the banished right "generally consisted of the bad writers and the bad artists"—not the same assumption as Murillo's "bad art is bad for the revolution." Less arguable is Arce's assertion that "We oppose the tasteless poetry that merely mixes up words in order to sound pretty'" and at the same time are aware of "the trap that in order to make revolutionary painting, we must paint *compañeros* in green with rifles in hand, or barefoot children in the *barrios*."

Of course the "new forms" that are developing may not be those we North Americans would prefer. The work we saw in the two Managua exhibitions was competent and occasionally excellent, but hardly innovative by SoHo standards. It is made to reinforce common ideals rather than to satisfy a (nonexistent) market. The most impressive painting, or assemblage, I saw was by Efren Medina, who is in his early twenties; it successfully combined an earthy Cubist/Mexican muralist style with deep, strong color and relief provided by a real cartridge belt. For the most part, the fine art was inseparable from other Latin American abstraction and figuration. There was no "conceptual art," but it does seem that photography has more potential for developing those "new forms"—perhaps paradoxically because its own form is more or less settled, limited to black and white rectangles of a certain size (by limited access to materials), leaving innovation to happen in the intersection between image and experience.

As Jack Levine, a photographer with our group, reflected, all artmaking is potentially an organizing process since good art is that which connects the artist's experience to the experiences of others. (I learned this from Suzanne Lacy, who has consistently put this idea into practice). For better or worse, contemporary Nicaraguan art has been nurtured by the experience of war. Where Somoza once said, "I don't want educated people, I want oxen," the FSLN armed their people with freedom of expression as well as with guns. *"No Pasaran!* All arms to the People! One single army!"* are the most popular slogans, and it follows that "Culture is the Artistic Gun of the Revolution!"

In the late '70s, the arts were incorporated into the struggle. "We learned to fight in the trenches," they say, "and we learned to dance in the trenches." The underground Praxis Movement was an arm of the FSLN. Poetry, songs and theater were particularly effective organizing tools. The idea was not to hand out culture like charity, but to learn from the peasant and soldier audiences and to reflect their ideas back into the art and out to others. When Somoza's Guard read workers' poems on the walls, they realized how dangerous culture could be. Near the

Jack Levine, *Ocotal, Nicaragua,* 198.

end of the armed insurrection, Radio Sandino broadcast popular songs from which people learned, for instance, how to take a rifle apart.

For a brief period after 1979, Sandinist cultural workers' major concern was how to maintain the momentum and unity forged within the war years, how to replace anti-Somoza politics with something constructive, but equally impassioned. Now, alas, they find themselves again in a state of war and emergency. The focus on counterrevolution has returned as cultural brigades are sent to the front—not to "raise morale" (Bob Hopeless), but to live with the soldiers and *campesinos* and to transmit their experiences to the rest of the country. In Ocotal, we saw a young woman playing the guitar to an audience of children and chickens; and we saw a truckload of young soldiers leaving for the front, but they weren't troops, they were a theatrical troupe. In one forty-day period, a total of 226 artists were mobilized and performed 280 times.

The ASTC (made up of artists who are both talented and militant—one without the other is ineligible) hopes that a great cultural mobilization of artists "creative in the struggle" will revolutionize, so to speak, Nicaragua's slogans and images, and broaden communication with the general population. There's a ways to go. The popular poster symbol of the four-year-old Revolution is *La Charela*—a plump, simpering cartoon of a little girl. The imagery is unfortunate, but the image is accurate. This is a very young revolution, won by "the kids," led by thirty-year-olds, for a population that is 70 percent under twenty-one. Many of the criticisms leveled at it are not only unfair, but premature. After all, as Secretary of State Shultz said the other day, "the evolution of a democracy is a long and difficult process, especially when there are concerted efforts to defeat it." He said this in support of aid to El Salvador, but it's still truer of Nicaragua. The Sandinists are preparing the seven political parties that participate in the government for an election in 1985—"if we are left alone." They note it was much longer after the American Revolution before general elections were held.

Cultural workers in Nicaragua are genuinely expected to provide the vision for the future, along with everyone else. Their vital sense of the *necessity of art* is unexpected for even those who, like me, insist that art is powerful. As we in the United States try to build an authentic oppositional culture that can still interact with and affect the dominant culture, the Nicaraguans have the task of building a truly *independent* visual culture. They haven't gotten there yet in terms of actual production, but the goals are intelligent and precise, the process is underway and I'm crossing my fingers for them, and for us, in every sense.

VI

COLLABORATE! DEMONSTRATE! ORGANIZE! RESIST!

Prefatory Note

I have always liked writing about art because it takes place in that abyss between verbal and visual that can never really be filled. If I'd been younger I'd probably have gone into film, but there were no film courses when I was in school and I didn't know independent film-makers existed. I describe photographs and use actual photographs in my fiction. I love graphic design, and by 1979 I was old and relaxed enough to do whatever I liked, so I finally started to make amateur comic strips, after talking about it for years. (My credentials consist only of studio art courses in college, where I also made and sold comic greeting cards and romantic woodcuts.) Comics were a way to find out exactly what I meant by saying it directly, with no qualifiers and references and verbal frills. In the last few years I've occasionally illustrated my own articles and made posters and page art alone and collaboratively.

As far as I'm concerned, all this does not make me an artist any more than an artist who publishes occasional articles becomes a writer. I can't take my visual efforts too seriously and I make no claims for the drawings, but I do enjoy doing them. I'd do more if I had more time. Time, and priorities, are finally what limit my work in the no-one's land between writing and art.

Since 1977, collaboration has become an important part of my life. Since Winter 1980 I have also worked in a steady partnership with artist/activist Jerry Kearns, on a series of installation/exhibitions, posters, forums, writings and slide performances, and as a consultant to the art gallery at District 1199 through the national hospital union's famous Bread and Roses program. Contrary to my conditioned expectations, collaboration makes my individual work move more rapidly, fueled by dialogue and expanded by ideas I wouldn't have thought of alone, but can develop on my own and apply to my own preoccupations. I like the feedback and experimental testing that goes on within a collaboration, and

Lucy the Lip, "Above It All and Below It All (2) with Polly Tickle," from four-page comix published in *Images and Issues.* Winter 1980–81.

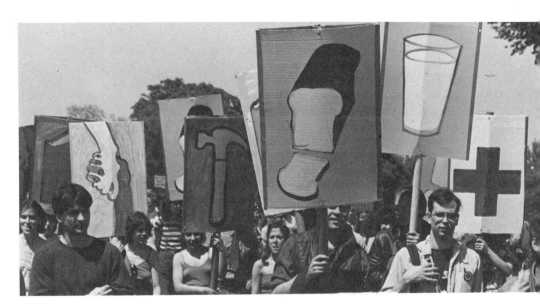

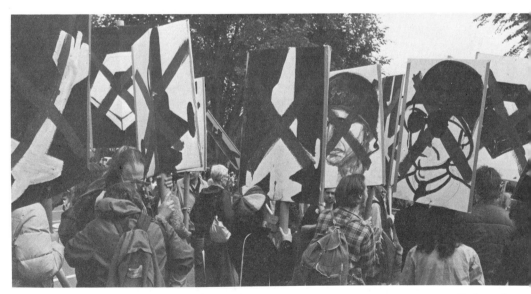

Political Art Documentation/Distribution (PADD), "Image War on the Pentagon," placards carried in Washington, D.C., demonstration against U.S. intervention in El Salvador, May 1981; images on the fronts were brilliantly colored "good things" being cut back or cut off by the Reagan administration, such as a glass of milk for school lunches, a loaf of bread for food stamps, a maple leaf for ecological destruction, a hammer for workers' rights, etc.; on the backs were black-and-white military images X-ed out in red. PADD members carried these in various combinations as an image-only performance piece during the march and the rally.

the support it lends to risky or vulnerable ideas. Politically it's important, because if we can't work with each other, how can we exchange with and extend our audiences? How can we communicate our own personal and political passions and support those of our friends and comrades? This is where Political Art Documentation/Distribution comes in, and the work of the activist artists with which this book ends, but with whom the organizing just begins.

*PADD is a progressive artists' resource and networking organization coming out of and into New York City. Our goal is to provide artists with an organized relationship to society and to demonstrate the political effectiveness of image making. We have an international Archive of socially concerned art, sponsor monthly public forums around art and specific political issues. We publish a monthly listing of left cultural events (*Red Letter Days*) and a more-or-less quarterly publication (*Upfront*). We sponsor public projects (like "Not for Sale," about gentrification on the Lower East Side, and "Death and Taxes," about the military buildup) and make demonstration art as well as analyze cultural organizing. In 1981 we sponsored "The February 26th Movement," a two-day national conference held at the headquarters of District 1199 in New York. PADD hopes eventually to build an international grass-roots network of artist activists who will support with their imaginations, their talents, their convictions and their political energies the liberation and self-determination of all disenfranchised people.* (From the PADD statement of purpose.)

Cashing in a Wolf Ticket*
with Jerry Kearns

Early in 1980, articles began to appear in the press announcing a new Paul Newman police movie to be shot in the South Bronx. It was about the notorious Forty-first Precinct—nicknamed "Fort Apache" (after the 1948 John Wayne movie) by the cops, who also saw themselves as a "thin blue line" between civilization and savage territory. (Since then the almost total demolition of this part of the South Bronx has led to the precinct's new nickname: "The Little House on the Prairie.") Community activists, forced to contrast the harsh realities of living in the Forty-first with the media's persistently sensationalist image of it as a symbol of urban blight and voluntary decay, began almost immediately to organize against the filming. They formed the Committee Against Fort Apache (CAFA), which eventually grew into a citywide coalition of some 100 organizations. The very day in March 1980 that they first met with the film's representatives—to be told their fears were unjustified and the movie was neither racist nor destructive, but "a tender love story"—they saw an ad in *Variety* describing *Fort Apache: The*

*Reprinted by permission from *Artforum* (Oct. 1981). Copyright © 1981 by *Artforum*. This article was accompanied by a five-page visual piece on *Fort Apache: The Bronx,* also a collaboration with Jerry Kearns. Designed for a square format, it is impossible to reproduce here as the "page art" it is. A few sentences omitted in *Artforum* have been restored in this version.

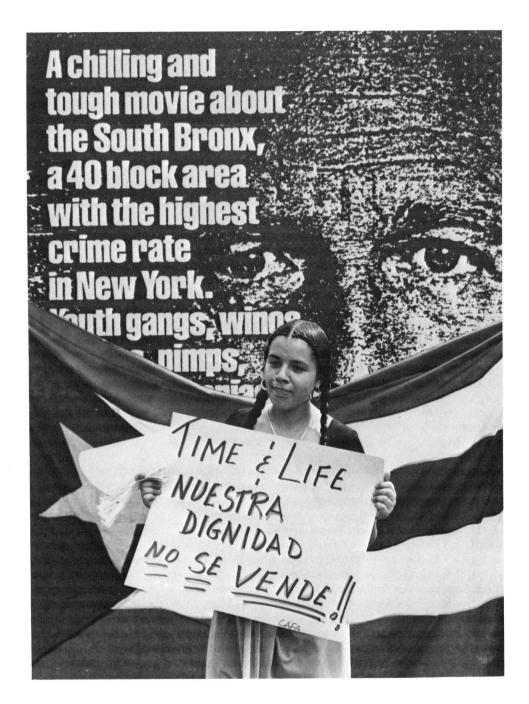

Jerry Kearns and Lucy R. Lippard, collage from "Cashing in a Wolf Ticket," 1981. The original work was five pages of combined visuals and writing; the image here is a much-condensed version for this book made from elements of the original.

Bronx as "A chilling and tough movie about the South Bronx, a 40 block area with the highest crime rate in New York. Youth gangs, winos, junkies, pimps, hookers, maniacs, cop killers and the embattled 41st Precinct, just hanging in there."

Among the members of CAFA were several artists. After all, such films provide an ideal target for analysis and sociocultural activism. CAFA was acting within a history of such protests against racist media going back to the "Greaser" films of the early 1900s and including *Girl of the Rio* of 1932—so prejudiced that it was the subject of international treaties. In the last few years a number of organizations have been formed to combat racist, sexist and homophobic films like *Cruising, Windows, Dressed to Kill, Charlie Chan,* and *Fu Manchu,* TV shows like *Beulahland,* and plays like *Lolita.* The convergence of art and activism around the issue of media exploitation has roots both in and out of the art world. For a decade now, fine artists have been confronting issues of representation and pictorial "truth" in photography, video, and public performance by analyzing the flow of information to which we are all subject. To name just a few: Leslie Labowitz, Suzanne Lacy, Martha Rosler, Allan Sekula, Jo Spence, Victor Burgin, Sarah Charlesworth, Barbara Kruger, Margia Kramer, Hans Haacke; and, more recently, Vanalyne Green, Doug Kahn, Lyn Hughes, Barbara Margolies, Micki McGee, and Mary Linn Hughes. In the process of developing oppositional strategies, they have arrived at positions that parallel those of academic theoreticians and of grass-roots activists beginning to realize how central culture is to social control.

Such artists and activists tend to be around the same age, or at least to have been formed by the '60s antiestablishment mood; their training grounds were the counterculture and the antiwar, racial liberation, and women's movements. These artists learned then that *all* images affect how we see, that how we see affects how we act. Despite a diet of movies and TV, they developed a critical consciousness of what they were being fed, of the connection between real and reel life. Like most people in America they distrust the media's "realisms," but unlike most people they are also aware of how shrewdly and subtly manipulated we are. Antonio Gramsci's concept of hegemony (summarized here by Todd Gitlin) illuminates the structure of that manipulation:

Hegemony is a ruling class's (or alliance's) domination of subordinate classes and groups through the elaboration and penetration of ideology (ideas and assumptions) into their common sense and everyday practice; it is the systematic (but not necessarily or even usually deliberate) engineering of mass consent to the established order. No hard and fast line can be drawn between the mechanisms of hegemony and the mechanisms of coercion, just as the force of coercion over the dominated both presupposes and reinforces elements of hegemony. In any given society, hegemony and coercion are interwoven. (*The Whole World is Watching,* Berkeley, University of California Press, 1980, p.253).

The people who formed CAFA did not just "pick a cause" as some liberal artists might pick a controversial theme. They saw *Fort Apache,* like virtually all Hollywood films about Latinos, defining mainstream culture by exploiting for profit yet another distortion of their lives. This movie was to be made in their own community, in an atmosphere of growing frustration, and at a time when the neighborhood was fighting for its life. Opposition to *Fort Apache* dovetailed

with current organizing activities; since 1977, Hispanic and Black activists in New York City have focused on the increased incidents of police brutality in their communities. Municipal neglect, redlining by the banks, arson by land-lords, planned shrinkage, and gentrification had also been opposed for years, with little or no positive attention from the press or city officials. Now the com-munity groups saw responsibility for the conditions in the South Bronx being laid yet again on the "savages"—on the street victims of the real villains.

Meanwhile the film-makers publicly congratulated themselves on bringing money into the community and on hiring nonunion extras. At one point they asked schoolgirls to try out for prostitutes' roles and "to dress nice and sexy"; this request was scotched by irate parents. At another point, the CAFA leadership was approached by an intermediary saying he knew that the film-makers would be willing to set up a writers' workshop in the community. CAFA turned the offer down, but a representative of the mayor's office, pushing for film indus-try money, still accused the demonstrators of "extortion" (*Village Voice,* April 7, 1981), and rumors continued to circulate in the South Bronx that CAFA was on the film payroll. This sentiment was later echoed by a self-righteous Paul New-man, who said of the demonstrators "In the final analysis, *they're* the whores" (*Los Angeles Times,* February 1, 1981).

Another of the film company's charitable acts, widely reported in the press, occurred downtown at the State Supreme Courthouse where attorney William Kunstler was presenting the case for an injunction against making the film. CAFA was outside mounting a support demonstration. About fifty Black and Puerto Rican teenagers from the South Bronx appeared and began a counterdemon-stration. Soon afterward, the film's publicist, Bobby Zarem, also press agent for the Governor's Office of Motion Picture and Television Development, stepped out of a taxi and the teenagers shouted, "There's the guy with the money!" and began running in Zarem's direction. He fled, and a wild chase began through the rotunda of the courthouse and back down the steps. Zarem made his escape in a taxi while several police officers held the angry youths back. The students then joined the CAFA demonstration and two of them later signed affidavits that they had been offered payment by the film-makers to come down and to picket against CAFA. They had been given signs to carry; one of them read, "Don't Mix Our People's Progress with Communist Political Advancement"—which all too neatly tied in with the image of community groups in the film itself. (An asso-ciate of Zarem's was later reported to say that neither she nor he knew about any money being promised.)

We'll skip over the rest of these philanthropic episodes to the punch line: On May 29, 1981, the *New York Post* reported that two former Forty-first Precinct cops, who had been advisers and bodyguards on the *Fort Apache* film crew, were ar-rested as part of a multi-million-dollar narcotics smuggling operation. One of these same policemen had told CAFA's Richie Perez on "Midday Live" that he shouldn't waste his time on movies, but should be up in the South Bronx fighting the drug problem.

For those of you who haven't seen the film, don't understand the commu-nity's rage, or feel that screen portrayals are inconsequential, it might help sim-ply to list several characters from the South Bronx community as portrayed in *Fort Apache,* in order of appearance:

- Pam Grier as a spaced-out Black whore/homicidal maniac who shoots two cops point-blank in the movie's opening scene.
- Young Puerto Rican and Black street jackals who creep out of abandoned buildings to rob the corpses.
- A suicidal Puerto Rican transvestite.
- A knife-wielding Puerto Rican psycho.
- Grier again, slashing the throat of a white pickup with a razor held in her teeth.
- A pregnant Puerto Rican girl who has been wearing a coat indoors all winter to fool her family; when she's in labor, no one knows what's wrong and only the white cop can save the day.
- Two Puerto Rican dope pushers who eventually murder the Puerto Rican "heroine"—a nurse who's also a junkie.
- Grier again, razor in teeth again.

And so it goes . . . there were no positive portrayals of Blacks and Puerto Ricans. "And what are the possible effects of such a simplistic and one-sided version?" asked Joy Gould Boyum in the *Wall Street Journal* (February 6, 1981). "Only and sadly, I suspect, the hardening of preconceived notions and reinforcement of prejudice."

A medium that breeds national fascination with an apparently random or psychotic violence, while ignoring its systematic class roots, has deadly effects on American life. For example, the *Taxi Driver*/Jodie Foster connection in the Reagan assassination attempt; or an item in the *New York Post* (June 2, 1981) describing how a young mother, two days after seeing *The Exorcist* on CBS, cut her daughter's heart out "because she believed the girl was possessed by a demon." Or the fact that Bill Wilkinson, Imperial Wizard of the Ku Klux Klan, "couldn't even get on TV programs like the *Today* show, and the *Tomorrow* show before he started predicting that there's going to be a race war soon. Now he's doing national television shows all the time" (as reported by Dean Calbreath, "Kovering the Klan," *Columbia Journalism Review*, March–April, 1981).

Racism and misogyny also exist in the high-art world, usually taking relatively subtle forms through exclusion or ambiguity. In the last two years they have escalated to a new violence. For instance, we have seen a racist slur used as an exhibition title and a beautifully executed photorealist canvas of a work-clothed man murdering a middle-class woman. (These recall an earlier photography book of "murdered" nudes accompanied by a do-it-yourself kit.) Such works, whatever their pretenses, don't analyze the role of violence but perpetuate and even reinforce it in the name of Art—where anything goes. The self-inflicted violence of early '70s body art has given way to artists attacking the bodies of others—specifically those of women and racial minorities. (A California "artist" has done a "performance" about having sex with a dead woman.) These artists are reflecting an alienated and disenfranchised world view, taking their cues from the reactionary mood of the circles that patronize them. A similarly deluded motive led Paul Newman and producer David Susskind to glorify images of decay and violence in the name of altruistic "realism," and to proclaim their own good intentions in making a film like *Fort Apache: The Bronx*.

Culture in the United States, where social control is largely maintained through the control of information, is on a sliding scale of form-and-content half-

lives that range from the dominant mass and high cultures, through numerous ethnic and racial cultures of differing class origins, to counter and oppositional cultures. Left, liberal, conservative, and far-right ideologies vie for attention and control of the various elements. The artist-as-social-advocate tries to transpose, juxtapose, and superimpose these half-lives and to develop a whole or synthesizing art form. For instance, covering the struggle around *Fort Apache: The Bronx* in this magazine is a way to show the interfaces between oppressed peoples (the Puerto Ricans and Blacks represented by CAFA) and ruling-class control of mass culture (the film industry) and high culture *(Artforum)*.

The relationship of current activist art to mass culture is not that of previous art movements, which have mined pop culture for subject or style. Dada, for instance, *incorporated* unchanged fragments from advertisements and other "found" material to gain humor and harshness. Pop Art *elevated* images from mass culture to high culture (elevated in scale and medium, as well as in status). Punk and New Wave often *imitate* the style and uprooted content of the sleazier fringes of the mass media. These processes remain, for the most part, unaffected by criticism or commentary, reinforcing the profitable exchange between mass and high culture—between culture as commodity for the many and culture as commodity for the few.

Today's activist artists are not interested in "raising low culture to high fashion" (camp) nor in "bringing high culture down to the masses" (charity). There is more to American culture than the homogenous cover-up of class conflicts that prevails today, for all the talk of pluralism and new waves, good and bad taste. These artists are trying to restore a heterogeneous viewpoint that recognizes and builds from the contradictions of its multiple base. Ideally, such a cross-culture would be part of our lives through participation and exchange, and could hardly be so easily controlled as most of the arts are now. Culture made in the heart of a social movement takes a different course from that made in the self-reflective aura of studio production. The first phase of an activist art occurs in collaboration with the people whose cause gives it reason to exist. This is the phase the art world finds hard to see as "art" because it is different from the propaganda by which we are surrounded (which is not called propaganda at all simply because it does surround us).

The stage was set for the development of an activist art in the '60s, when the fine artists looking to their own backyards began to evolve new vehicles for increased participation in the general culture. First Pop and Minimal artists rejected the "hand-of-the-artist syndrome," the personal touch and genius, the craft and relationism perhaps unfairly associated then with Europe. They sent their art out to be "fabricated" (executed by industrial workers) and some called themselves *artworkers* in a gesture of identification with the working class. They made forms that were generated by systems in an effort to reject the pretentiousness associated with artistic "inspiration." Yet both Pop and Minimal artists, perhaps unwittingly, continued to propagate the brand-name "single image" which was at the core of the New York School they were reacting against.

The next wave of artists (sometimes the same people) responded with the "multiple image," which, like television, speeded everything up and emphasized process over end product. This was the so-called TV generation coming of age, bringing with it an often uncritical gluttony for information. Most art students in the '60s learned about art from "audiovisuals" or reproductions of New York

art, so that printed pictures often seemed more authentic than the real thing. The seamless flow of television, with its blurring of first- and second-hand experience, promoted the homogenization of American culture. The loss of regional accents and local news programming on radio and TV was paralleled by the fast and frozen food franchises replacing the corner diner and home cooking. Communal influence was replaced by someone else's unverifiably "universal" fantasies. The gold of ethnic distinctions was tossed into the melting pot to produce one "happy," sometimes multicolored, Father-Knows-Best alloy—less durable, more interchangeable with everything else.

High art's embrace of the styles and methods of the media also paralleled a major transition in the U.S. economic base, when the manufacture of communications technology began to supplant heavy industry. This shift was immediately reflected in a rapid increase in consumption of these new technologies and a deluge of new "necessities" for Good Living. The media industry's values and products flooded the art world as they did every distant farmhouse, bringing with them an insatiable hunger for merchandise, as disinformation became indistinguishable from fact or entertainment, paving the way for today's "docudramas."

Some artists rebelled. "The world is full of objects, more or less interesting," wrote Douglas Huebler in 1969. "I do not wish to add any more" (in the catalog of "January 5-31, 1969," organized by Seth Siegelaub). But the Conceptualists' "dematerialization" strategy also played into the hands of the artworld branch of homogenizers who swiftly coopted just the right number (a "limited edition") of snapshots, Xerox sheets, empty rooms, and systems analyses. With little effort these too were transformed into decor for the steel-and-stone, black-leather-and-bulletproof-glass environments of the corporate world. Book art, video, performance, and Conceptualism all constituted a brave but finally unsuccessful attempt to open up new and more democratic options. These initial steps failed because of an idealized, politically naïve view of the needs of the much-sought-after "broader audience." New forms lacking new and more communicative content were not enough.

Yet despite the ease with which high culture's official avant garde was commodified, the art world did not go unaffected by the sense of great energy and possibilities for genuine progressive change that flourished in the political unrest of the late '60s. A whole nation was questioning its institutions, and artists too began to scrutinize the structures within which their art was made, seen and used. The Art Workers' Coalition was founded in early 1969 and spent its brief but raucous life scaring the institutions to an unexpected extent, giving artists a lot of insights into systems previously considered none of their business. Taking cues from the counterculture, artists also founded their own small presses, spaces, magazines, did streetworks, video productions, mail art, and isolated works in newspapers, TV and radio. By the early '70s, a critical consciousness of the media's social and exploitative functions was developing in the United States. Antonio Gramsci's theory of hegemony, Walter Benjamin's seminal essay "Art in the Age of Mechanical Reproduction," Herbert Marcuse, John Berger, Hans Magnus Enzenberger, and others were being absorbed into American leftist media theory.

But at the same time that artists were optimistically opening things up, the state began closing it all down. The network media helped create the conditions for repression by hyping a few "media revolutionaries" and isolating leadership

from the dissident masses. They covered bombings and senseless violence and conspiracy trials with great gusto. The message was "These are crazies and the war is over anyway, so go home and relax." The decade of intense struggle had led to a cumulative burnout. In the art world, the energy for change was blocked by withdrawal of economic and social bases for artists who had begun to look critically at their contexts. Some of the better-known dissident artists were accepted into the mainstream, leaving the more obstreperous and unsalable with a weakened support system and fewer options. (The exception was those women artists who were working with the rising momentum of feminism.)

Intensity of involvement was replaced with cooled-out cynicism and the objective stare. Analysis and self-criticism gave way to blandly decorative propaganda for the status quo. Photorealism offered pictures right off the TV screen, where white men fantasized all the shiny toys the American dream could drum up for them and the world was free of uppity women, free-speech students and troublesome Blacks. Vestiges of social commentary were weeded out as contact with progressive ideas diminished. This trend toward meaningless formalization was often called *distancing*—a perversion of the Brechtian concept.

The situation was mirrored in the schools. As the professional art world retreated to more conservative forms and messages, the word got through to the colleges. As a result, the more radical and adventurous graduates were effectively denied the teaching option and cut off from influence over the apolitical generation that followed them. The system worked, as the educational sphere hired teachers in response to the commercial sphere. Combined with budget cuts, this retrenching process also shut the door on the development of media alternatives, especially video, within university art programs. With few exceptions, media programs were forced to develop separately from the area of "fine arts," cutting off art students from more integrated and radical concepts. Those who persisted with "dematerialized" media and socialized content found the art world indifferent at best, and often hostile. High-art video was isolated in the commercial art galleries, where it proved hard to see and hard to sell. Some disillusioned young artists left the art world altogether, turning to the grass-roots political movements that were regrouping throughout the laid-back 1970s.

By 1980 a group of artists/activists had emerged from around the periphery of the art world. They were armed with a more coherent political education than the previous generation and now they began to work collectively, in defiance of the "me decade," to make an art that challenged the increasing attacks on 1960s social legislation.

CAFA organized in an atmosphere of emergency. *Fort Apache: The Bronx* is one example of the generally reactionary trend in contemporary mass culture. Across the country Puerto Rican and Black people were understandably outraged. We all should be. But our reactions must extend beyond sympathy for the people of the South Bronx to empathy. Racially motivated and murderous attacks on Black and Latino people are the handwriting on the wall for all of us.

CAFA's organizers were in the unfortunate position of being Puerto Rican and Black, and therefore among the first targets of right-wing attack. But if we think we're safe in our own little cultural nest, we're grasping at straws. The ramifications of the current political situation are multiple. Increasing private-sector control over the arts and increased violations of civil rights, increased Ku Klux Klan and Nazi activity, increased murders of people of color by civilians and police are

all parts of the same syndrome. The present degree of repression for most of us is obviously not so severe, but there's no reason to wait till it gets that bad. "The time to resist is now," said Victor Navasky, editor of *The Nation* and author of *Naming Names,* speaking at the "No More Witch Hunts" event on June 19, 1981 (part of a nationwide cultural/political campaign where over 1,000 people gathered in New York City alone). He traced the stages of repression from the House Un-American Activities Committee in the '50s to the illegal Cointelpro in the '60s to the phase we face now: "the attempt to make legitimate that which was previously illegitimate, to do overground that which the FBI has done underground."

"One of the problems is the intense ratings race between the networks. Sex and violence are used to generate high ratings," says Arnie Semsky, a senior vice president of Batten, Barton, Durstine & Osborne, Inc. (*The New York Times,* June 17, 1981). Mr. Semsky's "problem" is really a momentary bind; they'll solve it. His industry has made billions for itself and its advertisers by first fueling then exploiting our appetites for sex and violence. Everything's been just fine, but . . . uh, oh . . . wait a minute . . . now a Moral Majority group called the Coalition for Better Television has been organizing an intensive pressure campaign that threatens to boycott sponsors of those shows it deems "offensive." Corporate heads, being bright fellows, have been quick to see the fundamental *rightness* of the call for media uplift. Nothing like the fear of God to cleanse the land and shape up the flock, especially if he sells more soap in the process. Procter & Gamble, for instance, has already seen the light clearly enough to withdraw sponsorship this year from fifty network programs that did not meet the company's "program guidelines." And on June 1, 1981, a five-day-a-week religious soap opera, "Another Life," debuted on sixty-three stations around the country. The producer, employing only nonunion actors and staff, is the Continental Broadcasting Network, headed by Reverend Pat Robertson of the "700 Club." According to them, the difference between "Another Life" and major network soaps is that the new serial will have an underlying religious theme and "present positive answers to moral perplexities" (*The New York Times,* May 31, 1981).

As we write this, the whole United States consciousness industry is entering a period of conflict. A major battle is developing over the control of ideas, the framing of what's thinkable and sayable, what's legitimate social behavior. For the same reason Joe McCarthy went to Hollywood in the '50s, the New Right is there today. Their attack on television is an attention grabber; fake a left and run to the right. It's part of a strategy to destroy the legacy of '60s legislation and establish the Right Agenda. The Right blames TV's current "moral decay" on liberal excesses. The media can change the ideological climate of the country. With the threat of a Coalition for Better Television boycott, the networks are crying censorship (though negotiating in the back room—not necessarily because they approve of what the New Right is up to, but because they are afraid the corporations, who are cozying up to the boycotters, will use its momentum to increase control over programming content). The "creative liberals" led by Norman Lear, genuinely concerned about censorship, are developing countertactics. Meanwhile the Left, aware that attacks on "controversial" and jiggle shows are an early form of witchhunting, is preparing for battle.

No segment of culture will be exempted from the results of this battle, including popular culture, the entire educational system, the religious system, and, of course, the high-culture system. We in the art world, schooled in isolation and

atomization, may have trouble seeing how we are directly affected by events outside our sphere. Yet any analysis of high culture must begin with the location and examination of its function within the entire cultural apparatus. Hans Haacke made this clear in his article "Working Conditions" (*Artforum*, Summer 1981) where he outlined increasing corporate control of museum exhibitions and of public broadcasting's cultural entertainment packaging.

Manipulation of high culture is part of a state/corporate cooling-out process designed to reassure the liberal middleground that all is well within the status quo. It appears that Charlton Heston has succeeded with his savior act, and the cuts threatening the National Endowment for the Arts will be less severe than predicted. This will temporarily reassure the art world, but it is hardly cause for celebration. The money may stay, but the climate for funding is changing. Not only is the emphasis on "Quality" and off "populism" of all kinds, but Quality is going to be interpreted as the Moral Majority's version of Traditional American Values, rather than the (also right-wing) Greenbergian version.

At the same time, dissent of any kind is already being equated with "the international terrorist conspiracy." First Amendment rights are being eroded like all other liberal legislation. In 1981 isolated incidents involving style and intramural art politics have given way to: outright censorship (Paulette Nenner's *Crucified Coyote* removed from the Central Park Zoo show); and the arrest of artists for making artworks (a Political Art Documentation/Distribution project by Michael Anderson, who impaled a dummy corpse on the bayonet of an armory statue and was charged with criminal trespass and unruly conduct), or for trespass (Frank Shifreen, during a dispute with his landlord that temporarily closed the Monumental Show in Brooklyn). (Nenner lost at one hearing on First Amendment rights, but is appealing. Anderson was conditionally discharged; he is pursuing his own rights in civil court. Charges against Shifreen were dropped.) These are warnings it would be as dangerous for artworkers to ignore as *Fort Apache* would have been dangerous for the Black and Puerto Rican communities to ignore. They are ominously reminiscent of the "desecration of the flag" cases in the late '60s, when images (or symbols of patriotism) took on a significance denied them in less anxious times. Those who speak loudest and clearest—something artists are supposed to be good at—will be the first to get hit. The art world is a special sanctuary only if you stay within its bounds. Use your art to oppose the status quo and you run the risk of being shown precisely what we're trying to convey here: that artists are people, that the real world is closer than you think, that art and life are in the same place, if not in the same neighborhood. Make a picture that frames reality as seen by a Puerto Rican in the South Bronx, and you may discover a "*new* realism"—an art quite at variance with the notion that culture provides a "restful interlude from the stringent demands of the real world" (Mitchell Douglas Kahan, quoted in the Haacke article).

We hope it's obvious by now that we are writing in *Artforum* about *Fort Apache* not to make it into a cult film or to enjoy some condescending high analysis of a low organism. *Fort Apache* is not "just another film"—or some isolated example. It is one of a million little pieces being fit together into a terrifyingly repressive pattern that reinforces the racism and sexism necessary to maintain the status quo. It rationalizes and reaffirms the reasons why those who are on top are on top, and keeps those down who are down. CAFA and organizations like it emerge to interrupt the flow of misinformation, to replace the absorption of

distorted facts and false values with the tools for questioning, analyzing, and resisting them. Art is good at this, too, and CAFA as a cultural voice used some of the same provocative strategies employed by artists in another arena. All too many high artists, though, have been deprived by conditioning of the means to use their tools effectively.

Without a certain level of political consciousness, the contradictions and flexibility on which hegemony is based become too confusing to cope with. For instance, an oppositional movement defying the mass media is at the moment largely dependent on these same dominant media to spread the word. CAFA had to utilize the spaces in the infrastructure afforded by the competition between news media for news and audience. Similarly, by writing this article for *Artforum* we are doing what Haacke does, resorting to a kind of homeopathic remedy using part of the dominant high culture to criticize the function of the whole. While this process gives visibility to a movement or a message, it can misrepresent it. We are constantly being warned against commercialism from within the art world (yet!) and told to rock the world only inside the gold frame or the bank plaza. Our schools tell us to imagine that there are no limits to our imaginations, but that there are very clear limits to how far our images can go. On the left, we tend to be oversensitive to the dangers of cooptation—used in another way to scare dissidents away from communication with an unconverted audience.

There is also the danger that when "elevated," the fragments of opposition will float harmlessly on the surface of the dominant culture, defined only by the strictures of that context—rather than floating *intentionally,* sticking out like a sore thumb—which is the general role of oppositional culture. Nevertheless, an increasing number of oppositional artists are beginning to recognize that they are not so alienated from the art context as some would like us to think, that there is a constituency for activism inside as well as outside the art world. Criticism of media is a crucial meeting place for artworld and real-world concerns—a conjunction that misfired because of divisive tactics in the early '70s, but which now seems to be growing up to its potential. The days when films like *Fort Apache* could not be treated in the high-art media are hopefully giving way to the necessity for a vitalizing cross-fertilization, a blurring of those boundaries that benefit the establishment.

The activist art being made today is not the same old "political art" that was docilely contained or ignored or voluntarily isolated in the '70s. It is moving to incorporate social involvement as well as social concern. It is an advocacy art, taking advantage of the traditional notion of art as passionate and subjective but without swallowing the incommunicative element this is supposed to ensure. The subjective advocacy not only of individual but of collective rights is one of the ways progressive culture can avoid the pitfalls of cooled-out "neutrality."

Certainly it is clear that the development of an activist art is dependent on interactions with broader social movements. The next step in the ideological conflict is the development of our own economic base, of our own networking and distribution systems, to allow for further expansion. We will be doing this in an atmosphere of cutbacks and social unrest and legislation designed explicitly to keep us from expanding. CAFA is, therefore, a model to study carefully, as is the whole national media activist movement (an important part of which is emerging from the Asian community on East and West Coasts). These groups are at the moment better equipped than most fine artists to see what's going down.

Among the first things the new Republican-dominated Senate did was to set up a Subcommittee on Security and Terrorism (SST); a similar committee is pending in the house. SST is a born-again HUAC, and its leader, Jeremiah Denton, is reincarnating McCarthyism. Witchhunting is back. Suggested targets include such "terrorists" as *Mother Jones* magazine, the Institute for Policy Studies, Tom Hayden's Campaign for Economic Development, and the Mobilization for Survival. Reagan is preparing an Executive Order (which requires no congressional approval) to broaden the FBI's domestic spying base, at the same time that CIA Director William Casey has decided to cut out agency briefings for reporters, so as to "tighten security and reduce the visibility of the C.I.A." (*The New York Times*, May 28, 1981). This amounts to shutting down the competition, because as Sean Gervasi, a former consultant to UNESCO, said on a panel in June, "The C.I.A. is the largest news agency in the world today. They define the climate of opinion. By UNESCO estimates in 1978 they were spending almost $300 million a year; they had 1000 men in the field; they had 2000 people in the U.S. manufacturing lies into reality" (reported in the *Village Voice,* June 17-23, 1981).

So what's a wolf ticket anyway? On the street it's a warning. It's mind and mouth defeating stronger opponents by huffing up and blowing them away. It's sniffing out the agenda buried beneath the "truths" binding high and mass culture in a symbiotic embrace. It's the rap we've been slipped on our way to a right-wing con. It's an artwork. It's not an artwork. It's the not unconquerable dilemma facing artists and activists alike. It's winning against the odds. You get sold a wolf ticket, and you get embalmed in the status quo forever. You cash in a wolf ticket, and you get a shot at social change.

Long-Term Planning:
Notes Toward an
Activist Performance Art*

Performance art (together with sibling video) currently stands before its own crisis. It has the possibility to reach forward for an art of estheticized social content, or it can let itself fall back into the congealing pool of an "art history" that History itself has already supplanted. —KENNETH COUTTS-SMITH, 1978

The visual artist's need to invent "performance art" in the late '60s indicated some deep failure of the communicative potential in modernist painting and sculpture. At the same time it was also a hopeful symptom of resistance against the way art objects are isolated and used within capitalism. Commodities don't talk back. The

*Reprinted by permission from Bruce Barber, ed., *Performance as Social and Cultural Intervention*, special issue of *Open Letter* (Toronto: Coach House Press, 1983).

progressive artist's move from social concern to social involvement is embedded in performance art's own relatively short history.

California artist Daryl Sapien has described performance art as "the medium of transition," historically appearing in the interstices between prevailing art consciousnesses. It may also be transitional for individuals, quite literally providing a way of acting out one's fears or awareness and reaching toward a supporting sense of unity with one's audience. Performance parallels the '70s interest in so-called "primitivism" in that it goes back to the roots, to the bare bones of artmaking—the artist acting out artmaking, confronting the audience with this process. The number of people witnessing even a much-repeated performance may be smaller than those who see a much-exhibited canvas, but the intimacy of the interaction makes up in intensity what it loses in numbers. The need to speak out, to know one is being heard, is not, of course, limited to activist artists. That need has motivated the last fifteen years or so of a lot of relatively neutral experimental art; it absorbs the whole notion that the artist is part of the work, whether as autobiographer, fictional protagonist, self-reflexive body artist—or merely as speaker on the art school circuit, accompanying her/his slides with personal anecdotes. ("The artist will be present"; question is, will the artist have presence?)

Progressive performance art didn't just emerge from the art world. Its other parent was the general culture—feminism, street theatre, community arts, liberation movements, or media actions by nonartists, as when the Young Lords occupied the Statue of Liberty and hung from it the flag of Puerto Rican Independence, or when Abbie Hoffman did his various and often questionable media manipulations. Nor did progressive performance art disappear in the '70s, although it did go out of mainstream sight and academic mind. The most interesting work was being done in the public domain on the West Coast by feminists working out of the Los Angeles Woman's Building. By 1980 these models had seeped back into the artworld consciousness, along with those emerging from grass-roots organizing and militant opposition to the Reagan government.

Now and then I hear artworld denizens complaining about any and all "political art" that "it's like going back to the '60s; the '60s failed, so why try again?" Such attitudes not only demonstrate ignorance of the entire grass-roots cultural movement of the '70s, and of the vast social differences between the '60s and the '80s, but they also recall the treadmill on which avant-garde artists run in place under the impression they're "advancing." The treadmill itself is a product of the same cult of immediacy, fragmentation, planned obsolescence and instant playback as the culture imposed on the masses. Passivity is the fate of the audience in both "high" and "low" art today. The sense that everything will be different again tomorrow and still different again the next day discourages the hope that any action can be meaningful. As on network television, pluralism and posterior fads—post-this-and-post-that movements—are desperate tokens of the need to go *some*where, *any*where, reflecting a fear of history, of being caught up and forced to deal with history, a fear of being put stylistically in one's place by history, being "put back" as in grade school to a class of hasbeens or sufferers from the it's-already-been-done syndrome. As the Today show gives way to the Tomorrow show, the present and future emerge as a montage with no connections, a collage with no glue—or maybe PAC-MAN is a more timely metaphor.

People's lives are, of course, the fragments blowing in controlled randomness, and artists are no exception except for the fact that they tend to view

such a situation as freedom rather than control. Perhaps the myth most dangerous to performance art's social potential is that "artists are free, not at the service of any political line" (as Laurie Anderson put it in March 1981). This delusion threatens the intimacy and directness of all visual arts in its implication that political clarity is neither necessary nor compatible with esthetic integrity (which is my term for Quality). Such "freedom" often results in simple deracination and alienation, the forced espousal of anarchy and ambiguity because political commitment and clarity are seen as somehow "unfree," therefore antiesthetic.

Laurie Anderson is an interesting example of a serious artist and dynamic performer who has channeled much of her alienation but is still in an early stage of political consciousness. I know how matronizing this sounds, given her immense popular success, but analysis of her position shouldn't be taken as an attack. The feelings she so forcefuly conveys, with which her audiences clearly identify, are significant. Anderson came into more or less "political" performance from a familiar artworld position: "I'm really bored with working with things that can only be judged in esthetic terms," she said in 1981. "That's not enough anymore. I wanted to look at something more or less real, although the more I looked at these particular political issues, the more unbelievable they became. I'm interested in facts, images and theories which resonate against each other, not in offering solutions."

It would be naïve to offer solutions, and the collage method is one of my own favorites. However, there *is* a choice between not offering solutions and blocking the possibility of considering solutions, between clarifying issues and obscuring issues, between leading the audience to think for themselves and leaving them thoughtless under a performer's seductive control. These problems in liberal performance art can't be whisked under the rug of refusal to be dogmatic. When Anderson says, "Politics is about problem-solving. I wasn't trying to solve any problems, I was simply looking at problems and using them for my own purposes," I feel uneasy. My own understanding of politics is not problem-solving by politicians but the intelligent autonomy of a politically conscious people. At the same time, Anderson touches a distinct communal nerve when she says, "I feel helpless politically, as I think a lot of people do. . . . I don't see how it could be any other way after being able to see your own power in the '60s."

Actually, artists probably have more potential power in the '80s than we did in the '60s because we know more now. Also we are closer to the '60s than the '60s were to the '30s—the last progressive culture peak—and many of us can build on our *own* experiences, not those of our parents. This is not to say Anderson's frustrations aren't real. We all feel them. But the stylish "political look"—grainy photos, black and red swashes, guns and victims—used by many artists outside of any ideological framework simply blurs and weakens the possibility of a more effective political imagery. (Performance art has its own repertory of violence and cheap shots.) Positive militancy and rage get confused with angry infantilism; revolution, terrorism and state terrorism merge into a mere *effect*—dramatic, but satisfactorily meaningless to any political reality. Perhaps it's time that apolitical artists simply moved back into their own primarily esthetic territory. It would be the socially responsible decision for the artist who has decided to take no social responsibility, though I suppose it's a bit too much to hope for. I'd certainly prefer a deepening to a surrendering of consciousness.

The delusion of cultural powerlessness keeps artists angry adolescents in a

patriarchal world. It also leads people to picture "political art" as a creature of the Left alone, and to ignore the grip of the political status quo on the arts. An artist who likes to present her- or himself as "political" without bothering to examine his or her own politics is of service to no political line except the ruling one. All cultural practice represents a definable politics; denying this produces an art at the mercy of manipulation by the dominant culture and ignorant, in turn, of that manipulation. The artist's sense of powerlessness parallels in the cultural domain the powerlessness in the real world that makes working people passive in the face of government harassment. Both are producers, without whom those who profit from production would be profitless and powerless. Yet both have been separated from those who would provide them with the support and solidarity from which power springs. Artists have received their spurious freedom in exchange for a gilded cage, and even the glitter is a delusion. One way this happened was through separation of producer and consumer—the specialized compartmenta- tion which is the specialty of capitalism. Performance art, as an interdisciplinary medium, as a hybrid, stands a chance of subverting that barrier by interpreting the world directly to its audience, without benefit of commercial clergy.

When I organized a "political performance art series" at Elisabeth Irwin High School two years ago, the title—"Acting Out"—was initially disapproved by the school's director because in educational parlance it means Bad Behavior. In the artworld too, acting out instead of hanging out (or in) is not quite cool. One of the problems a lot of activist artists have is that they are made to feel foolish because they care, because they *believe* in what they are doing. Sincerity, earnestness, commitment, passion, and the big one—Democracy—are hardly fashionable in to- day's laid-back or neofascist ambience. So they get muffled in academic rhetoric, semiotic complexities, intramural squabbles and qualifications of qualifications until they're barely recognizable. *Then* the work is acceptable; it is defused through overdoses of irony and ambiguity; the audience is rendered passive again through incomprehensibility and we're all back under control.

In order to combat the prevailing cynicism, pessimism and defeatism, it seems to me one simply has to *believe* the message one is trying to convey and believe it passionately enough not to be embarrassed by the necessity to convey it. At the same time, obviously, the believed material has to be authentic, based in shared experience, complex and moving. Not a small job, but if we're all so free, it shouldn't be a problem.

The balance between personal and public meaning is crucial. Performance art is well suited to deal with the ways "the political is personal"—which is not the same thing as "the personal is political," though they meet somewhere in the mid- dle. It seems very important at this historical moment that our arts reflect the ways this apparently uncontrollable world affects our emotions and our lives. It's not an easy issue to analyze, and people of different ages and backgrounds think about it differently. Nevertheless, we need to focus culturally not only on inward relationships but on the broader outward relationships that control them—on why we are in this situation and who got us there and what we can do about it. People (audiences—or constituencies) have to be free to choose whether or not to be convinced; at the same time they must be given enough information to make their own choices intelligently. The educational aspect is incompatible neither with art nor with mass culture, as Brecht has taught us. (Herbert Schiller says "the idea that TV entertainment is not instructive must be classed as one of the biggest

deceptions in history.'') Nor is art incompatible with entertainment. The taboo that equates "crowd-pleasing" with "bad art" can be traced to a reading of crowd-pleasing as rabble-rousing.

There is, in fact, a distinct element of red-baiting in the pervasive notion (in the United States) that if an artist has done her/his homework, developed a political analysis and dared to apply it to culture, then that person is "no longer an artist," is "authoritarian," "rhetorical," "fanatic," "sentimental" or even (amusingly) "Stalinist." I worry about this, not only because I'm sometimes seen as one of those Stalinists, but because such red-baiting *can* be effective. Many young artists whose principles would naturally place them left of center are afraid of the Left. One such person, whose art I respect, told me he couldn't publicly call himself a "political artist"—not because of the stigma from the Right, but because he feared accusations of political incorrectness from the Left. Unfortunately his fears are well-founded, but at the same time the protective defeatism and frequent cynicism engendered by this conditioned resistance to critical discussion can be disastrous to the development of a strong progressive art.

Performance art contains the seeds with which to deal with this problem, since it is essentially confrontational. Context is a critical factor, dealt with so extensively over the last decade that it should suffice here simply to recall that the most sophisticated progressive artists have long "coded" their work for different places and people. This is not a matter of talking up or down but of understanding social locality. It's obviously dumb to deny oneself communication by sticking to an oblique artworld form when confronted with an audience that has no key to it; it's also dumb to be red-baited into an all-out avoidance of "propaganda" because of artworld taboos. Propaganda for what one believes in is nothing to be ashamed of, especially if one respects the intelligence of one's audience. Recently, I was struck by a simple remark in *Fuse* by Frank Love, a member of the Progressive Arts Club in the 1930s. He said about a play they did on unemployment and welfare, "most of the people in the audience were out of work. They were just going *through* what they saw themselves, and so *they* didn't consider it a 'propaganda play.' "

Any good community worker knows how knowledgeable many "ordinary people" are about political issues that affect them directly. Twice last year I saw this achieved culturally: First with Vanalyne Green's *This Is Where I Work,* performed for an audience of Wall Street secretaries at lunch hour by an artist who earns her living as a secretary. Afterwards, she dispensed organizing material for a clerical union with coffee. The second time was District 1199's *Take Care Take Care,* a musical labor revue performed for hospital workers and written from their own oral history workshops. There was the same kind of delighted response to lines barely comprehensible to an outsider.

In fact, most of the impressive social performance art being done today does not consist of single theatrical episodes, no matter how marvelous, but delves down and moves out into social life itself. There is an increasing number of artists working all over the world who are devoting themselves to an ongoing, high structured art conceived not as an esthetic amenity but as a consciousness-raising or organizing tool, media manipulation, or "life frame" (to use Bonnie Sherk's phrase). Their work is a long-term *exchange* with an active rather than a passive audience. It concerns itself with systems critically, from within, not just as reactive commentaries on them.

The Waitresses, *All-City Waitress Marching Band* at the Doodah Parade, Pasadena, California, 1979. (Performers visible in photo: Jerri Allyn, Cheryl Swannack, Cheri Gaulke, Vanalyne Green, Chutney Gunderson, Jeanne Shanin, Maisha Green, Anne Phillips, Rita Rodriguez, Diane Duplate, Annette Hunt, Terry Bleecher, Lynn Warshafsky, Elizabeth Irons). The Waitresses, a feminist performance-art group, originally worked out of the Woman's Building in Los Angeles. Their focuses are women and work, women and money, stereotypes and sexual harassment, all of which they incorporate into their performances in restaurants and at labor conferences. The Waitresses also functioned as a political art group, giving lectures, workshops and videos. (Photo: Rebecca Villaseñor)

Many of these artists are women, many from California, where throughout the '70s, the Los Angeles Woman's Building provided a fertile center of support and collaboration for groups like The Waitresses, Mother Art, The Feminist Art-workers and Sisters for Survival. Many of the individual artists began in the early '70s by dealing with gender and role-playing, enjoying the liberating sense that they could choose personae other than those imposed by social background, sex, race, and conditioning. Artists like Suzanne Lacy, Adrian Piper, Eleanor Antin, Martha Wilson, Martha Rosler and Lyn Hershman flaunted their independence from or awareness of historical and biological destiny in performances that reached out into the public domain.

This phenomenon was part of an exhilarating and necessary exorcism, especially for feminists, but there was a tendency to stop at self and forget about society. As Bruce Barber has said, "beyond the looking glass of modernism, we reduced ourselves to roleless beings needing to assume a multiplicity of roles." After a while what had begun as a revolt began to look as if it were indeed all done with mirrors. We found ourselves wanting windows into the outside world again. With growing political consciousness, some artists used their acquired personae to extend their own and their audience's experience to that of other races, classes and cultures, trying to do so without falling into a condescending cultural imperialism.

Suzanne Lacy, in particular, working within an opposition to violence against women, followed this path from individual disguise (becoming, among other things, an old woman and a bag lady) to collaborative works with an Asian woman *(The Life and Times of Donaldina Cameron)* and a Black woman in Watts *(Evelina and I: Crime, Quilts, and Art)*. Then she embarked on a series of

large-scale, long-term public campaigns based in media analysis of feminist issues, framed as correctives to the way the dominant culture distorts and sensation-alizes these issues. From 1977, sometimes working as "Ariadne: A Social Art Net-work," with Leslie Labowitz and other women, she made a float for a Women Take Back the Night parade in San Francisco and two complex, extended pieces in Los Angeles—*Three Weeks in May* (about rape) and *In Mourning and in Rage* (about the Hillside Strangler murders). All of these works can be considered per-formances as wholes, but they often incorporate several short specific perform-ance pieces and images into those wholes. Outside of a gradually developing political demonstration performance art, Lacy seems to be the only artist looking back to the history of labor tableaux and political mass pageantry. Her series of dinner parties as performances similarly introduce local history and organizing in-to art. The most recent piece—*Freeze Frame: Room for Living Room*—involved a hundred women from hugely different backgrounds divided into small groups and talking about survival in the open-walled "rooms" of a San Francisco furniture showroom. Combining real conversations with choreographed activities, it received enthusiastic press from outside the art trade papers.

In New York Mierle Ukeles has developed a model of long-term hybrid per-formance work since the late '60s. She began to have children and realized how little time she would have to make art, so she began documenting her domestic routines as art. When the kids got older, she began to work with maintenance systems in broader social contexts, beginning with art institutions, then office buildings, and most recently an ongoing project called *Touch Sanitation*. To over-simplify, it consists of Ukeles shaking hands with every one of 8500 men in the New York City Sanitation Department. (She was made, in the process, a Deputy Sanitation Commissioner.) The offshoots of this ritual included public relations and organizing with the men and their families as well as the media. Long con-cerned with what she called "the real sourball—after the revolution, who's going to pick up the garbage on Monday morning?" she sees her work with degraded domestic and maintenance workers as a feminist strategy (who else but women clean up the shit?) and has used it to evolve a support network that calls attention to all service work.

Bonnie Sherk's six-year stint as founder-director of the five-acre *Farm: Crossroads Community* in San Francisco, Stefan Eins' art-as-storefront gathering place at 3 Mercer Street and at Fashion Moda in the South Bronx (which he calls not an alternative space but a "cultural concept"), and Dan Higgins' Photo-Lounge in Winooski, Vermont, are communal performance activity *places* as pieces. Nil Yalter's and Nicole Croiset's work with Turkish and Greek immigrants in France and Germany; the Woman's Building's *Incest Project;* Miriam Sharon's "Desert People" performance series linking Bedouin women and Tel Aviv waterfront workers; Gloria Bornstein's *Soupkitchen* film, theatre and organizing pieces in Seattle's Cascade community are among other major examples of this "long-term" syndrome.

Among the liveliest such works is *Carnival Knowledge,* a large and loosely knit collective originated by Anne Pitrone and Lyn Hughes that has created a traveling streetfair subtitled "Bazaar Conceptions" ("See Men, Women and Children Fight the Moral Majority!"). It aims at educating a broad public on reproductive rights, takes on the antiabortion forces, the threatened Family Pro-tection Act, Human Life Statute and/or Amendment, the Chastity Bill and the Hyde

Amendment, and does so with higher spirits than any of these depressing legislations deserves. Games, performances, booths and other participatory events are the often hilarious vehicles by which important information is painlessly conveyed in art, feminist and political contexts (such as on the fringes of "Pro-Life" conventions). My favorite piece is Suzanne Fraser's tableau where the viewer can squeeze the balls of right-wing senators, causing a party popper to leap from a map of the states they represent.

Harder to categorize is the less visibly coherent incorporation of not-obviously-art-activities into one's art production. Jerry Kearns, for instance, sees his roles as "creator and curator" overlapping, envisioning himself as a "producer" (like a TV producer), as well as object maker. He includes his functional photography (used for the Black United Front and other groups to document, publicize and organize politically), his collaborative performances, and his gallery-oriented photomurals as inseparable from his organizing work with PADD or his introduction of other artists (the Black singing duo Serious Bizness, young rappers Susan Hargett and Ray Serrano, or the entire choir of the House of the Lord Church) into art contexts they would not normally appear in.

Similarly, Diane Torr brings to performance art spaces her inventive colleagues from New Jersey strip joints; Tim Rollins introduces the work of learning-impaired children he teaches in the South Bronx; and Carole Conde and Karl Beveridge in Toronto, and Fred Lonidier in San Diego make their art as work in and out of the trade unions. All of these artists might be considered heirs to the Duchampian theme "It's art if I say it is," transformed by social involvement into an effective as well as an affective mode of bridging the infamous "gap between art and life."

In meetings of progressive artists' groups, a frequent complaint, or self-criticism, is that theatre, music, dance and film, as well as poetry and radio, are more emotionally and politically affective (and effective) than painting and sculpture. This doesn't just reflect the visual artist's insecurity in the world, but is also a realistic assessment of the way people are moved to action—common knowledge in all political movements, Left and Right. (During the recent electoral farce in El Salvador, the fascist ARENA party blandly admitted its campaign strategies were borrowed from two sources: multinational advertising and the cultural Left). Artists, like teachers and the media, interpret the world for people, which could be, should be, and in the case of the mass media *is* a form of control *par excellence*. Both in its potential for intimacy and in its potential for mass pageantry, performance art could maintain the symbolic single-image strength of conventional mediums and augment it with the moving, rousing elements of the arts of and in time. While not *inherently* any more politically effective than any other medium, performance does have the advantage—on however small a scale—of breaking down the object/maker/spectator barriers and using that control democratically. Properly distributed, performance can be a way of giving voice to the disenfranchised through exchange and dialogue, unlike the "mass culture" to which no one can talk back, except through the medium of boycott.

Performance's potential responsiveness to a great diversity of experience, needs and issues is, however, totally dependent on access to and empathy with diverse audiences. By diverse, I mean different specific audiences, not a homogenized "everybody out there." Most performance art audiences consist of

other performing artists or professional artworkers, which has led, in New York at least, to a sloppy incestuousness that works against both communication and high standards. This is called, in other contexts, preaching to the converted—or maybe it's preaching to the unconvertible, since specialized audiences seem to prefer boredom to messages; our sense of ourselves *as* specialists seems to be threatened by any hint of "didacticism," even when we have plenty to learn—another example of the authority problem which marks the adolescent position of the artworker in society.

Oddly, political messages are more acceptable in the conventional theatre than in the "free" art world. So it may be a hopeful note that performance art since the late '70s has made a marked move back toward theatre. Along with a more organic infusion of vitality from the rock music scene, this has broken down the taboos against entertainment and can be seen as progressive in its lessening elitism and exclusivity. On the other hand, it may also encourage political as well as artistic conservatism. Much of social performance art's impact in the art world is probably due to its rough edges—a certain seductive exuberance. Performance audiences, on pillows on the floor, are more willing to take their chances, risk being bored or provoked, than the same people sitting in more expensive theatre seats.

This raises the whole question of amateurism/professionalism, which in turn recalls similarities between art and industrial work—in the ways the unskilled producer surrenders control over the means of production. It's been said that theatre is a collective endeavor and art is an individual one. But much art has been gradually collectivized by incursions from and into video, film, dance, music and theatre itself, where collaboration, or at least cooperation, are necessary technical components. This in itself is a progressive step, merging with the collective character of feminism and the Left. Collectivity also gives courage. Direct intervention into social spaces by artists accustomed to working individually is increasing as mutual support increases (and, alas, as public financial support decreases).

In the early '70s, most performance artists came out of visual art schools and studio backgrounds. By the end of the decade there was an influx from legitimate theatrical training in drama and communications. As a result, there is growing resistance, even by the non-professionally trained, to the idea that "anyone can do a performance." I have mixed feelings about the issue, because I'm an occasionally performing amateur myself and since 1978, when I did my first pieces, I've learned from it a lot about getting messages across. At first, I called what I did *Propaganda Fictions: A Fairly Dramatic Reading* because I was terrified of being accused of trying to be a performance artist. These *were* "fairly dramatic," for better or worse, and I was so nervous about doing them and so frazzled and emotional when I'd finished, it never occurred to me to have the discussions I always included with my ad lib "lectures" (which might also have been called performances, since they were improvisations in collaboration with the audiences).

Gradually, however, I began to realize how rarely social performance art actually includes the audience. Early in 1981 Joan Braderman, Mike Glier and I collaborated on a performance called *Help! I'm Being Helped!* which incorporated video, mural-scale drawing and acting out. It was about the ways we're manipulated by the media, and it ended with a series of rhetorical questions designed to make the audience think and act. In fact, it had the opposite effect on

some people, who felt we were manipulating them the same way the media manipulates all of us, because they couldn't really let us know what they knew.

So when Jerry Kearns and I began collaborating on slide-show performances (this time called "docu-slide dramas"), we decided the discussion had to be an integral part of the work. It's still kind of anticlimactic, breaking the illusion of our performance personae. But in a sense the discussions allow us to have our cake and eat it too. They demystify and offer identification at the same time. They serve different functions in different pieces, but they always allow us to propagandize more directly, to become "human" and speak directly to other individuals' needs and responses. Performance art, because it *is* a form of acting, offers a model for action. The audience can identify with those who are doing something in front of them and may be tempted to act, too, or rethink how they are acting. The incorporation of dialogue, then, introduces the Brechtian notion of critical distancing *from* the performers without sacrificing the emotional force of illusory identification *with* the performers. Ideally, the audience can be weaned away from the performers to acknowledge the fiction's force and carry it into nonfictional reality. Paradoxically, this process takes place within a more intimate or familiar interaction—the "discussion period." Discussion also allows for direct criticism, which is valuable for the performers and comprises action in itself. The goal is for the audience to lose, then find itself.

It remains to be seen whether performance art is concerned with outreach and political immediacy only in the limited sense of its artworld predecessors—streetworks, site sculpture, hit-and-run community work dragged back into the gallery system—or whether its dialectical history can continue to evolve new models for a truly public art, even lay the foundations of a real revolutionary program, an authentic cultural democracy. The intense discussions, arguments, fights about the proper balance between an artist's autonomy and political clarity will continue, engendered, at times enriched and at times debilitated by current political struggles. A fusion of action and analysis will be most effective if it's forged between artists and audiences, which means groups, and meetings and other dread responsibilities for the rugged individualist. As Coutts-Smith said, "Ultimately we are changed by art when we are permitted the potential to change it; interpenetration implies alteration."

It may be that performance art as a socially responsible medium is indeed transitional and will soon be absorbed into other political activities like labor, community and street theater, or a new kind of demonstration-protest art. Or it may be that with its initial vitality spent, it will have been valuable mainly as a learning process. Because labels are usually meaningless, though convenient, it doesn't matter if activist performance art becomes indistinguishable from agitprop or experimental theater or high art. At the moment, however, its uniqueness as an interventional technique lies in its fusion of contexts, including the empathy, militancy and exchange of a progressive activism, as well as the layers of complexity that come to it from the tarnished domain of high art. Mainly, it will be a matter of knowing why one is using these forms . . . and to say what.

"Aroused consciousness—the ultimate strength of human existence—is perhaps the only reliable force which can lead to change in the material-institutional environment."

—HERBERT SCHILLER

Activist Art Now

(a picture essay)

The following picture essay represents only a fraction of the work that was being done in 1982 around the world to develop a form, theory and distribution system for activist art. Making the choices within space limitations was a painful process, and this section is simply intended to suggest the diversity of practice, to augment the art reproduced in the rest of the book.

The relationship between art and struggle changes, according to the historical moment, the place and the issue. There is no clear model for what these artists are trying to do. What follows is the early stages of a social-change art that will be more developed even by the time this book appears. One thing is clear—that systems are changed by challenging their institutions, not by abandoning them to the opposition to do as they will. Thus the work these artists make exists in a dialectical relationship to the work they and others make in the high art world. They are walking a tightrope between art world and real world, esthetic and political effectiveness, trying to deal with the false conflicts on which the dominant culture bases these separations. The contradictions in which they work are part of the art they make.

Culture is embedded in all our lives. When the "authoritarians" and the "totalitarians" attack, they go for cultural freedoms as well as for political and economic rights. No real progress can be made without coherent independent organizations strong enough to pressure the system into change. Thus many of these artists work collectively and collaboratively. The cultural democracy we are all fighting for is a kind of affirmative-action program. It omits nothing, but rather adds to existing high art a decentralized, heterogeneous expression arising from grass roots as well as from professional production. It is the result of applying a socialist analysis to the *uses* of culture rather than to its forms alone.

Mike Glier, *White Male Power: Equestrian Statue with Citizens,* 1981, oil stick on canvas, 48½" x 100½". (Photo: D. James Dee)

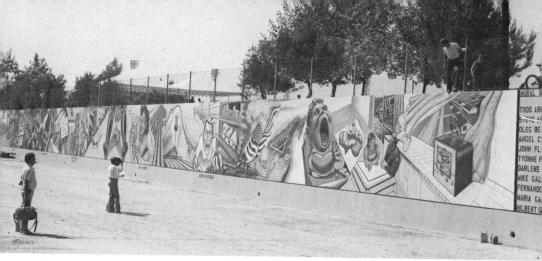

Judy Baca, supervisor, *The Great Wall of Los Angeles,* Tujunga Wash, Los Angeles, 13′ high by 1/3 mile long, 1976 to present. The mural was executed by young people from a great variety of ethnic backgrounds, but especially drawn from the Chicano community to which Baca herself belongs; some were employed while on parole from the juvenile justice program. The mural reveals the history of California from a Third World perspective and, so far, runs through the 1950s. It is a project of SPARC (Social and Public Art Resource Center) in Venice, California, directed by Baca. (Photo: Linda Eber)

Buster Simpson, *Shared Clothes Lines,* May 1978, Seattle, Washington. The line crossed Post Alley in the Public Market's Historic District, connecting five stories of the Pike and Virginia condominium with the Livingston-Baker low-cost apartment building. "It was a shared amenity between two different social/physical urban structures. When the wash was hung out from either end, from personal to public space, the clothing took on an element of banners of occupation/occupancy. On Sunday, 1978, yellow cotton was displayed as a solar clothes dryer demonstration. In the summer of 1978, during a Post Alley Street Fair, brightly colored polyesters were hung as a festive aerial display. When the wind was up and the line was bare, a low-frequency aeolian harp phenomenon was heard, resembling wind in the trees. Sometimes you could just about hear Johnny Horton out there singing 'whispering pines, whispering pines, tell me if it's true . . .' " (Buster Simpson). (Photo: Lewis Simpson)

Steve Cagan, *Demolition for National City Bank Building, Cleveland, Ohio, 1978*. "Ohio law allows cities to grant tax abatements for new construction in areas designated as 'blighted.' The Cleveland City Council declared one of the busiest downtown intersections a 'blighted area' in order to give an abatement to National City Bank, one of the most profitable banks in the country. NCB would undoubtedly have built in the city in any event. A number of old-line smaller businesses were eliminated as their buildings were razed to make room for the new, sterile NCB headquarters building." (Steve Cagan works with the *Cleveland Beacon* and uses his photographs as educational and organizational tools within the labor movement and other social struggles.)

Jerry Kearns, *Ground Zero,* 1980–82, hand-tinted photoenlargement on acrylic-painted wall, 76″ x 84″.

Carole Conde and Karl Beveridge, *Work in Progress–1928* (color photo from a series of eight), 1980–81, 16″ x 20″. These tableaux reflect the history of Canadian women against an interior and exterior backdrop of domestic and international history. (Photo: the artists)

Lee Quinones, *Allen Boys*, mural on Allen Street, New York City, c. 1981. Commissioned by the Allen Street Boys. (Photo: Jerry Kearns)

Michael Rios, *Homenaje a Frida Kahlo,* billboard, Galleria de la Raza, San Francisco, 1978. The billboard outside the gallery in San Francisco's Chicano Mission District was "liberated" from the billboard corporation and has been used ever since as a community arts bulletin board.

Tim Rollins with 15 kids from the South Bronx, *Ignorance Is Strength,* 1982–83, 5′ x 11′ paint on the pages of Orwell's *1984* (excluding the last page). Rollins teaches art and reading to illiterate and problem teenagers in a junior high school on Kelly Street in the South Bronx. In this case, Orwell's text was read out loud, the students drew, and then they collectively edited the results and composed the large work. The idea is to connect the imagery of the novel to imagery of daily life in the South Bronx. The finished paintings, says Rollins, "are ideological battlescenes and they portray the epic, furious combat that we *all* do daily in our wars between inculcated, fatalist belief and the oppressed, buried and yet deep-rooted will to make radical social change." (Photo courtesy Group Material; photograph by James Hamilton)

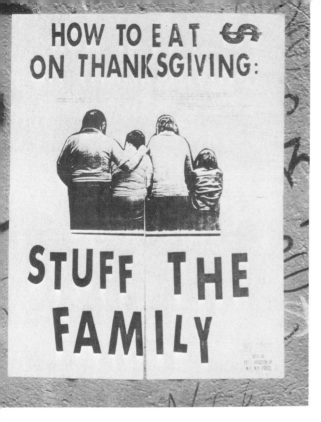

Anne Pitrone, *NY LOST series, Holiday Safety #2, Stuff the Family,* November 1979, xerox, 17″ x 22″. The poster appeared on the streets of Lower Manhattan and also was installed on the pulpit of St. Patrick's Cathedral at the noon mass for the movie *God's Police* by R. Cooney, J. Mendez and J. Stein, 1980. (Photo: Deb Destaffan)

Group Material, "Primer (for Raymond Williams)," installation of collective exhibition on red walls at Artists' Space, New York, May–June 1982. (Photo: Kenji Fujita)

Cecilia Vicuña, *What Is Poetry to You?* In the house of prostitution. Still from a film made in Bogotá, Colombia, 16 mm color, 1980. (Also included in the "Working Women Working Artists Working Together" exhibition mentioned below.)

Lorna Simpson (with Irene and Rejendra), *Untitled,* 1982, mixed media. This piece was made for the exhibition "Working Women Working Artists Working Together" at the Gallery 1199 of District 1199 of the Hospital and Health Care Workers Union, New York City, a Bread and Roses Project organized by Candace Hill-Montgomery and Lucy R. Lippard, in which artists collaborated on artworks with working women. The text on the dress tells the story of the housemaid who is the subject of the piece. (Photo: Jerry Kearns)

The Causes of Lesbianism:

a simple guide in pictures......

by Jo Nesbitt

It's a lesbian!

biologically determined?

disappointed wife transfers affections to Daughter..........

mother's fault

The Distant Father......

father's fault

Jo Nesbitt, *The Causes of Lesbianism: A Simple Guide in Pictures* . . ., from *Sour Cream* comics, London, 1980.

Tony Rickaby, *Festival of Light, 21a Downing Street, London W1,* 1978, conté drawing (from the series "Fascade" showing the building fronts of right-wing organizations), 19″ x 15½″. "The Festival of Light was formed by ex-missionary Peter Hill as a crusade for 'love, purity and family life' and against 'pornography and moral pollution'. It attracted the support of the Prince of Wales and of such right-wing figures as Malcolm Muggeridge, Peter Thompson and Mary Whitehouse in agitating for censorship of the media."

Seth Tobocman, "Hermies," from *World War 3*, no. 2, 1981 (collective comic book).

Jay Kinney, detail of *Too Real* from *Anarchy Comics,* 1980.

Gloria Bornstein, *Soupkitchenwork,* 1979–81, a performance report and protest on the destruction of the Cascade community, Seattle. Streetworks, performance and film executed in collaboration with the dispossessed residents of the neighborhood over a two-year period, culminating in a shadow-play/film at a local church; cutouts by Payton Wilkinsen. (Photo: Randy Eriksen)

Lyn Hughes, from *Media Photos,* 1980.

Q. How is this Carl's Jr. hamburger a threat to Women's Rights?

Q. Where is the irony in this Carl's Jr. billboard?

Barbara Margolies and Mary Linn Hughes, *Know Your Corporations Artwork,* 1980, two postcards with captions on reverse. The cards were enthusiastically received and widely dispersed in the streets, in restrooms and at Carl's Jr. restaurants; in one case they were used in a successful city council fight to keep a new Carl's Jr. from opening.

Index